Scotland 1907

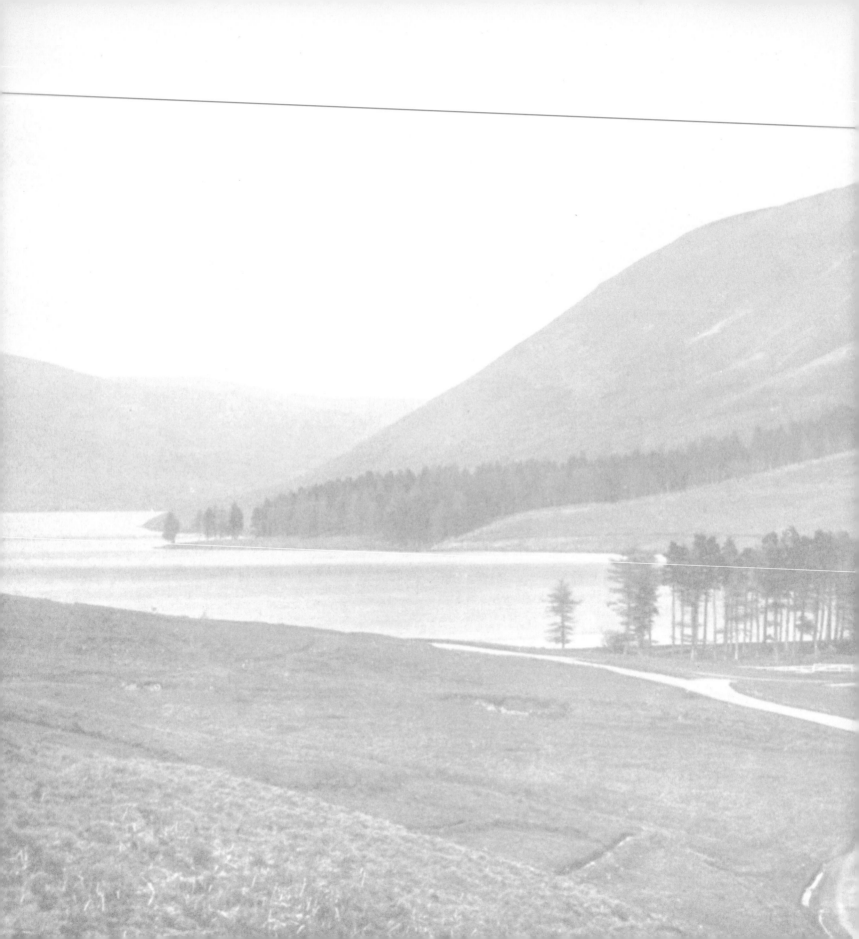

R. J. MORRIS

Scotland 1907

THE MANY SCOTLANDS OF VALENTINE AND SONS PHOTOGRAPHERS

BIRLINN

First published in 2007 by
Birlinn Limited
West Newington House
10 Newington Road
Edinburgh
EH9 1QS

www.birlinn.co.uk

Hardback
ISBN13: 978 1 84158 514 7
ISBN10: 1 84158 514 9

Paperback
ISBN13: 978 1 84158 660 1
ISBN10: 1 84158 660 9

British Library Cataloguing-in-Publication Data
A catalogue record for this book is available from the British Library

Permission to reproduce illustrations is gratefully acknowledged to:
Edinburgh University Library (pp. 37, 39, 41 lower);
St Andrews University Library (pp. 15, 21);
The Trustees of the National Library of Scotland (pp. 89, 91, 93);
University of Dundee: Archive Services (pp. 79, 85, 87)

The Publisher acknowledges subsidy from

Scottish
Arts Council

towards the publication of this book

Printed and bound in Slovenia

Contents

Acknowledgements

In a project which has ranged so widely over Scottish culture and history, I have gained from the help of many people, notably the archivists in the Universities of St Andrews and Dundee, and the librarians and their staff in the University of Edinburgh and the National Library of Scotland. I am grateful for permission to use materials in their care. It is to be hoped that the new devolved governments of Scotland realise just how important is the work of archivists and librarians to ensuring that a nation understands and respects itself. I have been helped by conversations with many friends and colleagues, especially Stana Nenadic, Graeme Morton, Charlie Withers, Hugh Cheape, Margaret Mackay, Donald Meek, and the man I met walking his dog in Auchtermuchty. The idea for this book originated in a conversation with John Tuckwell. The guidance of Hugh Andrew and Andrew Simmons at Birlinn Limited has been vital. Barbara Morris, as always, has provided support, criticism and enthusiasm in equal measure. I thank them all, but I would like to dedicate the book to my father, who first taught me to look at the scenery (I still have his father's copy of Baddeley's *Guide* to the Peak District) and to the late Maurice Beresford, who taught me to look at the urban and built environment.

RJM
Primrosehill Cottages, Duns
2007

Introduction

The photographs in this book are a selection of a selection. They come from some 400 images produced under the not very original title of *Bonnie Scotland* by the Dundee publishing firm of John Leng and Co. Ltd in 1907. They were issued in 20 weekly parts starting on 28 June 1907 and completed on 8 November. They were, in the words of the publisher, 'drawn exclusively from the famous series of Valentine and Sons Ltd, Dundee, London and New York'. The history of Valentine's goes back to the earliest days of photography in Scotland and activity reached a hectic peak in the postcard revolution of the 1900s. These images were produced to be enjoyed and 100 years later they should be enjoyed again, but that enjoyment can be made all the greater by looking with the eyes of those who produced and purchased such pictures when they were first put on sale. There are many stories weaving their way around these pictures. The images are part of the history of the camera, of chemistry, of tourism and of printing and postcards but, above all, they are part of the history of Scotland.

This book then is about looking at Scotland. It is about looking at Scotland at a particular time and through a particular set of eyes. The time was 1907, 200 years after the Act of Union between the parliaments of Scotland and England, an Act which had left Scotland a fractured, fractious and resentful nation. The Scotland of 1907 was very different. The Scotland of 1907 was a confident and proud nation. If that sounds too formal, the selectors and publishers in 1907 acted as if they were producing for a Scotland that was rather pleased with itself and quietly comfortable with its contribution to the United Kingdom. Scotland was a great industrial and trading nation. The evidence was spread across the globe. Glasgow was second city of the greatest empire in history. Edinburgh was a world financial and banking centre. There was an assertive national identity recognised by that rather odd agency, the Scottish Office. Scotland offered itself, especially its Highlands, as a place of romantic inspiration. Scotland was equally pleased with itself as a distinctively moral and religious nation. Much of the trading and industrial success of 1907 was traced to the Presbyterian history of the last three centuries. Indeed, Scotland had written itself a distinct history, not just of national achievement but of world contribution. The Enlightenment thinkers of Edinburgh – David Hume, Adam Smith and the rest – had initiated new patterns of thought which lay behind modern prosperity. The Scots had developed modern banking and key areas of industrial technology. There were few Scots who had not seen lantern slides of David Livingstone who, if he had not discovered Africa, had, in the opinion of most of them, certainly rescued many Africans from moral and religious darkness. Sir Walter Scott had invented the modern historical novel and shown how literary achievement in prose and poetry could bring a small nation to a world stage. Robert Burns had used the people's language to place his poetry on the same stage. The stone statues of Robert the Bruce and Sir William Wallace, who both fought for Scottish independence with great determi-

nation and violence, had recently been placed at the entrance to Edinburgh Castle. But that was quite in order, for, without the independence they had won, that great bargain between independent nations, the Act of Union of 1707, could not have been made and the resulting prosperity for both nations could never have been achieved. This was the Unionist Nationalism that was promoted by the Society for the Vindication of Scottish Rights. Accounts of Scottish education and military achievements only added to this sense of a comfortable nation. This was the Scotland that lay behind the looking in this book. There were other dimensions to this pride which will surprise the people of the early twenty-first century. There was municipal pride: Glasgow thought itself the best-governed city in the world, and men and women crossed the Atlantic to see this achievement.

There were many other Scotlands and mention of them must be made, not to spoil the sense of pride but as a reminder that the sense of comfort and enjoyment was produced by careful selection. The infant mortality of Glasgow and Dundee was at levels now considered unacceptable in the poorest places in Africa. Wages were usually around 10 per cent less than equivalent wages in England. The majority of Scots lived in one- and two-roomed houses with little or no sanitation. In some generations over half the young men and women in their twenties emigrated because their own country could not supply them with a living. The inspiration of the romantic Highlands was due to the slow insistent loss of population created by pressures we would now call globalization, as well as by the violence and irresponsibility of many landlords. Legislation for the management of Scottish poverty and many urban problems was often slow in coming because a London-based parliament found it hard to accommodate the processes needed by a country with a separate legal system. The lung-choking toil of the coalmines and foundries as well as the bone-chilling, arthritis-causing work of the fields got little mention. These matters emerge along with some other aspects of Scotland which the respectable Messrs Leng and Valentine preferred to ignore, notably a raucous popular humour, the urgent Catholic piety of a significant number of Scotland's people and also an obsession called football.

The eyes were those of William Dobson Valentine, son of James Valentine, founder of the firm. JV's initials appeared at the right-hand corner of thousands of postcards. William was photographer and businessman. Both labels matter. He was a photographer who knew every inch of his trade – a complex interaction of chemistry, optics and artistic skill – but he was also a business-man who knew what his customers wanted. There was a double audience. Tourists were important but these pictures were also for the Scots themselves. John Leng was selecting from over a quarter of a million images produced by the Valentines and treated marketing with care. The publication was dedicated to Lord Rosebery, aristocrat and Liberal party leader who kept his main residence at Dalmeny on the Forth. The foreward to *Bonnie Scotland* was provided by the Right Honourable Lord Strathcona:

> The publication . . . will give much pleasure and gratification to Scotchmen wherever they may be. Those who are living in their native land, and those who are in other parts of the Empire and in foreign countries, will look upon this collection of photographs of Scottish cities and scenery with feelings of national pride . . .

If there is one thing more than another which characterises Scotchmen it is their affection for the land from which they have sprung. This patriotism has made Scotland what it is, and has caused Scotchmen and Scotchwomen, to whatever part of the world they have gone, to take a pride in their nationality.

John Leng was canny in the publicity department and had sent out free copies to a selection of notables. By Part Eleven he was printing the letters of thanks from, amongst others, Lord Kelvin, Dr Whyte of Edinburgh, Lady Aberdeen, the Duchess of Sutherland, the Prime Minister and Mr J M Barrie of Black Lake Cottage, near Farnham, Surrey.

Here are the pictures which Scots and their tourists wanted to hang on the wall, print on the new picture postcards, sell to visitors and send to friends. To enjoy the pictures to the full it is necessary to make several journeys into Scotland and into the minds and lives of those who created, who bought and sold, who

collected, looked at, carried home and sometimes posted these pictures to all parts of the world. To understand these pictures involves a little technology and some commercial and company history. To this must be added some tourism and some national pride. Both of these require the taking out of some books, poems, old maps and guidebooks, many still familiar and others forgotten.

The photographs were the product of two family firms. They were intensely local in ownership and production but operated in national and international markets. Behind the calm assurance of the pictures lay a heady roller-coaster ride of skill, innovation, opportunism, expansion and vicious international competition. The Valentine story was one of three generations. Each one responded to changes in market opportunity, taste and technology. James Valentine, born in 1815, was sent to Edinburgh to train as a portrait painter. In 1832, he returned to Dundee to join his father's firm, which was engaged in block-making for the linen industry. Two years later they appeared in the Commercial Directory as J Valentine and Son, Engravers and Copper Plate Engravers. By the 1840s, James the son was producing engravings of local churches and propaganda for the Anti-Slavery, Temperance and Peace movements. That same decade he went to Paris to study the new art of photography. In a restless market the Valentines were always ready to try new ideas and technologies. He was a master craftsman who opened a successful photographic portrait studio in Dundee in 1851 and, by the 1860s, employed around 50 people producing views for the stereoscopic craze as well as portraits and the accompanying *cartes de visite*.

The firm gained a major national and international place in the production of 'views' as a result of the entry into the business in the 1860s of the eldest son of James's second marriage. William Dobson Valentine went to university in London and took a chemistry degree at University College. He then trained for a while at the Reigate studios of Francis Frith. Frith was notable not only for his photographic skills but also for his management and distribution abilities, not unrelated perhaps to his initial business as a Liverpool wholesale grocer. It was William who built and directed the collection of 'views' from which the 1907 selection was drawn. He saw the firm through the technical transition from the cumbersome wet collodion process to the less burdensome but still technically demanding dry plate process. To be a photographer in this period required an intense awareness of the fact that, at heart, photography was a chemical and optical process. He also had an instinctive artistic ability which responded to public demand in a satisfying and comprehensible way. The nature of the product was changing. When William's son, Harben, joined the business in 1886, it was the so-called 'local view scraps' which were important. These came in two sizes. Cabinet was 8 by 6 inches and imperial 12 by 8 inches. These were mounted for sale on bevelled and gilt-edged glass. There was a growing 'new class of tourists and trippers provided from the middle class and the workers'. They wanted to 'go further afield and adorn their homes with souvenirs of their travels', notably 'plush mounted photographs, along with china cups and other china articles bearing the coats of arms of places visited'. Valentine's plush mounted photographs were especially popular and they bought their own firm of suppliers of plush in Edinburgh. Albums of photographs were produced for various resorts and tourist areas. These could be purchased plain bound or in expensive morocco. This was a market with great variations of income and wealth. An early sign of Valentine's success was an order from Queen Victoria in 1867 for 40 views of the Highland scenery between Balmoral and Loch Lubnaig.

The sale of 'views' of all kinds, shapes and sizes was the basis of the expansion of the business over the following 40 years. William moved the management style from that of a craft workshop to an industrial one. An indication of this was the creation of the view registers in 1878. The initial pages entered 1,713 views, the accumulation of the early years of the firm. Subsequent entries showed William moving out from his Scottish base. In 1882, he made a trip to Yorkshire, taking pictures in York and at Bolton Abbey and Fountains Abbey. In the 1880s, he was adding around 1,000 new views a year. This increased to 2,000 in the following decade. Then came the postcard revolution and a huge expansion, reaching a peak of 6,082 in 1905. These figures were a minimum as many new photographs were simply stored under old numbers. The start of the view registers coincided with the growing popularity and reliability of the dry plate system. The

Ilford Photo Company began to market their dry plates that year. The dry plate technology vastly increased the productivity of photographers like William but, as he grew older, the firm and its finances required more attention and, as the number of new negatives increased, so did the need for photographers working for the firm. Nonetheless, a distinctive Valentine style persisted and this permeates the 1907 collection. Even when he was not crouching behind his tripod, William's influence as a landscape photographer was very evident.

The *British Journal of Photography* made the first of two visits to Valentine's in 1886. The dominant impression was of mass production achieved by an intense division of labour. The actual processes, apart from a much admired machine for washing the prints, were little different from those used by a well-equipped amateur or a small local photographer. The daylight-based printing was done in an open yard on racks sloping 45 degrees. Mechanisation was only evident in the 'small wheels upon a simple tramway in order that, should a sudden shower come on, the whole arrangement can be instantly run under the glazed roof of the printing shed'. Then followed the toning room, the fixing room, the print drying room, the rolling room and the cutting, sorting, mounting and colouring rooms. The negative storing rooms were in the basement, guarded against fire and flood by 18 inches of concrete. The most interesting division of labour was between the landscape negatives and the cloud negatives. The limited tolerance of the camera plates gave the photographer of the period a choice, to either underexpose the landscape and get a dark and gloomy scene, or overexpose the sky, thus burning out any clouds and getting a white sky. Hence, 'every landscape negative has its special cloud negative and mask, each of which bears its own distinctive number, and is registered in its own special place'. In 1904, it was the machinery which caught the visitor's attention, especially the new collotype machine – 'marvels of mechanical skill, scientific accuracy, and artistic beauty' – which served the mass production of postcards which had followed the changes in Post Office regulations in 1897. Competition was vicious and international. The German Swiss had taken the lead in the postcard industry in the 1890s and had no intention of losing

that advantage. By 1907, Valentine's profits and turnover had stagnated and the bank overdraft was rising relentlessly. Buildings were mortgaged, share issues attempted and a cartel called the Associated German Printers was campaigning to drive Valentine's from the British market by systematic underselling. The 1914–18 war probably saved the company.

Behind the calm assurance of the pictures of 1907 were all the anxieties of competition, capital finance and family income. The sense of creativity and individuality contrasted with the needs of mass production, stock control and marketing. Here were pictures, tourist souvenirs, national pride, local identity and much more. The 20 weekly parts were probably an attempt to combat stagnation. The direct evidence concerning the firm was sparse. Indeed, what has survived comes with heroic stories of archive material rescued from skips and derelict buildings. The picture material is now in the benign environment of the archives at St Andrews University. Many of the negatives used to produce *Bonnie Scotland* no longer exist. As the company struggled for survival in the 1930s and 1960s the negative collection was 'weeded'. The survivors have now been mounted on a web site: http://specialcollections.st_and.ac.uk/. This is surely a use of a new technology for distribution and presentation that would have delighted the Valentines who took the photographs.

PHOTOGRAPHY IN SCOTLAND

Why was Scotland the right location for one of the world's most successful photographic views and then postcard firms? One answer lies in the key role played by Scotland in the history of photography. At this level photography was and is at once a science, an art and a business. There were elements in the interaction between the early history of photography and Scotland's distinctive character as a stateless nation which gave Scotland a special place in that history. Despite the Act of Union of 1707, which abolished the parliament in Edinburgh, Scotland retained and developed many characteristics of nineteenth-century nationhood. Scotland retained an independent legal system and a distinctive religious tradition. Edinburgh remained a capital city

with an increasing number of national institutions. Scotland had its own network of intellectuals which had already created ideas and writings of world importance. But that network had the characteristics of a small nation; scientists, philosophers, lawyers, artists, poets and novelists talked and met with each other. It was a small world where intellectual production had had little chance to specialise. National identity was sustained by a sense of a particular history and an active dynamic culture which, through key poets and novelists, gained Scotland a world reputation.

Photography in its modern sense began in 1839 when Louis Daguerre and Henry Fox Talbot both published accounts of two very different methods of fixing a photographic image. Although the Fox Talbot calotype process lacked the fine detail of the daguerreotype, it proved to be the origin of modern photography. Those using Fox Talbot's method had the ability to produce many copies from the one negative. Both men sought monopolies but both, for very different reasons, neglected the fact that Scotland had an independent legal system and, hence, escaped the restriction. Central to this situation was Sir David Brewster who, amongst many other things, was Principal of St Andrews University between 1838 and 1859. He was a correspondent of Fox Talbot. Brewster's involvement in photography was part of his interest and enquiries into the nature of light and colour. Brewster brought the calotype process north. He worked with the two Adamson brothers, John and Robert, in St Andrews. By 1841, their development and skill had resulted in a stable enough process to produce portraits and, in 1843, Robert established a studio at Rock House on the Calton Hill in Edinburgh. Brewster may well have introduced James Valentine to the Adamsons as Brewster and Valentine shared the same politics and religious convictions. The momentum and knowledge which created the Valentine business was one small part of the energy generated by the Brewster network.

The next point of progress was the result of a bitter row which split the Church of Scotland. The Disruption of the Church of Scotland involved a walk-out of 123 ministers from the General Assembly and the signing of the Deed of Demission by 470 ministers to form the Free Church. David Octavius Hill, Secretary

of the Royal Scottish Academy, was one of many moved by this event and planned, as a celebration, a major painting, followed by engraved copies for subscribers. Sir David Brewster saw problem and opportunity and introduced Hill to Robert Adamson with the suggestion that portraits of the ministers involved should be taken to ensure that Hill had the likenesses he needed for a painting which would take some years to complete. This collaboration went further than the making of the Disruption painting, which now hangs in the Assembly Hall of the Free Church of Scotland. The two men went into partnership and within a year their work was being shown in the Royal Scottish Academy exhibition and being presented to the Académie des Sciences in Paris. Up to this point D O Hill had been known as the painter of lavish, spectacular landscapes, of which more later, but it was the portraits that made, and still make, the most impact. They did attempt a number of townscapes but the drama here comes more from the struggle between a new medium and the scale and variety of the scene. They were hampered by the task of taking their heavy equipment out of the studio and by the range of light intensity in a landscape view. The Hill–Adamson partnership, with Brewster networking in the background, was the perfect coming together of optics, chemistry and artistic skill.

Over the next two decades, Scottish photography was sustained and developed in two ways. A growing number of studios were opened by men who wanted to make their living as photographers. By 1857, there were 24 in Edinburgh alone and this number had risen to 48 by 1871. Their stock-in-trade was portraits, especially in that most portable, postable and reproducible form, the *carte de visite*. These studio portraits were pasted onto 2½-inch by 4-inch bits of card and handed round to family and friends. Photographs, as ever, were about memory so Mr J Howie, who was at 45 Princes Street between 1857 and 1862, assured his customers, 'duplicates may be had at any time'. Some businesses disappeared after a couple of years others lasted for a working lifetime. Hill and Adamson's studio at Rock House remained a key location. Archibald Burns was there between 1867 and 1880. He was followed by Alex Inglis in 1881. Portraits were the way in which the commercial photographer was assured of a

living, but many explored other outlets for their skills. Hill and Adamson's well-known portraits of Newhaven fishing people were part of a plan to publish volumes on *The Fishermen and Women of the Firth of Forth*, on *Highland Character and Costume* and several more. Memory was about buildings and places as well as people. Archibald Burns was commissioned in the late 1860s to photograph buildings in central Edinburgh which were about to be demolished. James Annan did the same in Glasgow. Technical innovation was making the street scene easier to manage, but the publication and production of multiple images was still costly. Prints could be produced, mounted and sold as single art works or small album collections as Valentine was beginning to do in Dundee. For book publication each copy required the pictures to be printed individually and then pasted into the books, copy by copy. The result was a prestige item such as those Annan produced for Glasgow and for the opening of the Loch Katrine waterworks by the Municipal Corporation. The Archibald Burns photographs followed a different and probably a commoner route for the period. They were used as the basis of an engraving which then formed a printer's block for the pages of James Grant's *Old and New Edinburgh*. Since the eighteenth century, those who could not afford to purchase their oil or watercolour painting had purchased and treasured their copper, and later steel, engravings. J M W Turner had profited greatly from this market. The photograph was reproducible, but at a cost. It provided an intermediate product in the market for pictures and the Valentine firm began its expansion by moving into this market. It was not until the 1890s that the photograph could be placed directly into the mass printing process, thus reducing the cost of reproducibility and opening the way to the publication of books like the 1907 collection.

Meanwhile, an interest in landscape and buildings as well as portraits was carried forward by Scotland's contribution to the 'amateur tradition' of the 1840s and 1850s. In these decades a number of men and a few women got their hands dirty (literally, given the chemicals involved) pushing the new technology to its limits. Personal networks, a new periodical literature, as well as specialist manuals were filled with details of technique and accounts of achievement. Thomas Keith, an Edinburgh surgeon,

and his friend John Forbes White, an Aberdeen flour miller, worked in this tradition. It was an indication of the demanding nature of photography in this period that, for them, it was a young man's hobby which lapsed under pressure from the serious matters of raising a family and running a business. John Muir Wood depended for his living on the family music business in Edinburgh but he clearly learnt from the example of Hill and Adamson and from his links with the contemporary art world. He experimented in great detail with different chemicals and papers. His success in meeting the conventions of landscape painting whilst keeping control of the calotype process was probably unequalled in Scotland. Trees and buildings were characteristic subjects. The 'amateurs' visited many of the places, notably Melrose Abbey, which were to appear in the 1907 collection.

The momentum created by these two streams, the business and technical skills of the professional and the inspiration of the amateur, with the greater opportunities for experiment and reflection, came together in the career of George Washington Wilson of Aberdeen. He was a crofter's son who came to Edinburgh in 1846 to train as an artist. On his return home, he established himself as a miniature portrait painter but was soon drawn into photography. He first offered photography to his clients in 1852, a year after the introduction of the wet collodion process. This was technically more demanding and cumbersome than the calotype but, for those who mastered it, the rewards were a greater quality of detail and tolerance of light variation. It was very good for landscape and Wilson rapidly proved himself with the new process. In 1854, he had his first call to Balmoral to photograph Queen Victoria's new residence as well a stag shot by Prince Albert. By the mid-1850s, he was producing local views for the growing tourist market and steadily expanded his repertoire of tourist locations. By 1865, his firm produced over half a million prints a year from 400 daylight printing frames. GWW was a wealthy and successful man, Photographer to the Queen, but still artist and photographer. As an expert user of the wet collodion process he had much greater control over the composition than the calotype user. As the writer of an occasional gossip column for the *British Journal of Photography*, he expressed very clear ideas

about landscape composition. He defended the photographer's ability to 'select and arrange his subjects'. The photographer displayed his taste by ensuring his picture was 'a satisfactory whole' by 'selecting his point of view, his light, and his foreground'. The photographer must 'compose in such a manner that the eye, in looking at it, shall be led insensibly round the picture, and at last find rest upon the most interesting spot, without any desire to know what the neighbouring scenery looks like'. He disliked 'bits, where the sky line of a mountain comes down to an abrupt termination at the side of the picture, tantalising the spectator with suggestions of lovely scenery lying beyond the limits of the photograph and the present capabilities of the art'. This is quoted at length because it is quite a good description of a William Valentine photograph. Indeed, the example of Washington Wilson was a crucial influence on William. As William entered the business in the 1860s and began to build the 'views' side of the trade, GWW was the man to beat. Wilson set the standards and practices of the trade and provided the major competition. William went to the same places as GWW and took nearly the same sort of views. The Wilson family claimed that Valentine put his tripod into the holes that had been made by George a few years before. The pictures had much in common but were never quite the same. In most places the characteristic GWW foreground, a black dark mass of something, usually a rock, indicates the older man's picture. George Washington Wilson also liked a little height for his pictures. He took a first-floor window for urban street scenes and climbed a little further up the hillside for open country and mountain scenery. Attempts to retake the photographs of both men soon reveal the difference. William stayed as near the road as possible whilst GWW was prepared to leg it up the hill, despite his heavier equipment, to look down and across his views. In the end, William Valentine was the greater survivor. He proved more adept at conquering the problems of mass industrial production and global marketing whilst GWW remained an outstanding craftsman who simply operated on a large scale.

At one level 1839, the birthdate of photography, appears as a stunning discontinuity. By submitting to the scarcely stabilised processes of chemistry and optics, the creator of images appeared to be distanced from the action of creation. Here was 'truth' at last. Here in the calotype at least was reproducibility. There was a mixture of science and magic in the first photographic images. This was sustained by the stereoscopic craze of the 60s. The eye-straining illusion of 3D images appeared to overcome time and space. The viewer was 'actually there'.

At another level this discontinuity was itself an illusion. The infinite reproducibility of the photograph which is now taken for granted took many years to develop. Indeed, it was not until the 1890s that photographs could be 'printed' in any modern sense. Equally, the sense of 'truth' was often compromised. It has already been shown that Valentine like many others chose whatever clouds he thought appropriate for his landscape. Most of the interventions, and in the 1900s Valentine had 40 'artists' at his Dundee base, were involved in retouching blemishes in the negatives and increasing the definition of key features, but closer study can reveal more serious changes. All this was in addition to the choices made by the man behind the tripod. The real and immediate gain was in the speed with which an image was captured.

MANY EYES AND MANY SCOTLANDS

The 1907 John Leng edition of Valentine's photographs was published in 20 weekly parts. Each issue was put together to appeal to as wide a variety of people as possible. There was always something for Edinburgh and something for Glasgow. Some weeks there was a picture for Aberdeen and the next for Dundee. There was often a seaside resort, some mountains, a bit of Scott and a touch of Burns. In short, there were many Scotlands.

Eighty-five years after his death, Sir Walter Scott, poet, novelist and folk song collector, still dominated the way tourists and Scots looked at Scotland. They read *Marmion* and *The Lady of the Lake*. They followed him to Melrose, Loch Katrine and Abbotsford. Few people now wander around the Highlands declaiming, 'The stag at eve had drunk his fill . . .' but it was there in the guidebooks of the 1900s. Despite the key role Burns played in being a Scot, he had a smaller part to play in looking at Scotland. There was also a small part for half-forgotten figures like

J M Barrie, now remembered as the author of *Peter Pan*. Second to Scott as a guide to Valentine's Scotland was Queen Victoria. Her books, *Leaves from the Journal of our Life in the Highlands* and *More Leaves from the Journal of a Life in the Highlands,* were still widely quoted and read.

The Highlands play an important part as wild places, as mountain places and as the location of the palaces of great lairds like the Sutherlands, but, for the purchasers of 1907, urban and municipal Scotland was equally important. The weekly parts were full of municipal pride, trams and town halls, parks and fountains, commercial and shopping streets. Industry tends to be hidden. The quaysides of the Clyde were preferred to the forges of Parkhead. Above all, Scotland was a place of small towns, the square at Huntly and 'Peebles for pleasure', as the printer William Chambers once quoted. Not all urban places got into the selection. It was tough if you wanted to send a postcard from Coatbridge and even Alloa was kept firmly on the skyline.

The people in these pictures were carefully chosen. Again, results were not quite what the early twenty-first century might expect. The iconic Scot was not the kilted Highlander. There were very few kilts on show in Valentine's pictures. The typical Scot seemed to be the fisherman, closely followed by those who worked the land. They were presented as primitive and strong against the elements, and the more primitive the better. In the photographs fishing was done in drifters and cobbles rather than steam trawlers. The modern stooks and fields do get into the foreground of pictures but close-ups were reserved for the ox cart and the 'natives' of St Kilda. The collection crossed Fife many times without seeing a miner, a coal mine or even a pit village. There were no engineers, clerks or domestic servants, although they were probably there amongst the crowds on the beach at Saltcoats and Portobello. This was the Scotland of the tourist, of the day trip and the fairs holiday. Tourists and their transport appear many times.

Looking at the view, if it is well done, must appear to be the most natural thing in the world. William Valentine was very good at making his views look so easy. His best pictures have that sense of completeness that George Washington Wilson wanted. Many of them had an instant recognisability, the Forth Bridge, Melrose Abbey, Princes Street in Edinburgh, the Highland glen, the beach, the steamer and more. In fact, he was building on a tradition of looking at landscape that was less than 150 years old. In the late eighteenth century, the serious seeker after scenery would have profited from a number of guides on the proper way to look at the view. In 1789, William Gilpin, Prebendary of Salisbury and Vicar of Beldre in the New Forest, published *Observations Relating Chiefly to Picturesque Beauty made in the year 1776 in Several Parts of Great Britain Particularly the Highlands of Scotland*. Gilpin was splendidly didactic. He was anxious to teach his readers the 'rules'. Mountains had to have 'an elegant and varied line'. Poor Ben Lomond was 'rather injured by the regularity of its line'. He disliked Edinburgh except for the Castle, which had to be seen from the 'correct view' at the base of the Castle Rock. He liked tree-clad mountains but not over cultivated land. Walks by rivers were especially important as long as they were not too regular and formal. Picturesque was literally about making a picture. Gilpin had with him an apparatus he called a camera. This was one of a variety of devices which enabled the user to project an image of a landscape onto paper so that it might be sketched with greater ease. The result, in Gilpin's book, was a series of rather incoherent colour washes. Some of Gilpin's 'rules' survived to guide Valentine and the landscape photographers of the late nineteenth century. Gilpin liked the way in which Scottish mountains would 'frame' a picture and advised a careful choice of foreground or, as he put it, 'the ornament of some object which both characterises a scene and adds dignity to it'. Especially important were the emotions associated with various kinds of scenery. They might be amusing, romantic or sublime. Others were 'suited to contemplation', or 'the exercise of imagination'. Uvedale Price, whose *Essay on the Picturesque* followed in 1794, was even more rule-bound. All this steadily diffused itself into the conventions of landscape painting and the engraved prints associated with such painting. In 1840, D O Hill provided 80 pictures for *The Land of Burns: A Series of Landscapes and Portraits Illustrative of the Life and Writings of The Scottish Poet*. The 'Literary Department' was provided by Professor Wilson of the University of Edinburgh and Robert Chambers, the popular author and publisher. Here was David Octavius Hill at work in the moment before he was seduced by the

new medium. The engraved illustrations have their frames and foreground, just as the typical Valentine photograph would do. In 1838, Thomas Allom, W H Bartlett and Horatio M'Culloch had provided 116 views for *Scotland Illustrated* by William Beattie MD, graduate of the University of Edinburgh. In their time these books served much the same market as *Bonnie Scotland*. Many of the 'views' which appeared in these two books were also in the 1907 collection.

Much more practical was the publication in 1799 of Mrs Sarah Murray's *A Companion and Useful Guide to the Beauties of Scotland*. Sarah knew her picturesque scenery but was equally prepared with useful ideas on enjoyment and comfort. Take bed linen, the traveller was told, and provide a seat for your manservant on the carriage so he is available to open gates when needed. The list of spare parts and tools for the carriage was formidable. The Wordsworths, the poet and his sister, came in 1803, although Dorothy's *Recollections* were not published for general circulation until 1874. Walter Scott was already well known through the publication of his *Minstrelsy of the Scottish Border* in 1802 and he gave the Wordsworths some help with their tour, but Scott's serious contribution to the agenda of Scottish tourism came with the publication of the great verse dramas, *Lay of the Last Minstrel*, *Marmion*, *Lady of the Lake* and *Lord of the Isles*.

William Valentine showed in his pictures that he had inherited many of the conventions and emotions of the picturesque traveller and the landscape painters of the late eighteenth and first half of the nineteenth centuries, but Valentine delivered them in a relaxed and expansive manner. To the emotions recognised by Gilpin, Price, Mrs Murray and Dorothy Wordsworth he added a few of his own, such as municipal pride, the buzz of a city-centre shopping street and the excitement of a steamer turning in the loch. Many of his pictures had a frame of trees, mountains or buildings that would have won Gilpin's approval. The foreground was carefully chosen. The middle ground linked the viewer to the scene. The chosen subjects would have been both familiar and surprising to Gilpin and Hill. The well-shaped mountain and the waterfall were there but so, also, was municipal building and the holiday crowd on the beach.

By the 1840s, the railway was arriving together with tourists in greater numbers. With them came more guidebooks. The second edition of Black's *Picturesque Tourist of Scotland* appeared in 1842. Revised editions appeared at regular intervals and were available to the purchasers of the 1907 photographs. The most appropriate reflection of the Scotland experienced by the purchasers of these pictures came from the *Thorough Guide Series* edited by M J B Baddeley. A new edition of *Scotland: Part One* appeared just after the editor's death in 1908. Mountford John Byndon Baddeley was born the son of a Uttoxeter solicitor in 1843. He took a classics degree at Cambridge. In 1884 he realised that writing guidebooks was much better than being assistant master at Sheffield Grammar School or writing classics primers and he began his series, which became noted for its practical and literary detail. As transport improved and guidebooks were published something curious happened to Scotland which is evident from the individualistic and disconnected nature of the pictures in the 1907 books. Scotland became less a place of tours after the manner of Gilpin, Mrs Murray and the Wordsworths. Scotland became full of places. When the German novelist Theodor Fontane visited Scotland in 1858 to worship the places of his idol Walter Scott, he stayed mostly in Edinburgh and made trips from there. By the 1900s, the *Michelin Guide* took this to extremes by presenting a list of places, with commentary, listed in alphabetical order without even an attempt to separate England from Scotland. The advice on golf courses, racecourses and where to purchase Michelin tyres was, however, excellent.

To look at these photographs is to see Scotland through the eyes of William Valentine, but he was not alone. He needed to sell, so his eyes were guided by the market. He was drawn to the bits of Scotland that Scots and their visitors wanted to buy, to frame and hang on walls, to stick a stamp on and send to friends and family, or just to purchase for inspiration and pleasure. These photographs were made to enjoy but this requires several journeys into the minds and lives of those who created, bought, sold and collected these pictures. It involves seeking out those who taught Scots and their visitors how to look at the view. Valentine was guided by the men and women who had gone before him, by

William Gilpin, Mrs Murray, Dorothy Wordsworth, D O Hill, Robert Adamson and George Washington Wilson. In *Bonnie Scotland* the result was a piling up of self-contained images with little attempt to order them by theme or region. Just as there were many eyes behind the lens, there were many Scotlands in the resulting pictures. The selection made for this publication involved gathering pictures into some of the many Scotlands represented in those 20 weekly parts in 1907. Each picture and group of pictures has been set alongside a commentary. Some of the commentary is direct. Others take the form of quotations. Guides, descriptions, timetables and poems were all ways of looking at scenery. In many cases the appropriate commentary on a picture must be visual, involving maps, engravings and photographs from those who went before. There will be reminders of some of the Scotlands missing from Leng's selection, perhaps a postcard from Coatbridge. The pictures were made to be enjoyed and that enjoyment can be all the greater for knowing a little about the people and the Scotland which lay behind and in front of the lens. The mood of the Scottish pictures in 1907 was thoughfully expressed by the *Inverness Football Times*:

On January 16th, 1707, the Scottish Parliament agreed, to an incorporating union with England. The momentous event, whether for good or ill, was not the work of a day. Intimidation, diplomatic scheming, constantly recurring war extending over many centuries – all had been resorted to by England without success until on that eventful day two hundred years ago Scotland signed away her Parliament and many of her ancient rights and privileges. It were almost futile to discuss at this time of day whether, on the whole, Scotland gained or lost by the transaction. There can be but one opinion – that the Union of the Parliaments inaugurated a new era, full of blessing for both countries, and that in commercial activities especially the way was thus early prepared for the great industrial era which was about to set in . . . The Union was a great blow to national development, but it by no means destroyed Scottish nationality . . . Not a few of the factors that are required for national unity were reserved to Scotland intact. She was allowed to retain Presbyterianism as the State religion, and without this concession the Union would never have taken place. Our system of law and justice is another factor essential in creating a truly national life, and it is well known that at the Union Scotland reserved her right to have her own system administrated. Her own system of education was also retained, and in commercial life certain privileges and peculiarities in banking were not lost . . . The Parliamentary machine has broken down under pressure of work, and it follows that new machinery must be devised. Scottish business has suffered most of all, and the appointment of a Scottish Grand Committee, as an institution, not merely to be set up at the whim of the Government in power, has now been virtually agreed upon. It is an interesting experiment . . . We do not desire to revoke the Union sanctioned by the Scottish Parliament in 1707, but we do desire to see live again in all its old intensity, with its power for progress and for good increased and extended, the old national spirit, Scotland where it was – Scotland a nation.

Complete in 20 Parts.

BONNIE SCOTLAND

LENG'S PORTFOLIO of the Scenic Beauties of SCOTLAND.

The Most Complete and Comprehensive
Collection of Scottish Scenery ever
published.
JOHN LENG & Co Ltd., DUNDEE & LONDON.

7d. nett.

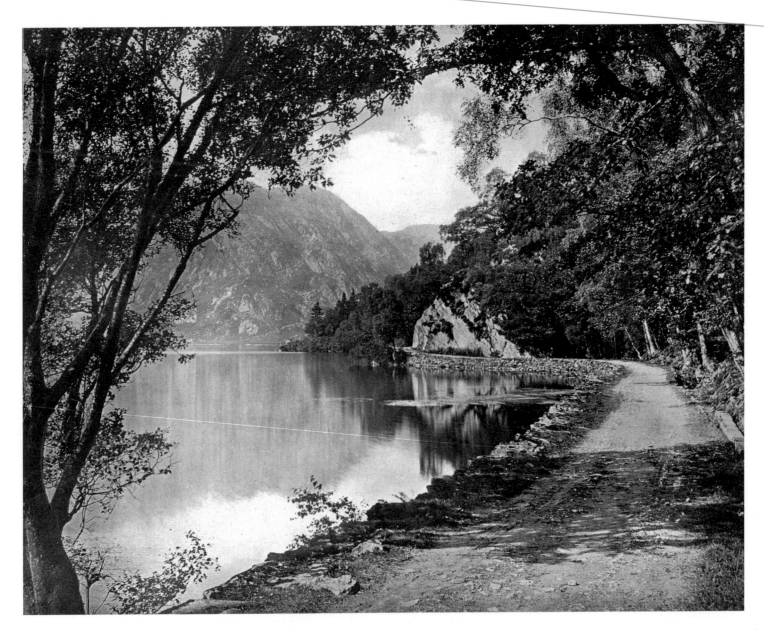

THE PATH BY THE SHORE, LOCH KATRINE

CHAPTER I
Sir Walter Scott's Scotland

When it came to learning to look at Scotland in 1907, Sir Walter Scott was still undoubtedly the great master and Loch Katrine and the Trossachs was the place to start – what John Buchan called the 'domesticated picturesque'. Reading the great verse narratives loved by the nineteenth century is an art which is almost lost now, although the *Lady of the Lake* is still in print and regularly on the bookshop shelves of Scotland. No nineteenth-century guidebook was complete without quotes from the great stag hunt across the bens and glens and the subsequent encounters.

'The path by the shore' has many of the qualities of a typical William Valentine photograph – the sweep of a full horizon (a little more hidden than usual here), the central focus of the rock, the frame of the trees and the curving path linking it all to the viewer. George Washington Wilson had been here with his camera before Valentine, but to understand what they were both doing it is necessary to go even further back to the work which Thomas Allom did for Beattie's *Scotland Illustrated* in 1835. Here is the same path and the rocks in the centre, and possibly the same tree making the frame on the left.

The Valentine photograph was registered in 1878, and it may have been one of the earliest in this collection. A second look shows the tricks of the engraver. The vertical height of the mountain was exaggerated for effect and the huntsman with his dogs and the horse dying of exhaustion were added into the picture. The comparison indicates what the critics meant when they spoke of photography as somehow conveying 'truth'. The first

photographer to stand here was in fact Fox Talbot himself. Guided by the reputation of landscape created by Sir Walter Scott he came north in the mid 1840s to create the photographs for his *Sun Pictures in Scotland*, published in 1845. There were seven pictures of Loch Katrine. One was taken from exactly the spot on which Allom, Wilson and Valentine stood. The image – same path, same rock – peers out from the calotype.

There was little attempt to look for a frame of trees, still less to look for a horizon of mountains. The struggle with the medium was all too evident. There was an emotion in these early pictures which had little to do with artistic merit and much to do with wonder. Other pictures in *Sun Pictures* included a 'highland hut'.

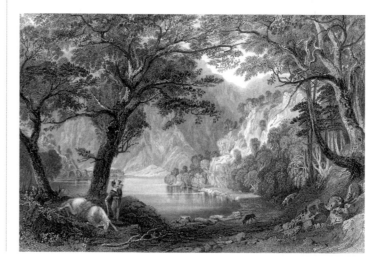

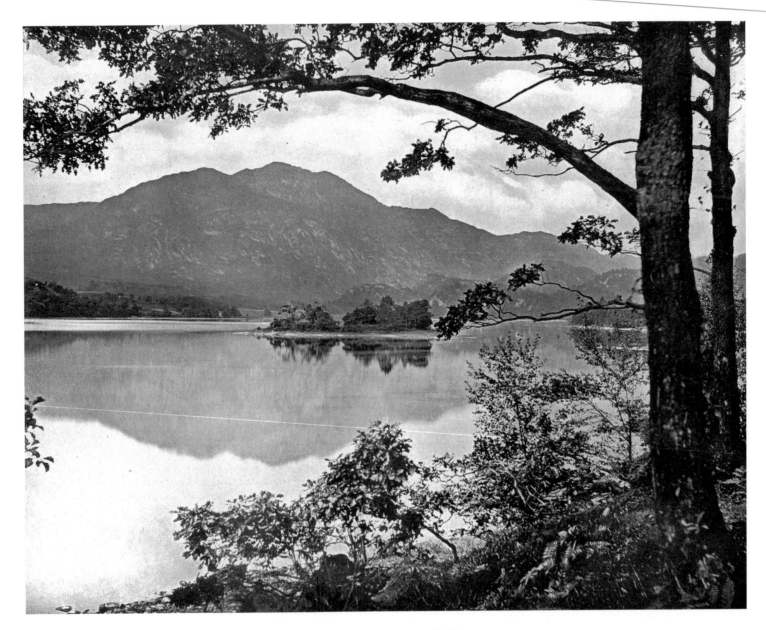

LOCH ACHRAY AND BEN VENUE

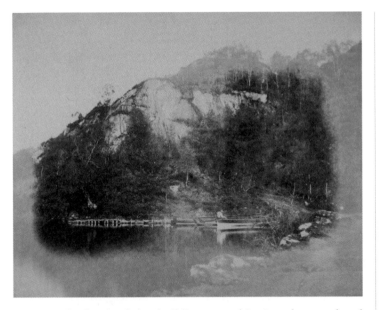

The rough detail of the building was this time better placed against the background of the lake and mountains. In his struggle with the new medium, Fox Talbot had found a scene with the even balance of light he needed for his unstable process.

The path is a compelling lesson in the continuity with which Scottish landscape was viewed by the poet, by the artist (probably helped by a camera obscura) and by three generations of photographers. The next pictures came straight from the *Lady of the Lake*, but perhaps it is better to be guided by one of the best of the contemporary guidebooks. The *Thorough Guide* series, written and edited by M J B Baddeley, BA, was central to intelligent tourism at the turn of the nineteenth century. Although he was dead when the 1908 edition of *Scotland: Part One* appeared, his comments and advice lived on with the details of train and steamer times and hotels updated by his publisher, Thomas Nelson.

Main Route continued. One mile beyond Callander, at the old *Kilmahog Toll,* the Trossachs road leaves the main road and the entrance to the Pass of Leny, turning sharp to the left and crossing the river and railway.

A rather shorter, and, in dusty weather, much pleasanter route from Callander is by the opposite side of the river. Cross it by the old bridge in the middle of the village, and take a footpath which descends at once by the side of the bridge and crosses one or two fields, passing close to the meeting of the Leny and the Teith, between which is a picturesque old graveyard. This path enters a pleasant road in a wood close by the rebuilt Hydro. Turn to the right about a mile further, and crossing the Teith by a stone bridge, you will enter the regular coach-road in a few hundred yards.

The first part of the route to the Trossachs from Callander owes more of its interest to Sir Walter Scott than to its own merits. Almost every house on the way is associated with the famous hunt described in 'The Lady of the Lake'. Immediately after crossing the railway we have the farm-house of *Bochastle* on the left. Here the pace began to tell decisively; the 'tailing' had already commenced at Cambusmore on the other side of Callander:

'Twere long to tell what steeds gave o'er,
As swept the hunt through Cambusmore;
What reins were tighten'd in despair,
When rose Ben Ledi's ridge in air;
Who flagg'd upon Bochastle's heath,
Who shunn'd to stem the flooded Teith.

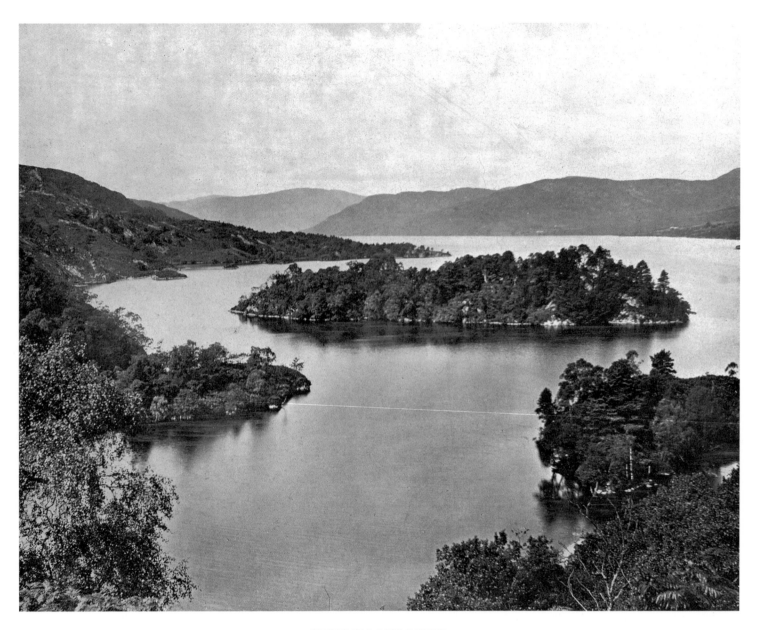

ELLEN'S ISLE, LOCH KATRINE

At the foot of Loch Vennachar is, or rather was, *Coilantogle Ford,* where Roderick Dhu flung down his gage to Fitz James:

See here all vantageless I stand,
Arm'd, like thyself, with single brand;
For this is Coilantogle Ford,
And thou must keep thee with thy sword.

Had the 'Black' Roderick lived now, he would probably have chosen another spot for the dramatic episode herein described; otherwise, his historian would have had to substitute for 'Coilantogle Ford' 'the great sluice of the Glasgow Waterworks,' and to give this a poetic ring would have puzzled even such an eminent word-painter as Sir Walter Scott. The sluice, however, terrible dissipater of romance as it is, has its advantage; it keeps back the water in and above Loch Vennachar against a drought.

The peculiar colour-charm which is more conspicuous in Perth-shire than in any other Scottish county, is nowhere more so than around Callander. Not only are the hill-sides all aglow with the light purple of the ling, but also the rocks, and consequently the roads, are deeply tinged with the same hue. The members of the ' Hant' did not, after all, see the scenery at its best: 'The heather *black* that waved so high. It held the copse in rivalry' is but a sorry substitute for the same plant in full bloom. Yet the description is a true one, as everybody familiar with the moors of Scotland or of the Peak of Derbyshire, *out* of the flowering season, well knows.

We now cross the famous BRIG OF TURK. Here, as every reader of the 'chase' in the *Lady of the Lake* knows, there was only one in it: 'the headmost horseman rode alone,' and his onward route was a very different one from the carriage-road along which the tourist now careers. Then:

Up the margin of the lake
Between the precipice and brake,
O'er stock and, rock their race they take,

'they' being the solitary hunter and his 'two dogs of black St. Hubert's breed, unmatched for courage, breath and speed'. The present 'brig' has no beauty to boast of.

LOCH ACHRAY, whose side the road now skirts, is one of the most charming little lakes in Scotland, when seen from its eastern end. The wood, however, through which the road passes greatly obstructs the view. At its head commences that unrivalled mingling of purple crag, silver-grey birch, oak-copse, and green herbage which we call the *Trossachs* (the 'bristly country'). Ben Venue rising directly behind it, broken, rugged, and precipitous, adds a grandeur to the scene far greater than its actual height (2,893 *ft.)* would lead one to anticipate. It is, perhaps, the glossiest mountain in Scotland, rivalling in this respect, and even surpassing in richness of colour, the fells of the Coniston and Langdale portion of English Lakeland. Ben Venue is as different from the ordinary run of Scottish mountains as velvet is from calico.

At a bend of the road along the lake-side there is a fine point of view, from which Turner took one of his pictures, and a little further we reach the TROSSACHS HOTEL. For many years the Gaelic name for this house, *Ardcheanocrochan* ('the height at the head of the knoll'), manfully held its own over the doorway against the usurping 'Trossachs,' but, alas, like the Welsh *Pontrhydfenligaed,* which, when the railway was opened, no English porter could be found able to pronounce, and no Welsh one to render intelligible, it has at length succumbed, its memory alone serving as an indication of the unrivalled lingual powers of the Celtic race. The building has 'extinguisher' turrets, designed to be in keeping with its natural surroundings. The hotel is a first-class one, and contains a Post and Tel. Office.

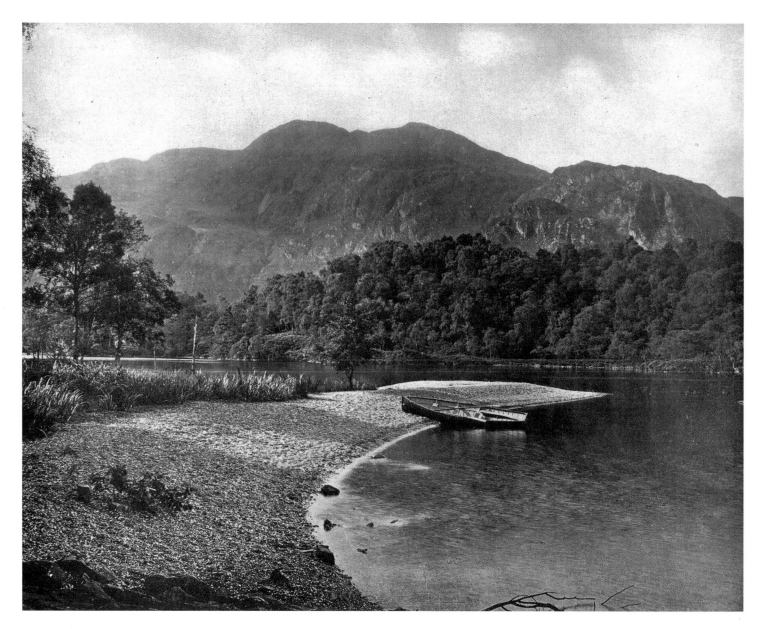

THE SILVER STRAND, LOCH KATRINE

Address – *via* Callander. Wire 'Trossachs.' *Public Luncheon, 2s. 6d.*

There are three pleasant CIRCULAR STROLLS from the *Trossachs Hotel* through the Trossachs:
(1.) To the SLUICES at the foot of LOCH KATRINE, and back by the PASS OF ACHRAY (3½ *m.*). Proceed along the main road for nearly a mile, and 70 paces beyond the 9th milestone from Callander take a path to the left. Where the ground is boggy there are stepping-stones. In 1¼ miles this path reaches the sluices, after crossing which (a) you return by a path to Loch Achray Farm, on the Aberfoyle road, ¾ mile from the hotel; or (b), taking a path to the right, you at once cross a foot-bridge and, turning up the hollow, join the path from Loch Achray Farm to the PASS OF BEALLACH-NAM-BO, which is seen strewn with boulders, and here and there a stunted tree, high up to the right. After a pleasant up-and-down walk of a mile or so, the stiff ascent begins. From the top, by climbing the little knolls on the right, you get a lovely view of Loch Katrine, with Ellen's Isle just below, the Trossachs, Ben A'an opposite, Lochs Achray and Vennachar, and a host of mountains. The whole walk will take 3 hours.

Beallach-nam-bo ('Pass of the Cattle') is so called from the fact that the old 'caterans,' or cattle-rievers, used it as a pass through which to drive their stolen flocks and herds.

(2.) By the OLD TROSSACHS track, where Fitz-James lost his gallant grey, to LOCH KATRINE, and back by the present road, 3¼ *m.* Old track very sloppy after rain. Quit the main road ¼ mile beyond the hotel, opposite the divergence of the Aberfoyle road. After a good mile of up-and-down through woods you enter the road along the north side of Loch Katrine, by the side of a burn; ¼ mile beyond the steamer-pier, whence it is 1¼ miles back to the hotel.

TROSSACHS HOTEL TO ABERFOYLE, **7 *m.; iee* . . .** Dangerous cycling; closed to motors.

From the Trossachs Hotel to the STEAMBOAT PIER the road passes through the heart of the TROSSACHS. The distance is about a mile, and the country traversed is a rich copse-wood dingle, which admits of little distant view except the peak of *Ben A'an,* whose rocky crest rises to a height of 1,500 feet on the north. The pier and its surroundings are the very essence of rustic beauty:

A narrow inlet, still and deep,
Affording scarce such breadth of brim
As served the wild ducks brood to swim.

So abruptly do the purple crags rise out of the water, and so closely do the trees – birch, hazel, dwarf-oak, and others, that love to burrow their roots through the rocky chinks – grow to their edges, that even under a noontide sun deep shadows are cast on the still waters of the land-locked bay.

ROW-BOATS may be hired at the pier. Charges: By the hour. 1s. 6d., 1 hr.; 2s. 6d., 2 hrs.; 3s. 6d., 3 hrs.; 5s., whole day; more than 4 persons, 6d. each per hour. The road itself, gradually degenerating into a cart-track, is continued along the northern shore of the lake, passing *Ellen's Isle* and the *Silver Strand,* the latter a mile beyond the pier. So *far* the tourist should certainly stroll. The entire route (about 8 miles in length, and not to be recommended except in an emergency) takes the pedestrian to the farmstead of *Portnellan,* about a mile beyond that part of the lake which is opposite the Stronachlachar Hotel. There a boat may be hired to Stronachlachar, or possibly one may be hailed opposite that hostelry. The lake is half a mile wide at that point, and to raise a smoke is a recognised signal. The walk

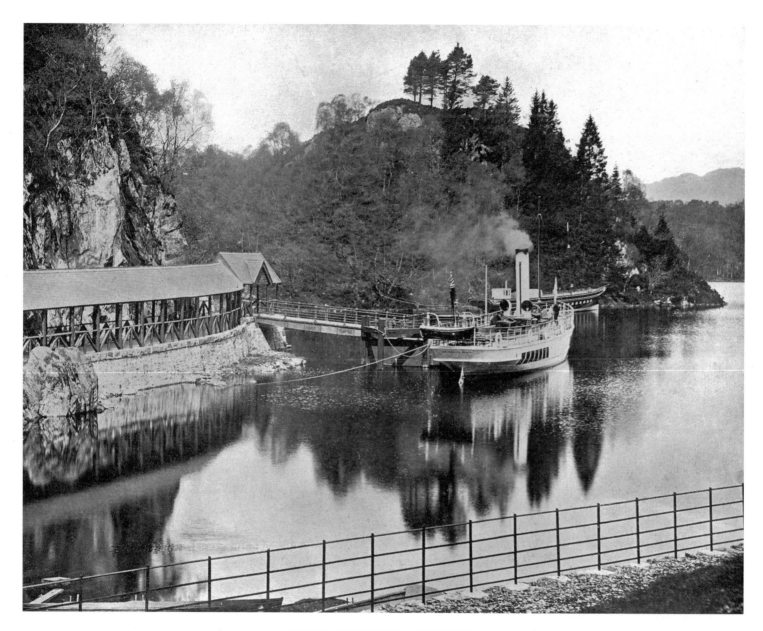

THE PIER AND STEAMER, LOCH KATRINE

admits of a fine view of Ben Venue, but otherwise nothing can be seen to greater advantage than from the steamer. Near the Silver Strand the tourist will notice the disastrous effect on timber which an artificial raising of the level of a lake, though it be only one of 7 feet, can produce. CYCLISTS must take steamer up Loch Katrine.

The steamer usually passes to the right of ELLEN'S ISLE, on the beach of which the 'blighted tree,' against which the Harper reclined, is still pointed out. For beauty of outline and delicacy of foliage – mainly birch – this island is certainly unsurpassed. Opposite is the SLIVER STRAND, a promontory which has been made an island by the raising of the water. The Goblin's Cave (Coir-nan-Uriskin) and, above it, Beallach-nam-bo (Pass of the Cattle) are seen well up the slope of Ben Venue. The mountain ahead, as we look up the lake, is Stob-a-Choin.

Scott's description still needs no substitute:

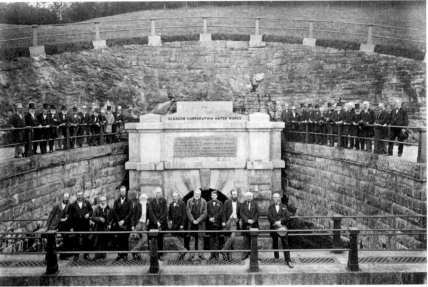

High on the south, huge Ben Venue
Down on the lake in masses threw
Crags, knolls, and mounds confusedly hurl'd,
The fragments of an earlier world;
A wildering forest feather'd o'er
His ruin'd sides and summit hoar,
While on the north, thro' middle air,
Ben A'an heaved high his forehead bare.

During the sail up it, Ben Lomond comes into view on the left, and, soon after, the works of the Glasgow Water Company, marked by a villa amid fir-trees, are passed on the same side. By these the level of the lake has been raised 7 feet, and even the variation caused by these means has had a disastrous effect on the timber on its immediate shores, particularly noticeable on the track to the Silver Strand. The loch has been further raised, the ultimate height contemplated being 12 feet.

Mr M J B Baddeley, with his talent for sardonic comment, enthusiasm and practical advice, gave clear warning that the landscape invented by Sir Walter was under seven extra feet of water and about to disappear further. The loch was the site of discreet contest between modern and romantic. The works linking Loch Katrine to the water supply of Glasgow had been opened with great ceremony by Queen Victoria in 1859 and made a major contribution to the reduction of deaths in Glasgow. They inspired a very different set of photographs by Thomas Annan, taken at the urban end of the 34-mile aqueduct. His photographs appeared in a volume called *Photographic Views of Loch Katrine and Some of the Principal Works Constructed for Introducing the Water of Loch Katrine into the City of Glasgow*. The intention was to enable members of the Water Committee to 'better understand the nature and extent of the works'. Annan moved from understated pictures of Ben Venue, Ellen's Isle and the rest to celebrating the engineering skills of salmon leaps and sluices, syphon pipes and aqueducts.

Local people did not let Scott have it all his own way. Readers of the 1894–5 *Gazetteer of Scotland* were reminded that

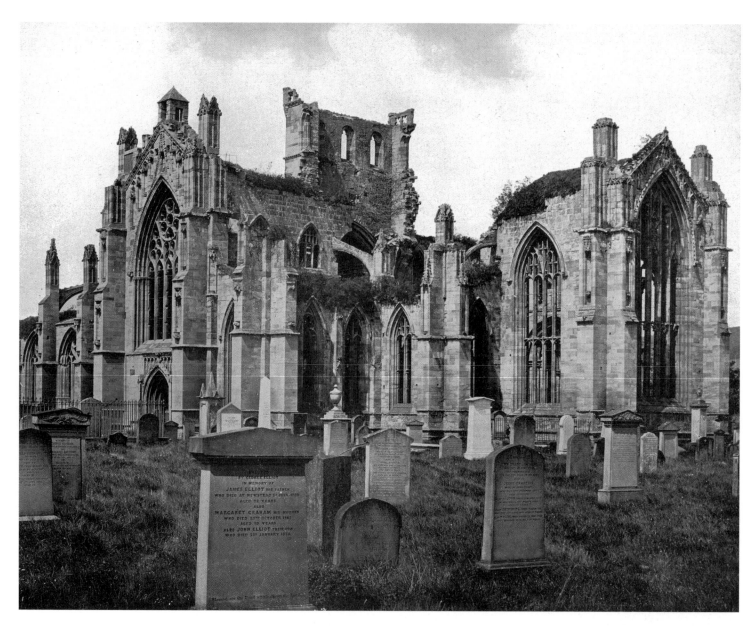

MELROSE ABBEY

the Wordsworths had visited in 1803, well before the *Lady of the Lake* was published in 1810. Moreover, the beauties of the place had been well publicised by Rev. William Thompson in his *Sketch of the most remarkable scenery near Callander of Monteith*, a 'part of the country having been of late much resorted to by strangers'. At the east end of 'Loch Catherine . . . Nature has put on her rudest and most grand attire'. He recommended a call at the farm of Arkenknockan beyond the Bridge of Turk to 'enquire for a guide . . . John Stuart has engaged to attend strangers, to provide them with a boat, to explore both sides of Loch Catherine, to point out the most remarkable places and tell their names, and to recount the traditions current in the country.' There were many landscapes folded one under the other behind the well-ordered photographs of Messrs Valentine.

The great Border abbeys and especially the Cistercian Abbey Church of Melrose had been fully described by the eighteenth-century antiquarians, but Melrose, like Loch Katrine, was placed in the landscape of Scotland by Walter Scott:

If thou would'st view fair Melrose aright
Go visit it by pale moonlight.

This was a fine bit of cheek as he freely admitted he had never visited the place in moonlight. But he certainly knew the details of the tracery and foliage of the abbey:

Nor herb nor floweret, glistened there,
But was carved in the cloister arches as fair . . .
Then framed a spell, when the work was done
And changed the willow wreaths to stone.

Gilpin had missed it, but in 1772 Pennant's normally rather cool and scientific prose was raised in admiration of the 'elegance' of the tracery. Indeed Groome's *Gazetteer* admitted that Sir Walter 'drew towards it the wondering eye of the judiciously imitative crowds who looked to him as a master of taste'. Some of the first to come were the Wordsworths in 1803 who had the best of tour

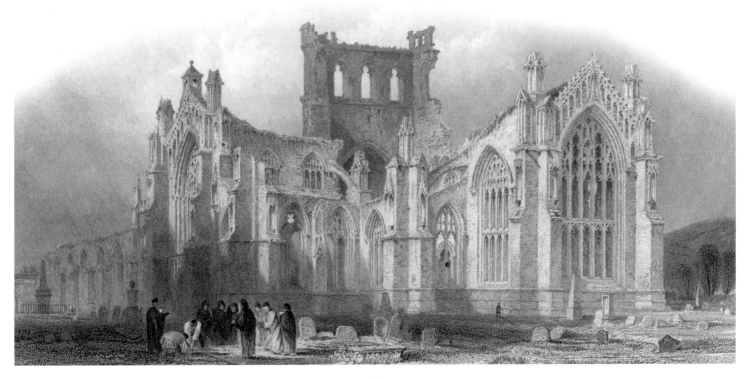

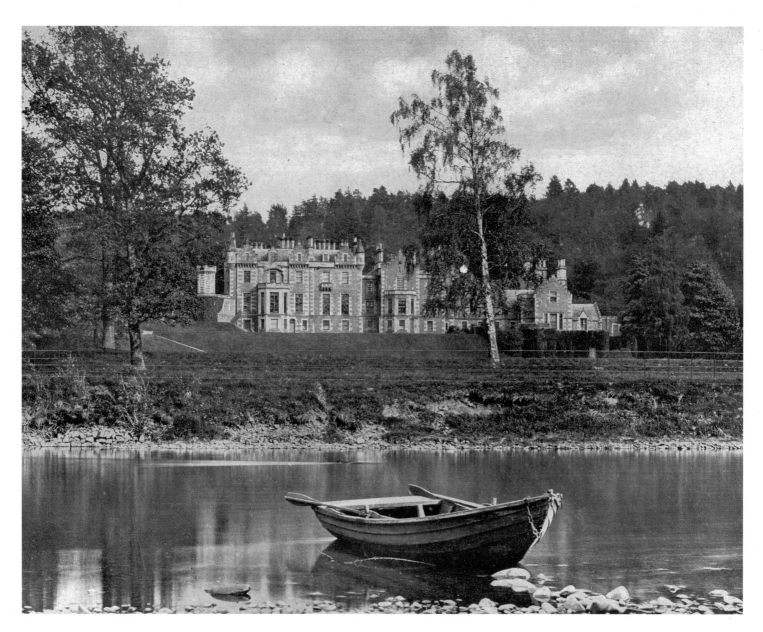

ABBOTSFORD FROM THE RIVER TWEED

guides, Walter Scott himself. 'He was here on his own ground', wrote Dorothy in her *Recollections*, 'for he is familiar with all that is known of the authentic history of Melrose. He pointed out many pieces of beautiful sculpture in obscure corners which would have escaped our notice.' Two years later the *Lay of the Last Minstrel* was published and the flood of tourists began. Theodor Fontane's enthusiasm took him there in 1858 from Edinburgh. He put up at the Railway Hotel and could not decide 'wherein its particular magic resides: situation, material, imposing dimensions, historic memory and the richness and elegance of its detail'. He copied bits from Scott and one of those guidebooks which 'trans-ferred or mangled' the account from Grose's *Antiquities – The Land of Scott or tourists guide to Abbotsford, the country of the Tweed and its tributaries*, published by Thomas Nelson in 1858.

Valentine stood where GWW stood, who stood where Thomas Allom stood in 1835, who stood where Pennant's artist stood in 1772 to the south-east at the edge of the burial ground, but again the print engraver has the advantage. The central tower and the east window have both been given a twist so they can be seen better and a tasteful funeral party added to give delicious thoughts of mortality to romantic sensibility.

The visit to Abbotsford was obligatory. The great magpie's nest, a 'romance of stone and lime', was completed in 1824. Here Walter Scott sat in his last years scribbling away desperately trying to write his way out of debt, surrounded by the objects and archi-tectural fantasy that inspired him. The effect on visitors was mixed. Next to the entrance, Theodor Fontane found:

> a sort of porter's lodge about as large as a moderate sized wardrobe. In it sits an old man who continues quietly to consume his breakfast and continually to cut off fresh slices of ham without letting himself be disturbed by our arrival on the scene. He answers my most humble inquiry, whether we might see Sir Walter's rooms, with a growling sound which seems to belong to no particular language, dead or living, but unmistakably expresses his wish that we should kindly wait until he is ready. During Sir Walter's lifetime this

rather disobliging old gentleman acted as a sort of forester or gamekeeper.

The German romantic was left in pensive mood:

> even one who is familiar with Scottish history and song walks through these rooms as though they were a waxwork show. I took my departure from the 'Romance in Stone and Mortar' without experiencing any particular uplifting of my spirit and certainly without feeling any enthusiasm; even so I look back with pleasure to that quiet, grey day. The drive to Abbotsford was a pilgrimage, a duty which I had fulfilled, a step to which my heart had urged me. What fame would Scotland have, had it not been for this same Walter Scott?

Valentine had no such doubts. Abbotsford was again an early regis-tered title. The trees framed the house. The windows of the library and the room where Scott died were prominent. The boat which brought the photographer provided scale and foreground. George Washington Wilson was there too with the same boat but left the boatman in the picture, hopefully less disobliging than the old gamekeeper. Fox Talbot had also been here for *Sun Pictures* but he had only peered at the house from the side like countless modern tourists' pictures. The intermediate contribution to the history of looking at Abbotsford came from Thomas Nelson's guide of the 1850s, illustrated with an engraving 'from a photograph'. As there was no cost-effective method of printing photographs for all but the most expensive publications, the romantic engravers had a last burst of freedom and vertical exaggeration. Lady and gentleman tourists were in that boat. Trees were every-where. Mountains and house (just recogni-sable) were twisted round to suit.

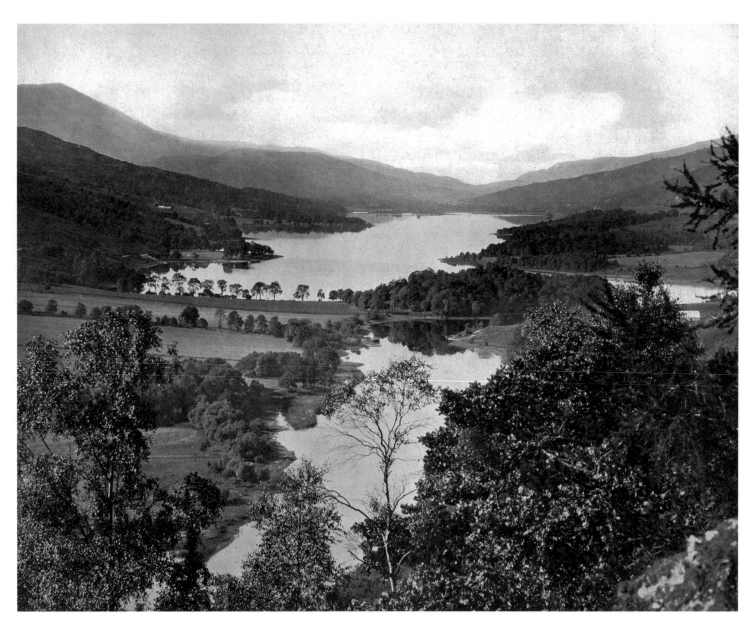

QUEEN'S VIEW, LOCH TUMMEL

CHAPTER 2
Queen Victoria's Scotland

Queen Victoria had a small but important part in the process of looking at Scotland. The discovery of Balmoral in the 1840s and the purchase and subsequent rebuilding between 1852 and 1855 were defining moments for the Highlands and for Scotland. From the start, the Queen and Prince Albert used photographs in a very modern way to secure and memorialise their lives for themselves and to define themselves and their surroundings for others. As the building started, George Washington Wilson was called from Aberdeen to record the process and the family. In many ways it was not the harsh white outlines of the house itself which mattered. The house was a powerful presence for a public gathered at the gates and who were occasionally admitted to the grounds – 'From May 1 to July 31 in the absence of the Court, on Tuesdays and Thursdays, 10am to 5pm. Entrance Fee 1s, devoted to charities' according to Ward Lock's *Illustrated Guidebooks, Eastern Scotland, c.*1925.

The key moment was the publication in 1865 of *Leaves from the Journal of Our Life in the Highlands from 1848 to 1861 to which are prefixed and added extracts from the same journal giving an account of earlier visits to Scotland and yachting excursions.* This was edited by Arthur Helps, then Clerk to the Privy Council. There were many editions during the century. The illustrated ones were poised on the transition between the steel engraving and the photograph. The most important edition was illustrated by 42 photographs taken by Washington Wilson and indicated the way in which the book defined Royal Scotland. There was a cluster around Deeside

from Braemar to Balmoral and Ballater and another around Pitlochry, Killicrankie and Loch Tummel. The Queen was in many ways the first modern tourist. She had none of the purposeful drive of a Pennant or even of a Theodor Fontane. She simple wanted to enjoy herself. She was, as Arthur Helps said, 'a mind rejoicing in the beauties of nature'. Her theory of tourism was simple: 'the Royal Tourists [show] the willingness to be pleased upon which the enjoyment of any tour depends'. There was no journey but a series of expeditions from that great country cottage on the Dee, some going as far as Inveraray, Iona and Mull as well as to Taymouth, Stirling and Edinburgh. The Queen followed fashion and made fashion. After reading the *Leaves* visitors could

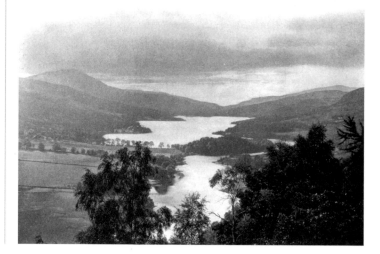

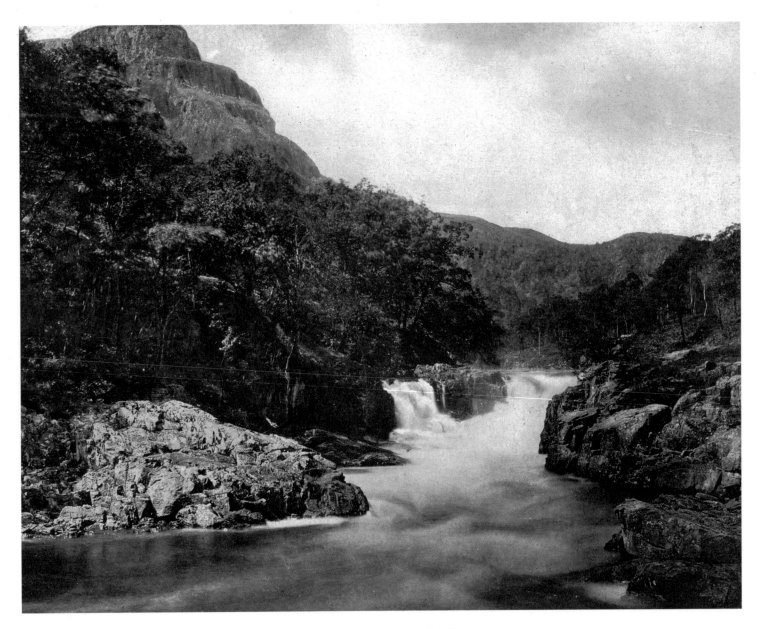

FALLS OF TUMMEL, PERTHSHIRE

visit where the Queen had visited and share her picnic spot in places like the 'Queen's View' which looked down over Loch Tummel.

The Washington Wilson photograph used in Groome's *Gazetteer* had the trademark black mass in the foreground, whilst Baddeley was ever the informed guide.

The *Bridge of Garry* forms part of the Killiecrankie scenery. From it the view up the pass is very beautiful. Beyond it the road ascends through a birchen copse, passing in about a mile the castellated mansion of *Bonskeid*. It then makes a considerable circuit round and across the *Fincastle Glen*, beyond which, on a lofty abutment of rock, reached through a wicket, is the 'QUEEN'S VIEW', a prospect whose reputation is secure in the eyes of all lovers of the beautiful. Westward is seen the full length of LOCH TUMMEL, its shores fringed with wood and meadow, and gradually rising to a heath-clad moor. At its upper end is a real valley, green and culti-vated as any in Westmorland; but the feature of the scene is Schiehallion, which rears its tapering cone beyond the far end of the lake. For simple unaffected grace no Scotch mountain can compare with Schiehallion. Immediately below, the lake narrows to the river between banks of emerald green. The one thing requisite for a just appreciation of Loch Tummel is sunshine. There is nothing grand or mysterious about it, and when the green of its meadows, and the blue of its waters are dulled, and Schiehallion is, as it were, beheaded by clouds, those who do not care to mis-understand nature had better stop away from the 'Queen's View'.

A little further on, our road descends to the outlet of the lake. A ferry-boat takes us across. Hence the return route along the south side of the Tummel is very delightful. Though very hilly, it scarcely ever returns to the height of the outgoing one, and the view from it is restricted to the valley itself. The Queen's View and the mansions we have mentioned are seen high up

on the other side of the stream. In 4 miles we are opposite the –

Falls of Tummel, to which a steep, short footpath descends. Their height is not more than 15 feet, and that is broken; but after a heavy downpour the volume of water and the picturesque character of the surroundings give both eye and ear a rare treat. Beyond them proceed by path or road, crossing the river at *Cluny Bridge*, 1 mile short of Pitlochry.

Francis Groome claimed that the view along the Loch had been called Queen's View some time before she took tea there on 3 October 1866. The Queen as tourist shared the powerful desire to capture the experience by illustration. Of a day in Glen Tilt she wrote, 'I wish we could have had Landseer with us to sketch our party, with the background it was so pretty, as were also the various "halts" etc. If only I had had time to sketch them.' Valentine hurried to the same spots in Glen Tummel as Washington Wilson but in doing so showed some of the difference between the two photographers. Wilson had his characteristic dark foreground mass setting off the mountains and the Loch fading to the horizon. Valentine carefully framed the Loch and the Falls to ensure they were centre stage. Last word should go to the postcard senders of 1908. L Mackay of Pitlochrie, a local postcard maker, produced a Queen's View of quite dreadful quality but the message on the back for Mrs Robertson had all the eternal qualities of the holiday card.

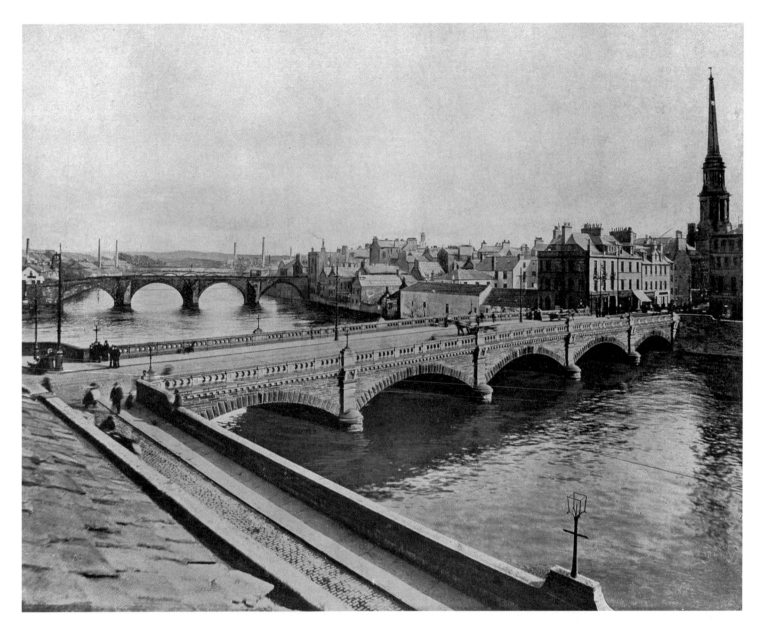

THE TWA BRIGS O' AYR

CHAPTER 3
Robert Burns and Scotland

The sense of place which Burns provided for Scotland was quite different from that of Scott or Queen Victoria. There was the usual stuff of the literary biography tour, birthplace, death-place, monuments and mausoleum, places where Robbie had a girlfriend and places where Robbie had a good day out. This could be provided for any literary figure. There was little equivalent of Rob Roy country or Ellen's Island. The real impact of Burns was much more diffuse. One hint was provided by Professor Wilson's book, The *Land of Burns*, illustrated by soon-to-be photographer D O Hill. There was an emphasis on the south-west of Scotland, Brig o' Doon, Shanter Farm and so on, but it does not take long with the book to find that the real land of Burns was Scotland as a whole and, increasingly, that was how the poems were read, especially at the Burns suppers which grew in number over the nineteenth century. Burns was a major contributor to a Scotland of the mind which grew over the nineteenth century and pervaded the photographs of 1907. It was a Scotland of small towns and honest folk, of 'drouthy neebours' and elemental toil, of a world threatened with loss and in need of rescue and, indeed, actually being rescued each time a Burns poem was read. His use of Scots language, felt to be threatened and diluted by the received pronunciation of English, was vital.

Nowhere can this be better seen than on the twa brigs o' Ayr – an old and new debate produced with a bustle and lack of pretention that Scott could never match.

> Auld Brig appear'd of ancient Pictish race
> The very wrinkles gothic in his face . . .
> New brig was buskit in a braw new coat,
> That he at Lon'on, fre ane Adams got . . .

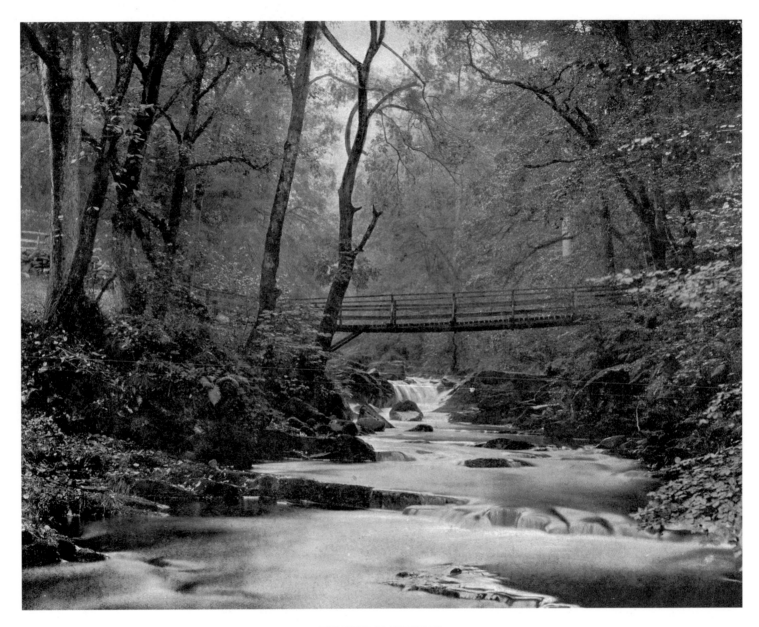

THE BIRKS OF ABERFELDY

In other words, the old bridge built in the fifteenth century to join Ayr to its suburbs of Wallacetown and Newton had been joined in 1785–88 by a new bridge designed by Robert Adam. The new bridge had needed replacement after flood damage in 1878 to the delight of Burns's readers who quoted the auld brig's words, 'I'll be a brig when ye're a shapeless cairn.'

It was a near thing for the auld brig, which was threatened in the 1900s and rescued by a public subscription of over £10,000 led by Lord Rosebery. A similar fate had been averted for the Brig o' Doon in the 1830s, when public pressure stopped its replacement by the Road Trustees.

Burns's cheerful attitude to place can be seen to perfection with the Birks o' Aberfeldy. He turned up there in August 1787 with the tune The 'Birks of Abergeldie' in his head and realised that with a slight change it would not only sound better but celebrate a good day out, and off he went:

> The braes ascend like lofty wa's
> The foaming stream deep-roaring fa's
> O'er-hung wi fragrant spreading shaws
> The Birks of Aberfeldy

There was a great debate as to whether Aberfeldy had ever had any birks (birches). There were none there in 1907. Baddeley thought the rowans must have replaced them but then Dorothy Wordsworth had seen none in 1803. Certainly there were rowans, but then it didn't really matter as the poem could be read anywhere in Scotland which had tree-clad banks and a flowing stream.

In some ways, the styles of the photographers, painters and engravers were uneasy companions for Burns with his sense of detail and texture and bustle. The photographic style as perfected by Valentine with its sweep of scenery, careful stage setting, its deliberate framing and sense of completeness was much better suited to reading along with Scott. The photo men followed the engravers and painters. The readers of Burns must read their way out of this tight frame, but as they do so let the mood and words filter into the rest of the 1907 pictures.

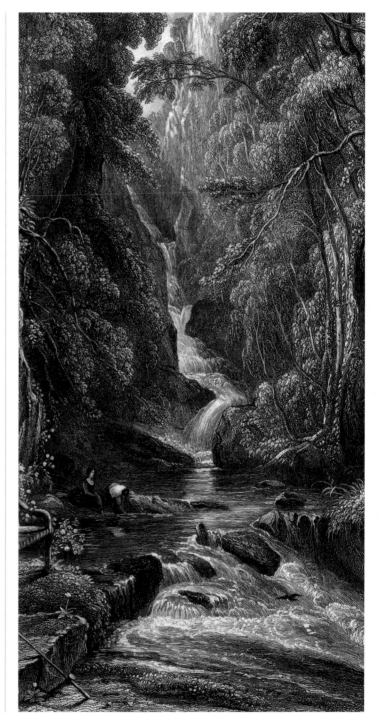

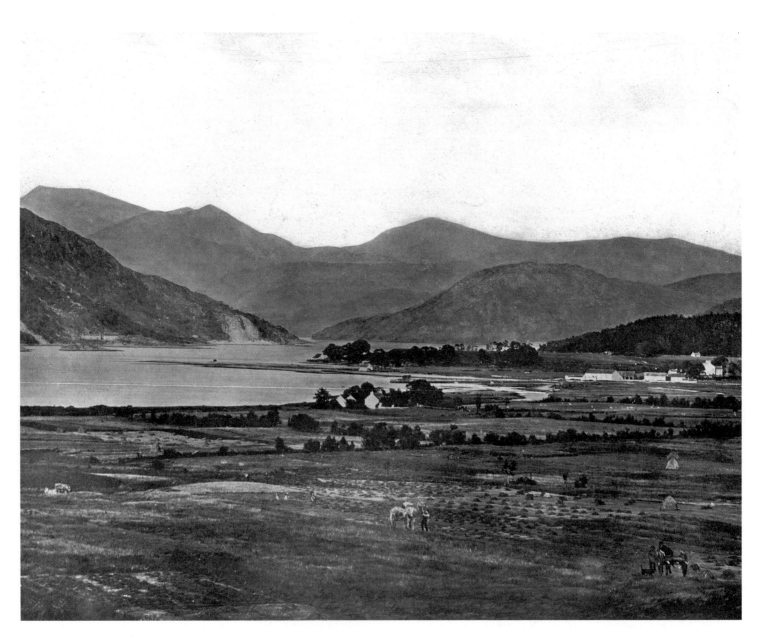

LOCH ETIVE FROM TAYNUILT

CHAPTER 4
Wild places

It is time to go north away from the domesticated Highlands and towards the 'wild and open spaces of the north and west'. The view of mountains and wilderness changed in the eighteenth century from being terrible places to be avoided, or at best improved, to being places of inspiration and emotion. The people of 1907 inherited many ways of looking at the mountains, lochs and glens of Scotland. Loch Etive was a good place to start. The Valentine picture was unusual. The Highlands were usually seen as places empty of people. This picture taken from somewhere west of Taynuilt showed the hay harvest being gathered in. With the recent Highland Railway in place the approach could be made from Oban or through the Pass of Brander. As ever, Baddeley had practical advice:

> Quitting Oban the railway makes a wide sweep up the hill-side behind the town, revealing on the left hand a fine view across Loch Linnhe to the mountains of Mull; then, overlooking *Dunstaffnage Castle (p.299)* on the same side, it descends to *Connel Ferry Station* and the side of LOCH ETIVE. Just here the loch contracts into a narrow channel through which, when the tide is low, its waters twist and swirl about most tumultuously. The scene is called the FALLS OF LORA or *Connel*. At Connel Ferry Station the new line to Ballachulish strikes off, spanning the Falls of Lora by a handsome viaduct. Thence skirting the loch we reached *Ach-na-Cloich (no*

inn). Here is the tiny pier whence the excellent little steamer starts. Lunch is provided on board.

All the turn of century writers – Baddeley, Groome and the anonymous writers for Valentine and John Leng – knew they were following others up the Glen. Professor Wilson of Edinburgh University was still remembered for his enthusiasm. The Professor, editor of the conservative *Blackwoods Magazine*, knew his Burns and his Wordsworth. For him the Glen was indeed a place of inspiration and emotion, as it was for William Beattie. They were 'the very regions of sublimity'. He displayed a love of his country and had a sharp word for anyone who thought that the Alps of Switzerland were adequate competition. In *Remarks on the Scenery of the Highlands* (1845) he wrote of the 'matchless magnificence of Loch Etive':

> to know what it is you must row or sail up it, for the banks on both sides are often richly wooded . . . while the expanse of water is sufficiently wide to allow you to command a view of many of the distant heights. Above Bunawe . . . huge overhanging rocks on both sides ascending high, and yet felt to belong to the bases of mountains that are sloping far back to their summits among clouds of their own in another region of the sky. Yet they are not all horrid; for nowhere else is there such lofty heather – it seems a wild sort of brushwood;

LOCH ETIVE AND BEN CRUACHAN, THIRD EDITION, ORDNANCE SURVEY MAP

tall trees flourish, single or in groves, chiefly birches, with now and then an oak – and they are in their youth or in their prime . . . Cruachan wears the crown, and reigns over them all – king at once of Loch Etive and of Loch Awe. But Buachaille Etive, though afar off, is still a giant, in some lights comes forwards.

And so he goes on, in a language alien to the modern reader. He was followed a generation later by Archibald Geikie, Professor of Geology. Geikie had the same enthusiasm for the hills. He knew his poets and eighteenth-century savants, Wordsworth, Pennant and some lesser-known ones like John Maculloch, the physician and geologist, but the geologist no longer saw a scene of eternal and remote hills. He acknowledged 'an uneradicable desire to find an explanation of natural appearances'. 'The origins of scenery' lay in his vision of rocks formed under the sea, raised by 'upheavals of land', and then shaped and weathered by wind, water, frost and above all by ice. 'There can be no doubt that Scotland once nourished glaciers in her large glens as Norway still does . . . the effects of the glaciation are still so fresh as to afford materials for forming a vivid mental picture of the general aspect of this country when the rigorous climate of the ice age was at its height.' (*The Scenery of Scotland*). Geikie had a tour section, very different from Wilson or Baddeley:

the Pass of Brander . . . The railway runs too close under the slopes of Ben Cruachan (3611 feet) to allow the imposing form and mass of that mountain to be appreciated; but as the traveller moves down Loch Etive and looks back he obtains from time to time a good view of the great Ben, so prominent a landmark in the Western Highlands. He will notice, too, the marked contrast of foregrounds when he leaves the schists and granites and enters upon the volcanic rocks of the Old Red Sandstone which extend along both sides of Loch Etive. The terraced forms of these younger rocks are particularly marked on Ben Lora, which rises as the outer eminence on the north side of the loch. Connal Ferry is

the place from which the curious tidal waterfall may be seen . . . On the north side of the loch at this point there is a fine example of the 50-feet raised beach, which here extends as a broad platform almost across the loch, and is partly covered with peat. The railway now turns inland, and, running through a picturesque district of crags and knolls formed of the volcanic rocks of the Old Red Sandstone series, makes a wide bend and descends to the pier at Oban.

Wilson knew that there were others in the Glen alongside him who were guided by the map and compass rather than the poets: 'Were they who made the trigonometrical Survey to be questioned on their experiences, they would be found ignorant of thousands of sights, any one of which would be worth a journey for its own sake.' The Ordnance Survey had originated in the early years of the nineteenth century, taking some inspiration from the Military Survey of Scotland made after the 1745 rebellion. The initial surveys were an inventory of a nation, bringing its landscape into the realms of accurate knowledge, understanding and government. At some point in the last third of the nineteenth century, this knowledge began to be produced for and used by the walkers, cyclists and tourists who simply wanted to enjoy it. In part the innovations were simple. The maps were folded and backed with linen. The cartography of the Third Edition One Inch to One Mile Series was especially important. It was dynamic, accessible and attractive, giving a vivid sense of topography with a mixture of contour lines and hachures.

By 1890, another group was following Wilson and Geikie in

VIEW OF THE CRUACHAN TOPS FROM BEN EUNAICH.

1, *The Nameless Top* : 2, *Stob Garbh* ; 3, *Stob Diamh* ; 4, *Sron an Isean* ; 5, *Drochaid Ghlas* ; 6, *Ben Cruachan* ; 7, *Stob Dearg* ; 8, *Meall an Riaghain* ; 9, *Ben a Chochuill.*

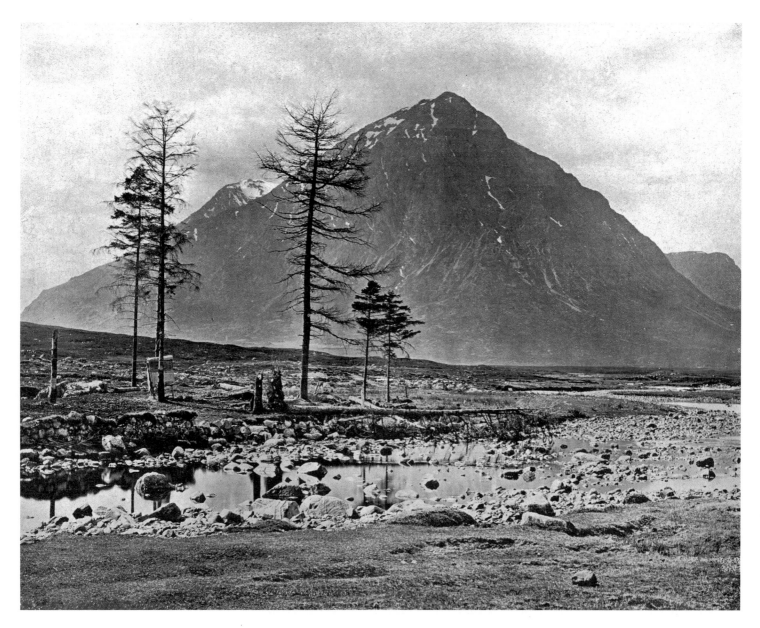

BUACHAILLE ETIVE MOR AT HEAD OF GLENCOE

FIG. 56.—Ice-worn Knolls and Perched Blocks, Loch Torridon.

increasing numbers. Unlike Professor Wilson, they did not think the best view was from the Loch side. The Scottish Mountaineering Club was formed in 1890 and its Journal expressed a distinctive view of the landscape. William Douglas, one of the founders, wrote about Ben Cruachan:

Let us away then to the mountain itself. From the Loch Awe Hotel, far into the Pass of Brander, we find its base fringed by a belt of trees – alder, hazel, birch, mountain ash, and oak – growing on a slope so steep as often to baffle those who try to penetrate it at other than a few recognised points. From these, up to the 2,500 or 3,000 feet contour line, run grassy slopes of hill pasture land, and above that out crops the smooth sloping slabs of red granite, and great stretches of huge oscillating granite blocks, tumbled on the top of the other in mighty heaps.

The journal was full of sketches identifying and naming the peaks. There was much talk of steep gullies and precipices and the need for proper equipment in winter, 'ice axe, warm gloves and a protection for his ears, – the blizzards being at times terrific, and on the upper and steeper slopes it is occasionally impossible to avoid an impromptu glissade without the anchoring claw of the axe'. Douglas knew his geology but he also knew the poets and tourists who had been before him, even the sixteenth-century

cartographer Pont who had been first to put the name of the mountain on a map. Like the climbers the geologists took and published photographs but these tended to be rather muddy and undistinguished. They were probably taken with a hand-held camera and utilising the thin emulsions of the new roll films. Many of Geikie's publications were illustrated with work drawn from a photograph, usually sketches and colour washes done by the Scottish Geological Survey artist and draughtsman, Ben Peach.

The sketchbook of the climber and the geologist pulled very different things from the landscape which was being so carefully framed by the Valentine camera in the valley below.

Wilson, Geikie and the mountaineers all continued up Loch Etive towards Rannoch Moor and the head of Glencoe. At some point just west of the Kingshouse Inn ('much improved' according to Baddeley), they looked back at the bulk of Buachaille Etive Mor. Everyone paused to translate the Gaelic into English, 'shepherds of Etive'.

The Third Edition of the Ordnance Survey did provide a fine and dramatic view of the Buachaille Etives, but the map reviews in the *Scottish Mountaineering Club Journal* were done by Colonel H J Munro. He liked John Bartholomew's new series of reduced Ordnance Survey maps. He was especially keen on the layer shading. Looking at these maps – the one included here was part of the Baddeley *Guide* – it is easy to see the attraction. They lack the drama of the Third Edition OS, but they have the clear uncluttered lines of modern design. Munro was busy making his tables of mountains over 3,000 feet which have obsessed walkers and climbers ever since. The first versions were being published in the journal. The layer shading was just what he and his followers needed for identifying the 3,000-foot peaks and getting to the top.

Further north was Loch Torridon which Valentine used as the base for his picture of the dominating bulk of Ben Liathach. Baddeley makes clear this was an area for scenery and geology:

KINLOCHEWE TO LOCH TORRIDON, 12 *m. Mail cart every day on arrival of coach from Achnasheen. Fare, 3s.* There is a small *Temp. Inn,* with a bed or two, at Torridon, whence boats may be hired to Shieldaig, in the

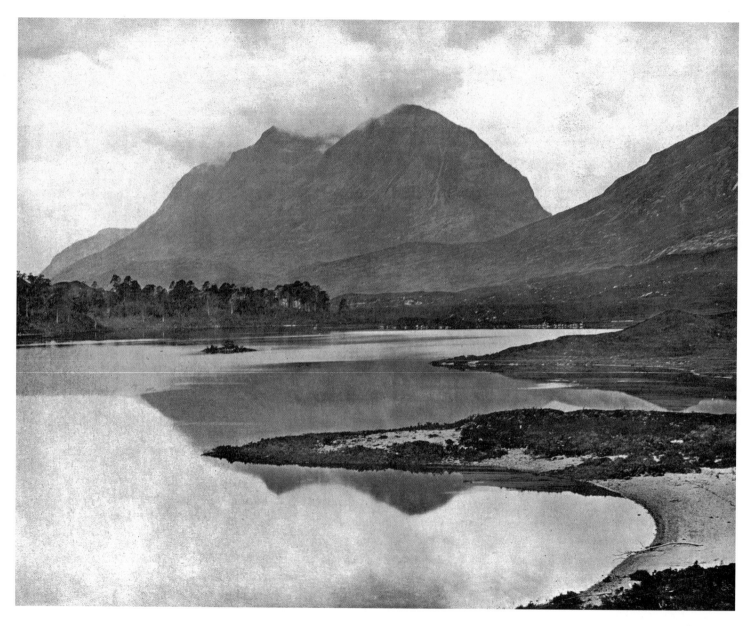

LOCH TORRIDON AND BEN LIATHACH, ROSS AND CROMARTY

Applecross district *(8m. from Torridon).*

This interesting route passes under the steep eastern scarp of *Ben Eay,* which from the exposed quartz formation of its upper part has almost the appearance of a snow mountain. Beyond it, on the same side, rises its fellow in height, and even steeper in appearance, *Ben Liathach.* Both these mountains send down steep precipitous sides into *Glen Torridon,* near the entrance to which, on the left hand side, is a strange muster of small grassy hillocks called *Coir-na-ceud-criach,* the 'hollow of a hundred spoils'.

Loch Torridon, which can only be seen by adopting this route either one way or the other between Kinlochewe and Shieldaig, has a high reputation for grandeur of scenery. It is a fine expansive arm of the sea, all but landlocked near Shieldaig, and surrounded by high precipitous mountains. Torridon House (Dun. Darrach, Esq.) is splendidly situated at the base of Ben Alligin. The scenery all about here is greatly enhanced by the rich red hues of the rocks (Torridon sandstone).

Valentine's photographs showed little of the quartz. It was and to some extent is very hard to photograph in a way which gives emphasis to the rock formations. Hence the need which Geikie

and Peach had to redraw, as in this sketch of An Teallach to the north-east reproduced here.

These pictures of remoteness could be domesticated with ease. Francis Groome gave Loch Torridon a touch of Queen Victoria and an account of the facilities of Torridon itself:

The Queen drove over from Loch Maree on 15 Sept. 1877, and Upper Loch Torridon she describes as 'almost landlocked and very pretty . . . To the W are the hills of Skye, rising above the lower purple ones which close in the loch. To the S are Applecross and the high mountain of Beinn Damn (2958 feet), with, in the distance northeastward, the white peaks of Liathach . . . An old man, very tottery, passed where I was sketching, and I asked the Duchess of Roxburghe to speak to him; he seemed strange, said he had come from America and was going to England, and thought Torridon very ugly! *(More Leaves,* 1884). At the head of the Loch, 10 miles WSW of Kinlochewe, is the tiny hamlet of Torridon, where are a small inn, a post office, with money order and savings bank departments, and a public school. Torridon House, 2 miles WNW, on the northern shore of the Upper Loch, is a fine mansion, built by Duncan Darroch, Esq. of Gourock, who purchased the estate in 1872 for £63,000.

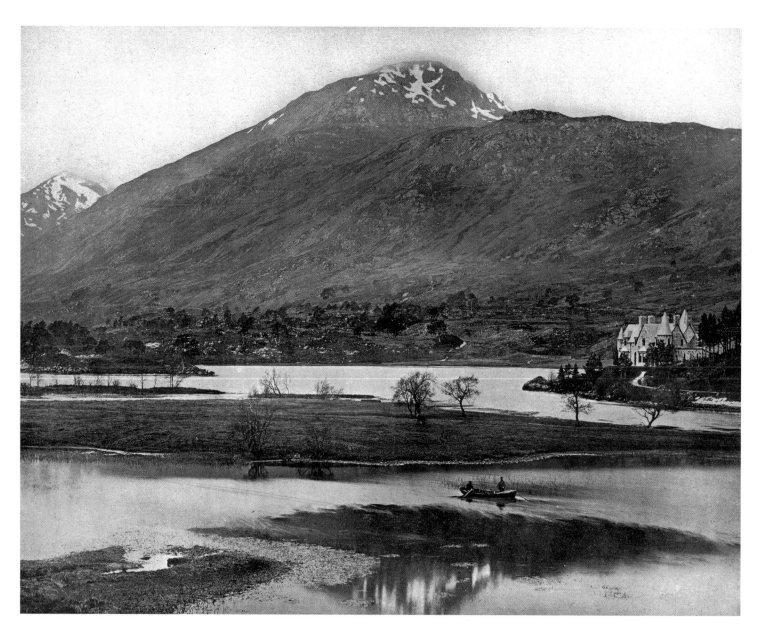

LOCH AFFRIC AND 'ANCIENT' PINE FOREST

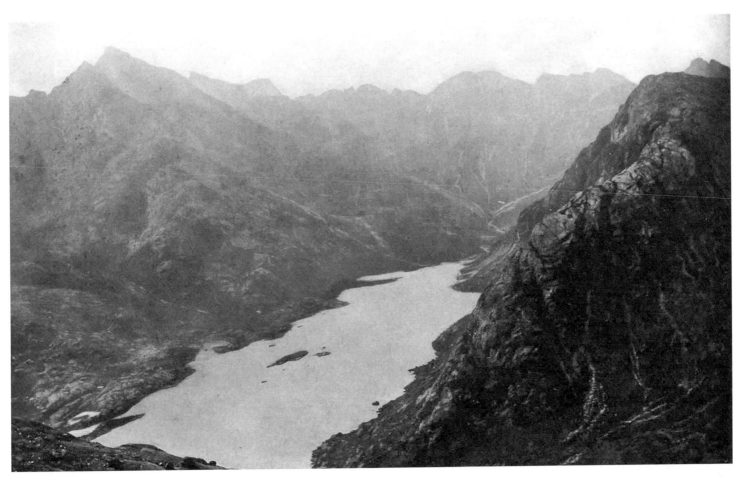

Loch Affric in Inverness-shire was easier to domesticate. The picture was a characteristic Valentine composition with the bulk of Scuir-na-Lapich reflected in the Loch. Baddeley recommended the hotel and the three shooting lodges and Groome was enthusiastic about the salmon. These good things were represented in the picture, but the chief actors were the scattering of birches and pines in the middle ground of the picture. These were, said Leng's copywriter, 'descended from the ancient and once extensive Caledonian Forest'. Every country needs its lost Eden ruined by the evils of civilisation, and Scotland had an intermittent love affair with the story of a one-time dense forest cover, destroyed variously by Romans, Vikings, the English and industry. In as far as a dense tree cover once existed, it was reduced by climatic changes in the Bronze Age which swamped much of it in peat. The Glen Affric trees were probably typical of the scattered, mixed cover which emerged from such changes and suffered irregular attrition from the cultivation of everything from oats and barley to sheep and deer.

Those who sought the finest experience which Scotland had to offer of wildness and isolation went to Loch Coruisk on the southern coast of Skye. Valentine framed it with the crisp outline of the mountains, whilst George Washington Wilson, in contrast, climbed above the loch to create his characteristic dark foreground, directing the eye down to the loch and across to the Cuillin Hills fading into the background. Both took care to eliminate any trace of human activity.

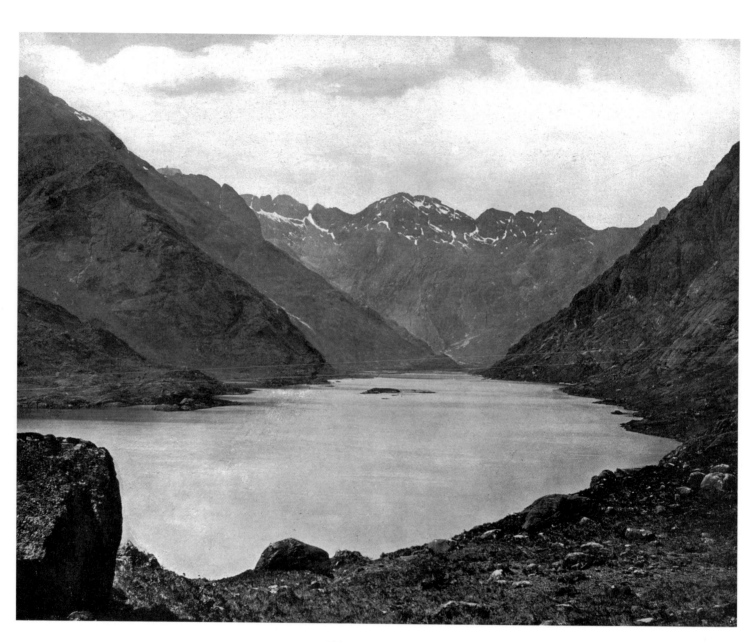

LOCH CORUISK, SKYE

The Third Edition of the Ordnance Survey was well suited to the drama, but the script for all this had been written by Sir Walter Scott in 1814 in his last great narrative poem, the *Lord of the Isles*. 'The Bruce' made his landing at Coruisk but it was the descriptive verse that everyone remembered.

Rarely human eye has known
A scene so stern as that dread lake,
With its dark ledge of barren stone.
Seems that some primeval earthquakes sway
Hath rent a strange and shattered way
Through the rude bosom of the hill.

The choreography was by J M W Turner whose watercolour was produced for and used to illustrate the 1833–34 edition of Scott's *Poems*. Turner's picture was set even higher than GWW's photograph. He appears to be higher than the Cuillin summits. Knowledge of the watercolour and its engraving was sustained by Ruskin's enthusiasm for it in *Modern Painters*. He considered it a better account of the strata than anything a geologist could produce.

The paradox of a place, which, even before the coming of the railway and steamer, had become a popular attraction for the discerning and determined tourist, principally because of the apparent lack of any human activity, was a paradox brought out by Alexander Smith in his *Summer in Skye*. A minor poet and Honorary Secretary of Edinburgh University, he made several trips to Skye in the early 1860s just before the railways changed the whole flow and ease of tourism. 'Picking your steps carefully', he wrote, 'over huge boulders and slippery stone, you come upon the most savage scene of desolation in Britain.'

His guide and friend M'Ian knew exactly how to deal with such sentiments:

Under M'Ian's guidance, we reached the lunching-place, unpacked our basket, devoured our bread and cold mutton, drank our bottled beer, and then lighted our pipes and smoked-in the strangest presence. Thereafter

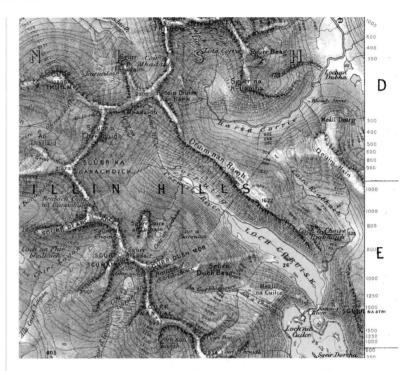

we bundled up our things, shouldered our guns, and marched in the track of ancient Earthquake towards our boat. Embarked once again, and sailing between the rocky portals of Loch Scavaig, I said, 'I would not spend a day in that solitude for the world. I should go mad before evening.'

'Nonsense', said M'Ian. 'Sportsmen erect tents at Coruisk, and stay there by the week – capital trout, too, are to be had in the Loch. The photographer, with his camera and chemicals, is almost always here, and the hills sit steadily for their portraits. It's as well you have seen Coruisk before its glory has departed. Your friend, the Landlord, talks of mooring a floating hotel at the head of Loch Scavaig full of sleeping apartments, the best of meats and drinks, and a brass band to perform the newest operatic tunes on the summer evenings. At the clangour of the brass band the last eagle will take his flight for Harris. The Tourist comes and poetry flies before him.'

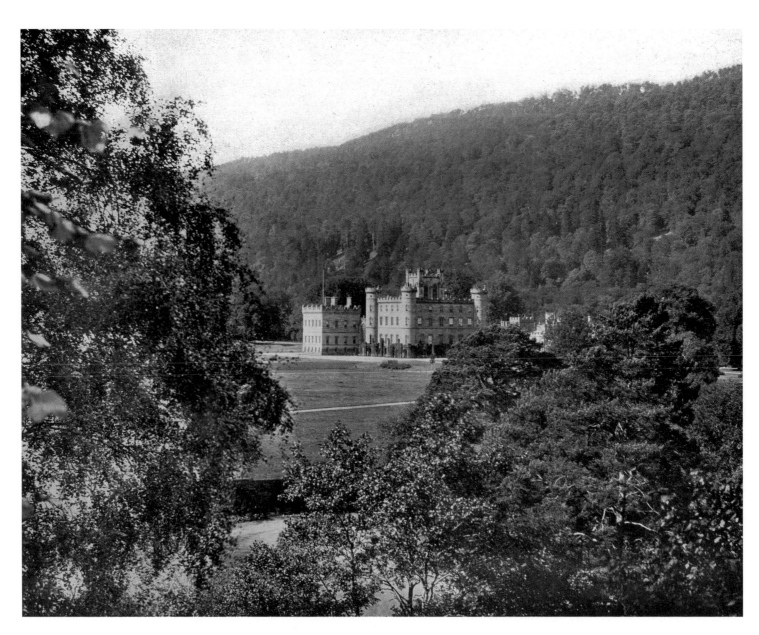

TAYMOUTH CASTLE

CHAPTER 5
Highland palaces

If the landscape of Scotland appeared empty of people in picture after picture, then there were many, both romantic and radical, who placed the blame upon the landlords. The concentration of landownership in a few hands was greater than anything experienced in England. These families were firmly identified first with the clearance of land for sheep farming and then with a further emptying of the land to create a great playground for deer and their wealthy hunters. Both phases were identified with the building and use of 'princely palaces' like Taymouth. The picture has all the Valentine qualities. The palace, built between 1801 and 1842 by the Earl of Breadalbane, took centre stage framed by the trees for which the estate was famous.

In terms of meanings for the people and visitors of Scotland, Taymouth was a place which, by 1907, had rather lost its way. When Pennant visited in 1772, he had no doubt that he was on the frontier of improvement and civilisation. He gloried in the organisation and productivity of the landscape. 'Much flax was cultivated in these parts . . . oats . . . Every person has his potato garden . . . a good many sheep . . . the best black cattle.' Dorothy Wordsworth, like the 1849 *Gazetteer*, was enthusiastic about the 'neat white cottages' and 'neat church' of the village of Kenmore, which was laid out at the gates of the castle. Taymouth was a palace, a playground and a pleasure ground. Pennant was one of many overwhelmed by the pictures and furnishings: genealogical portraits by the Scot and Jameson, as well as two Van Dykes and paintings by Titian, Rubens and others.

Burns visited in 1787 and wrote some not very memorable lines about, 'the outstretched lake, embosomed 'mong the hills' but this was enough to bring Professor Wilson and the painter D O Hill along in the 1830s. The Breadalbanes, a branch of the mighty Campbell clan, had moved from being Highland warlords to civilizing, improving landlords. Hill's painting, taken from the 'fort', showed a picnic of parasoled ladies and kilted gentlemen re-enacting a mythic past as the servants fired cannon across the lawns.

By the 1900s, Baddeley had little to say: 'The park contains some fine forest timber . . .' There was no fee for admission to the grounds, which were open from 8 until 4. The house was sold and the estate broken up in the 1920s.

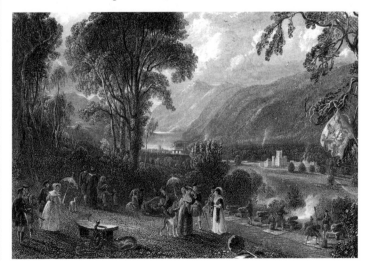

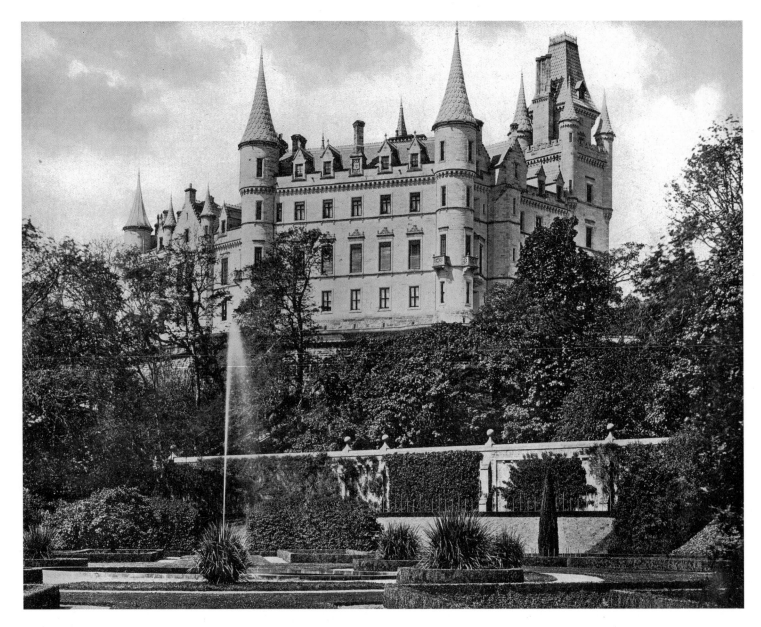

DUNROBIN CASTLE, GOLSPIE

Dunrobin Castle, one of the many homes of the Duke of Sutherland, was, said all of the guidebooks, 'a curious mixture of national styles . . . German Schloss, French Chateau and Scottish Fortalice'. It looked uncomfortable and out of place in the Highland scenery, gazing down on Italianate garedens that would have better suited a bleak seside resort. To the Scottish eye of 1907 this 'solid mass of masonary' represented a fierce mixture of emotions linked to the 'clearances' in the early nineteenth century under James Loch, Patrick Sellar and the then Countess of Sutherland.

The Sutherland agents might protest that over half a million pounds was spent on new villages, fishing harbours, textile mills, salt pans and coal mines but the stories which stayed in the mind of Scotland were sheep, emigration and evictions.

The second Duke ignored all this and set about a major campaign of conspicuous consumption. Dunrobin was one result. Queen Victoria did come to stay in 1872, 20 years after luxury apartments overlooking the sea were prepared for her. The Queen, Scotland's premier tourist, conveyed to perfection in her *Journal* the mixture of fantasy and an elite leisure economy.

> At six we were at Golspie station, where the Duchess of Sutherland received us, and where a detachment of the Sutherland Volunteers, who looked very handsome in red jackets and Sutherland tartan kilts, were drawn up . . . I will now describe my rooms . . . a beautiful bed with white and gold flowers and doves at each corner . . . The little boudoir has a small domed ceiling, spangled with gold stars . . . The Duchess told Brown to open the sitting-room, and we found it occupied by a policeman in bed, which we were not at all prepared for . . . passed through the village of Golspie . . . Annie called out a nice looking girl who makes beautiful Shetland shawls . . . The heather is very rich all round here . . . we stopped to take our tea and coffee, but were half devoured by midges . . . Dunrobin Glen, which is very wild . . . Brown espied a piece of white heather, and jumped off to pick it . . . past the mill under the railway bridge . . . the small fishing village of Brora, where all the people were out, and

where they had raised a triumphal arch and decorated the village with heather . . . one of the new coal mines which the Duke has found . . . we all went down to see a haul of fish . . . saw some deer on the very top of the hills . . . had some haggis at dinner to-day, and some sheep's head yesterday . . . the people were very enthusiastic, and an old fishwife, with her creel on her back, bare legs and feet, and a very short petticoat began waving a handkerchief . . .

The later Dukes thought of themselves as 'kindly' landlords and were praised by the Crofter's Commission for their co-operation but it was the anger that remained. The Land League and the Inverness papers were always ready to pounce on any incident with echoes of earlier years. In 1889, there was the case of the Widow Paul who, according to a letter of the local minister of the Kirk in the *Scotsman,* was evicted from her family home after some complex negotiations:

> At the instance of the Duke and of Mr Scott, the shooting tenant . . . in the interests of proper estate management . . . the house and lands were given over to Mr Scott, whose shooting box is but a few yards distant from the house referred to . . . a step son of Mrs Paul's calls His Grace in a letter sent to the Inverness paper 'a judicious, a kind, and a considerate landlord' . . . There is no evidence to show that the local branch of the Land League had, in its corporate capacity, instigated or even approved of the unwise course pursued by Mrs Paul [but] a procession under the wing of the League passed along one day by the spot where stood the tent Widow Paul had erected – an accompanying piper meanwhile playing 'a lament'.

The Duke offered the widow all sorts of alternative accommodation, just as he was to offer land for settlement to the Congested Districts Board. There was little he could do to dispel the smell of burning that hangs around this picture, and the fact that shooting estates provided the most reliable rents.

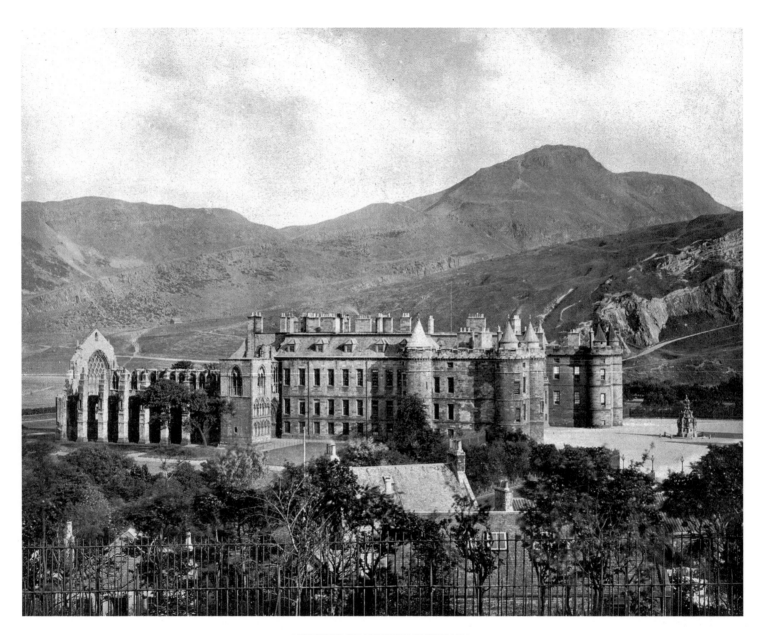

HOLYROOD PALACE FROM CALTON HILL

CHAPTER 6
Edinburgh

At any time in the 50 years before the publication of the Valentine photographs, the well-informed tourist would arrive in Edinburgh by way of the train from London, emerge from the noise and smoke of the Waverley Station and take one of the hotels around the east end of Princes Street.

Theodor Fontane, German romantic novelist and hunter after everything to do with Walter Scott, did this. It was an all-night journey. Fontane found himself in Johnson's Commercial and Temperance Hotel in Waterloo Place, an establishment which, in his view, fitted perfectly into a 'starched, expensive and self-torturing Britain'.

Fontane admired Princes Street and the Gothic Scott monument but the first after-breakfast walk was along the base of Calton Hill by way of Regent's Road to look down upon Holyrood Palace. This was the view Valentine took for his photograph. Many photographers took this in their own way. Washington Wilson was there as was Alex Inglis but in 2007 this is no longer possible as trees have been allowed to block the view. Fontane was fascinated by the stories of Mary, Queen of Scots and, above all, by the murder of her favourite, Rizzio. Inspecting the blood stain on the steps was the highlight of his tour.

For the hundreds of visitors who looked over this view and read and dreamt of the stories of Bonnie Prince Charlie and Mary, Queen of Scots, there were a select few who looked around and beyond the palace and saw different landscapes. Fontane noticed that the palace was in one of the poorest and unhealthiest areas of Edinburgh and hurried down 'a street of scattered poverty stricken houses' as quickly as he could. Robert Louis Stevenson had written his much-loved *Picturesque Notes on Edinburgh* in 1879 and delighted in the city's contradictions: 'The Palace of Holyrood has been left aside in the growth of Edinburgh; and stands grey and silent in a workman's quarter and among breweries and gas works.'

Others would raise their eyes beyond the palace and see a landscape of quiet drama created by long-gone volcanic action.

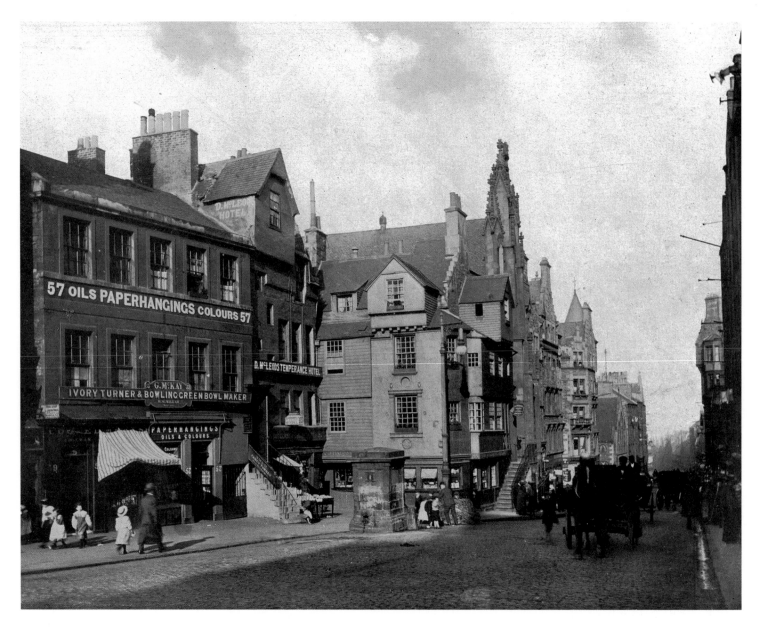

JOHN KNOX'S HOUSE, EDINBURGH

James Hutton, eighteenth-century Edinburgh geologist, had been first to tell the story, much to the disgust of those who believed that God had made the world in six days, but perhaps the most dramatic account came from Hugh Miller, stonemason, geologist and devout evangelical Christian. For him geology was the study of *The Footsteps of the Creator* and the tension of his faith and his science informed his account of Holyrood Park:

> The trap-rocks [a contemporary term for the type of volcanic rocks found in Holyrood Park] of Edinburgh and its neighbourhood consist of vast beds, such as that of Salisbury Crags, injected apparently among the sedimentary strata, – of hugh masses, like that which forms the Castle rock, and which are in all probability the upper portions of tower like columns protruded from below, and descending to very profound depths . . . mark the trap-dykes that seam the stratified rocks all around . . . could we but actually see the landscape as I have asked you to conceive it, stripped of superficial deposits, I entertain little doubt that we would see these dykes radiating from the mountain at their centre . . . Very terrible convulsions must have accompanied the protrusion of those immense prominences . . . the disturbing agent with its fine flood of molten matter, again cemented, in most instances, what it broke.

Others would insist on reading Scott's *Heart of Midlothian*, one of two great novels set in the park. James Hogg's *Confessions of a Justified Sinner* was the other.

Fontane returned up the Canongate with its poverty and overcrowded housing. The poverty could be read in the critical social reformer's manner but many clearly enjoyed it as part of the picturesque attractions of Edinburgh.

James Bone is little read now but he was a reflective man with a keen eye and relished the fact that this area of Edinburgh had once been home to the elite of Scottish aristocracy and society. Bone was the Scottish answer to what the French called the *flaneur*. He walked the streets and looked and:

wondered what was inside those curtainless windows, what faced those ungirthed matrons and maidens I saw at the windows . . . Where did the little white skulled boys, nursing babies in the dark entries under sculptured coats of arms, go when they left entries empty? . . . a quiet middle aged shuffling woman with a shawl over her head, whom I visited at the top of a Canongate close, had a great deal in common with the gentle-women of Old Edinburgh who had to pass through a zone of rough tenants at the bottom of her stair, and was passed herself by the hardy denizens who lived in the attic stories.

In her stair it was dark at all hours. Many of its tenants were tramps and rough folk who smashed in the doors of the empty houses and took shelter for the night. There were always rows on the stairs, and the police were often in and out. Cries and appeals and threats were common noises in the darkness. Nobody knew who had the next room – at any rate, my elderly tenant didn't, and didn't want to . . . bad characters every one. 'I meet them often', she said, 'on the stairs, but I've never seen yin o' them. It's aye black dark there – black as the Earl o' Hell's waistcoat. But I come and go, late and early, and nobody ever put a hand to me.' She had no fear, but considerable power of description. Her account of the noises would set most people's nerves to jangle; the incessant abuse and taunts and cursing, the scraping and stumbling of heavy boots and the blows and panting of combatants – and all this in the darkness, though it was bright morning in the street outside.

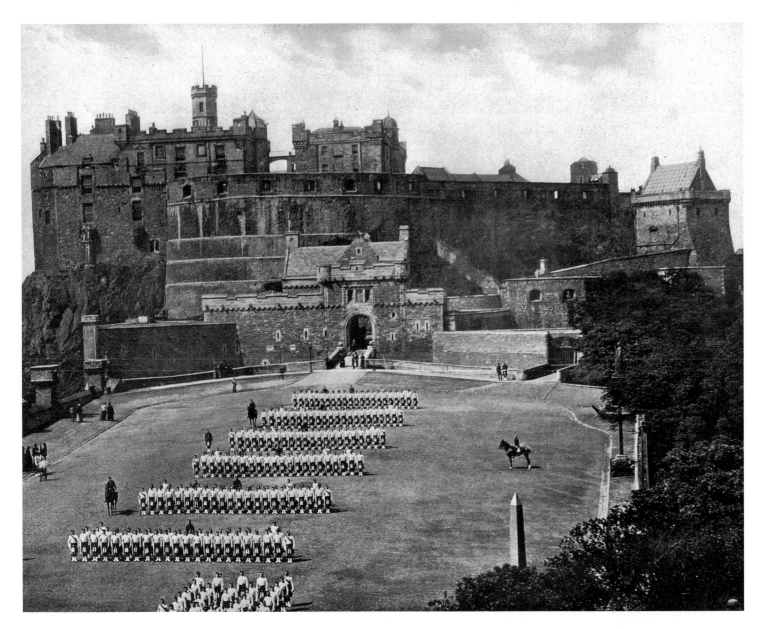

EDINBURGH CASTLE FROM THE ESPLANADE

Chimney-pieces naturally make a peculiar appeal to a northern people. In Scotland for eight months of the year the main interest of a room is the fire . . .

Ten years ago there seems to have been three times as many [of the old chimney pieces], but in the interval the craze for eighteenth century work has set in severely and the landlords have disposed of the best, while the old curiosity dealers have made captures in their own account . . . In one house I was told by the tenant that she had been offered £8 for hers . . .

The wife of a sweep in a *land* behind the High Street told me, with many details, how the mantelpiece I admired so much had been summoned by her husband out of a shapeless clod of paint and dirt. She was very proud of him and of it. 'It was funny,' she said, 'the way it cam' about, for naebody had ever ta'en it into their heid that there was a beautiful carved piece o' wark there like thon. He was sittin' at the fire ae nicht cuttin' his

tobacco wi' 's knife, and something – he doesna ken himsel' what it was – but it attrakit him, and he began to pike awa' wi' 's knife that he was cuttin' the tobacco wi'. You wouldna hae ken't the mantel then. It was a' cloggit up wi' paint and varnish and dirt and stuff, and it was flat as a board – naebody would hae ken't there was a bit o' wark on't. Weel, here's him pykin' awa' and pykin' awa', and says he, "What's this?" An' if he hadna pykit oot that bird! There it was wi' its wings fleein', and the rest o' the mantel jist black – black, and naething to be seen. Eh, wi' that he yokit tae't, and he howkit awa' an' he cam' to the nest wi' th' ither yin in't – here 't is – an' then the floo'ers, and then we was aye wond'rin' what was comin' next. He couldna hae been mair careful, no if it had been the "Lord Provost's lum," says he.' She told me, too, how he had stoppet in at nights and had went on at the howking with his tobacco-knife, how a neighbour who was a painter had told him about burning off the old material, and how after the burning he had rubbed it with beeswax till it was just awful nice.

Bone claimed somewhat mysteriously that 'Photography – although it has not yet confirmed William Blake's discovery that Islington is like the New Jerusalem – has confirmed the story of old travellers: Edinburgh is like Athens . . . the east wind reminds one, the likeness does not hold very far'. Bone preferred the elegant and understated sketches of his collaborator, Hanslip Fletcher.

The road up the High Street went past John Knox's House and Valentine had his picture of it, just as Washington Wilson had taken his and the engravers earlier in the century had made theirs. No one was sure that Knox had ever lived there but the fact that everybody believed he had meant the house was never demolished in the nineteenth-century urge to improve everything.

That road led to the Castle, which was the icon of Edinburgh. The eighteenth-century visitor had been advised to go below the castle and experience the excitement of looking up. The romantic artists of the early twentieth century still went to the Grassmarket for their paintings.

In Leitch's painting the Castle floated like a fairy tale above the dark mass of activity in the town below. It illustrated a book called *Romantic Edinburgh* by John Geddie, but the view of choice was, by 1907, from the Castle Esplanade with the military on parade. This was the age of Empire, best represented by the Castle and the growing number of memorials gathered around the parade ground. The Castle itself was artfully presented as that 'ancient fortress' but, in fact, the bulk of the buildings in the picture were a product of the late nineteenth century. In 1886, the

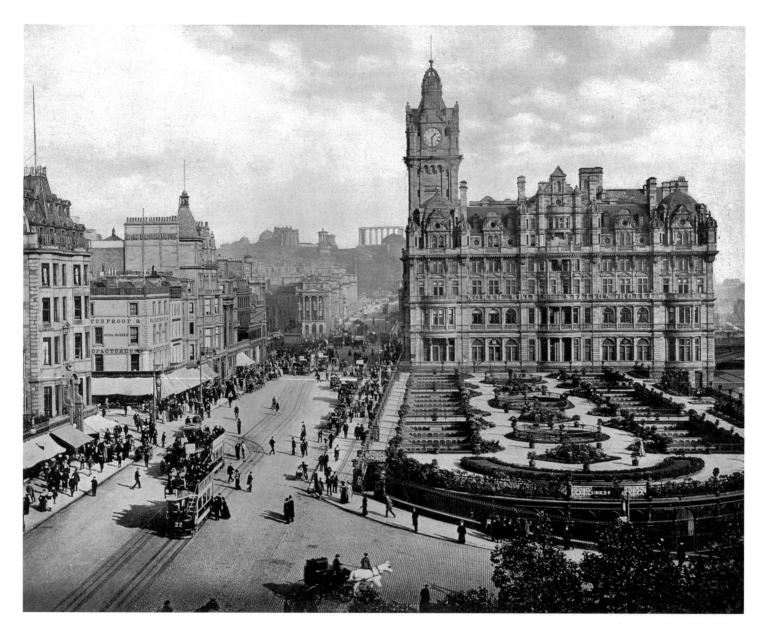

NORTH BRITISH HOTEL, PRINCES STREET

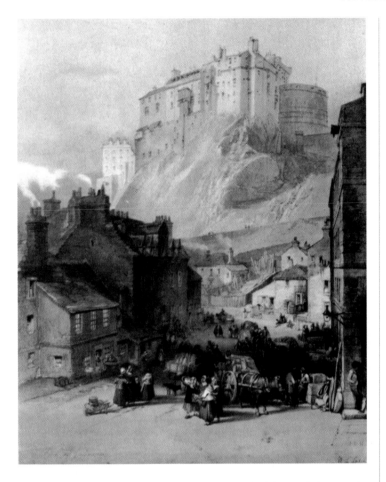

printer William Nelson had financed the rebuilding of the Argyle or Portcullis Tower on the right of the photograph. The government completed the central entrance flanked by statues of Wallace and Bruce – a choice which in Scotland linked nationalism and empire.

The Castle looked down on Princes Street. By the time Baddeley arrived to do the research for the 1908 edition of his guide to Scotland, the names of many hotels had changed since Fontane's visit but there was a hierarchy to choose from.

Princes Street, according to Professor Blackie, charismatic Professor of Greek at Edinburgh University, was the 'finest street in Europe', although it was said that there was a man from Glasgow who thought it was 'only half a street'. The guidebooks

all drew attention to the Scott Monument, the Royal Scottish Academy and the National Gallery as well as the North British Hotel, but Princes Street was about shopping.

Grant's bookshop is sadly long gone but it looks as if it was selling postcards, which would include pictures in this selection. The shops of Princes Street were an education and a temptation. John Inglis was chief clerk and assistant cashier to an Edinburgh legal firm. His diary of the years around 1880 was lovingly transcribed by his granddaughter. One of his favourite relaxations was a walk along Princes Street. In Hill's window he saw 'pictures of ladies of fashion'. He bought digestive biscuits from Mackie's and 'saw shop newly opened for the sale of popcorn in its natural state . . ., bought 2d worth'. He was a rough old radical, reader of

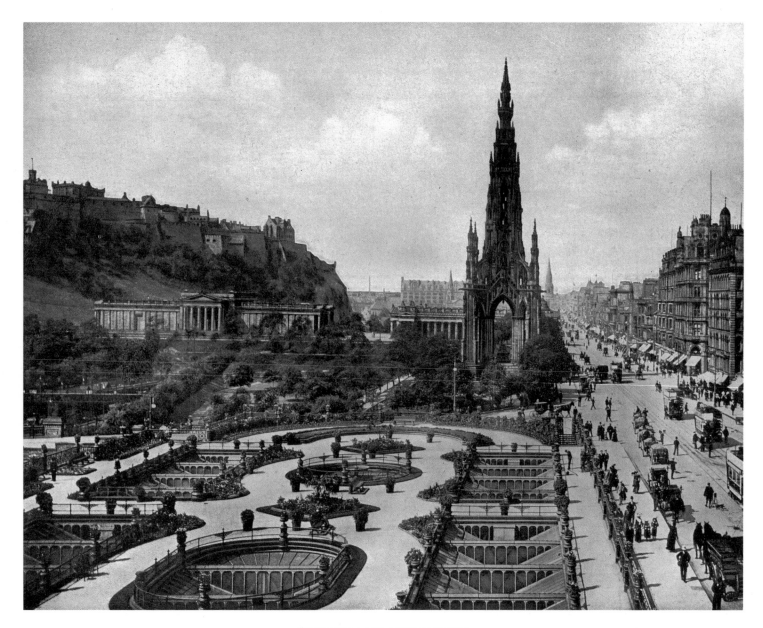

SCOTT MONUMENT, PRINCES STREET

vegetarian and freethinking literature whose views were summed up in the claim that 'it was the Tory party who crucified Christ', but his argumentative self was always soothed by a walk through Princes Street Gardens with his young wife, Teen, and their son. Jenner's department store survives from this period. The current building dates from 1893–95 and was designed by the same architect as the North British Hotel. It cost £125,000 and claimed

to reflect a wide range of fashionable styles, including the Bodleian Library in Oxford. John Reid's *Guide* claimed 'the female figures give symbolic expression to the fact that women have made the business concern a success'.

When the clerk John Inglis had time he loved to climb Calton Hill and look across at this view of Edinburgh. The shadows show that Valentine took his picture in the sharp morning

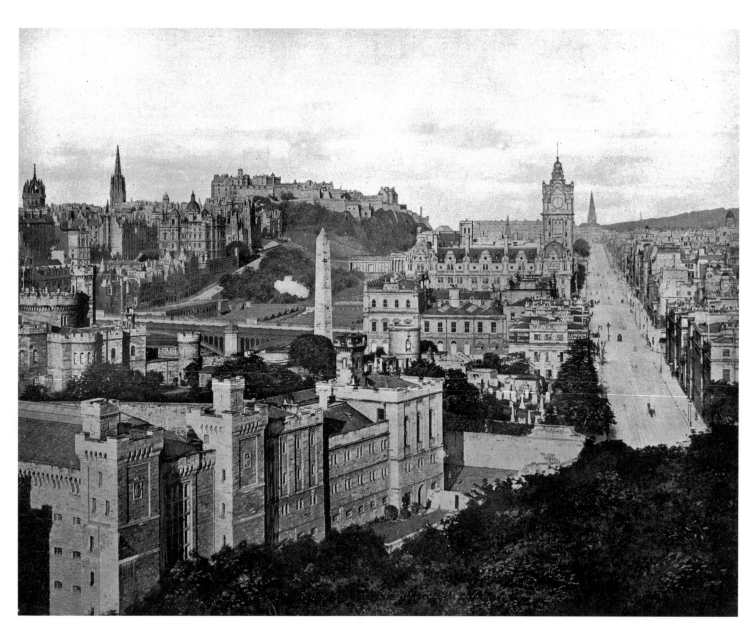

CALTON GAOL AND PRINCES STREET

sunlight. Central for Valentine was the 'lofty obelisk . . . in memory of five political martyrs who were banished in 1794 for espousing Liberal principles'. In a subtle way this is a very political picture. Thomas Muir and his friends were transported in 1793 in the midst of the political repression of the French Revolutionary period. Their actions and memory were appropriated by the nineteenth-century liberals who set up the obelisk in 1844 with the following inscription:

TO THE MEMORY OF THOMAS MUIR, THOMAS FYSSHE PALMER, WILLIAM SKIRVING, MAURICE MARGAROT AND JOSEPH GERALD. ERECTED BY THE FRIENDS OF PARLIA-MENTARY REFORM IN SCOTLAND AND ENGLAND, 1844.

The foreground was dominated by the Calton Gaol. It was the very pattern of a nineteenth-century prison, clean, disciplined and with an exterior that was both threatening and playful with its romantic mock castle-like exterior. James Grant chose a picture from below which reflected the business-like aspect of the area:

The prison buildings of the city occupy the summit of the Dow Craig . . . The first of these, the 'Bridewell' was founded 30th November 1791 . . . It was finished in 1796, at the expense of the city and the county, aided by a petty grant from Government. In front of it shielded by a high wall and ponderous gate, on the street line is the house for the governor. Semicircular in form, the main edifice has five floors, the highest being for stores and the hospital. All round on each floor . . . is a corridor, with cells on each side, lighted respectively from the

interior and exterior of the curvature. Those on the inner are chiefly used as workshops, and can be surveyed from a dark apartment in the house of the governor without the observer being visible. On the low floor is a treadmill, originally constructed for the manufacture of corks, but now mounted and moved only in cure of idleness or the punishment of delinquency.

At the east end of Waterloo Place, and adjoining the Bridewell, is the town and county gaol. It was founded in 1815 and finished in 1817, when the old 'Heart of Midlothian' was taken down. In a Saxon style of archi-tecture, it is an extensive building, and somewhat castel-lated – in short, the whole masses of these buildings, with their towers and turrets overhanging the steep rocks, resemble a feudal fortress of romance, and present a striking and interesting aspect . . .

From the lower flat behind a number of small airing yards, separated by high walls, radiate to a point,

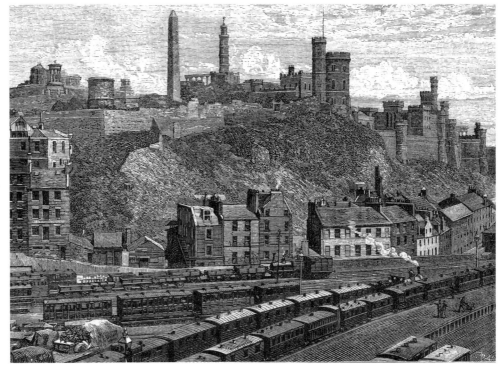

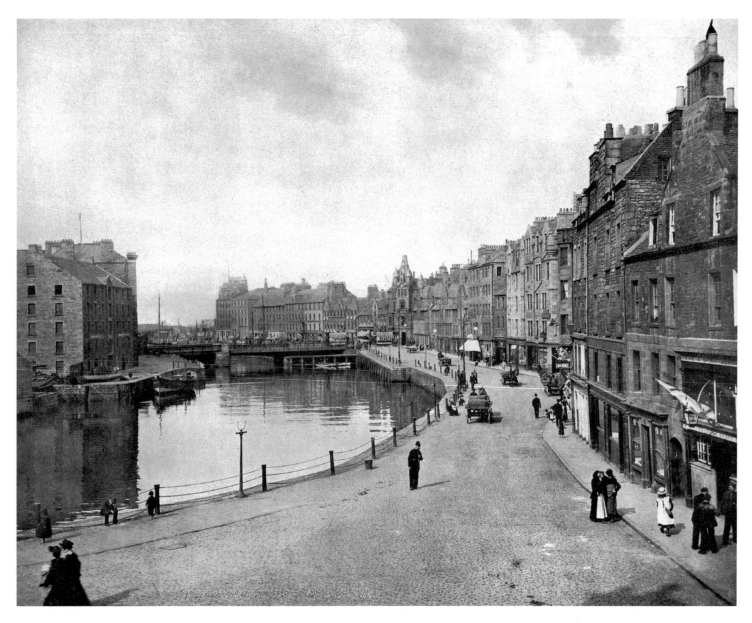

THE SHORE, LEITH

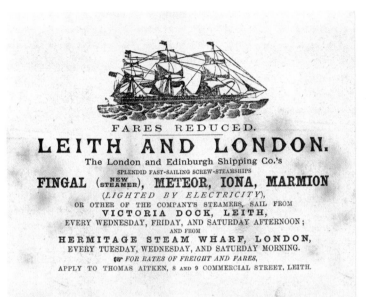

where they are all overlooked and commanded by a lofty octagonal watch-tower, occupied by the deputy governor. Farther back, and perched on the sheer verge of the precipice which overhangs the railway, is the castellated tower, occupied by the governor. The whole gaol is classified into wards, is clean and well managed, and possesses facilities for the practice of approved prison discipline.

For Robert Louis Stevenson this was one of the best viewpoints of Edinburgh. He could see both the Castle and Arthur's Seat. It was 'a place to stroll on one of those days of sunshine and east wind which are so common in our more than temperate summer'. Even Stevenson was taken in by the 'romantic' exterior:

Immediately underneath upon the south, you command the yards of the High School, and the towers and courts of the new Jail – a large place, castellated to the extent of folly, standing by itself on the edge of a steep cliff, and often joyfully hailed by tourists as the Castle. In the one you may perhaps see female prisoners taking exercise

like a string of nuns; in the other schoolboys running at play . . .

The Shore at Leith was a tram ride away from all this. Leith was the hard commercial end of the Edinburgh economy, fiercely independent in attitude and municipal government. The shadows suggest the picture was taken late afternoon. The heavily loaded rulleys moved slowly between warehouse and docks. Men dressed in rough work clothing, in close discussion, stood outside the public house. The women, strictly segregated, were in the nearby roadway whilst the girl with a satchel wove her way between them. Baddeley did not include Leith in his list of excursions from Edinburgh, although those who wanted to approach by sea were informed that the London and Edinburgh Shipping Company took 30 hours from Hermitage Wharf, Wapping.

The rough but cheerful nature of the place had probably not changed much since Hugh Miller, stonemason, geologist and devout evangelical, had arrived there in the 1820s: 'Leith with its thicket of masts, and its tall round tower, lay deep in shade in the foreground – a cold, dingy, ragged town, but so strongly relieved against the pale smoky grey of the background, that it seemed another little city of Zoar, entire in the front of the burning.' He was desperate to sell a dilapidated and profitless house he had inherited on the nearby Coalhill:

Two of our tenants made moonlight flittings just on the eve of the term; and though the little furniture which

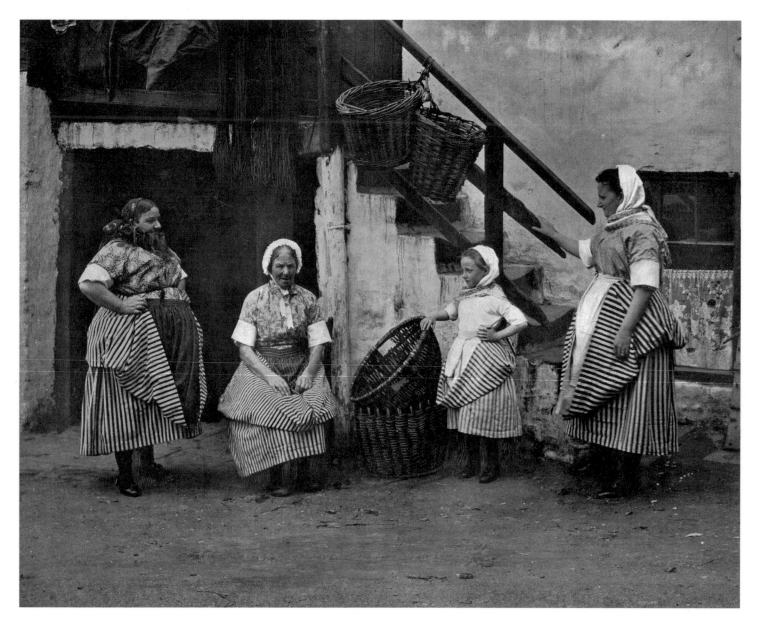

NEWHAVEN FISHWIVES

they left behind them was duly rouped at the cross, such was the inevitable expense of the transaction, that none of the proceeds of the sale reached Cromarty. The house was next inhabited by a stout female, who kept a certain description of lady-lodgers; and for the first half-year she paid the rent most conscientiously; but the authorities interfering, there was another house found for her and her ladies in the neighbourhood of the Calton, and the rent of the second half-year remained unpaid.

All photographers and many visitors to Edinburgh had to make a trip to Newhaven, and Valentine was no exception. It was here that Hill and Adamson, founding fathers of Scottish photography, had made their iconic studies of the fishwives. The fishing people of the port had an almost mythical image as a race apart, of Flemish origin, who did not intermarry with the Celt and Saxon. This was almost certainly based upon their very distinctive costume which not only provided very practical workwear but also made a spectacular ceremonial dress, not least when the photographer visited. The reputation of Newhaven's fishwives went back long before Hill and Adamson. They appeared in Black's *Guide to Scotland* in 1842 and were the subject of some very male remarks in *Blackwood's Magazine* in 1826: 'I like to see their well-shaped shanks aneath their short yellow petticoats. There's something heartsome in the creak o' their creeshy creels on their braid backs.'

Many nineteenth-century men found watching working-class women work especially attractive. Charles Reade in his much read Newhaven novel *Christie Johnstone* gave a full account of this:

Their short petticoats reveal a neat ankle, and a leg with a noble swell; for Nature, when she is in earnest, builds beauty on the ideas of ancient sculptors and poets, not of modern poetasters, who with their airy-like sylphs and their smoke-like verses fight for want of flesh in women and want of fact in poetry as parallel beauties. These women have a grand corporeal tract; they have never known a corset! so they are straight as javelins; they can lift their hands above their heads! – actually!

Their supple persons move as Nature intended; every gesture is ease, grace, and freedom.

There was some evidence that young women visiting Edinburgh would dress as Newhaven fishwives to have their studio souvenir photographs taken. The one nearby came from a family album and was taken in the 1880s in Thomas Burns's studio in Grove Street. The young lady had the same firm set of mouth as her more conventionally dressed mother in the same album. She may have envied the freedom she attributed to the Newhaven women.

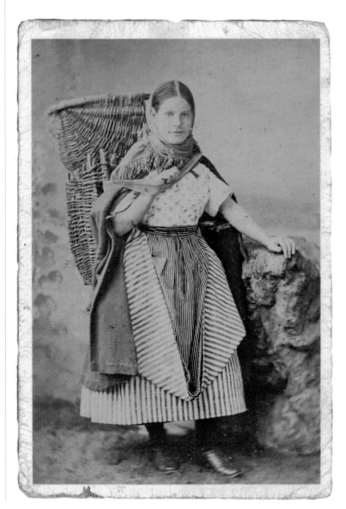

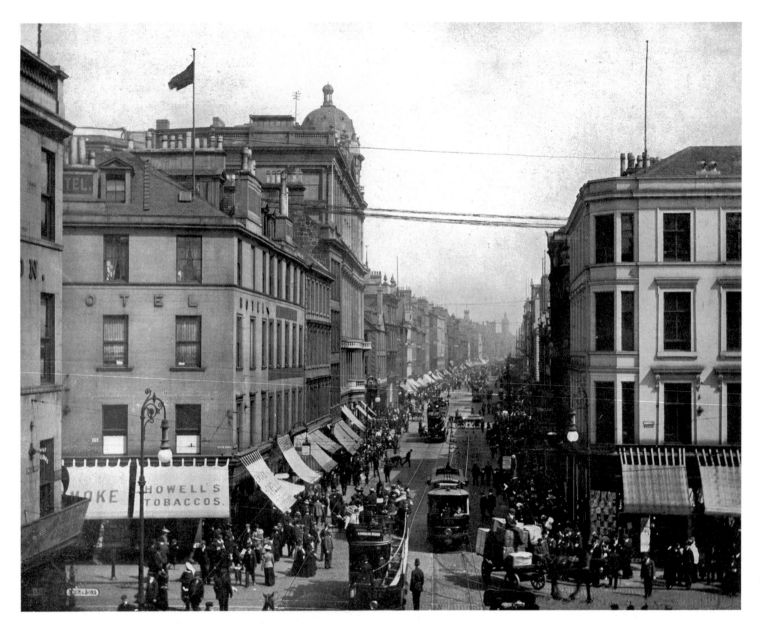

ARGYLE STREET

CHAPTER 7
Glasgow

There were several ways of looking at Glasgow and the view down Argyle Street was one preferred by many inhabitants. Argyle Street was a place of drink and shopping. It had lost caste a little as Glasgow's middle classes moved west. The kindest account came from James Hamilton Muir, *Glasgow in 1901*, prepared for the international exhibition of that year. J H Muir was, in fact, an amalgam of three journalists including James Bone, already met as the *flaneur* of Edinburgh. Argyle Street was:

a place where are the waxworks and the thieves, who if you are not wary steal your watch while you crane your neck to see the tops of the high buildings – the Polytechnic where braws can be purchased much under cost price . . . Argyle Street is also the haunt of the loafer, the bookmaker, and that shabby hopeful legion who gather in every city and wait on the turning up of things. At the same time it is the busiest street in the city. Here business cracks her stoutest whip, and men move fast and silently and work very late. Every species of merchandise, from twopenny watches to cargoes of sugar,

is sold in this district, and the buyers and sellers are ever on the pavement; and, besides these, there are debt-collectors and clerks out of collar making efforts to return to thraldom. You are jostled by Polish tailors running with hot-pressed clothes; little commission agents holding tight their black sample bags, which are

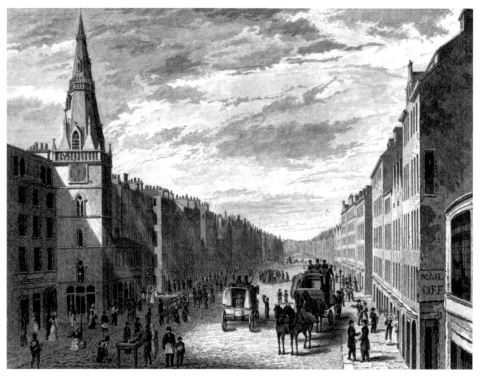

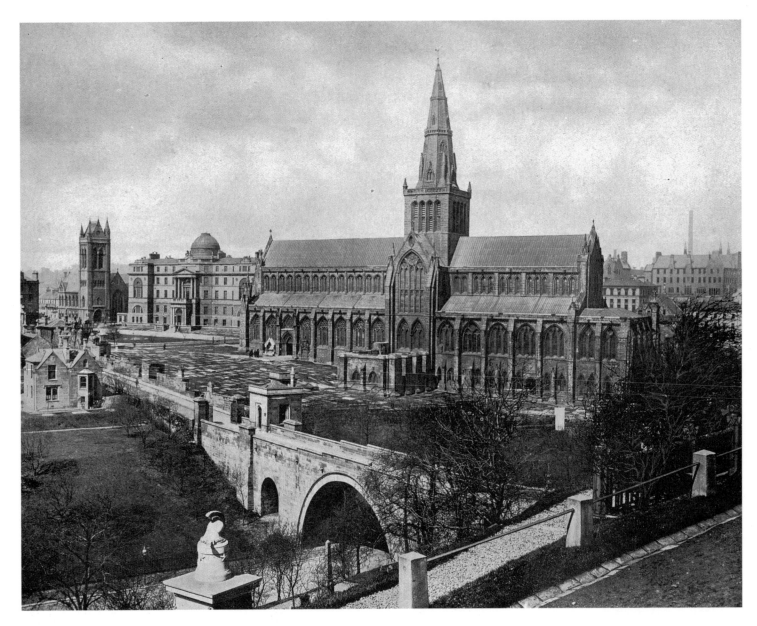

GLASGOW CATHEDRAL

their last straw to keep head above water. It is what you will – the saddest or merriest part of Glasgow. At night it is the Sauchiehall Street of a slightly poorer class. The lads and lasses of Gorbals and Gallowgate come daffing in crowds, chivying one another into the streets and up the entries, conducting their love-making by means of slaps and 'dunches', and showing the Scots' self-consciousness that makes it so pathetically unspontan-eous. If the nights are rainy, the young folk have either of the two 'Wonderlands' or the 'Brit' for their solace, and the street is deserted save for racing touts and hot-potato men. On Saturday night Argyle Street holds Saturnalia – not the 'Continental Saturnalia' we hear so much about, but a time of squalid licence, when men stagger out of shuttered public-houses as out of a pit, and the street echoes to insane roaring and squabbles, to the nerve collapse that ends a day's debauch of drink and football. On Sundays Argyle Street is a pleasanter place. The faithful pass to church, and the unregenerate make off to country places or to Paisley by the buses which start from opposite a vast, dull hotel, where

ambassadors of commerce are breakfasting in brown rooms to the smell of O.K. sauce. All day the street is a promenade, where the halflins sport their violet trousers and the girls their dresses of royal blue and magenta. All is peace and reconciliation, and the stains of the Saturday night fechts are washed away and forgotten.

Joseph Swan engraved the street in the 1820s. The roadway was occupied by street traders, pedestrians and onlookers as well as wheeled vehicles. By 1907, the centre was held by the electric trams of which Glasgow was so proud, the rest of the roadway by the rulleys. Wise pedestrians kept to the procession which occupied the pavements.

Glasgow Cathedral stood awkwardly away from the nineteenth-century centre of Glasgow. It had been scraped bare by the Reformation. The city was proud of the fact that it had been 'saved from the unreasoning violence of the Reformation mobs'. Legend had it that the city's craftsmen had refused an order to demolish it. Presbyterian commentors like Smith and Leighton in the 1820s were annoyed that anyone would think that genuine reformers would ever give such an order, although they were

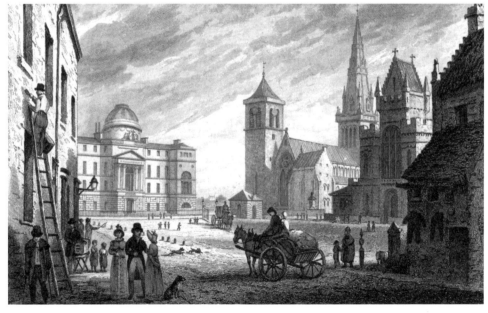

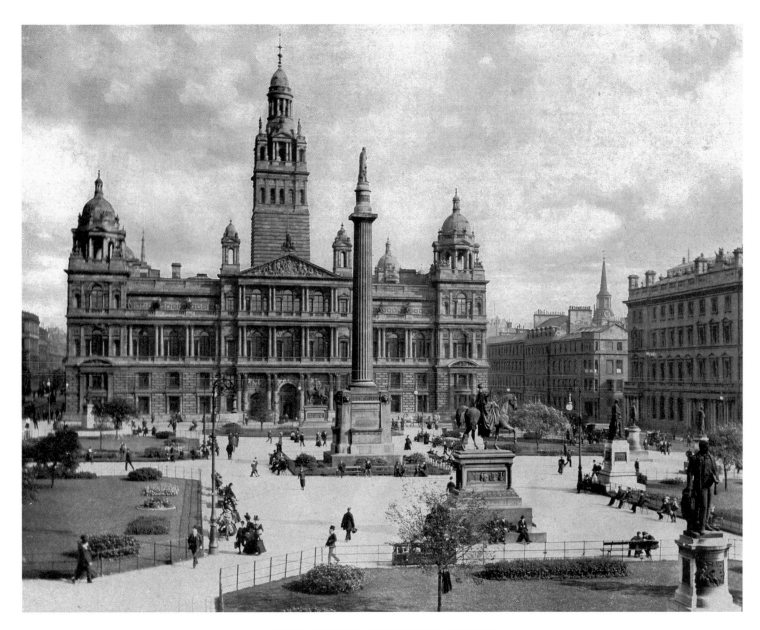

GEORGE SQUARE AND THE MUNICIPAL BUILDINGS

pleased that the building was the 'scene of a pure and rational worship' and not 'the attractive though degrading worship' of earlier times. Everyone liked the stories of the foundation of the Cathedral by St Mungo on the banks of the Molendinar Burn. In fact, the building of 1907 was as much the product of nineteenth-century Glasgow as of the Reformation. Two western towers had been demolished, the interior tidied up and the windows supplied with stained glass from a Munich workshop. The photograph was taken from the necropolis on the hill to the south-east. Behind the shoulders of the cameraman was John Knox in stone, fixing his stern gaze on the scene of rational worship below.

Swan's engraving of the 1820s showed the one and a half western towers still in place. The Infirmary to the left was the Robert Adam building of 1792 but, in 1907, about to be replaced.

Glasgow was many things. In 1907, it claimed to be 'the best governed city in the world'. Indeed, visitors came from all over the world to see its municipal socialism in action. George Square and the ceremony laying the foundation stone of the City Chambers in 1883 enshrined all this, as the following extracts from the souvenir book published at the time of opening show:

Chief Constable M'Call
Police Constables and Officer carrying Civic Banner
Town Officers with Halberts
The Lord Provost
Magistrates
And Members of the Town Council
Town-Clerk, City Chamberlain, and other
 Officials of the Municipality.
Architect (Mr. Young), City Architect (Mr. Carrick).
The Contractors – Messrs. Morrison & Mason.
Police Constables.
Lord-Lieutenant, Convener, and Deputy-Lieutenants
 of the County.
Police Constables.
Sheriffs of the County.
Lord Dean of Guild and Directors of the
 Merchants' House.

Deacon-Convener and Members of the Trades' House.
Master of the Clyde Navigation Trust.
President and Directors of the Chamber of Commerce.
Bedellus (with Mace) and Principal and
 Professors of the University.
President and Faculty of the Physicians and Surgeons.
Dean and Faculty of Procurators.
Chairman and Members of the School Board.
Rector and Masters of the Glasgow High School, and
President of Masters of Board Schools.
Chairman and Inspectors of the City, Barony,
 and Govan Combination Boards.

The servants of the municipality had evidently made great efforts for the occasion, their display of models, bunting, and decorative designs being unusually fine.

The Employees of the Water Department, numbering 200, were preceded by the Ladyburn (Greenock) Brass Band. On a lorry, drawn by three horses, were placed two beautiful cartoons, representing Fitzjames and the Lady of the Lake.

The Employees at Dawsholm Gas-works mustered 250 strong, and they were led by the Kilsyth Brass Band. The flags carried were the Union Jack and Ensign, and on a large banner was represented Siemens's regenerative system of heating retorts, while a banneret had the motto 'Gas, the light of the present', surmounted by a model of a colossal burner and gas flame. Two model gas-pressure gauges, a gas governor, a by-pass valve, and models of various workmen's tools were borne by the processionists.

The Cleansing Department was well represented, the Employees turning out to the number of 620. They had with them a beautiful triumphal arch on a lorry drawn by six horses; a water butt, on which was inscribed 'Down with the Dust'; and a sweeping machine, drawn by two horses.

The Statute Labour Department representatives, to the number of 250, were preceded by the band of the

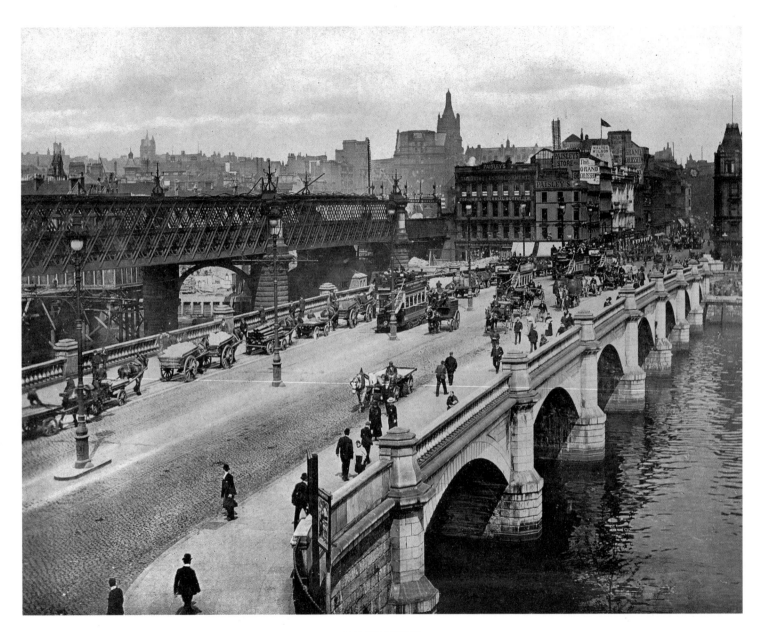

JAMAICA BRIDGE

2nd Renfrewshire Rifle Volunteers. They had along with them three lorries, on which workmen were engaged making granite sets, cause-waying, and working a cesspool.

The Sanitary Department was represented by 54 men and a couple of decorated vans, on which were the following inscriptions: 'This testing of your drains saves sorrow and fever pains', 'We are seeking to secure pure foods, drugs, and drink for the citizens', 'The people's health is the city's wealth'.

The Lighting Department came last. It was represented by 130 individuals, who, being nearly all Celts, were accompanied by a couple of pipers. They carried numerous models of lighting apparatus, from the old oil torch used in 1834 to the improved one in use at the present time.

Glasgow was rightly identified with the ring of heavy industries which surrounded the city, from Parkhead Forge to Templeton's Carpet Factory on Glasgow Green. Glasgow was also a commercial city. The largest male occupational group in the 1911 census was that of 'clerk'. World commerce meant that the river and its bridges were important to Glasgow both in fact and as symbols. They appear in picture after picture. The name Jamaica Bridge was carefully chosen for one layer of Glasgow's wealth had been gained supplying the slave plantations of the Caribbean. The Bridge of 1907 had been built in 1895–99 but, as a result of Glasgow opinion, had been built in the style and with some of the facings of an earlier Bridge designed by Thomas Telford (1833–35). Beyond it was the recently completed Caledonian Railway Bridge, a ten-track, openly modern structure of granite and steel. The endless stream of carts linked warehouses and quays whilst the electric trams linked suburb and suburb.

The suburbs were one of the hidden environments of Glasgow. These were Scotland's tramcar suburbs remembered in some detail by J J Bell in his 1932 book *I Remember*.

About 8.30 began the pilgrimage of Hillhead's Papas into town for the purpose of making pennies . . . some running after a tram-car and nimbly boarding it, without troubling the horses to stop, others making up their minds to walk into the City for the good of their health . . . The office being new is fairly airy and well lighted. Papa . . . having got rid of the cuffs, and changed his jacket for an old one, on the left sleeve of which he can so conveniently wipe his pen, he seats himself on a stool at a high, sloping desk, and goes through the morning's letters . . . At last he will come to his home, brightly lighted behind the heavy curtains, and absolutely all ready for him. A wash, an easy old jacket, but still the cuffs, and he is prepared for a quiet evening. Yet first a visit to the night nursery, the young family has already been bedded. Then tea, with fish or eggs – a simple repast – and the news of the day from Mama.

[These houses were put to full use for the carpet dance.] The drawing room, with its big marble mantle-piece and bright steel and brass fireplace, is a cheerful apartment . . . To-night the drawing room wears an unwonted aspect. In the morning came two strong men who carried away all the furniture, except the piano, removed the door from its hinges, took down the heavy curtains, and stretched over every inch of the carpet, in the most amazingly tight fashion, a great white cloth with a gliding surface . . . The piano, a 'cottage' . . . stands close against the wall . . . Tonight the performers will be amateurs. For the average dance party, home-made music is good enough, and even the most unmusical home has its relatives and friends who can play the right notes, or keep steady time, or, perchance, do both . . . every gas jet in the house is alight.

Let us look at the guests – ladies first . . . Their dresses are elaborately pretty, showing a fair expanse of – or, rather, an expanse of fair – bosom, but scarcely – under voluminous, frothy skirts – a hint of ankle . . . Plumpness is no crime. On the contrary, the gentlemen prefer it to skinniness, i.e., slimness. . . . Not that the

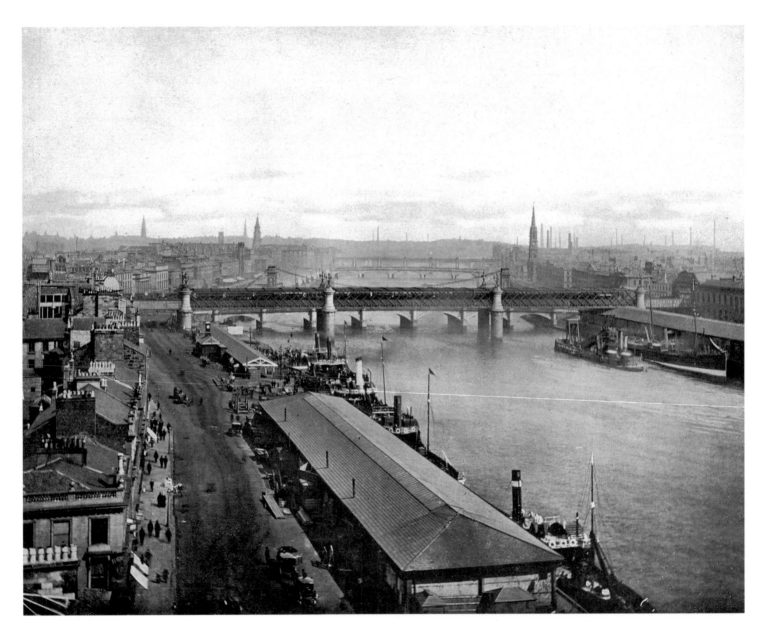

BROOMIELAW QUAY AND RAILWAY BRIDGE TO CENTRAL STATION

gentlemen have abandoned the 'lord of creation' air . . .
The squares are formed, the musicians unleashed
themselves, the couples bow, the dance begins . . .
I [young J J Bell] descend to the dining-room . . .
Upstairs they are dancing the Highland schottische. The
ceiling moves visibly, the gaselier bobs and jingles. The
dance goes on.

Broomielaw Quay was a place of many emotions for Glasgow. It
was the beginning of many holidays 'doon the watter'. More of
them later. It was also the way to Ireland. Nearly a fifth of Glas-
gow's population had been born in Ireland in 1851. Although this
fell to 7 per cent by 1911, many born in Glasgow thought of
themselves as Irish. The contradictions of Irish experience
identified with those who landed at the Broomielaw were best
represented by John Wheatley, one of the finest politicians to come
from Scotland. He became a minister in the first Labour
government and produced Britain's first effective Housing Act. He
was seen here through the eyes of fellow socialist and political ally
David Kirkwood, in *My Life in Revolt*:

John Wheatley was one of the multitude of men of
Southern Ireland who, having been brought over to the
West of Scotland by their parents, have grown up in an
atmosphere of divided loyalties. They love Scotland, but
retain a deep affection for Ireland. They live in a very
Protestant community and remain devoted and
sometimes aggressive Roman Catholics. Educated at
schools inferior to the schools of the Local Authority,
they are below the standard of their Scottish neigh-
bours, but have a quick wit and a marked fondness for
public affairs. They seldom fall foul of the Glasgow folk,
but are frequently in trouble with their fellow-Irishmen
of the Loyal Order of Orangemen. Much of their
antagonism is traditional and not personal. It finds a
safety-valve in cheering their pet football teams, the
Celtic, many of whose players are Protestant, and
booing their pet aversion, the Rangers Football Team,

some of whose players are Roman Catholic. The
converse is also true.

As a result of the ingenuity of youthful Pressmen,
the Billy and Dan scraps which seldom do more than
disturb the quietness of a noisy street, are described as
'Riots in the City of Glasgow'!

John Wheatley was born in Ireland and brought
over to a mining district near Parkhead in infancy.
There he was reared in a house of one apartment.
Having a strong leaning towards learning, he studied in
his spare time. He was a coal-miner. He left the pits and
became an assistant in the shop of a licensed grocer. He
then worked for some years as a canvasser for advertise-
ments for a local paper called an 'organ of Roman
Catholicism'. At length he set up in business for himself
as an advertiser. The business was unusual. Having
obtained from the clergy the right to publish a New
Year Blotting-pad, he gave them a few pages for
parochial news and filled up many pages with advertise-
ments of local tradesmen. The blotters were given free
to the parishioners. It was a clever device and proved
highly profitable. In time he became rich.

When I first met him, he was in trouble. He had
declared himself a Socialist and founded the Catholic
Socialist Society. This was too much for his co-
religionists and their spiritual leaders. There was little
they could do. They decided to do the little. They could
not burn the heretic, so they made an effigy of him,
which they carried through the streets and burnt amid
much pious rejoicing at John Wheatley's front gate. He
had been warned of the danger of being in the house,
for an Irishman under the influence of religious mania,
like one under the influence of alcoholic drink, is
reckless. To the consternation of the inquisitors, John
Wheatley stood with his wife at his open door, smiling
at the fanaticism as if it had been fun.

The following Sunday morning he appeared at
Mass as usual, and the trouble died down.

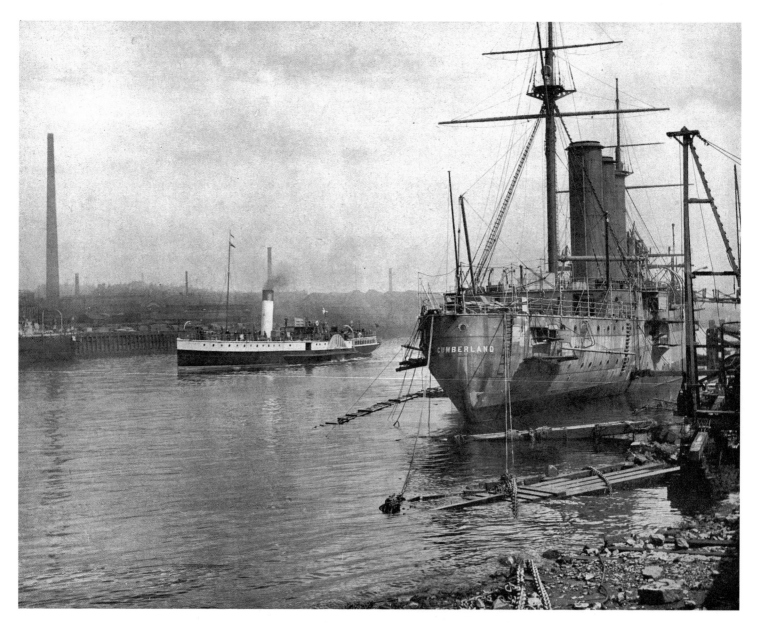

CLYDE AT GOVAN WITH HMS *CUMBERLAND*

The warships, passenger liners and cargo ships built in the Clyde were the hard physical embodiment of Empire. HMS *Cumberland* was an armoured County Class Cruiser built about 1902 by the London and Glasgow Engineering and Iron Shipbuilding Company. She was a small part of the massive naval arms race that preceded the First World War. Built for speed, she captured a number of German merchant ships during Atlantic patrols before being scrapped in 1921. Behind the raw power of the naval ship and the business of the paddle steamers and cargo ships were the forges and engineering shops of the Clyde, described here by another Glasgow socialist politician, Tom Bell, in *Pioneering Days*:

Parkhead Forge in the early eighties was controlled by the Beardmore family. It manufactured steel plates for all kinds of work, from quarter inch plates for tubes to 5 in. and 6 in. plates (and guns) for warships; as well as locomotive tyres. Earlier still it made cannon balls. The old puddling process was carried on till a late date side by side with the Bessemer open hearth furnaces. The furnaces, foundry, rolling mill, steam hammers and press engaged a large staff of highly skilled labour – including bricklayers – and all under the patriarchal eye of old 'Bill' and 'Isaac' Beardmore.

The plates, ingots of steel, propellers and keels for ships were hauled down to the Clydeside on a chariot-like conveyance which consisted of a car on two wheels at each end of a long pole – a 'monkey' as it was called. This 'monkey' was drawn by a team often, twelve and more horses, according to the load. To bring the load to the main road, which led to the shipyards of Govan or Clydebank, there was a steep incline from the gate up the New Road (now Duke Street) to Parkhead Cross. When, as often happened, the horses got stuck, I have seen Isaac Beardmore come up to the Parkhead Cross, and call upon the workers who were to be found at the street corner to come and give assistance to the horses and haul at a rope. Once on the straight road the men and Beardmore would adjourn to the corner public-house, and all engage in drinks at Isaac's expense.

With the expansion of imperialism, its shipbuilding, armaments, etc., Beardmore's grew like a mushroom. By the war of 1914 the old puddling process had died out. Electric furnaces, cranes, automatic conveyers and up-to-date methods had wiped out the old patriarchal conditions. The family concern had become a giant armament ring with tentacles stretching throughout the mines and shipyards of the Clyde Valley, and to international concerns. During the Great War (1914–18) over 10,000 workers were employed on munitions and the by-products of the steel plant. It gathered workers from all parts of the country. The village of Parkhead had become a congested cosmopolitan area of many dialects . . .

The conditions under which the moulder worked were vile, filthy and insanitary. The approach to the foundry resembled that of a rag and bone shop, or marine store. The entrance was usually strewn with all kinds of scrap iron and rubbish. The inside was in keeping with the outside. Smoke would make the eyes water. The nose and throat would clog with dust. Drinking water came from the same tap as was used by the hosepipe to water the sand. An iron tumbler or tin can served as drinking vessel until it was filthy or broken, before being replaced by a new one. The lavatory was usually placed near a drying stove, and consisted of open cans that were emptied once a week – a veritable hotbed of disease. Every night pandemonium reigned while the moulds were being cast. The yelling and cursing of foremen; the rattle of overhead cranes; the smoke and dust illuminated by sparks and flames from the molten metal made the place a perfect inferno. Glad we were, when it was all over.

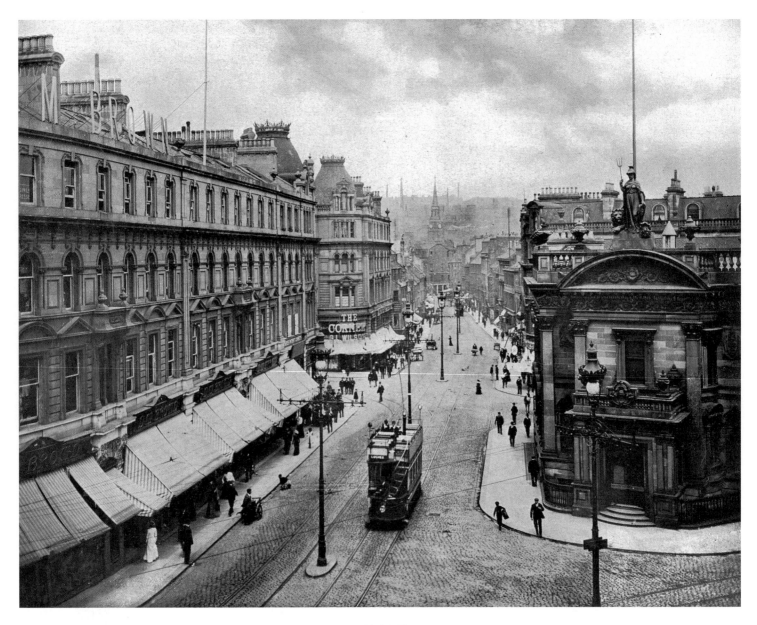

MURRAYGATE

CHAPTER 8
Dundee

Dundee was the hard industrial end of big city Scotland. There was little of the mediating influence of merchant cities or bankers and lawyers. It was the city of jute and linen mills and independent mill girls. It was also the home town of William Dobson Valentine, photographer, and his publisher John Leng. Dundee was one of the heartlands of Liberal Scotland and Leng was its MP from 1889 to 1905, a radical advocate of 'Home Rule all Round'. As editor and publisher of the *Dundee Advertiser* and *The People's Friend*, he was one of those who made Dundee a centre of journalism and publishing. When they presented their city, the dominant theme was improvement and the municipal. The 1871 Dundee Police and Improvement Act was the key document. Behind the 1907 pictures of Murraygate and the High Street was a move from narrow congested streets to wide modern streets suitable for shopping and commerce and banks.

These were major before-and-after pictures of Dundee. Improvement was a numbers game. The rapid increase in population was quoted with pride, as was the increase in property prices. Another meaning of improvement was provided by the department store of D M Brown to the left in the Murraygate picture. The *Dundee Year Book* gave an account of the opening of Brown's new arcade which was an invitation to enter an exotic and fantasy world:

Entering it from the High Street side the visitor is flanked by a double row of massive green pillars in Cipollino marble. A few steps treading on a marble pavement, beautifully inlaid, and the visitor is cut off from the noise and hustle of High Street, in a cool and quiet haven, with objects of beauty all around him. The

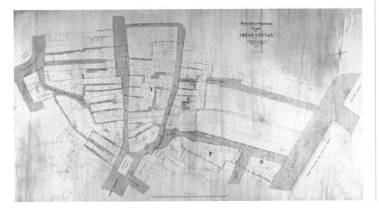

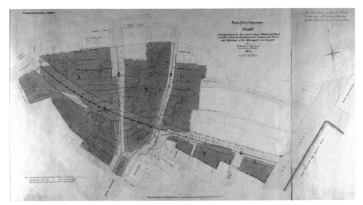

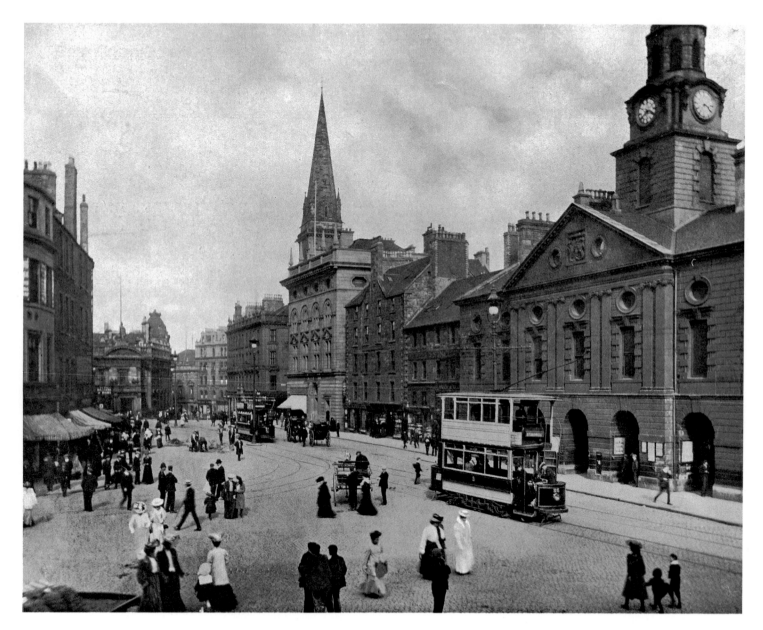

HIGH STREET

classic quarries of Greece and Italy, of Sicily and Sweden, of Norway and Belgium have been laid under contribution for the flooring. Overhead the roof towers dazzlingly white. The plaster work is modern – English Renaissance. The ornamentation takes the form of conventionalised fruit, flowers, and foliage, in festoons, pendants, and wreaths. The archways are similarly treated, and the translucent green pillars are surmounted by entablatures of white-veined Calicala marble. The upper clerestory windows are filled with Byzantine glass, and the woodwork, of the finest mahogany, is prettily carved in designs to harmonise with the plaster. The windows which line the arcade consist of a succession of broad and narrow bent panes, alternating with each other, and the contents of each are so arranged that it is possible to see right through six or seven windows from Commercial Street to High Street. There is no crowding, and that is a big thing to say when through the two entrances to High Street and the one on the Commercial Street side there passes in and out during business hours a constant stream of sightseers and of patrons . . . From sightseeing to purchasing is but a step. The Arcade is free to all. The inducements to buy are seen, not shouted; but the glass way leads to the counter and to all the multifarious departments of the great commercial house. A few strides takes the visitor to the lifts which whisk him to the luncheon and tearoom or to whatsoever department his purchasing requirements lie. Below the Arcade have been constructed new quarters for sale and excellent parcels post system, wherein is conducted a vast volume of business. Through the pneumatic tubes with which every section of the establishment is connected to a central exchange in the basement the cash clatters with exactness and dispatch. The telephone system is complete with 25 instruments connecting the outer world to every department of a warehouse where every item in the drapery business is obtainable.

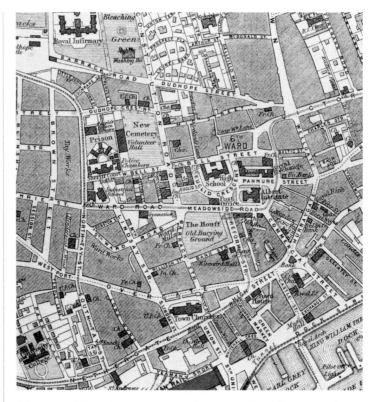

Like many Victorian towns, Dundee wanted confirmation that it was a civilized place. It had gained city status in 1892 after a sustained campaign. Confirmation could come in all sorts of ways. The most important was the Royal Visit, celebrated by the engravings around the fountain in Albert Square.

Dundee proved it was a civilized place in many ways. There were the new wide streets and the buildings with their Venetian windows. Dundee never had a 'new town' or a true 'west end' like many growing towns. The Bartholomew map showed that the new streets burrowed through the old centre and the industrial suburbs. The map also showed that other sign of civilisation, the large number of public buildings, halls, libraries, churches, institutes, wash houses and the prison.

The order and authority behind all this was formidable, the power to assemble and rearrange property in broad straight lines, the discipline of the street with its pavement, granite sets, lighting, drainage and tram lines linking to other parts of the town. Behind

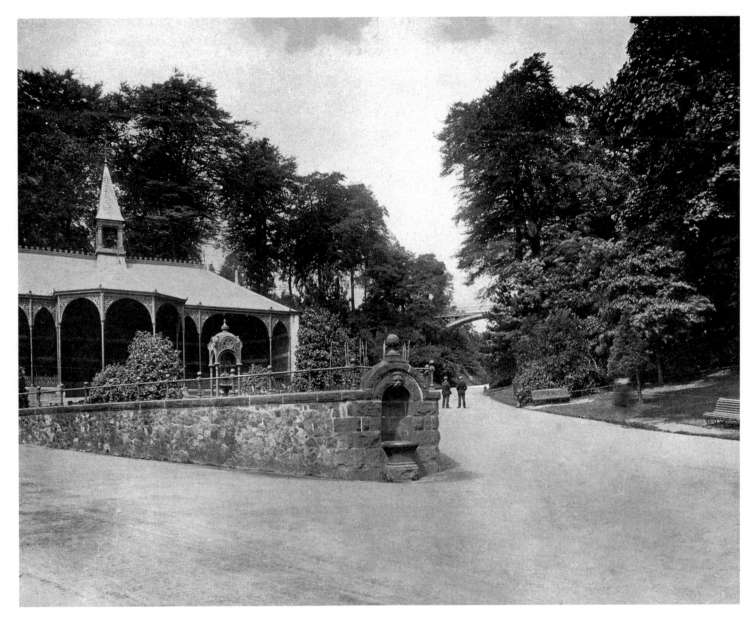

BALGAY PARK

all this was that key actor in Scotland 1907, municipal Scotland, sometimes derided and often forgotten. The best place to celebrate municipal Scotland is in the municipal park, but first, a list not just of the standing committees of the Dundee Municipal Council but, perhaps more important, the growing list of paid officials of the council with their tasks and qualifications.

Works Committee
Public Health Committee
Police Committee
Parks and Cemeteries Committee
Markets and Baths Committee
Water Committee
Gas Committee
Tramways Committee
Electricity Committee
Finance Committee
Lord Provost's Committee
Included in the list should be the Guildry Incorporation with the Dean of Guild, Deacons and Assessors who enforced building regulations and the Parish Council of Dundee Combination who cared for the poor.

Town Clerk – William H. Blyth Martin, City chambers.
Depute Town Clerk – James M'Lagan, City chambers.
City Chamberlain – David Bannerman, City chambers.
Police, Water, Gas, and Electricity Treasurer –
 Alex. W. Stiven, C.A., 95, Commercial street.
Burgh Engineer – William Mackison, F.R.I.B.A., F.S.A.
 Scot., C.E., 91, Commercial street.
Assistant Burgh Engineer – James Thomson, C.E.,
 91 Commercial street.
Water Engineer – George Baxter, A.M.I.C.E.,
 93 Commercial street.
Gas Engineer – Alexander Yuill, Gas Works,
 East Dock street.
Electrical Engineer – H. Richardson, A.M.I.E.E.,
 Electric Lighting Station, Dudhope Crescent road.

Tramway Manager – Peter Fisher, 4 Vault.
Inspector of Weights and Measures – Alex. M. Imrie,
 29 North Lindsay st.
Public Analyst – George D. Macdougald, F.Inst.Chem.,
 13 Shore terrace.
Medical Officer of Health – Charles Templeman, M.D.,
 D.Sc., West Bell st.
Sanitary Inspector and Shop Inspector –
 Thomas Kinnear, West Bell street.
Superintendent of Cleansing – James Arthur,
 28 East Dock street.
Superintendent of Markets and Slaughterhouses –
 J. A. Baxter, Slaughter-houses, East Dock street.
Veterinary Inspector – Andrew Spreull, F.R.C.V.S.,
 31 and 39 Yeaman shore and 78 Ward road.
Superintendent of Fish, Fruit, and Flower Markets and
 Collector of Petty Customs – James Walker,
 Craig Street Market.
Council Officer – James Robertson, City chambers.
Assistant Council Officer – James Cousins, City chambers.
DUNDEE BURIAL BOARD – The Lord Provost,
 Magistrates, and Council are the Parochial Board
 for burial ground purposes.
BURIAL GROUNDS – Eastern Necropolis, Arbroath road;
 Western Necropolis, Balgay hill; New Burying
 Ground, Constitution road; Howff, Meadowside;
 St Peter's, Perth road; St Andrew's, Cowgate;
 Roodyards, Ferry road; and Logie Churchyard,
 Lochee road.
John Carnochan, Superintendent, 93 Commercial street –
 Office open during the week from 9 a.m. till 3 p.m.,
 and from 6 till 7 evening; and on Saturdays from
 9 a.m. till 12 noon only. Offices at the Eastern Necro-
 polis and Western Necropolis open during the day.
CITY PARKS AND BAXTER PARK, including Balgay Hill.
 – D. Mathers, Convener of Committee. John
 Carnochan, Superintendent – Office,
 93 Commercial street.

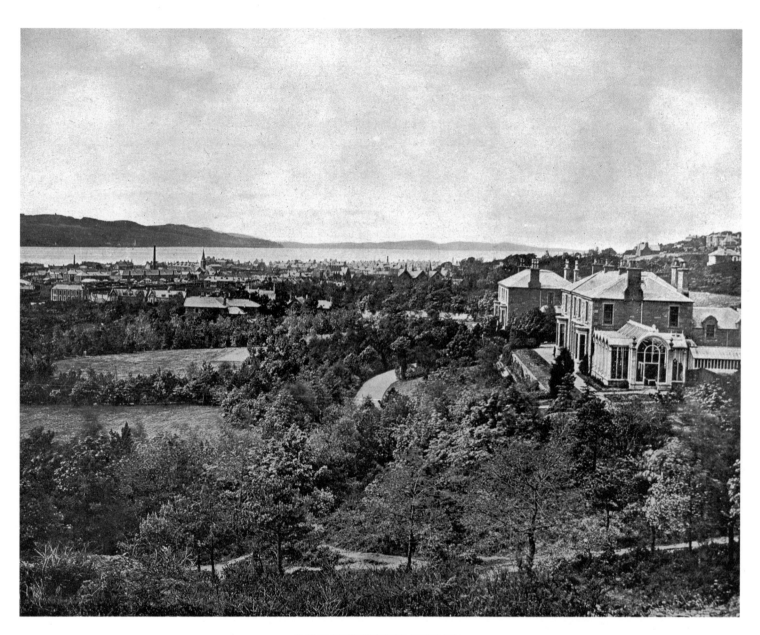

BROUGHTY FERRY FROM RERES HILL

CITY POLICE ESTABLISHMENT – Central Office, West Bell street.

District Stations – Northern Office, Union street, Maxwelltown; Eastern Office, Princes street; Western Office, Scouringburn; Lochee Office, South road, Lochee; Harbour Office, Dock street. David Dewar, Chief Constable and Procurator-Fiscal. One deputy chief constable, seven superintendents, seven inspectors, nine detective officers, twenty-six sergeants, and one hundred and sixty-eight constables. Total strength, 219.

SANITARY DEPARTMENT, West Bell street. – Charles Templeman, M.D., D.Sc., Medical Officer of Health; Thomas Kinnear, Chief Inspector; one sanitary inspector, five practical inspectors, nine sanitary officers, two clerks, one van driver, and two lady health visitors.

CLEANSING DEPARTMENT – One inspector, six foremen, two hundred and twenty scavengers and carters, four blacksmiths, and four joiners. James Arthur, Inspector, Dock street.

JUDGES OF POLICE COURT – The Lord Provost and Bailies of the Burgh. The Town Clerk, Assessor.

H. M. PRISON, West Bell st. – Major Wm. Stewart, Governor; A. M. Stalker, M.D., Medical Officer; Rev. D. R. Robertson, B.D., Chaplain ; Very Rev. Provost Mackenzie, Church of England Visiting Clergyman; Rev. J. Doherty, R. C. Visiting Clergyman; Miss Hutton, Matron; two Head Warders; one First Class Warder, twelve Second Class Warders, four Second Class Female Warders, and three Organists.

FIRE BRIGADE – Central Station, West Bell street; J. S. Weir, Fire-master; J White, Deputy-Firemaster; eight permanent firemen; eight auxiliary firemen. Northern Station, 66 Union street, Maxwelltown – three auxiliary firemen. Western Station, South road, Lochee – three auxiliary firemen. Total strength, 10 permanent and 14 auxiliary firemen.

This extract perhaps lacks the charm and excitement of quotes from Burns, Scott and Baddeley but read it slowly for, without these men and women, none of the photographs of the great towns would be possible and that includes Balgay Park.

Balgay Park was purchased by the Police Commissioners from Sir William and Lady Scott and laid out as a pleasure ground in 1871. It included a carriage drive and had a cemetery on the left-hand side. The nineteenth century was the age of the search for green spaces. Dundee also had Baxter Park and Lochee Park on land gifted by the major jute manufacturers. Like the street, the park was disciplined and orderly with its rules and organised spaces. The central place given to the ornamental fountain was no accident. This was a society battling premature death, especially amongst children, and clean water for drinking was central to the battle. The band stand and the green of the trees were also part of the civilising effect of the municipal.

The residential suburb, detached, leafy, a place of large houses was a key part of any successful industrial city. Broughty Ferry was an independent police burgh, linked to Dundee by railway and was in the process of having an electric tramway link completed. By 1907 Brought Ferry had a double purpose. For many years it had been a place where the merchant princes and other wealthy members of Dundee society took shelter from the noise and dirt amongst which they made their wealth, but it was increasingly the

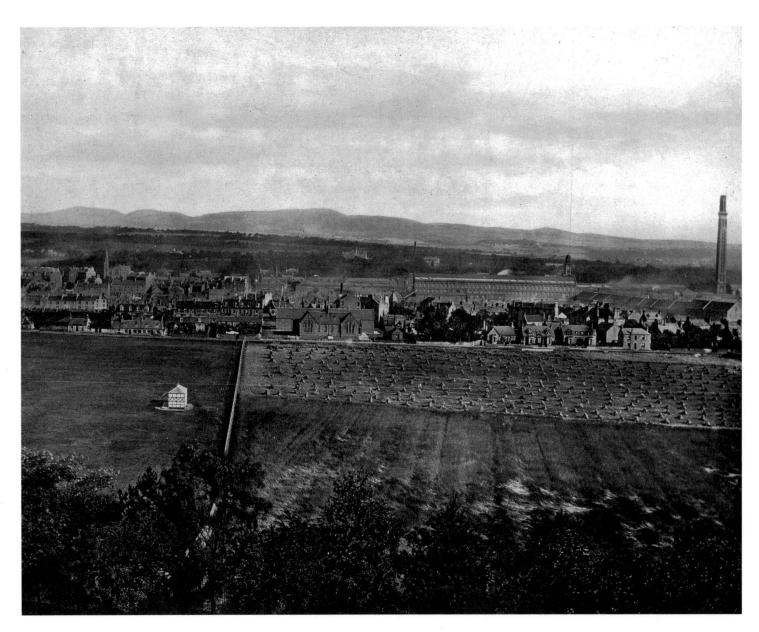

LOCHEE AND CAMPERDOWN LINEN WORKS

day at the seaside for many of the population, with sands, band stands and recreation grounds.

A glimpse of what Broughty Ferry was really about comes not from the municipal council but from a listing of the associations and clubs which the active resident might join: Church of Scotland Beach Chapel, St Margaret's Cottage Home, Broughty Ferry Beach Mission, Broughty Ferry Benevolent Trust, Broughty Castle Bowling Club, Broughty Bowling Club, Broughty Ferry Horticultural Association, Broughty Curling Club, Broughty Ferry Amateur Rowing Club, Broughty Golf Club, Broughty Ladies Golf Club, Forfarshire Cricket Club, Forthill Athletic Football Club, Ardenlea Football Club, Broughty Ferry Quoiting Club, Broughty Ferry Games Club, Broughty Ferry Angling Club, Unionist Club, Broughty Ferry and District Liberal Association, British Workman Public House and Broughty Ferry Volunteer Artillery.

Lochee was an integrated industrial suburb to the north-west of Dundee itself. The Camperdown Works were the largest jute factory in the world. Here Valentine preferred to stand back and let the fields in harvest stand between industry and the spectator. It was a massive and organised site of 25 acres. Even here the Renaissance theme was continued with the huge chimney stalk built at a cost of £6000, which would carry the smoke well above the suburb and distribute it across the surrounding countryside.

Baddeley was not quite sure what to say about Dundee. He recommended trips to Broughty Ferry and Lochee and decided 'the town is best known for its marmalade'.

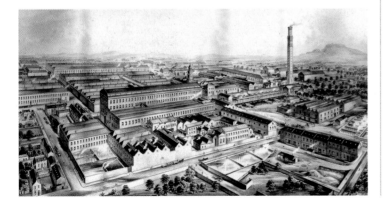

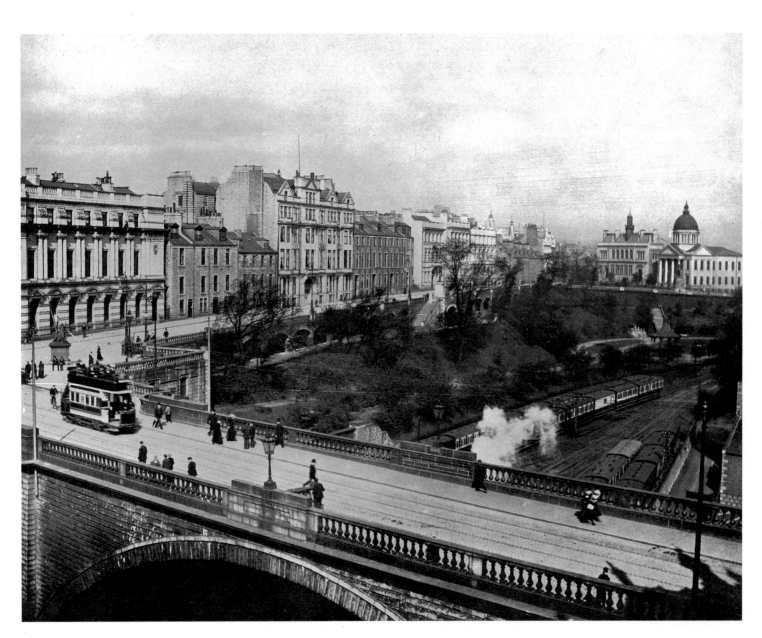

UNION TERRACE

CHAPTER 9
Aberdeen

Aberdeen presented itself to the world in many ways. It was the granite city, chief town and seaport in the North of Scotland, the capital of the Yorkshire of Scotland, the city of St Nicholas as well as 'Our ain "braif toun" o' Bon Accord'. Valentine led the purchasers of his photographs up Bridge Street from the Joint Station (opened in 1867) to the Union Bridge (1800–03). In one direction was Union Street and, to the north, Union Terrace, results of the legislation of 1800. After Argyle Street, Princes Street and High Street/Murraygate, the message was clear; big cities were about shopping and commerce. When Charles Knight and his contributors visited Aberdeen in the late 1840s, the impact of Union Street was evident:

> certainly a noble thoroughfare that same Union Street, running north and south, and so connecting the old and mechanical portion of the city with the modern and fashionable quarter. It possesses all the stability, cleanliness, and architectural beauties of our own London west-end streets, with the gaiety and brilliancy of the Parisian atmosphere. We could have imagined ourselves trans-ported to a continental capital upon a bright May day. The lofty, elegant houses, the beautifully white, flowing muslin curtains in the first and second floor windows, the expanded shop fronts, set out with such a profusion of rich and costly wares, made all Union Strtet seem one

continuous bazaar or fancy fair. Almost every other shop appeared to be either a confectioner's or a jeweller's; and it was difficult to say which of these wore the most brilliant appearance. The jewellers' shops shone in the sunlight a perfect blaze of wealth and ornamental beauty; rings, bracelets, chains, crosses, brooches, seals, cut from the mineral productions of Aberdeenshire – the onyx, the topaz, the amethyst, the aqua-marine, mica, talc, and many other pretty gems were there, telling of the richness of the Scottish soil and the ingenuity of Scottish workmen. Nay more than this, it is not more than a century or so since that veritable pearl fishery existed in the bed of the river Ythan, yielding a rather considerable annual sum.

Aberdeen had never appeared so exotic, but there were also more practical offerings such as those of Joseph Ellicock of 489 Union Street whose cabinet, chair and upholstery works were in Justice Mill Lane:

> Solid Oak PARLOUR SUITE, in Best Leather, Couch, 2 Easy, 4 Single Chairs £6 10s.; same Articles in Embossed or Plain Velvet, £7 *10s.*
>
> Solid Oak or Mahogany DINING-ROOM SUITE, in Pegamoid, Couch, 2 Easy, 6 Single, £12 10s.; same Articles in Morocco or First Quality Velvet, £16 10s.

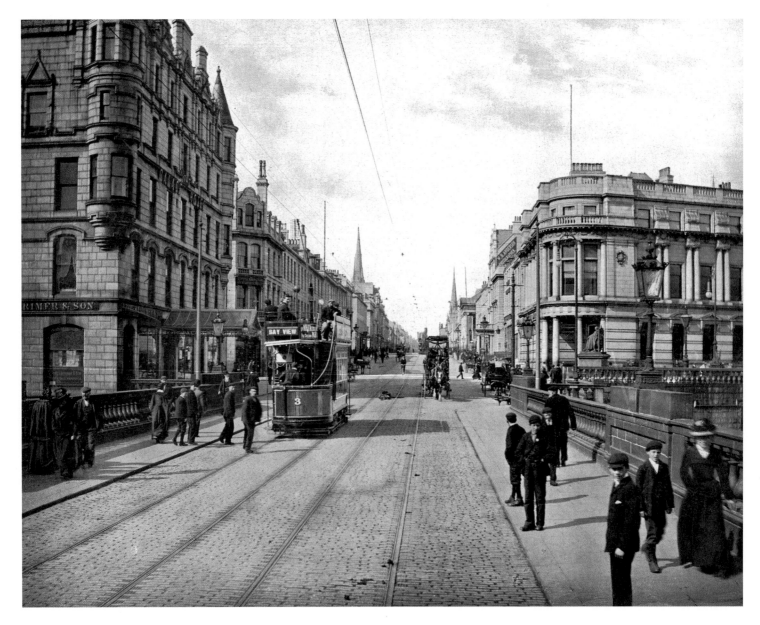

UNION STREET

There were other ways of looking at the great towns of Scotland. It is time to get excited by numbers and municipal by-laws. Aberdeen took numbers very seriously, perhaps because they feared demotion from third place in the ranks of Scottish towns as a result of Dundee's formidable growth. James Valentine's account of *Aberdeen As it Was* was just that. The easy picture came from the simple numbers of total population. For every town a growing population was a sign of 'progress'.

When Francis Groome prepared a new edition of his *Ordnance Gazetteer of Scotland* some 20 years later, numbers were a staple part of the account. He praised the improved streets but issued the following warning:

the very improvements, or at least the openings for the new streets, and the clearing for some public buildings, together with the forming of the railway, have produced the evils of placing grandeur and meanness side by side, and greatly augmenting the density of the poorer population. No fewer that some 60 narrow lanes and about 168 courts and closes, of an average breadth of at most 7 feet still exist; these are mostly situated in the vicinity of fine new streets. Nevertheless, the death rate per 1000 diminished from 22.5 during 1867–72, to 20.7 during 1881–90, being thus below the average of the eight large Scotch towns.

Density of Population in Map Districts.

No. of District.	Square Yards to each Person.	No. of District.	Square Yards to each Person.	No. of District.	Square Yards to each Person.	No. of District.	Square Yards to each Person.
1	107·14	16	20·44	31	137·90	46	76·03
2	21·02	17	44·32	32	403·30	47	116·64
3	23·90	18	15·51	33	No pop.	48	39·18
4	31·64	19	357·91	34	do.	49	83·64
5	25·36	20	63·28	35	172·15	50	125·52
6	61·41	21	88·44	36	63·41	51	61·80
7	41·44	22	26·87	37	52·68	52	155·16
8	28·44	23	99·69	38	42·83	53	791·86
9	44·45	24	71·63	39	76·76	54	101·18
10	25·74	25	17·22	40	137·93	55	231·40
11	24·67	26	17·90	41	57·86	56	1023·10
12	21·93	27	19·08	42	60·97	57	224·25
13	28·97	28	31·45	43	154·33	58	521·27
14	23·10	29	26·32	44	828·05	59	161·88
15	20·59	30	121·50	45	43·59	60	3401·13

CROWDED PARTS OF THE CITY.—By far the most thickly populated part of the city is our District No. 18, situated between East North Street, Justice Street, Castle Street, and King Street. That district is not exceptionally small in area, and there are only 15½ square yards of ground to each person. The district where the people are next most densely packed is No. 25, which comprehends all one side of the Gallowgate from Littlejohn Street northwards, West North Street and Littlejohn Street being the other limits. This district is more than 12 acres in extent, and on the assumption of equal distribution, there is very little more than 17 square yards to every person; but as there are several large bleach-greens, &c., at the back of Seamount Place, the parts of the district built on are proportionally more densely peopled. The Old Machar residents have in general much more space than those in St. Nicholas. The most closely populated part of Old Machar is District No. 48, which includes a large part of Skene Square, the block of lofty houses on the Rosemount Road known as Gray's Buildings, and the Industrial School. It should be observed, however, that although this be the densest district in Old Machar, eighteen of our map districts in St. Nicholas are more thickly peopled.

BREATHING SPACES.—The population district No. 32 has clearly the smallest number of inhabitants in proportion to area of any part of St. Nicholas. This district includes the Fisher Squares, to which we refer elsewhere; but it will be seen that a considerable part of the Links and the Sea Beach is within this district. The most sparsely peopled district within the urban part of the city is No. 56, where each person has 1023 square yards of space. District No. 60, as explained before, is almost entirely rural, therefore the figures bring out about three-quarters of an acre to each person.

—

SEVENTY YEARS' PROGRESS.

The following table shows the population and increase at each Census of the Parliamentary Boundary of Aberdeen :—

I. Total Population and Increase from 1801 to 1871.

Year.	Population.	Increase on previous Census.	Year.	Population.	Increase on previous Census.
1801	26,992	1841	63,288	6607
1811	34,640	7,648	1851	71,973	8685
1821	43,821	9,181	1861	73,805	1832
1831	56,681	12,860	1871	88,125	14,320

James Valentine (no known relative to the photographers) divided his Aberdeen into numbered Districts and presented the contrast as bleak square yards per person to two decimal places.

Watching numbers was one way of imposing order on the great towns like Aberdeen. Readers could check their own area on the map provided. District 18 was just north of Castle Street at the wrong end of Union Street. Union Terrace was in District 39 with 101 square yards per person.

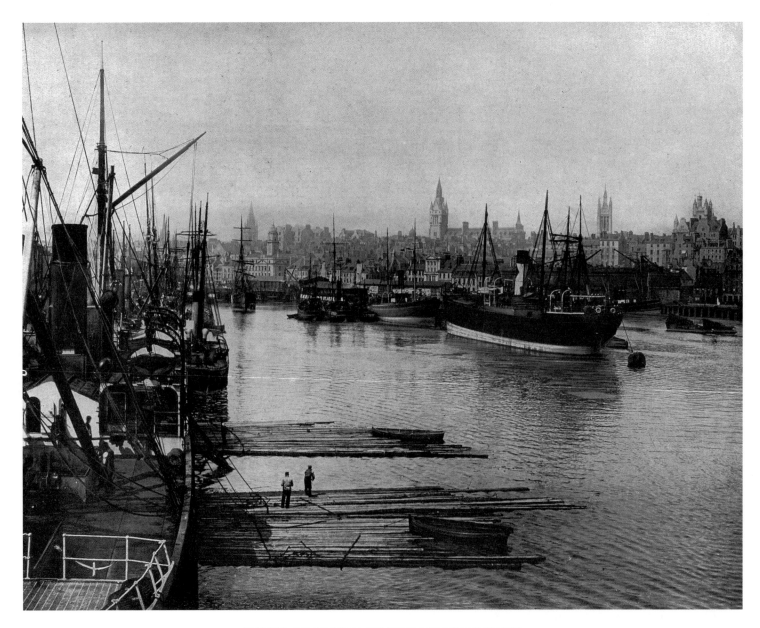

HARBOUR AND MUNICIPAL BUILDINGS FROM BLAIKIE'S QUAY

Groome found Union Street 'enchanting' and the harbour was full of shipping; more numbers were quoted, but the Municipal imposed order. There was no aspect of the three pictures of Aberdeen which did not have a committee of the Municipal Council to keep order.

CONVENERS OF COMMITTEES
Appeals and Arrears, Councillor Dunn
 Lighting and Fires, Councillor William Coutts
Bills and Law, Baillie Kendall-Burnett
 Links and Parks, Councillor Wallace
Churches, Councillor Todd
 Public Health, Councillor Wishart
City Concerts, Councillor Todd
 Sewerage, Councillor Robertson
Cleansing, Councillor Edwards
 Streets and Roads, Councillor Lorimer
Gas and Electric Lighting, Councillor Kemp
 Tramways, Councillor Taggart
Improvements, Councillor Wilkie
 Water, Councillor Wilson (Rubislaw)

The harbour had its own commission partly elected from the council and partly by a special electorate which included 'shipowners to the extent of 25 tons'. The photograph of the harbour was taken from Blaikie's Quay by the timber sheds. Beyond the ships the spires and towers of the skyline presented a formidable display of authority of all kinds; from left to right, there was St Nicholas Church, the Harbour Office, the Municipal Buildings, Marischal College and, on Castle Hill, the Salvation Army Citadel.

All this activity was supported by a complex web of by-laws and local legislation which had grown in density, especially after the Act of 1862. The powers were formidable. 'The [Town Council] . . . shall have power from time to time to appoint, at such salaries as they think fit, Treasurers, Collectors, Clerks, Inspectors, Surveyors, Engineers.' The order on the 'enchanting' streets was very direct.

CCXLIII.—The [Town Council]* shall, as often as occasion may require, cause the Streets to be watered, and the Sewers and Drains to be cleansed and scoured, and for that purpose they may use and apply the Water supplied under the authority of this Act,[1] and may provide all necessary apparatus and Works. (147) Streets to be watered, and Drains cleansed. ACT 1862.

CCXLIV.—In time of Snow or Frost, the occupier of any Shop or other apartment on the ground floor of any Dwelling house or other building along which a Foot Pavement has been laid shall be obliged from time to time to sweep and clear away the snow and ice that shall have fallen or formed upon the pavement opposite to such shop or other apartment (148) In time of Snow or Frost, Foot Pavements to be cleansed by Occupiers. ACT, 1862.

The greatest powers were acquired to discipline those who refused to pay their rates, but a close second were powers for the organisation and disposal of waste matter. The council provided scavengers, dust boxes, public waterclosets, privies and urinals but they insisted that 'the whole manure within the limits of this Act shall be vested in and be property of the [Town Council]'. Even those who wished to spread their own manure on their own gardens had to obtain permission. And so back to numbers. Under the Act of 1862, 'The owners of houses and other buildings in the streets shall mark their Houses with such Numbers as the [Town Council] approve of.'

The order and enchantment were fragile. Nowhere was this better demonstrated than in the rambling entertainment of Alexander Clark's *Reminiscences of a Police Officer in the Granite City* which mainly concerned the 1840s. There was the practice of horse dealers putting a horse through its paces with leish and lash in the public street. Attempts to arrest were met with abuse and threats from all the dealers. Sailors and coal carters from the pie and porter establishments of Guestrow and Huxter Row were involved in frequent chases down Queen Street and Union Sreet. Off stage, there were the great granite quarries of Rubislaw contributing their own sort of order in the granite sets, the paving and the polished shop fronts which were as crucial as police and by-laws in the order of the Valentine photographs.

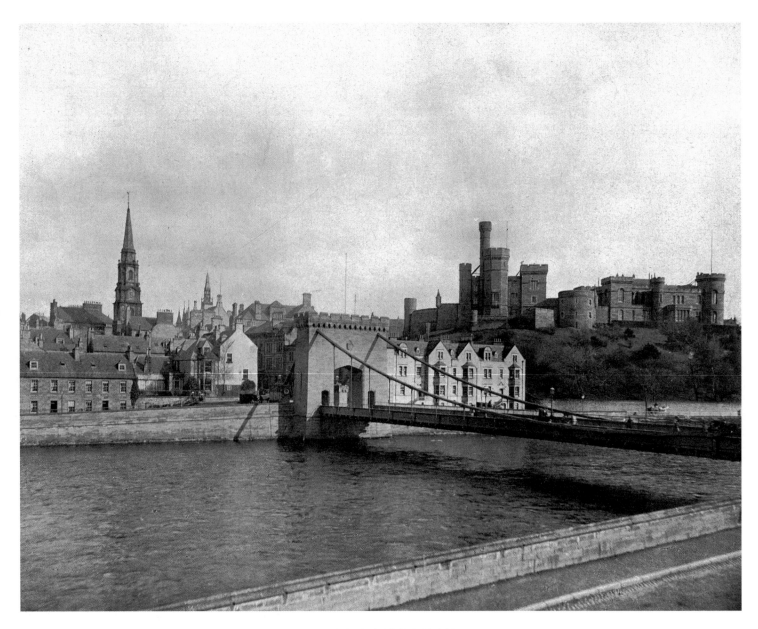

INVERNESS CASTLE AND BRIDGE

CHAPTER 10
Inverness

Inverness was very different from the big four Scottish towns. It claimed to be 'the capital of the Highlands', a position earned from its site at the eastern end of the Great Glen and enhanced by the opening of the Caledonian Canal in 1822. The town was very conscious of a violent history stretching back to Macbeth and ending with a brutal military occupation by the Duke of Cumberland after the 1745 rebellion. Perhaps, because of this, emphasis was placed upon a history of 'improvements' begun in the late eighteenth century under the then Provost, William Inglis, and continued by Mr Mackenzie of Ness House, agent to the Bank of Scotland and first Provost after the reforms of 1833. Another Provost, Dr Nichol of Campfield, established the 'Ladies Walk' along the riverbank. Inverness had been transformed into a place of resort and retirement as well as a centre of commerce and government. Walking, especially along the banks of the Ness, was a sign of status and respectability. It was important in Isabel Harriet Anderson's account of *Inverness before the Railways*:

> The usual hour for a constitutional walk in Inverness was three o'clock for, of course, as almost all the townspeople lived above their offices and shops, and could not otherwise obtain fresh air, the daily walk was quite an institution. At three o'clock or a little earlier, many gentlemen might be seen issuing from their doors, accompanied by their wives and daughters – Banker Wilson being one who seldom missed his daily promenade . . . Sometimes, in summer,

these walks were taken at a later hour, but not by the lawyers. Almost all of them took a rest at home between dinner and tea, and then returned to their offfices from tea time till supper time – a custom which is now impossible, owing to late dinners and villas out of town.

It was the civilised elegance of these 'walks' which drew Valentine to the riverbank just as it had drawn Thomas Allom working for William Beattie's *Scotland Illustrated*.

Allom and his engraver crammed a lot into this picture. The seven-arch bridge of 1685–89 was there, shortly to be swept away in the floods of 1849 and replaced by a government-funded bridge. The kilted Highlander was a reminder of the frontier status

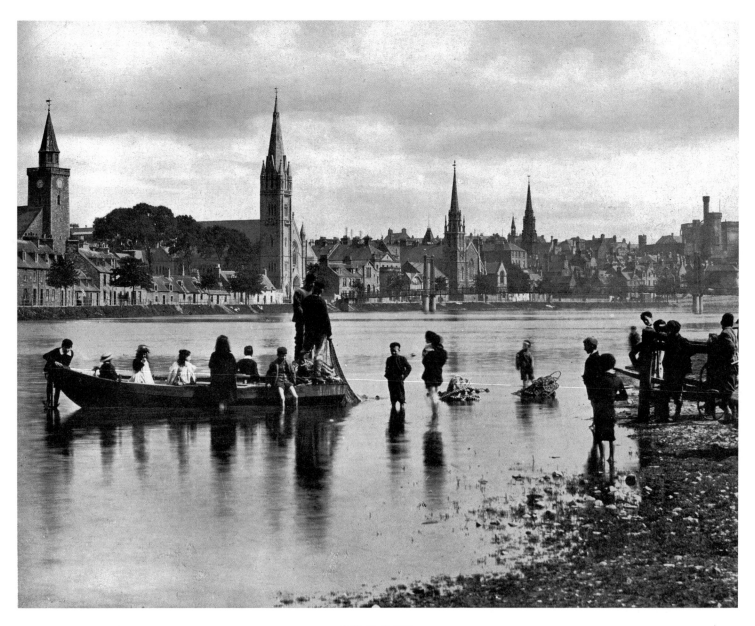

FRIAR'S SHOTT

of Inverness and the gentry in the open carriage of the respectability of the county town. The roadway was soon to be improved with Aberdeen granite sets and Caithness flag paving. The messages in the engraving and the photographs were much the same. Inverness was about salmon and government. The Friar's Shott photograph was dominated by the salmon fishers and carefully posed children (when they would keep still). Allom's skyline was dominated by the square tower of the seventeenth-century Old High Kirk, by the Town's Steeple of 1789–92 and the toy fort of the Sheriff Court, which was to be the County Buildings of the photograph. By 1907, this had been joined on the Castle Hill by the District Court built as the Gaol in the 1840s and projecting power by its fortification-like fantasy architecture. The Castle Hill had been a site of several violently contested fortifications, the last of which had been destroyed by the Jacobite rebels to prevent it falling to Cumberland.

Modern power came in less brutal but no less assertive forms. Inverness was still a frontier town for the civic and civil society of Scotland 1907. The events of this frontier can be followed through the pages of the *Inverness Football Times*. In 1907, the annual dinner of the Gaelic Society took place in the Station Hotel with loyal toasts to the King and a long speech from the President, the Marquis of Tullibardine. It was a world in which Highlanders were always faithful to King and Country and the barracks of the Cameron Highlanders stood on the hill above the town. There were demands for an education system with Gaelic speaking teachers. Inverness saw frequent meetings of the Highland and Agricultural Society, a long-standing body for bringing 'improvement' to the Highlands. The day-to-day meaning of that frontier and the significance of those fortifications on Castle Hill, central to photograph and engraving, were best indicated in a report of the meeting of the County Executive.

A meeting of the Executive Committee of the County Local Authority was held in the County Buildings yesterday. The first business on the card was the election of Chairman. Mr P. G. Macdonald of Torbreck was unanimously chosen and took the chair.

A letter was read from the Board of Agriculture enclosing a new sheep dipping order, which consolidated and slightly modified previous orders.

There was read a report by Mr A. M'Hardy, chief constable, regarding fresh outbreaks of sheep scab in Skye and North Uist, the total number of sheep affected being 220. The affected animals were being dipped and isolated.

The case of crofters in Rona, Raasay, Isle of Oronsay, and Harris who had failed to comply with the regulations as to dipping, was handed over to the Procurator-Fiscal for prosecution.

The long arm of urban regulation reached across the huge county of Inverness from the Castle on the Hill. The *Football Times* did report on many football games. Trips were made to the frozen pitches of Kilmarnock, but football supporters were required to debate other serious matters. It was 1907. The Act of Union was two centuries old. There was no better place for debating its value than Inverness, frontier of modern society.

BURNS BIRTHDAY

Yesterday, the natal day of Scotland's national poet, was celebrated in customary fashion by the Burns' Clubs and Societies which are so numerous all over the English-speaking world . . . these annual demonstrations on each recurring anniversary of his birth has a further value as helping to fan the national idea in our breasts, which we fear is otherwise and at all other times but a feeble flicker. There is a growing conviction that sooner or later the legislative machine at Westminster will be so over-burdened that a certain amount of devolution of work will be found necessary in order, with any degree of adequacy, to overtake the legislative work of the component parts of the Empire. 'A gude conceit o' oorsels' in that case will be useful, and cannot more appropriately assert itself than in connection with the birth of one who was so deeply saturated with the national spirit as was Robert Burns.

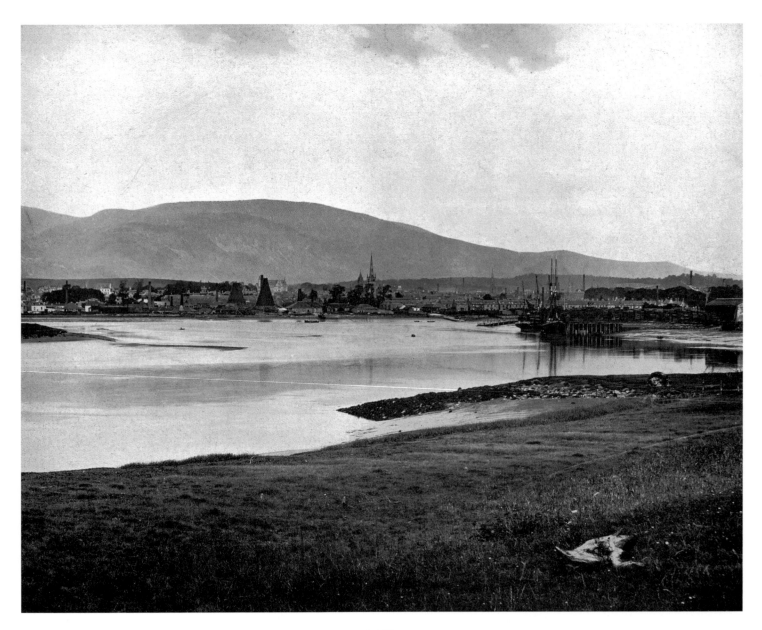

ALLOA

CHAPTER 11
Industrial towns

Valentine was very cautious about introducing his customers to Scottish industry. He did not ignore industrial towns, but he liked to keep them at a distance. ALLOA was seen across the River Forth. The port with one set of coal staithes was on the right and the pot banks of the pottery were to the left. The Ochil Hills in the background allowed a suitable framework. Another way of looking at these places was through the Ordnance Survey maps. The Third Edition was being produced at the same time as most of the Valentine photographs. The style was striking and

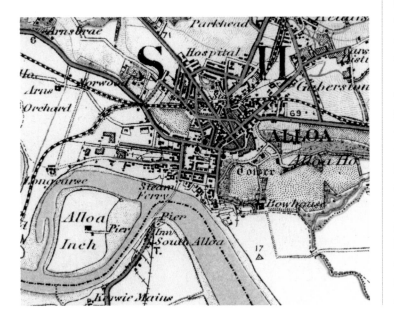

combined the modern precision of the contour line with the impressionist sketch of the hachured lines. The Third Edition also caught these small and medium sized towns at a point in their history when they could be imagined in one glance. There was Alloa, distinct from the places around it, with the port. Coal was the main export. There was the house and park of the Earl of Mar and Kellie and the well-ordered town centre with the spire of the kirk, 1,560 sittings. It was the sort of place that could be walked around and out of in less than an hour. Even the piped water supply was only two miles away at the Gartmorn Dam. The place was complete and controllable. The only major problem was the continual silting up of the docks for which a powerful steam dredger had been purchased.

DUNFERMLINE was seen across the meadows. The railway was allowed to lead the eye towards the town which made its own skyline. To the left was the Abbey and to the right one of several weaving factories which produced the damask tablecloths for which the town was famous. Accounts of the town delighted in its links to the 'sainted' Queen Margaret who was buried there, and to Andrew Carnegie, who had made his money elsewhere, in faraway Pittsburg and bestowed much of it on his native town. The great west window of the Kirk was his (1884). The park stood behind a massive set of gates that seemed to announce at least an earl's town mansion but, in fact, led to parkland and flower beds and the ghostly memories of dollars of profit from the other side of the Atlantic.

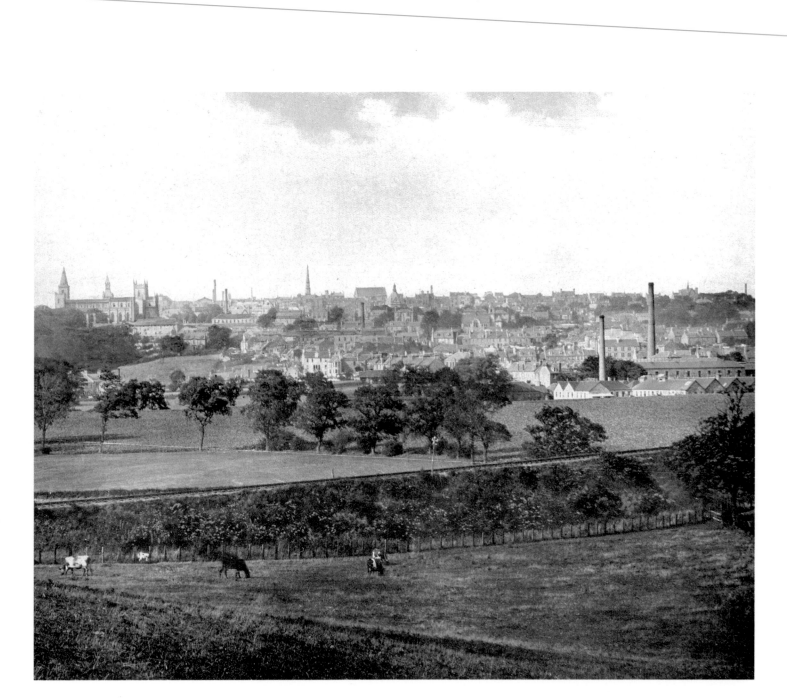

DUNFERMLINE

KILMARNOCK brought a return to municipal Scotland, that unsung hero of the nineteenth century. Kilmarnock still had an active carpet industry as well as long-standing bonnet making, but the growth area was in the foundries and machine-making industry which included engines, gas meters and agricultural machinery. The Glasgow and South-Western Railway had its repair workshops here. What was on show in the Valentine collection was Kay Park, a spectacular product of the alliance of the municipal and the philanthropy of local wealth. The initial purchase was made from the legacy left by Alexander Kay in 1866. The 40 acres were laid out and ready for the public opening in 1879. Another 8 acres were purchased at public expense. Here was the Reformers' Monument, opened by the Earl of Rosebery, 17 October 1885 – a Corinthian pillar with a Statue of Liberty on top. Kilmarnock was one of Scotland's many fiercely Liberal burghs. Near the centre was the Burns monument, opened 1878–79, a shrine to the local poet with a fine statue. The fountain was a gift from Mrs Crooks of Wallace Bank and brought a hint of the baroque fountains of Rome to the west of Scotland. The bandstand was no doubt a product of a local foundry and the site for what was called 'rational recreation'. The old centre of Kilmarnock was the Cross, with its statue of Sir James Shaw, local-born and sometime Lord Mayor of London, 8 feet of Carrara marble and a base of Aberdeen granite.

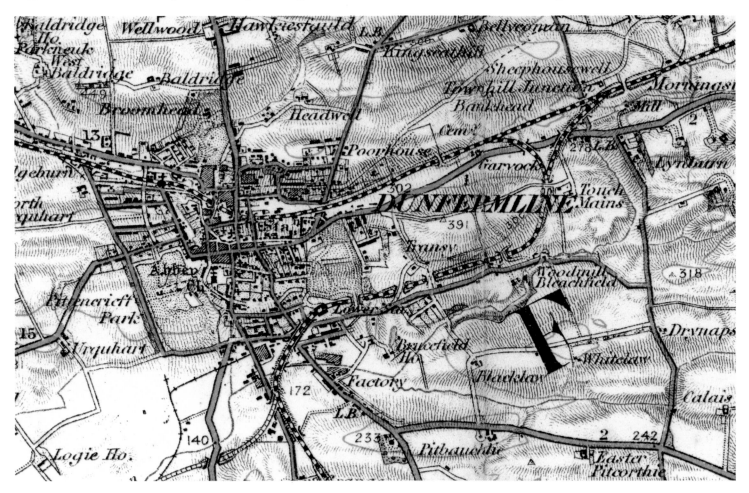

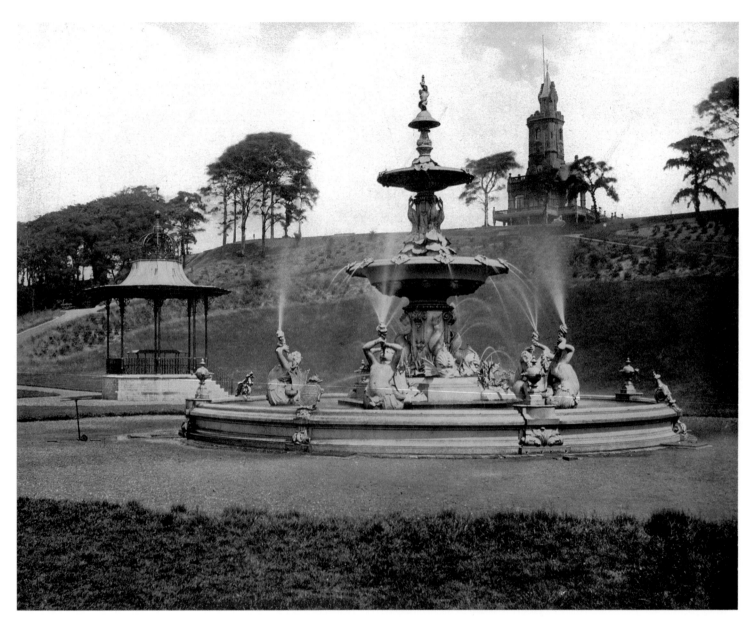

THE FOUNTAIN IN KAY PARK, KILMARNOCK

POST CARD.

PRINTED IN GREAT BRITAIN

The Address only to be written
here

Miss Cumming
c/o Mrs Mc Bain
Kinrara Aviemore
Invernesshire

This side may have a message written upon
it for Inland Postage, but the right hand side
must be reserved for address and stamp only.

POST CARD

The Address to be written
on this side.

Miss Isa Cumming
For Alvie Cottage
Aviemore.

The Cross, Kilmarnock

Coatbridge
seems to be unrivalled for those
in need of "Change."

Municipal pride and gazing from a distance was all very well, but what was to be done if you wanted to send a postcard from COATBRIDGE? It is time to introduce Miss Isa Cumming, who stayed in Alvie Cottage, Aviemore, in the years of the Valentine photographs. Miss Cumming had a lively relationship with a variety of postcard senders. She collected them and they eventually ended up being sold by the second-hand dealers of 1990s Edinburgh. They were truly the illustrated e-mails of the Edwardian age. Kilmarnock Cross was one she received in 1906 'Frae Ane Ye Ken' but GR had the Coatbridge problem. The solution was to send a few jokes.

A few years later, David, writing to his cousin William Clelland at the Station House in Chirnside, came up with that other solution: send a picture of the Town Hall, or rather the municipal buildings.

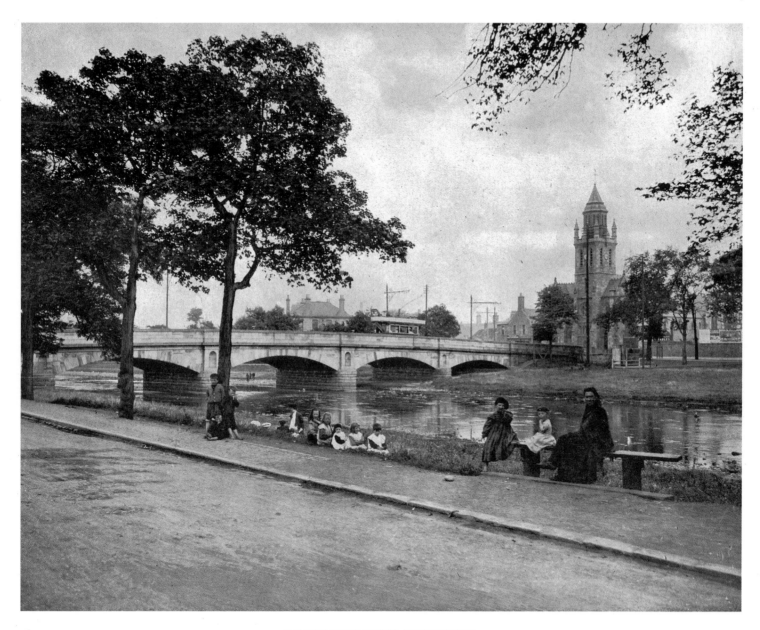

THE NEW STONE BRIDGE, MUSSELBURGH

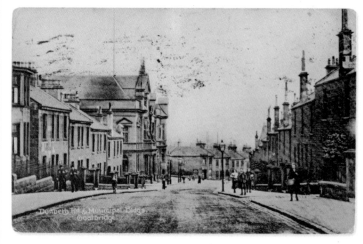

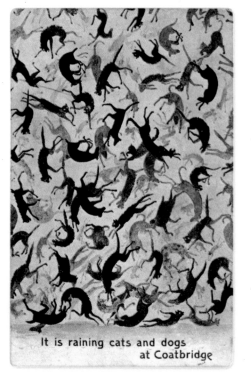

It is raining cats and dogs
at Coatbridge

woman in the foreground. Turning left after the bridge led towards the High Street and the very pleasant suburb of Inveresk. In fact, Inveresk was the name of the parish and the site of the parish church. The church across the bridge was a recent product of the industrious architect William Burn. Turning right led to the main industrial area. There was a wire works, net manufactory and a massive paper works. For true smell and nastiness there was seed crushing, oil refining and glue making.

The strategy for MUSSELBURGH was different. The eye of the citizen and visitor was led across the bridge over the River Esk towards the town. The only hint that this was a fairly tough industrial place lay with the barefoot children and shawl-wearing

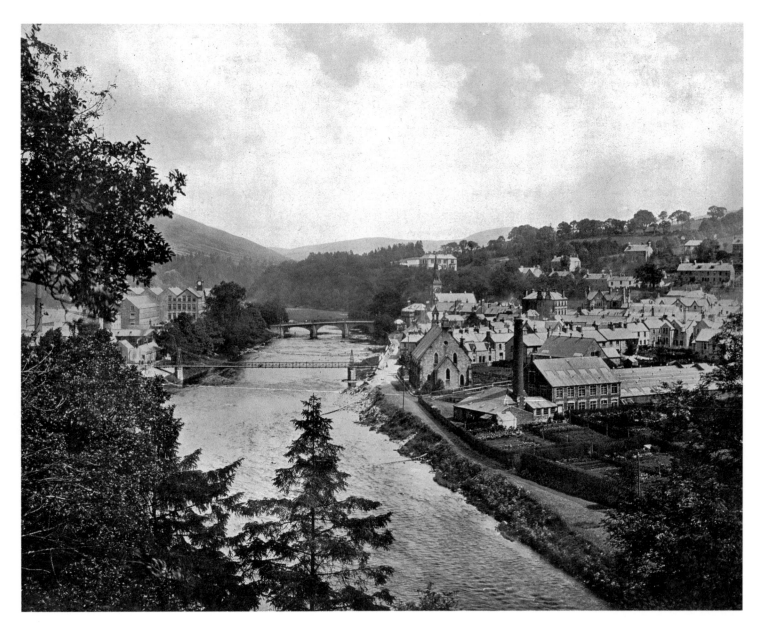

LANGHOLM

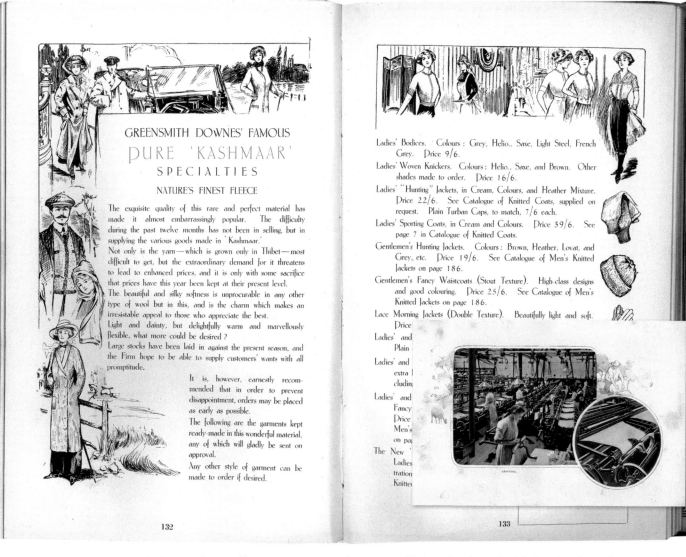

LANGHOLM represented the Borders mill towns. It was a place on the edge of Scotland that could be taken in at a glance in the valley of the River Esk. It was everything that a well-ordered town should be. It had a statue to an Admiral, an obelisk for a General, and a charter as Burgh of Barony under the Duke of Buccleuch. The initial specialisation had been in shepherds' plaids and check trousers but, by 1907, six mills worked in high quality tweeds. By the 1900s, the Scottish Border mill towns projected an image of being deeply embedded in local wool and tradition but were as likely to have wool from Australia and alpaca from South America to mix with local products. The place to look for details was *The Book of Scotch-Made Underwear* from Greensmith Downes, an Edinburgh firm that traded across the world. The pictures linked wealth and work, skill and comfort and placed Scottish small towns in the Edwardian version of globalisation.

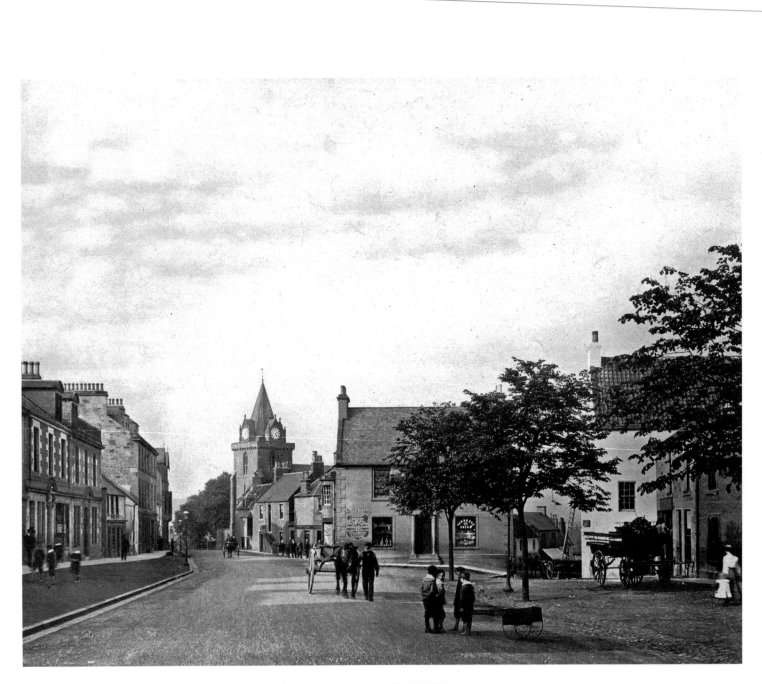

HIGH STREET, INVERKEITHING

CHAPTER 12
Small towns

FIFE AND KIRRIEMUIR

To many purchasers of Valentine's photographs, one of the glories of Scotland lay in its small towns and villages. There should be little surprise in this. The small towns were where many people 'came from'. It was a Scotland of the mind that was carried into many corners of the world as well as into the big cities. When the publisher William Chambers wrote a *Memoir* of his brother Robert, he recounted the story of the man who had visited Paris and, on his return, gave voice to the verdict 'aye but Peebles for pleasure'. James Valentine and his sons were essentially Fife people. They knew the area well and photographed it over many years. Fife was a place of small towns and villages. The picture of INVERKEITHING was a perfect representation. The High Street was an enclosure of calm where children could safely gather in the roadway, carts go about unhurried business and the horse brake waited outside the Burgh Inn. It was a self-sufficient space. Centre left was the fourteenth-century tower of the Kirk. Centre right was Mr Watson's shop selling Cadbury's Cocoa, and everything needed for cycling.

Many of these small towns gained status by the frequent telling of their history. Inverkeithing never lost an opportunity to remind everyone that it was a Royal Burgh with a charter from William the Lyon, although, by 1907, it was a humble Police Burgh under the Act of 1892, but still the Provost claimed the right to ride beside the Provost of Edinburgh at the opening of the Scottish Parliament.

These small towns were places that people left and remembered so, naturally, a dominant form of literature was the reminiscence. It was in the nature of such writing that they should look back to earlier decades. This had the effect of seeming to draw a whole century of history into the years around 1900. James Simson had left Inverkeithing in the 1830s and wrote from New York in the 1880s. These accounts had a common cast of characters, the minister, the dominie, the kindly neighbour and the loving, hard working parents. Simson added the dancing master and Giles, the Irish marine with his chickens.

There was a delight in the small-ness and knowableness of the place:

Indeed in a place like Inverkeithing the most trifling thing became a subject of more or less interest. Even a

ESTABLISHED 1865. TELEGRAMS—WATSON,
INVERKEITHING.

J. WATSON,

Blender of Scotch Whiskies, Wine Merchant, Grocer, and Cycle Agent.

Speciality—Very Old Whisky, "Glen Keith."

The Whisky for the World—17/ per Gallon in Jar or Cask. 36/ per dozen Bottles.

Carriage paid to any Railway Station in Great Britain in quantities of 2 Gallons or 1 doz. Bottles and upwards; Sample Bottle 3/, Postage 9d. Put up in 2, 4 and 6 Gallon Jars, and in Casks 10, 12 or 15 Gallons and upwards.

"**Glen Keith**" is a fine mellow old whisky, and is very highly commended by the medical faculty.

Agent for Melrose's Teas.

Agent for the following Celebrated Cycles Humber, Swifts, Royal Enfield, New Hudson, Rossleighs, Speedwells, &c.

Humbers and Enfields from £10 10s, be in time, large demand.

Have you seen the Royal Enfield at £12 12s, best value going.

Machines on Hire, Moderate Charges. Large Stock of Accessories at Wholesale Prices.

List of Furnished Houses kept, applicants please state requirements. *No Fees.*

Orders solicited and delivered by own van in Inverkeithing and surrounding district.

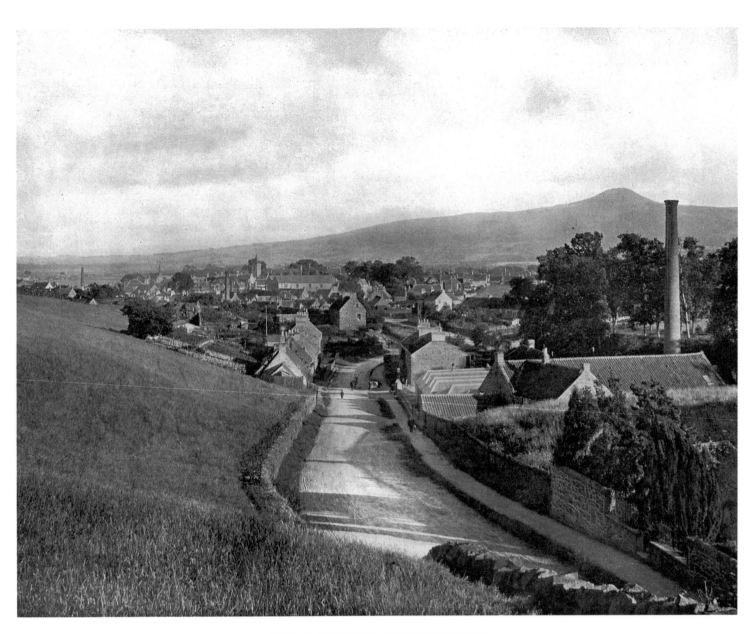

AUCHTERMUCHTY FROM THE NEWBURGH ROAD

journeyman tailor from Edinburgh taking up his residence in it became the town's talk, as to how he would succeed, and who would 'patronize' him. Occasionally a regiment or several companies of foot-soldiers would be billeted in the town . . . droves of cattle pass through it on their way from the north. These would sometimes have their front feet shod to enable them to stand the travelling. The examination of the parish school was always an event in the place; but it was exceeded by the sacrament in the parish church, on which occasion there would be present people that were hardly ever seen inside of it at other times. I particularly recollect an excitement caused by a trial at the town-house of several 'big blackguard boys' for annoying the children of several families while on their way to and from school; and of their parents paying a heavy fine rather than let them go to jail, which effectually stopped that trouble. Laying the foundation of a building was a matter of no small importance in the place. Three of these I particularly remember. The first was that of the provost, who was a grocer, building a shop, and a house over it, immediately opposite the opening that led to the cross, and on ground that had been occupied by some miserable old houses, one of which was entered by an outside stair, and in which dwelt a crooked, lame and limping woman that lived by begging and selling 'spunks', that is, splints of wood dipped in brimstone, and used in connection with a tinder-box and flint and steel, for at this time a lucifer-match was not to be seen in the place . . . The return of an Inverkeithing man from the East Indies, with a coloured wife and a large family of children, all born there, and a corresponding establishment of servants, or rather slaves, was quite an event in the social history of the place. At first the children attended the parish school, but afterwards had a tutor, which created a sensation. I have no recollection of political or municipal squabbles, although there were doubtless such; nor of social meetings beyond a dim

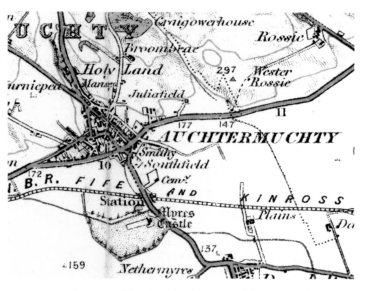

remembrance of feasting, in the way of dinners and suppers, and especially suppers and the invariable toddy drinking . . .

These small towns each had their selection of industry, usually tucked out of sight of the camera. Inverkeithing had a shipyard, distillery, ropeworks and huge paper mill. The town was dominated by the Hendersons of Fordell Castle, whose coal was sent by wagonway to the quayside.

AUCHTERMUCHTY also had a distillery, malt kilns and several small linen factories. Muchty was also made a Royal Burgh in 1517 but seemed to fail to send a member to Parliament at a fairly early stage and went quietly bankrupt in 1816. The corporate property was sequestrated with the exception of the town-house, gaol, steeple, bell and customs. There was also some common land above the town which still survives as a public resource. Auchtermuchty was an irregular, shapeless sort of place. The town-house turned its back to the sun. Valentine had to struggle to get the mood he wanted so he distanced himself from the town like the eighteenth-century engraver/painter and stood on the rising ground beside the Newburgh Road. A small factory with its loom sheds stands to the right and the town-house tower was outlined against the Lomond Hills to the left.

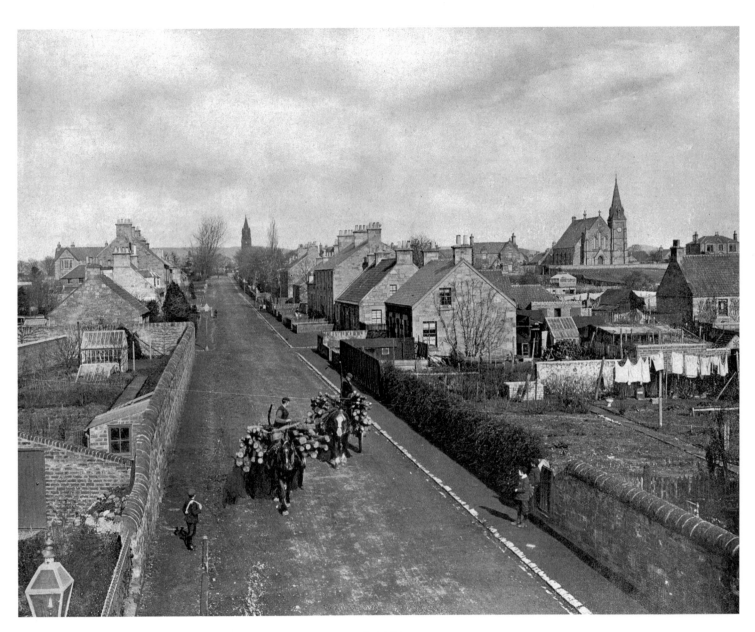

LADYBANK

Places like Inverkeithing and Auchtermuchty gained little mention in guidebooks like Baddeley except as places on the railway routes to the north. Many of them made a mark through the poetry of place with ballads and narrative verse that made their way into the great collections like those of Burns and Robert Chambers and the earlier Allan Ramsay's *Tea Table Miscellany* (certainly still in print in the 1870s). A distinguished contribution of this poetry of place was the ballad of *The Wife of Auchtermuchty*. This was a tasty bit of gender politics based upon the ploughman who thought that housework was the soft option, changed places with his wife, made a mess of everything and was suitably chastened. It was an early example with a familiar mixture of moral lesson, narrative and Scots language.

> In Auchtermuchty thair dwelt ane man
> Ane husband, as I hard it tawld
> Quah weill cowld tippill owt a can
> And nathir luvit hungir nor cawld.

He comes home to 'see his wyf baith dry and clene'.

> The man being verry weit and cauld
> Quoth he, 'Quhair is my horssis corne?
> My ox hes nathir hay nor stray!
> Dame, ye mon to pleuch to-morne
> I salbe be hussy gif I may.'

Everything goes wrong including,

> Than he geid to tak up the bairnis
> Thocht to haif fund thame fair and clene
> The first he gat in his armis
> Was all bedirtin to the ene.

Finally, he agrees

> 'And I will to my pleuch agane
> For I and this hows will nevir do weill'.

LADYBANK was quite different. It had no ancient history. The hard straight lines of the Valentine picture of Church Street were a warning that this was a result of modern processes. This marshy, waterlogged area of the Howe of Fife had been Our Lady's Bank where the monks had the right to cut peat. Ladybank was made possible by the science of field drainage and had its origins as a planned village for linen weavers. The impetus to growth came in the late 1840s when Ladybank became a junction on what was to be the North British Railway.

Part of the comfort and liveability of these places lay in countless small societies and organisations that gave personality and social expression to place. Auchtermuchy had an agricultural and a horticultural society, Inverkeithing a masonic lodge and a curling club. Ladybank had a golf club, a curling club, football clubs and a friendly society. Together with the many churches and the municipal corporations these associations produced a landscape of detail which often hides in the carefully staged Valentine pictures. Inverkeithing showed its pride in the ancient burgh status with the detailing of the eighteenth-century town-house.

In Auchtermuchty, it is the Victoria Hall along Burnside that dominates the road junction. It was for lectures, concerts and

 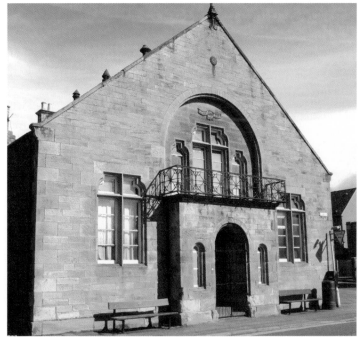

public meetings and was complemented by the People's Institute for reading, recreation and the temperance refreshment room.

Valentine had crossed western Fife without ever adding a coalmine or coalmining burgh to his collection, but the street detail of Cowdenbeath, Lochgelly and the rest require a pause for they represent an endeavour that was a vital part of small town Scotland. This is not a plea to think about the dangerous and squalid conditions in which many miners worked but to look at the achievements of the Cowdenbeath Co-operative Society with its beehive and clasped hands of friendship and the now decayed achievements of the Lochgelly Miners' Welfare.

This iconography of the street would not be complete without going back to Ladybank. With just over a thousand people, Ladybank had still acquired a Free church and an official Kirk from the splits of the nineteenth century. Close examination of the towered church in the picture revealed its evangelical origin in the burning bush of faith that will never be consumed.

Anstruther was many things. In terms of being an ancient Royal Burgh it was two of them, Easter Anstruther and Wester Anstruther, which had aquired their charters in the 1580s. The real business of Anstruther was fishing and the new harbour had been completed with considerable difficulty in 1877. It was a product of the Union Harbour Bill of 1860. The building involved loans from the Treasury and the Board of Fisheries and the loss of burgh rights over the harbour to a Board of Commissioners – 'a sprat to catch a mackerel' in the view of one of the baillies at the time.

Where ANSTRUTHER excelled in the small town status stakes was in promoting well-known local people, like Thomas Chalmers. He was the leader of the evangelical wing of the Kirk and, in the view of many, the architect of the Disruption which produced the Free Church and the duplication of so much religious effort and real estate in Scotland. Tales were told with pride of Chalmers returning to the scenes of his youth and the huge barn of the Chalmers Memorial Church dominated the skyline for many years. The side door on Anstruther history was provided by George Gourlay in *Anstruther or Illustrations of Scottish Burgh Life* in the 1880s. He claimed he learnt his history by hanging around the local bookshop:

I was associated with the bookseller's shop when it was still the news or coffee room, in which neighbours came from far and near to discuss the events of the day. How the silver haired fathers liked to dwell upon the bright world of their youth . . . I have done my best to recall the stories that they liked to tell.

The real star of the show was not Thomas Chalmers but Maggie Lauder. The original song was attributed to one Francis Semple from Renfrewshire about the middle of the seventeenth century.

Wha wadna be in love
Wi' bonnie Maggie Lauder;
A piper met her gaun to Fife,
And speir'd what was't they ca'd her;
Right scornfully she answered him –
'Begone, you hallanshaker,
Jog on your gate, you bladderskate,
My name is Maggie Lauder.'

'Maggie,' quo' he, 'and, by my bags,
I'm fidgin' fain to see thee,
Sit doon by me, my bonnie bird,
In troth I winna steer ye;
For I'm a piper to my trade,
My name is Rob the Ranter,
The lassies loup as they were daft
When I blaw up my chanter.'

'Piper,' quo' Meg, 'ha'e ye your bags,
Or is your drone in order?
If ye be Rob I've heard of you,
Live you upo' the border?
The lassies a', baith far and near,
Have heard o' Rob the Ranter –
I'll shake my foot with richt gudewill,
Gif you blaw up your chanter.'

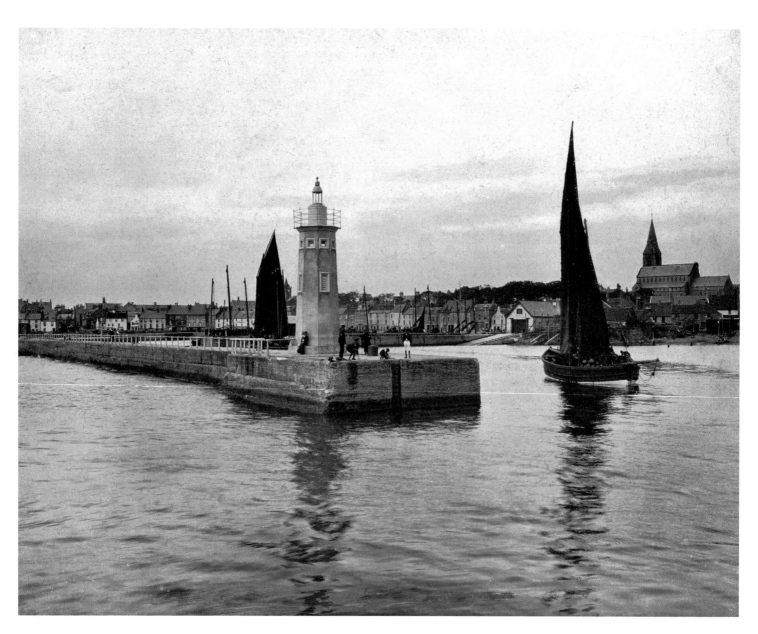

CHALMERS LIGHTHOUSE, ANSTRUTHER

Then to his bags he flew with speed,
Aboot the drone he twisted;
Meg up and wallop'd o'er the green,
For brawly could she frisk it.
'Weel done!' quo' he; 'Play up,' quo' she;
'Weel bobb'd,' quoth Rob the Ranter,
'Tis worth my while to play indeed
When I ha'e sic a dancer.'

'Weel ha'e you play'd your part,' quo' Meg,
'Your cheeks are like the crimson,
There's nane in Scotland plays say weel
Sin' we lost Habbie Simpson.
I've lived in Fife, baith maid and wife,
These ten years and a quarter;
Gin ye should come to Anster Fair,
Speir ye for Maggie Lauder.'

Modern folk singers at times express wonder that such a ribald song escaped destruction in Presbyterian Scotland but they forget the Victorian love of playing with words. This can, after all, be read as the simple story of a sociable young lady who liked bagpipe music. Much of the fault lay with William Tennant, another local man, who ended up as a Professor in St Andrews but, in the process, incorporated the tale of Maggie Lauder in his mock heroic poem *Anster Fair*, mixing it with a variety of legends and fantasies. Still, George Gourlay was happy to quote the full song alongside such stirring lyrics as 'Spare me the Bible, 'tis alone my prop', by self-taught local genius Thomas Brown, but more to the point was the insistent tourist trade which the names of Thomas Chalmers and Maggie Lauder brought to the town. Tennant had confidently identified Maggie as a wealthy heiress who lived in East Green.

And so every antique house in the thoroughfare has come to be entwined with her name. There are few visitors, indeed, to the East of Fife who do not turn aside to 'spier for Maggie Lauder'. Her house is, of course, an object of special interest. An elegantly attired group not so many years ago bustled to the top of the old outside stair. A polite knock with the parasol brought the housewife in hot haste from the porridge pot to the door. 'This is Maggie Lauder's house, I believe,' said one of the ladies graciously. 'Eh na, mem, she disna bide wi' us,' was the modest reply. 'Oh, no, no, it is long ago,' laughed more than one silvery voice. 'Oh, then it was Jeannie Forrester, but she's dead,' said the mistress, reddening to the eyes. 'But this is the house we wish to see,' continued the visitor, attempting to push past the housewife, who meanwhile had set herself like a barricade on the step. The rear pressed on, but the citadel was not to be captured – no, for springing back with the indignant protest, 'Ye'll no see my dirt and rags this day,' the occupant slammed, bolted, and barred the inner door in the face of the invaders, who had thus to retire with ill-concealed chagrin, as they came. There is also the anecdote of the Ayrshire divine who visited Anstruther. On enquiry, the house connected with Maggie Lauder was instantly pointed out; but when he asked the maid in the hotel if she knew the house Dr Chalmers was born in, she was totally ignorant on the subject, but excused herself saying, 'Ye see I come frae Blairgowrie.'

These pictures from the 1907 collection are about Scotland feeling comfortable with itself. If the close community of the small town was vital to such a feeling of comfort, then the type site for the Scottish affection for such places was KIRRIEMUIR. In many ways Kirriemuir was an ordinary place. It had been a Burgh of Barony to the Earls of Home and, in 1875, became a Police Burgh. Since the eighteenth century it had had a reputation for weaving coarse linens and by 1907 had acquired two power loom weaving factories. The Linen Works of J & D Wilkie dating from 1868 was featured in the centre of Valentine's picture of the town. In the background was the spire of the parish church, that other symbol of local virtue. Kirriemuir gained its particular place on the map of Scotland, because of the novels and stories of J M Barrie, who

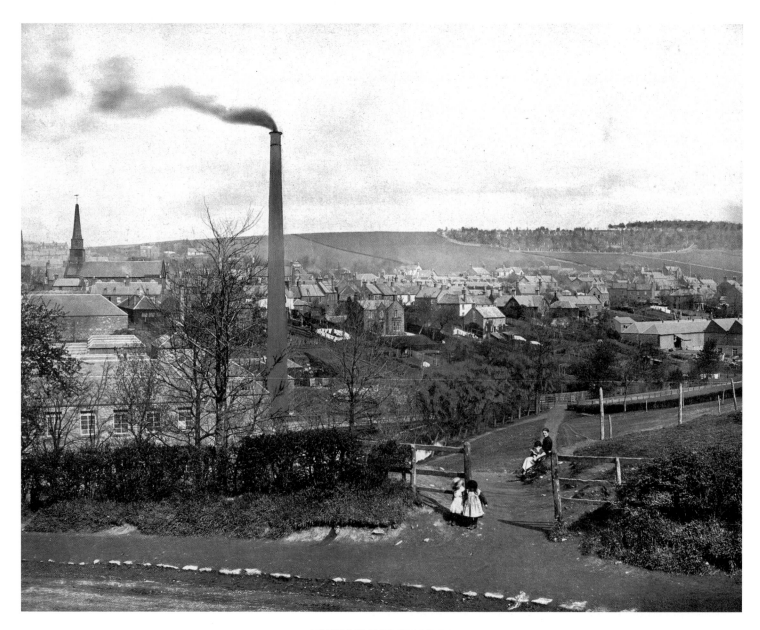

KIRRIEMUIR FROM THE SOUTH

presented a particular version of the town to an international audience. *A Window in Thrums* appeared in 1889. From the start, the account of the House on the Brae, the inevitable subject of a Valentine photograph, was about change and memory; 'the bump of green round which the brae twists . . . where is now the making of a suburb'. There was a delight in smallness, in characters and in honest sentiment which he inherited from the *Reminiscences* and *Accounts of literature* of the small town. His writing was later derided as 'kailyard' and he anticipated some of

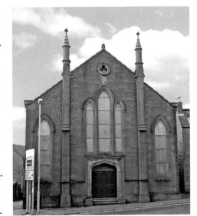

this: 'you must not come in a contemptuous mood, thinking that the poor are one removed from beasts of burden'. He worried about ageing and changing and countered this with a sense of unchanging renewal: 'the world remains as young as ever . . . the world does not age. The hearse passes over the brae . . . but still there is a cry for the christening robes . . . I also see the grandchildren spinning the peerie.' Some of the hostility can be accounted for by the great fracture of the 1914–18 war and by an angry resentment at the discipline, some would say oppression, that lay behind the calm of Thrums. It is worth remembering that Barrie also produced *Peter Pan* and 'never never land' and everybody loved it. The sharpest account of small-town Scotland, which he both loved and left, was in his earlier *Auld Licht Idylls*: 'twenty years ago, its every room, earthen floored and showing the rafters overhead, had a handloom, and hundreds of weavers lived and died . . . "ben the hoose" . . . Thrums is but two church steeples and a dozen red stone patches standing out of a snow heap.' He took a pride and delight in the varieties and divisions of Scottish Presbyterianism: 'Thrums . . . had four kirks in all before the disruption and then another which split in two immediately afterwards'. A number of these still remain in the landscape, assertively plain with trim Gothic windows to emphasise piety.

His eye for detail filled the market square with his prose:

Every Friday there was a market, when a dozen ramshackle carts containing vegetables and cheap crockery filled the centre of the square . . . A score of farmers' wives or daughters in old world garments squatted against the town-house within walls of butter on cabbage-leaves, eggs and chickens . . . rival fish-cadgers, terrible characters who ran races on horse-back, screamed libels at each other . . . it was time for Auld Lichts to go home . . . and read their 'Pilgrim's Progress'.

The sharpest account for affection and irony was as follows:

the rouping of the seats of the parish church . . . an auctioneer was engaged for the day. He rouped the Kirk seats like potato-drills, beginning by asking for a bid. Every seat was put up for auction separately; for some were much more run after than others, and the men were instructed by their wives what to bid for. Often the women joined in, and as they bid excitedly against each other the church rang with opprobrious epithets.

Barrie was not the first the write about Kirriemuir. David Allen had published his *Sketches* in 1864 with the usual mixture of changes and characters, although his account of the eighteenth-century meal riots and the weavers' riots of 1839 were a little less benign than those produced by Barrie. But it was Barrie that made Kirriemuir something out of the ordinary. John F Mills, editor of the *Kirriemuir Observer*, produced his guidebook of 1896 for the new breed of literary tourists: 'these far travelled strangers, who, in the holiday season, visit Kirriemuir – mayhap to pay homage to Barrie, or to spend an all-too-short but well-earned rest and needed change from the smoke-begrimed city'. Mills reflected the mixed feelings which Scotland had for 'the quaint life

'WINDOWS IN THRUMS', KIRRIEMUIR

pictured by the idyllist of Thrums . . . a dreamy village of rude and rugged weavers, or in a little company of old-world sectaries'. He directed the visitor's attention to the factory of Messrs Wilkie, with its power looms, steam power and the electric light. Kirriemuir was modern. The House on the Brae looked down on steam and electricity. The Ordnance Survey map showed the compactness which Barrie and his followers loved, the links

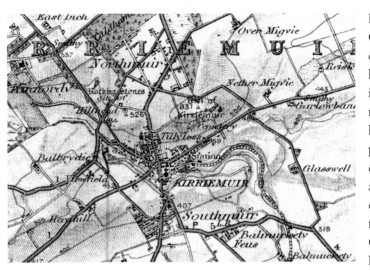

with the countryside and hills crucial to the small burgh story, the inevitable rail branch line and the suburb of Southmuir from where the House on the Brae looked across the valley. Essentially, Valentine's photograph was the view from the house.

RENFREW TO IRVINE

There were many small towns in the industrial west. They could be plucked from the map as separate, distinct places. Urban sprawl had not yet enveloped them.

Renfrew still carried the prestige of its history. It became a Royal Burgh in 1396 and claimed to be the largest port on the Clyde in 1614. Valentine, as usual, took his camera to the main street. It was a place of bare-foot children and the signpost at the left side gave a rather cruel reminder that Renfrew was hemmed in by the rapidly growing neighbours of

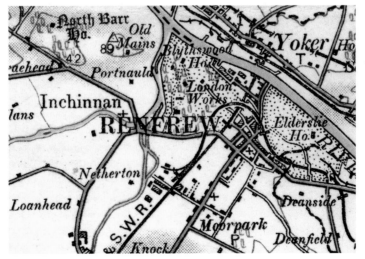

Paisley and Greenock. Francis Groome regarded Renfrew with contempt: 'Its old prosperity . . . has been completely eclipsed by its younger and more vigorous rivals, though why it is a little hard to say. Probably when the pinch came it relied more on the dignity of its long descent and ancient origin than on its energy.' This was a little harsh. In fact, the straightening of the Clyde had left the town centre half a mile from the main channel, and the great houses of Blythswood and Elderslie had reduced the potential for a new frontage on the river.

Renfrew had iron shipbuilding, a dyeing and chemical industry as well as those two assets of a self-respecting burgh, a new Town Hall and a Royal Visit. The foundation stone of the new municipal buildings was laid with due masonic ceremony on 1872. The style was 'a free adaptation of modern French Gothic, with a colouring of Scottish baronial'. To the Provincial Grand Master the building was a symbol of 'the freedom of our country and the freedom of our local institutions'. In Europe, Colonel Campbell told them ancient ruins 'remind me of those who have stood up in the cause of freedom and fought battles against despotism. I can assure you that I look on our municipal institutions in much the same light: for without them I feel we should not be able to keep in our hands that local government which conduces so materially to our local independence and freedom.' The municipal was more than a handy visual asset

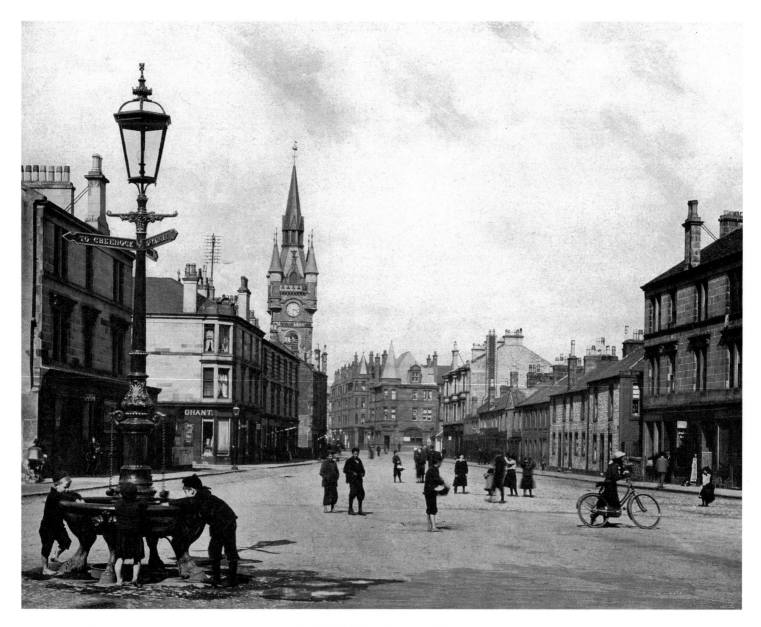

HIGH STREET AND TOWN HALL, RENFREW

for the photographer. In 1907 the town hall was the centre of a brief visit from the Prince and Princess of Wales as they made their way from the railway station to Blythswood House where they were to stay the night:

Their Royal Highnesses will proceed to the Town Hall, Renfrew, by Canal Street, where a Guard of Honour, furnished by the Renfrew Company of the 2nd V.B. Argyll and Sutherland Highlanders, with the Band and Pipers of the Battalion, under the command of Captain W. Craig Barr, will be drawn up in front of the Town Hall.

6.25. – Their Royal Highnesses will arrive at the Town Hall, where the Magistrates and Councillors will be assembled, and Lord Blythswood will present to Their Royal Highnesses–
The Provost of Renfrew (Peter Ferguson, Esq.), and
The Town-Clerk of Renfrew (Andrew R Harper, Esq.).
 The Provost will present to Their Royal Highnesses –
The Magistrates and Councillors of Renfrew, and
The Town Chamberlain (John McLaren, Esq.).
 The Provost will hand an Address of Welcome to His Royal Highness the Prince of Wales as Baron Renfrew by the Town Council of Renfrew, and ask the acceptance thereof by His Royal Highness.
 His Royal Highness will hand the Provost of Renfrew a reply.
 Miss Kate Ferguson will offer a Bouquet for the acceptance of Her Royal Highness the Princess of Wales.
6.35 p.m. – Their Royal Highnesses will leave the Town Hall and proceed by Hairst Street, and Inchinnan Road to Blythswood.

And the ten minutes of municipal glory were over.

WEST KILBRIDE was quite different. The staple industry remained weaving for the manufacturers of Glasgow and Paisley. Masons, carpenters and blacksmiths served the agricultural parts of

the parish. It was a life which the Reverend John Lamb, chronicler of the parish in lectures given in the West Kilbride Parish Church Mission Hall, called 'self enclosed'. An earlier minister had detailed an idyllic picture for the *Old Statistical Account*: 'Seclusion has saved the inhabitants from the enroaching influence of that corruption which in other places of more business and resort has produced so great a change in the morals of the people. They still are characterised by industry, sobriety and decency.' But, said Reverend Lamb 'the tide of change will not brook to be stemmed by any, and so the luxuries of an advancing civilisation and refinement find their way even into West Kilbride'. What really mattered was the arrival of the railway in 1878 – 'an influence, under which it is gradually being transformed from a quiet rural retreat into a popular watering place and summer resort'. The minister had a good Victorian delight in numbers. In 1883, passenger tickets had numbered 29, 913 but, in 1895, were sold 59,512 and one half. Goods traffic, postal traffic and telegraph communications showed the same increase. With the railway came the Hydropathic and Sanatorium at Seamill with 'hot and cold, fresh and sea water baths of various kinds'. In 1894, this was joined by the Convalescent Home of the Glasgow and West of Scotland Co-operative Society. Across the bay at Ardneil was the seaside children's home of the Glasgow Fresh Air Fortnight Scheme run by the United Evangelistic Association: 'Relays of forty children from the fetid lanes of Glasgow enjoy the benefit of a summer holiday'. John Lamb produced a version of his lectures for 'the benefit of the annually-increasing numbers who are frequenting the district as a resort in search of health or recreation . . . [with a map] of service to all but especially to cyclists and pedestrians'. A golf course, bowling green, skating ponds and boats for hire were also on offer as well as the reading matter of the West Kilbride Select Library which stood at the top of the winding main street with its well-shod children.

 IRVINE on the Ayrshire coast was surrounded by collieries, coal pits, forges and foundries as well as the workshops of the Glasgow and South Western Railway Company, two shipyards, a ropeworks and chemical works, which included Nobel's dynamite factory. In such circumstances the Valentine picture was quite an

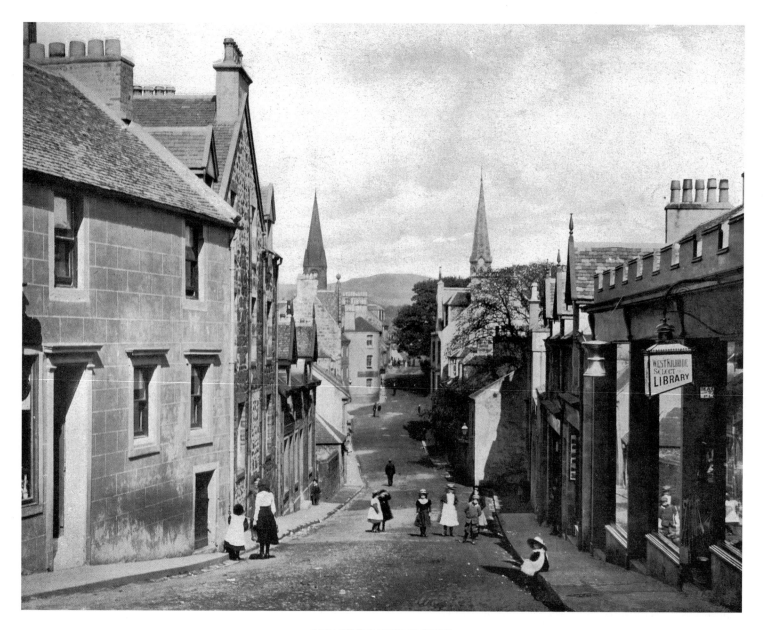

MAIN STREET, WEST KILBRIDE

achievement. The calm, encapsulated High Street was bathed in afternoon sunshine. Although some were barefoot, the children were disciplined under the watchful eye of the Right Honourable David Boyle, born in Irvine, married into the family of the locally dominant Earls of Eglinton and rising to be Lord Chief Justice General of Scotland. He had presided in the courts which ordered the hanging of Burke, the body-snatching murderer, as well as being involved in hanging three weavers who took part in the radical rising of 1820. He was a powerful symbol of authority and discipline. Beyond him was the Town Hall built in an assertive Italian style in 1859–1861, a result of adopting the Police Act of 1857. The Council Chamber, Court Hall and Library made it a more benign symbol of authority.

Irvine was fortunate in having all the assets of a self-respecting burgh. The new town hall was complimented by a Royal Charter from Alexander II. Irvine was the birthplace of John Galt whose novels *Annals of the Parish* and *The Provost* had set the agenda for Scotland's celebration of the small towns. Characters like Provost Pawkie were modelled on Irvine people. Above all, Irvine had Robert Burns, who spent a brief, if formative, six months in the town in an ill-fated attempt to learn to be a flax dresser. As a result, Irvine had one of the best-endowed Burns Clubs in the world, including manuscripts and a 'silver tassie'. Ex-Provost Murchland delivered his lecture on the *Heckling Shop of Robert Burns* in the Masonic Hall, Irvine on Friday evening, 25 January 1907, a day he described as one of 'reverential reminiscence . . . for Scotsmen in

every part of the world . . . his [Burns] reassertion of primal human rights helped mightily to revolutionise our arts and letters, as well as inaugurate new measures of social and political progress'. The ex-Provost based irrefutable fact, of Burns's brief stay in Irvine and the occasionally disputed fact that the heckling shop in question was in Glasgow Vennell, upon an interview with retired weaver John Findlay, then in his ninety-second year. The Burns link also meant that D O Hill, in his pre-photography days, painted the town as part of the illustrations to the Wilson and Robert Chambers *Land of Burns*. The result was a very different way of looking at the town. The artist stood back from the town and gave central place to the church and the manse. The figures chosen for the foreground appeared engaged in leisurely pastoral activities, including the women washing clothes by the riverbank.

SOUTH QUEENSFERRY was a variation on the theme of the small town. The population was less than 2,000 but it was a Royal Burgh, although the details had been lost and had been contested by Linlithgow up to the seventeenth century. It was the place from which Queen Margaret had crossed the Forth in her journeys between Edinburgh and Dunfermline. By the 1800s, the Queen had become almost a Protestant saint with her own recently refurbished chapel in Edinburgh Castle. The burgh had a claim to be on the Sir Walter Scott itinerary for the 'Hawes Inn' appeared in the *Antiquary*. Royal Visits had been recorded and the town had its claim as a resort and watering place. William Wallace Fyfe, in his account of *Summer Life on Land and Water at South Queensferry,*

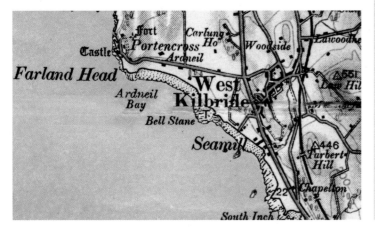

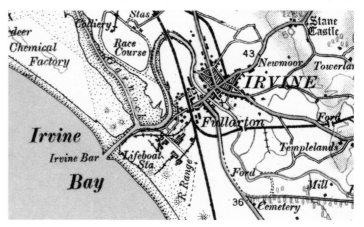

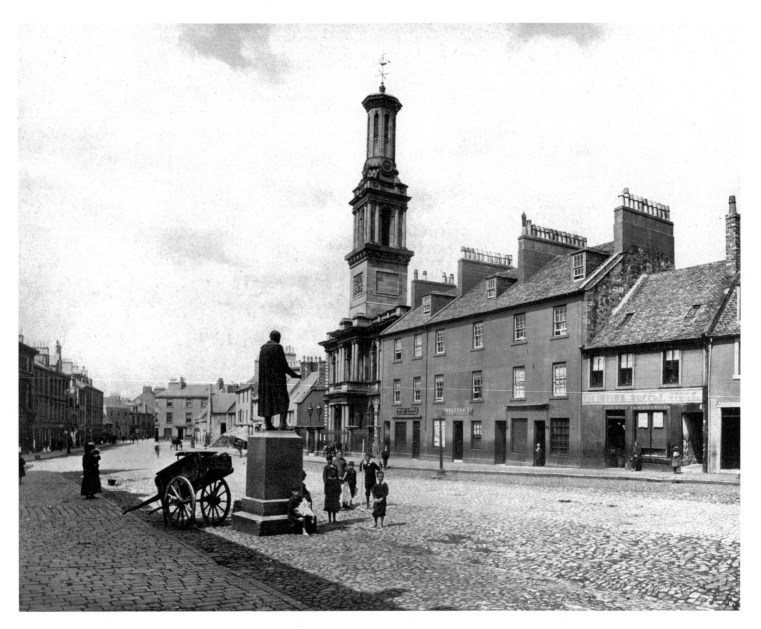

HIGH STREET, IRVINE

recommended 'to the summer visitor . . . a pleasant Sabbath-day's journey to attend sermon in this little church' [Dalmeny]. He added, 'His [Rev. Dr Robert Muir] discourses are eminently adapted to alarm the conscience, convince the sinner of his guilt, and demolish his self-reliance.' Perhaps sea bathing was a more relaxing option: 'The present understanding respecting the bathing places of either sex, and the admirable facilities for undressing in the nooks and corners of the rocky shore . . . are in fact in themselves regulations far more decorous than the almost promiscuous bathing from the machines at Portobello.'

It is worth looking at the street which Valentine photographed in the early morning sun, again calm, tranquil and free of traffic, as were so many he included in the collection. In part, this was a product of the photographer's patience. In part, it was a world waiting for the motor car. Daimler cars were advertised in

the 1907 publication but no motor car appeared in the pictures. It was also a world full of children, orderly and available. In town after town the photographer was able to line children half across the street to give life and definition to his pictures. From Golspie to Kingussie, the sameness of the streets of two-storey houses was relieved by the line of children, especially where there is no town-hall or church to give focus. Cards like these called Isla Cumming with an e-mail-like message to a weekend visit in Kingussie.

'Ye ken yer sel', with his delightful habit of writing upside down, knew he had not done very well with the picture of Burnside in Scone. The sender surely must be male.

Mr Clelland, 'uncle', did much better with the children lined up in Penicuik, as well as a promise of the holiday photographs which 'we have got taken'.

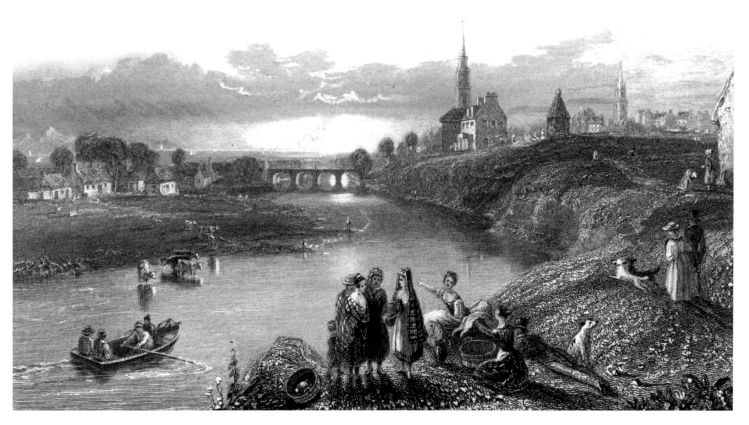

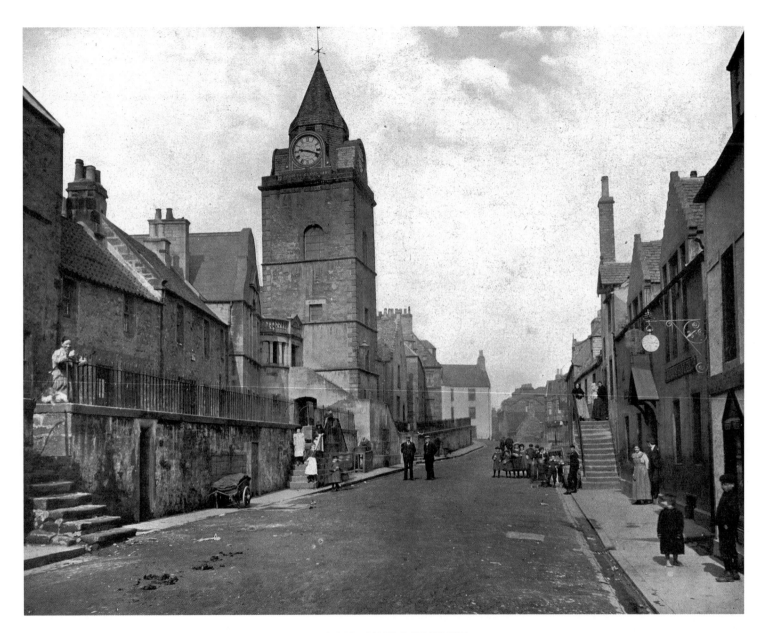

HIGH STREET, SOUTH QUEENSFERRY

Burnside, Scone.

POST CARD.

THIS SPACE MAY BE USED FOR COMMUNI-

THE ADDRESS ONLY TO BE WRITTEN HERE.

Kingussie. High Street

Valentines Series

J. Johnstone, Kingussie

POST CARD.

For Inland Postage only this Space may be used for communication.

THE ADDRESS ONLY TO BE WRITTEN HERE.

Penicuik, High Street.

POST CARD.

The address to be written here

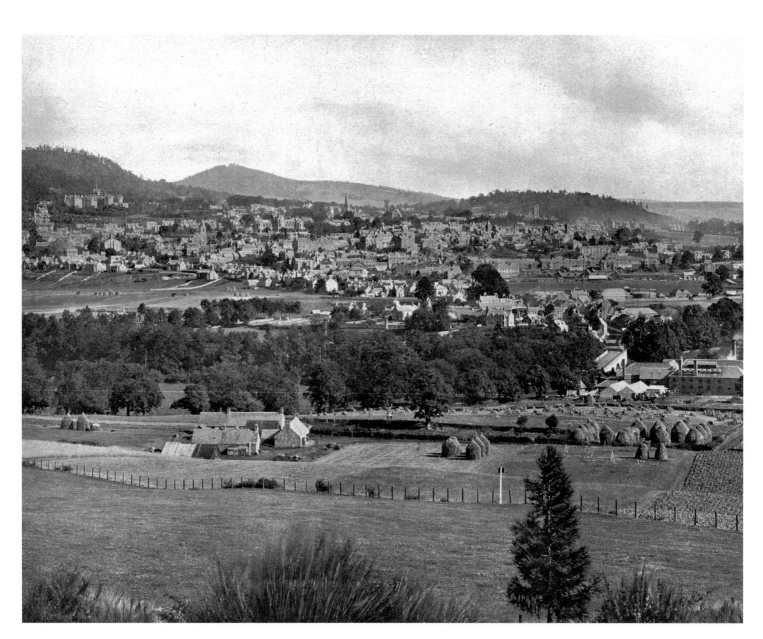

CRIEFF

CRIEFF TO BRORA

It is time to go north once more to the rich southern edge of the Perthshire Highlands. By the 1900s CRIEFF was suitably distanced from a history of violence and burnings and could claim to be 'the Montpellier of the Highlands'. The so-called 'kind gallows' hung with kilted Highlanders earned the town a brief place in Scott's *Waverley*. The town had been burnt in the 1715 rebellion. James Drummond laid out James Square as he promoted the rebuilding of the town in 1731, but he chose the wrong side in 1745 and the town was placed under the Commissioners for Forfeited Estates which promoted a mild industrialisation. Valentine stood back from the town to take in the sweep of the hills, the line of villas behind the town but, above all, the massive bulk of the Hydro.

The breakthrough for Crieff came with the arrival of the Caledonian Railway in 1856 and 1866. Macara's *Guide to Crieff* gave a careful account with municipal Scotland as hero:

It was the construction of the railway system to Crieff, by the construction of the branch from the Scottish Central main line in 1856 – prolonged to Comrie in 1890 – that gave it its greatest filip towards present expansion and assured prosperity. The only drawback for a period was the absence of a complete system of local government. Under the old Baron Bailie and his court, powers were limited for meeting the multifarious wants of a modern community. The household inhabitants of Crieff and its suburbs, however, sensibly adopted the General Police and Improvements Acts, and now it has a full and public-spirited municipality of Provost, Bailies, and nine Town Councillors. They have done wonders in making and mending roads and footpaths, in lighting handsomely both main and side streets and suburbs. But, above all, they have introduced from Loch Turret a supply of water as pure and overflowingly abundant as was ever carried by aqueduct and channel to any Italian city. The inhabitants have responded to the public spirit of the Town Council. The oldest streets have been practically rebuilt, and few provincial towns present a cleaner and daintier aspect. Certainly in none of the same size can such a wide and admirable choice of all that makes living attractive be obtained. Ladies may find a reflex of the latest fashions, and gentlemen all that pertains to luxurious town or rural enjoyment. And whether it be for golfing, fishing, or shooting, sportsmen can be fitted with all the requisite paraphernalia as cheaply (perhaps more so) and as completely as in London or Edinburgh. Living is cheap compared with that at many of the health and fashionable resorts in the South, and house-rents are moderate. Not a season passes but both east and west, on the bracing southern slopes of the Knock, new and commodious villas and cottages ornées are added to the terraces and avenues, which have been opened up of late years. For the tourist or bird of passage the hotels have a reputation for comfort and smart attention, while the summer visitor who seeks quiet seclusion, and the free enjoyment of the healing and bracing ozonised air, there is a varied choice of furnished villas and less expensive apartments.

After accounts of churches and schools the best was saved to the end.

If cleanliness be next in importance to godliness, then following the churches ought to come some notice of the far-famed STRATHEARN HYDROPATHIC INSTITUTION – one of the largest in the kingdom, and probably the most successful. It was really founded by Dr Thomas H. Meikle, and although it is now the property of a limited liability company, the largest shareholder is still the far-seeing, energetic and skilful founder. The approach to the quite palatial institution is by Ewanfield Terrace, on which, indeed, various roads converge from different parts of the lower town. Strathearn House stands mid-way up the southern slope of the Knock,

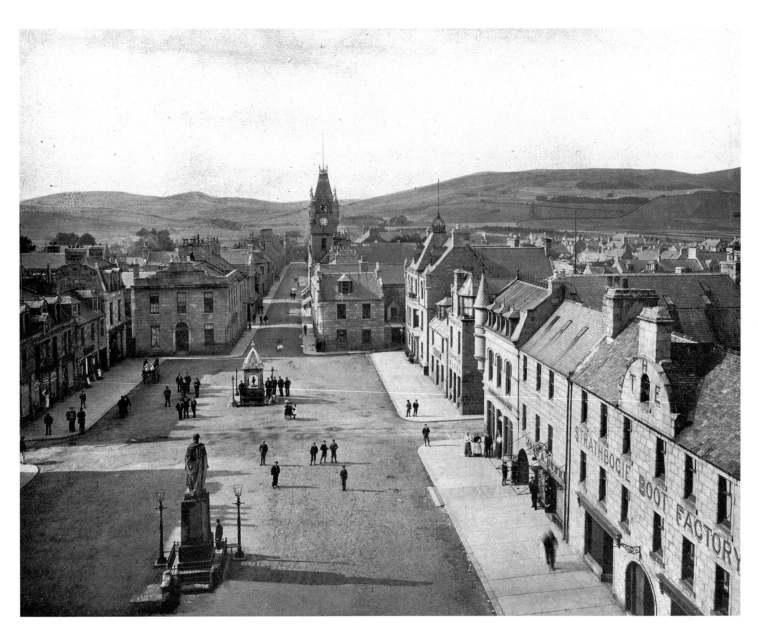

HUNTLY

about 440 feet above the sea level. The full range of external buildings – designed in a striking adaptation of domestic Elizabethan architecture – occupies a commanding plateau, sheltered on the north by most lovely and fragrant pine woods, . . . Over 300 guests can be received, and in the early autumn the house is generally overflowing. There is a small endowment left by a gracious-hearted philanthropist, under which clergymen are received at special terms, but to the general visitor, even at the most attractive season, the charges are strikingly moderate. The whole establishment has been carefully and scientifically planned with a view to the cheerfulness, comfort, and health of visitors. The public rooms are lofty, simply but effectively decorated, and in addition to the handsomely-furnished drawing-room, quite baronial dining room, writing-room, and billiard-room, the ball-room is a striking chamber, which can be converted – it often is in the season – into a concert-room or bijou theatre for amateur theatricals. The grounds, with bowling greens, tennis and croquet lawns, are nicely laid out with handsome plantations, shrubberies, and flower borders, and a short walk from the gardens is a private golf course, quite sufficient to test the best players. In wet or stormy weather the magnificent corridors – 300 feet in length and say 20 broad – afford a most agreeable promenade. Indeed, the lower corridor with its plant decorations is an attraction at all times and in all seasons, alike to the young and to valetudinarians. But Strathearn House is not only a huge and pleasant caravanseri, it is chiefly a hydropathic establishment, at which 'the cure of the suffering and exhausted is specially aimed at'. The water supply, of the most crystal brightness and purity, is brought from Glen Turret, four miles away, and the bathing arrangements, carried on by experienced and skilled attendants, are of the most complete description – including Turkish, Russian, and electric baths. A sojourn at Strathearn House is a tonic to the most languid lady, worn by a

season's city gaieties, and to the brain-fagged and nerve-exhausted professional or business man. Try it.

Crieff had come a long way since hanging Highlanders.

HUNTLY was a market place for the rich agricultural lands of north-east Scotland. Since the charter of 1545 it had been a Burgh of Barony to the Earls of Huntly. The Duke of Richmond and Gordon had laid out the neat grid and spacious square to take advantage of the position on the Aberdeen to Inverness road. The arrival of the Great North of Scotland Railway in 1854 enhanced this. The disciplined square was dominated by a huge sandstone statue of the last Duke and a memorial fountain to James Robertson, local bank agent. The bank was back left of the Square and the turreted Stewart's Hall along Gordon Street. Just beyond the centre right side street was the Huntly Temperance Hall, an attempt to divert the farmers and labourers visiting the many markets. The map reflected this self-contained aristocrat's burgh with the ruined castle a feature in the pleasure grounds of the hunting lodge.

Groome found a well organised place including the many places of worship found on the map.

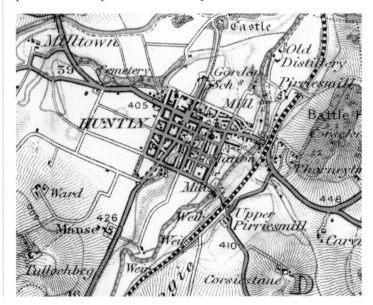

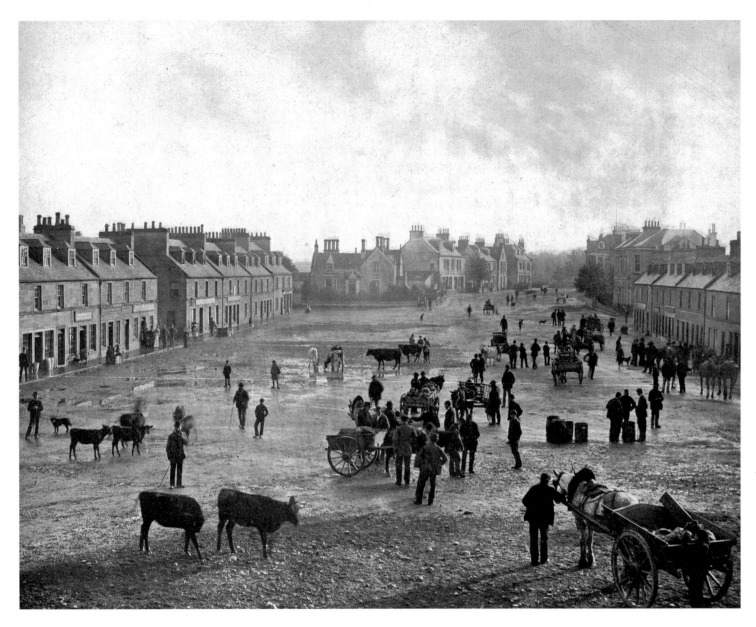

THE SQUARE, BEAULY

The town is well lighted with gas by a joint-stock company started in 1837; and in 1867 water was brought in from the Clashmach at a cost of £3140. Stewart's Hall, erected in 1874–75, but burnt down in 1886 and rebuilt in 1887, is a handsome edifice, the bequest of the late Alexander Stewart, a solicitor in the place. It is surmounted by a lofty clock-tower, and the large hall, used for public meetings, etc., can seat 650 people. The parish church is a plain structure of 1805. The Free church was built in 1840 at a cost of over £1300, in result of the famous Strathbogie movements that preceded the Disruption. Other places of worship are the U.P. church (1809), the Gothic Congregational church (1851), Episcopal Christ Church (1836), a small elegant Gothic pile with a spire, and a handsome Roman Catholic chapel.

Huntly has a post office, with money order, savings bank, insurance, and telegraph departments, branches of the Union, Town and County, and North of Scotland banks, a local savings bank, several hotels, a farmers' club, a horticultural society (1846), and a Saturday newspaper, the *Huntly Express* (1863). Thursday is market-day; and cattle-markets are held on the first and third Wednesdays of every month. Several bleachfields of great repute were long in operation on the Bogie; and the manufacture of fine linen, introduced from Ireland in 1768, towards the close of the 18th century had an annual value of from £30,000 to £40,000. These industries have ceased, as also have tanning and distilling; but agricultural implement making, the manufacture of bricks and tiles, brewing, woollen manufactures, etc., afford employment to a considerable number of the inhabitants. Other sources of prosperity are the marketing and export of eggs and cheese, and an extensive retail trade in the supply of miscellaneous goods to the surrounding country. Under the Burgh Police (Scotland) Act of 1892 it is governed by a provost, 2 bailies, and 6 commissioners. Sheriff small-debt courts are held on the second

Mondays of March, June, September, and December. Pop. (1831) 2,585, (1861) 3,448, (1871) 3,570, (1881) 3,519, (1891) 3,760. Houses (1891) inhabited 825, vacant 28, building 7.

BEAULY amongst other things was cattle country and gained Baddeley's attention.

> Two miles after leaving the waterside the railway sweeps round to the right across the *Glass,* and enters BEAULY (pronounced 'Bewley'). The town of *Beauly* (Hotels: *Lovat Arms*, and *one* or *two smaller ones*) lies half a mile to the right. It contains the ruins of the chapel of a Priory founded in 1230. Otherwise Beauly is chiefly noteworthy as the starting place for the beautiful scenery of Strathglass and the magnificent pedestrian route through Glen Affric to the West Coast. Turning due north for a while, the line, commanding a fine view westwards to the peaks of Strath Conon and Glen Orrin, reaches MUIR OF ORD (*Tarradale Inn*). This place is famous for its cattle fairs.

The Square was less disciplined than Huntly but still attracted the praise of Francis Groome.

> Beauly (French *Beaulieu,* 'beautiful place'), a village in Kilmorack parish, Inverness-shire, with a station on the Highland railway 10 miles W of Inverness. A burgh of barony, a sub-port, and a great tourists' centre, it stands on the left bank of the Beauly river, a little above its mouth; presents a well-built, clean and pleasant appearance; and has a post office, with money order, savings bank, insurance, and telegraph departments, branches of the Bank of Scotland and Commercial Bank, gas-works, hotels and inns, a Roman Catholic church (1864: 350 sittings) and the ruined priory of St John the Baptist . . . fairs are held in the village or on the neighbouring Moor of Ord on the third Thursday of

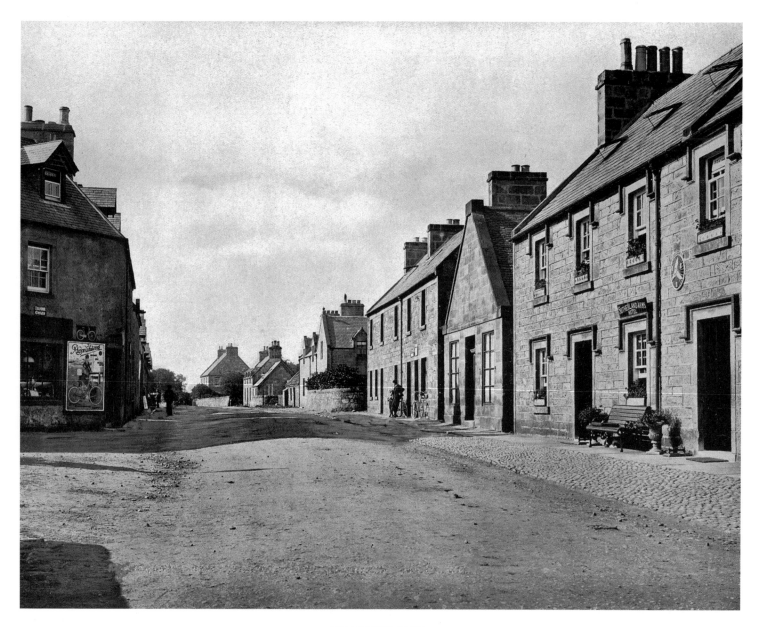

MAIN STREET, BRORA

January and February, the third Wednesday and Thursday of March and April, the second Wednesday and Thursday of May, the third Wednesday and Thursday of June and July, the Wednesday and Thursday of August, September, and October before Falkirk, the Wednesday and Thursday of November before Edinburgh Hallow fair, and the Thursday after the third Wednesday of December. The village has a safe and convenient harbour, and carries on a considerable trade in timber, coal, lime, and other commodities. A small debt court is held in January, May, and September . . .

The road north goes through Golspie and past Dunrobin Castle to the village of Brora. History requires a comment on the huge investments the Dukes of Sutherland made in a desperate attempt to create an industrial revolution to compensate for the clearances of inland villages for sheep farms. The colliery and brick works had been reopened in 1872 and the Sutherland Woollen Mills prospered, as did the tile works producing field drains, but the distillery still did much better than the brewery established by the Lady Stafford in 1815. Close examination showed that the Valentine photograph was about something else. To the left was Mr Sinclair's shop, where 'boots and shoes of all kinds, cycles and all cycle accessories, and all golfing requisites, are to be got'. Across the road was the Sutherland Arms Hotel, 'built so long ago as 1818, but has had to be enlarged several times since. It continues to be an excellent hostelry, and the happy landlord soon makes visitors at home, and is able to give valuable hints as to how one may be successful at fishing on loch or sea'. Mr Polson, JP, author of the *Guide,* might have added that on the wall was the winged-wheel symbol of the Cyclists Touring Club. The Club had been founded in 1878. The 'safety' bicycle like those outside the neighbouring shop had made cycling for pleasure widespread. Maps like those of Gall and Inglis, the Edinburgh engravers and printers, traced cycle routes across Scotland. The Sutherland Arms was recommended in the *Road Book of Scotland* and Polson suggested 'Some visitors will no doubt wish to visit Kildonan Strath famous for its clearances and its gold. Strong cyclists may go by the Glen

Loth road, which they will likely find a bit rough . . . The more pleasant way, however, is to train to Kildonan Station, and then cycle back.' Others might prefer the golf course guided by the description of Mr Hugh Gunn, MA and HM Inspector of Schools. But the Brora picture was about the bicycle which, for a brief moment, was the fastest vehicle on the roads and a means by which the tourist, both male and female, reached places like Brora: 'the botanist, the conchologist, the fisherman in salt and fresh water, the landscape artist, the sociologist and the antiquary will find the place brimful of interest'.

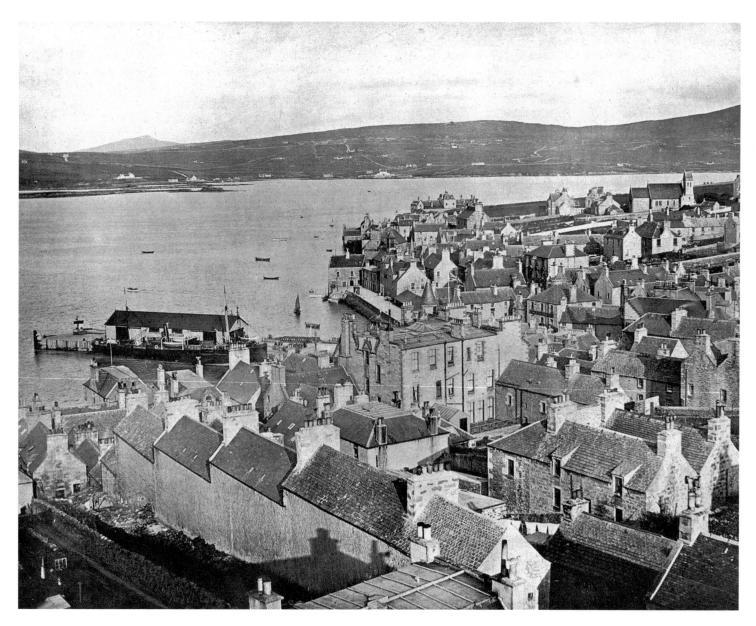

LERWICK

SHETLAND TO STORNOWAY

This careful gaze at Scotland's small burghs has been a long one because pride and affection for such places was such a vital part of Scotland's sense of well-being and self-presentation. This tour ends with the twin towns of the Shetlands, LERWICK and SCALLOWAY. Shetland was part of Scotland's exotic. The Islands were different. The Reverend John Russell, who spent three years as a minister in Shetland, realised that this was part of the attraction for the tourists:

> In summer a constant stream of tourists, conveyed by commodious and well appointed steamers, is landed at Lerwick and Scalloway, who, roaming over the islands, survey with admiration the scenery, and feel interest in observing the manners and customs of the people so different in many respects from those to which they have been accustomed.

He likened writing about Shetland to writing about India. He gave an account of the Shetland people in distinctly racial terms. The inhabitants 'chiefly of Norse origin have displaced the Celts whom they found in possession; local legend had it that they brought slaves of Finnish race who were short and swarthy; the ruling class and landowners are of Scotch descent'. Groome traced the origins of Lerwick to the seventeenth century, when the sheltered bay had provided for the Dutch fishing fleet. Scalloway was then the dominant centre and Scalloway patriots like Eleanor B Harcus, who printed her account for the Scalloway Public Hall and Library Bazaar in 1898, traced that small settlement back to the open-air parliament of the Norse period. The tyranny of Norse Kings, Scottish Kings and the Earls of Orkney was part of the history of both places. Scalloway Castle, built by forced labour in 1600, was a visible reminder of this in the Valentine photograph.

Populations were tiny but this did not stop either place claiming status. Scalloway (pop. 732) was the ancient capital that had become 'Haddockopolis' in the fishing boom of the 1880s. As a result they had a steamer a week, two hotels, a United Presbyterian Church and an extended Blackness Pier.

Lerwick (pop. 3,039) was the county town, a Police Burgh and Burgh of Barony. It was laid out with a long narrow street along the shore and a 'new town' on high ground. Lerwick had its own version of the municipal. When the Police Burgh was created, the authority had no adequate meeting place and the burgh had little chance of finding the finance to build, so a limited liability company was formed. The Lerwick Town Hall Company was formed with a capital of £4,000 in £2 shares. A further subscription was raised for the tower of the Gothic baronial building. Lerwick was full of stories of distance. There were the ministers who travelled by way of Hamburg to get to the General Assembly in Edinburgh. There was the clock repairer who thought he would catch a passing ship to take him back to Lerwick and ended up hunting whales for a season in the Davis Straits. Distance did not stop Lerwick having a Royal Visit. The old fort originating from the Dutch Wars had become a Royal Naval Reserve training establishment. The burgh spotted that the then Duke of Edinburgh, Admiral Superintendent of Naval Reserves, was on a tour of inspection and HRH agreed to lay the foundation stone.

The 24 January 1882, the day appointed for the ceremony, and which the Magistrates had recommended should be observed as a general holiday, was wet and stormy. It was blowing a gale too, and much anxiety prevailed as to whether the Admiralty Yacht *Lively,* with his Royal Highness on board, would arrive in time. At last, about 10 a.m., she was seen in the offing, making her way into the bay through fog and rain.

HRH was landed at the Gas Pier and did the job with trowel and oaken mallet, manufactured by Marshall and Son of Edinburgh.

Lerwick was 'our metropolis' to Dr Edmondston of Unst. His daughter, Jessie Saxby, gave the best account of the shock of the urban, Shetland style, in *Reminiscence*, printed for the Lerwick Church Improvement Scheme Bazaar in 1894. As in so many other burghs the theme was change:

> Modern Improvements have rapidly changed our island metropolis; and though such alterations must be

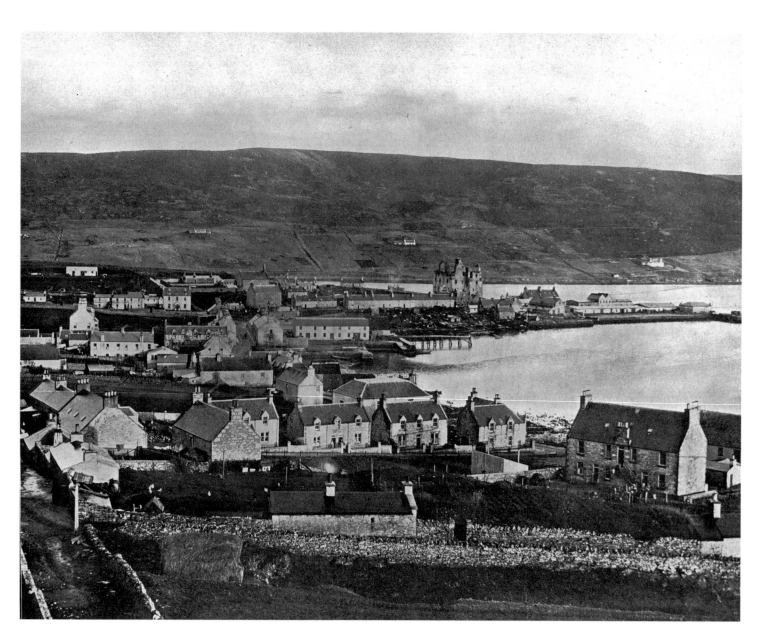

SCALLOWAY

beneficial . . . there are many old Lerwegians who love to remember the auld toon as it was . . . In Unst I had never seen anything resembling a street . . . no policeman, no public house, no place of assemblage but the kirks and schoolrooms; no bakery. . . . [We] passed along The Street which looked as if it were closing on us . . . Two drunk men occupying the breadth of the street at one spot, and a country cart blocking the way at another . . .

I learned my first lessons in the ways of the world that morning when we went out walking. 'Don't look behind you Jessica; it isn't proper – at least in town!' said Miss Ogilvy, as I wheeled about to study the garb of some French Officers who had just passed. . . . 'don't dance along on your toes, everybody is looking at you', said my sister next . . . Small, early tea-parties were very popular in Lerwick. They included a carpet dance and a hot supper . . . and left a more lasting sense of benefits received . . . than the more elaborate and formal affairs of the sort which I have endured rather than enjoyed in a more ambitious metropolis than that of Shetland. A curious kind of sausage, and a case of queer square bottles containing cherry brandy and some other foreign liquor (doubtless come without paying tribute to the Queen).

Reverend Russell thought that Shetlanders had 'a strong feeling of aversion to the Scotch', a sense of dislike and dispossession linked to their history. Jessie Saxby had a more subtle account: 'The Shetlanders are not a quarrelsome folk, and one heard very little of law or lawyers in the old days . . . but an army of Scottish lawyers seems to have invaded Lerwick.' Another influence was more benign:

Auld Lerwick was satisfied with anything in the form of kirk and minister. She did not trouble herself about the faith, and piety was not conspicuous in town. Elderly men liked their dram, and were not refused 'the ordinances' because of various immoralities. Young men 'went the pace' and nobody frowned. The ladies invited each other to balls and tea-parties, were charitable after a fitful fashion to the poor, and gossiped about this, that, and the other thing; meaning no harm, but certainly not stirred by much religious sentiment.

To-day, Lerwick is to the front in all good works. She has her Dorcas Societies, her Temperance Associations, her well-attended, well-appointed churches of all denominations . . . She is earnestly, enthusiastically employed in furthering every scheme which appears to 'make for righteousness'. [the explanation] A very few ladies (Scottish, Irish, and English), who, marrying Shetland gentlemen, brought to Lerwick that beautiful, unobtrusive religion which works marvels in a silent, unseen way. These good and womanly women have been 'as leaven, leavening the whole'.

Stornoway was the main town for the island of Lewis in the Outer Hebrides. This view along South Quay was one of the busiest in the Valentine collection. The inevitable line of children which the photographer had gathered were well shod, indicating a degree of prosperity in the town. Prosperity in this period was herring. The barrels for the salted herring were stacked on the quay in front of the Town Hall. The four girls walking and knitting were probably taking a rest from the fish gutting and processing. The product of their work was almost certainly ganzies, a crucial part of fishermen's clothing.

In the 1900s, Lewis was still Matheson country. The island had been purchased in 1844 by Sir James Matheson with wealth from the opium and tea trades of China. Groome praised him for his 'improvements', drainage, roads, new quay and harbour facilities as well as new breeds of cattle and sheep. By 1900, steamships were bringing visitors attracted by remoteness and the romantic novels of William Black. All those who read newspapers would know that Lewis was one centre of the crofters' revolt. The crofters and cottars of the rural parts of the island deeply resented the manner in which 'improvements' had cleared long-established

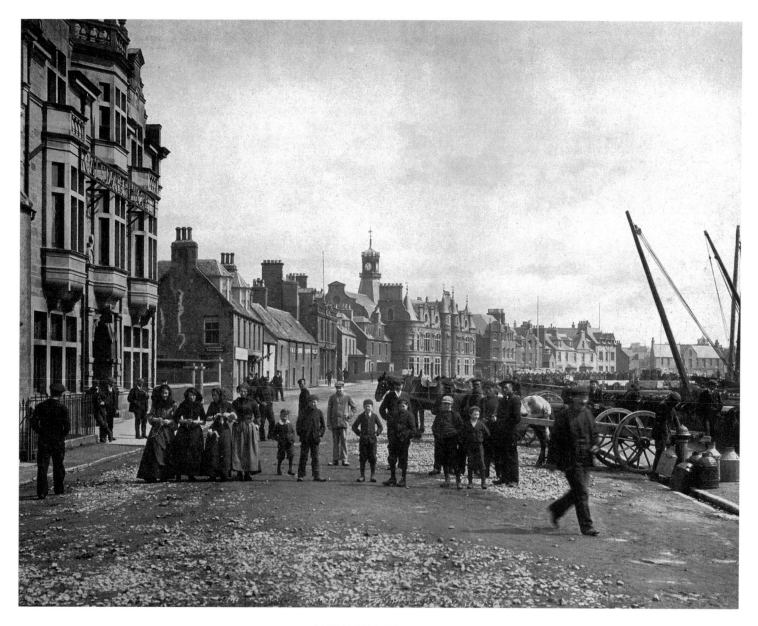

SOUTH BEACH, STORNOWAY

townships to create tenant sheep farms and, above all, to clear land for deer and the associated shooting parties. In the late 1880s, Lewis required four Royal Navy vessels and parties of marines and Royal Scots to bring 'land raiding' to an end.

The solid and active appearance of Stornoway owed much to Matheson money and to herring.

The town now consists of about a dozen fairly well-built streets, with a number of straggling suburbs. There is a reading-room and library, a drill hall, a court house, a prison, a custom house, a sailors' home, & fire-engine station, lifeboat station, coastguard station and Royal Naval reserve battery, a rifle club, a masonic hall, and a new fish mart erected for the harbour commissioners in 1894 at an expense of £1,200. There are in the town Established, Free (2), U.P., and Episcopal churches, and several schools. The parish church, built in 1794 and repaired in 1881, received additions in 1885. The English Free church was built in 1878, and contains 630 sittings. The Gaelic Free church, erected in 1894, is seated for 400, and has a hall in connection. The U.P. church was erected in 1873, and the Episcopal church (St Peter), with sittings for 120, in 1839. The latter was reseated, decorated, and had a new altar and reredos erected in 1892. At Lady Matheson's Female Industrial School, instruction is given in the ordinary branches and in needlework; and education is also given at the Nicolson Public School – partly endowed and the site granted free by Sir James Matheson – and a Free Church school.

Stornoway is also the centre of the greatest of the Scottish fishery districts, embracing the whole of the Outer Hebrides. In 1893 . . . 721 boats fished in the district, and employed 5047 men and boys and 3114 other persons, while there were 85,597 barrels of herrings cured. Fully three-fourths of the total barrels cured were exported to St Petersburg.

The feuars and burgesses obtained in 1825 a charter from the superior, empowering them to elect 2 bailies and 6 councillors to manage the affairs of the community; but municipal affairs are now attended to by a provost, 2 bailies, and 6 commissioners acting under the Burgh Police Act of 1892. The waterworks were transferred to the police commissioners in 1870, but gas is still supplied by a private company. The town has a post office, with money order, savings bank, insurance, and telegraph departments, branch offices of the British Linen Company, Caledonian, and National Banks, and three good hotels. Among miscellaneous institutions may be noticed a battery of Artillery Volunteers, a Coffee House Company, a Horticultural Society, a Literary Association, Oddfellows' and Good Templar lodges, and Young Men's and Young Women's Christian Associations. Horse and cattle fairs are held on the first Tuesday of July and the last Tuesdays of August and October. The sheriff-substitute for the Lewis district is resident here, and ordinary and small debt courts are held every Wednesday during session. (Groome)

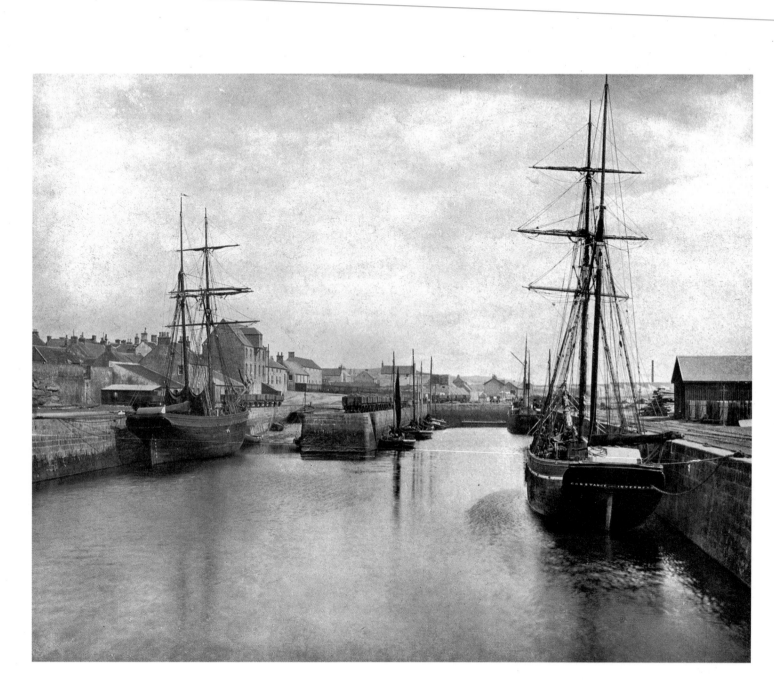

BURGHEAD HARBOUR

CHAPTER 13
Ports and harbours

Ports and harbours were a long-standing subject for painters, engravers and photographers. They had all the qualities required by the picturesque. The harbour structures themselves tended to enclose and encapsulate their subject. The town or cliffs provided background and the ships themselves contributed a story and a drama which completed the picture. For Valentine this meant the fishing harbours and villages of the east coast of Scotland. There were several ways of looking behind these pictures. There was Francis Groome in the *Gazetteer,* studied and studious, with his figures, lists of institutions, outlines of municipal government and helpful literary references. Specific to this group of photographs was *The North Sea Pilot. Part Two. North East Coasts of Scotland,* published in 1895 under the direction of Staff Commander J R H MacFarlane, RN and published from the Hydographic Office of the Admiralty. The series had begun in the 1830s and been updated many times since. It provided a severe, practical and sometimes brutal counterpoint to the calm of the Valentine pictures:

> Along its [the north and east coasts of Scotland] whole extent there are only two harbours which can be run for in any weather . . . the weather is usually boisterous and inclement . . . south, and south-easterly gales, shifting to the north-east, are not uncommon, and sometimes blow with fearful violence, sending home, on this refugeless coast, a heavy sea, which is highly dangerous to vessels

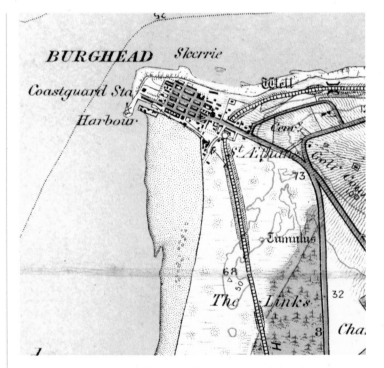

> close in shore, and frequently causes wrecks in the winter season.

Burghead was a grain port and a fishing port on the Moray Firth. The grid plan revealed by the Ordnance Survey map indicated that it was one of the many planned villages carefully laid out in Scotland as part of landowners' economic development plans.

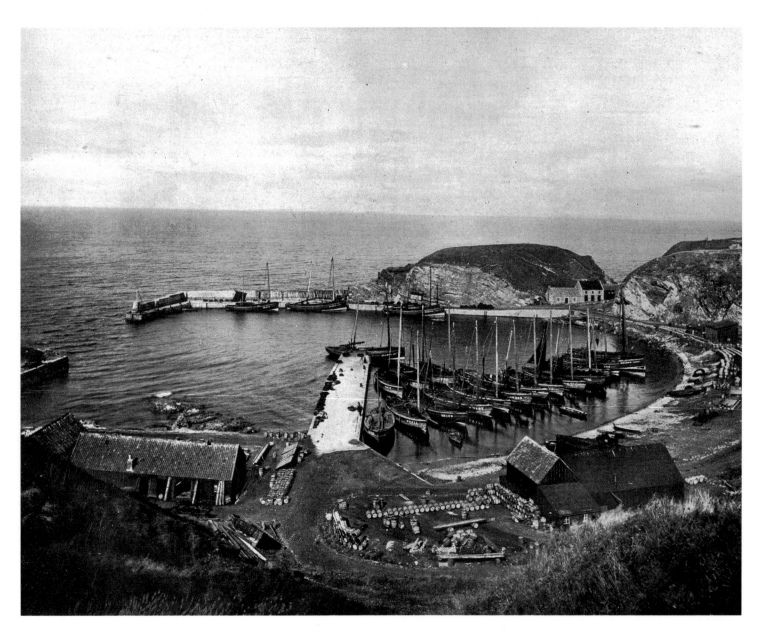

PORTKNOCKIE HARBOUR

Groome added the practical details:

The town stands on the slope of the promontory, on a branch of the Highland railway, opened to Hopeman in 1892, 5½ miles NNW of Alves Junction, 10¾ NW of Elgin, and 12½ NE of Forres. Laid out on a regular plan, with well-built and substantial houses, it is much frequented as a summer watering-place; carries on considerable commerce, an extensive herring fishery, and a limited salmon fishery; and has a post office, with money order, savings' bank, and telegraph departments, a branch of the Caledonian Bank, a public reading-room, a suite of baths, a coastguard station, a custom-house, a *quoad sacra* parish church, a Free church, and a U.P. church. The Morayshire Chemical Works, for the manufacture of artificial manures was started in 1864; and boat-building and fish-curing are also carried on. The harbour, fronting westward or towards Cromarty, was begun in 1807, and completed in 1801; extended considerably in 1881–87, at an expense of £40,000, until it is capable of accommodating ships drawing 17 feet of water; and, besides serving for the local commerce, accommodates passage vessels on a ferry to Sutherland, and receives calls of steamers plying between Leith and Inverness. The harbour is well protected from the north and east winds, and consequently vessels can enter with perfect safety. A public school, with accommodation for 595 children, had an average attendance of 334 in 1891, and a grant of £332 11s 6d.

Groome hints at the third way of looking at fishing harbours. Along with the golf course and evidence of ancient histories, they were part of the tourist attraction.

PORTKNOCKIE, further east along the southern coast of the Moray Firth, was a prosperous fishing village which claimed to have been established in 1677 by people from the nearby port of Cullen. Portknockie had a reputation as an active and enterprising place. The photograph showed a modern harbour, completed in 1890 and several of the 'Zulu' style fishing boats, with their straight stem and heavily raked stern which dominated fishing between 1880 and 1914. The *North Sea Pilot* gave a practical account of a well organised place.

PORTKNOCKIE, 4 miles to the eastward of Buckie, is a fishing village of some importance, and has more natural protection than any other place on this side the Firth of Moray. The village, built on a brae above the harbour, its most conspicuous object being a church with a belfry had, in 1891 a population of about 1,400, and has railway communication by the Great North of Scotland railway; all the men, with the exception of a few small tradesmen, are fishermen; 117 boats, employing 320 men belong to it; it is a curing station, and great quantities of haddock are caught and salted in the winter. Imports: coal, salt and fish; exports fish.

Harbour. – The harbour of Port Knockie, which was opened in 1890, consists of a north quay, about 140 yards in length, in a W.N.W. direction, with a short cant to the south-west; its outer extremity, on the northern side, is partly formed by the point of Ett.

There is a depth of 12 feet at the quayhead, and about 9 feet at low water, spring tides, for a distance of about 50 yards inside; fishing boats drawing 9 feet enter the harbour at all states of tide, and there is a deep water berth, at low water, for a vessel drawing 10 feet.

On the south side of the harbour, a pier, about 70 yards in length extends in a N.N.E. direction, and further improvements are contemplated, which will include the narrowing of the entrance.

An ensign is hoisted at the flagstaff when it is dangerous to enter the harbour.

Harbour dues 3d. per registered ton; kedge and warp 5s; ballast 1s. per ton on the quay.

Lights. – A *fixed white* light is exhibited from an iron pillar on the north pier-head, Port Knockie, at an elevation of 27 feet above high water, visible in clear

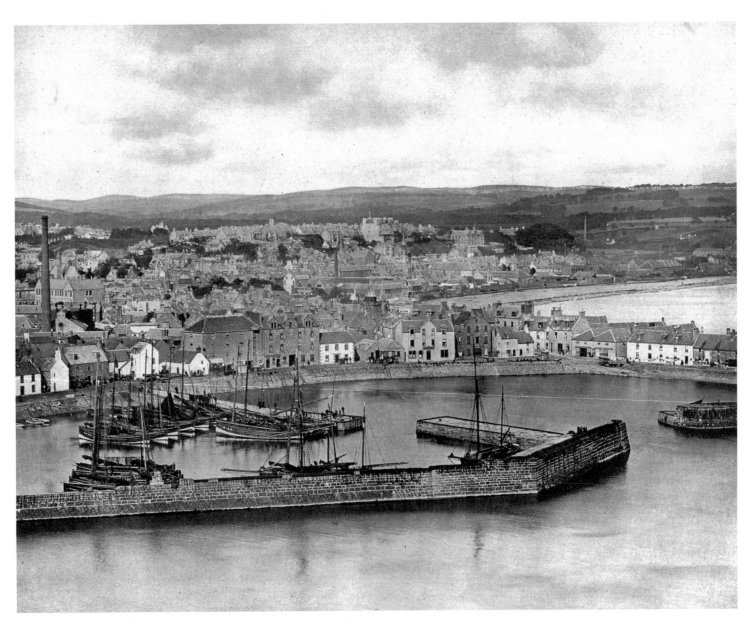

STONEHAVEN

weather from a distance of 8 miles.

Leading lights are exhibited, at elevations above high water of 159 and 130 feet, from poles situated on a hill near the harbour. Both lights are *fixed red;* but when it is considered dangerous for boats to enter the harbour the lower light is changed to *fixed green.*

These latter lights are exhibited from the middle of August to 1st May.

STONEHAVEN on the Kincardine coast south of Aberdeen had successfully made the transition to a dual role of fishing port and holiday and residential destination. Like many Scottish towns it had an old town and a new town. The harbour and the old town had very ancient origins but owed their modern growth to the Harbour Commissioners established in the 1820s and the subsequent improvements. The new town across the River Carron had been laid out in 1759 and developed with stately slowness until the tourist boom of the 1890s. The Valentine photograph gathered up all these developments. The modern 'Zulu' boats sheltered behind the solid harbour wall. Over 100 boats fished for herring from Stonehaven in the 1890s. To the left was the chimney of the gas works and the County Buildings. In the centre was the 'quaint' copper-covered steeple at the head of the High Street, erected by public subscription in the 1790s. Beyond that was the tower of the market house which with its Square formed the centre of the new town.

The *North Sea Pilot* praised the appearance of 'this picturesque little watering place' but then gave a severe lesson looking at a potentially hostile coast:

Stonehaven Bay . . . has a sandy bottom, but is much encumbered by rocky ledges . . . The outermost point

of all, named the Toutties, is near the centre of the bay, abreast the fishing village of Cowie, and lies with Gelnury distillery Chimney, in line with the west cottage in Cowie, bearing NW by W; it is cleared on the outside in 6 fathoms water by keeping a red-tiled cottage at the inner end of Stonehaven pier in sight, SW by W 5/8ths W.

Stonehaven was a well-organised place. Groome again:

There are a considerable number of summer visitors every year. The summer residence of Professor M'Kendrick, of Glasgow University, on Main's Hill, was erected in 1894–95. Stonehaven has a head post office, with money order, savings bank, insurance, and telegraph departments, branch offices of the Bank of Scotland, North of Scotland, and Town and County Banks, a branch of the National Security Savings Bank, a temperance savings bank, and several hotels. There are also a farmers' society, a news and reading room, a literary society, a horticultural, ornithological, and industrial society, a choral union, an orchestral society, cricket and football clubs, a Conservative club, a masonic lodge (St John's, No. 65), a court of the Ancient Order of Foresters, a company of rifle volunteers and a battery of artillery volunteers, and the usual religious and philanthropic associations.

But, as the Professor indicated, Stonehaven was the ideal place for a respectable holiday and suitable publications poured off the local presses. There were *Descriptive Historical Stonehaven, Picturesque*

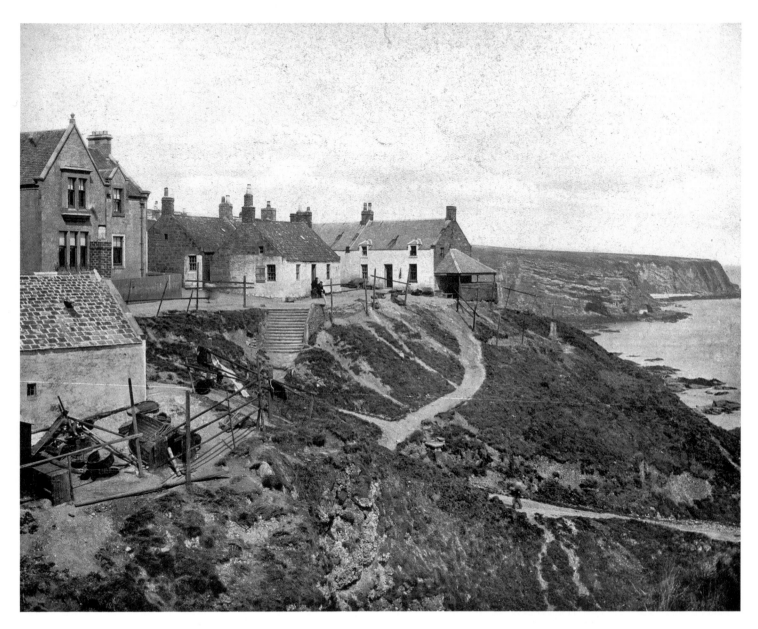

AUCHMITHIE

Stonehaven and, most important of all, *Salubrious Stonehaven*. Great emphasis was placed upon sanitation and the victory of the 'party of progress . . . formed by a number of the more intelligent members of the community . . . The New Town has now got into a most satisfactory sanitary condition. The Water Supply is as good as any in the kingdom. The water, which is abundant and of the greatest purity comes from springs on the uncultivated hills.' If that was not enough, 'From every quarter the wind brings tonic air . . . from the sea the breezes are laden with ozone, gathered on their flight across the German Ocean.' These claims were backed up with suitable statistics on longevity. Thirty-nine out of every 100 deaths were those who had passed the Psalmists' 'three score years and ten'. There were easy railway access, good hotels, golf, tennis and bowls. The beach was safe for bathing. Nearby were excellent cycle runs and walks including one to Dunnottar Castle where the Covenanters had been imprisoned. This was time for a compelling story of suffering and salvation for Presbyterian heroes, as well as a visit to Dunnottar churchyard where the Covenanters' grave had inspired Walter Scott in writing *Old Mortality*.

It was the inimitable prose style of *Salubrious Stonehaven* which identifed the vicarious excitement of the fishing harbour itself as a major tourist attraction:

Stonehaven really consists of two parts – the old and the new; the former picturesque with the quaintness of age, the latter up-to-date in all that the modern holidayer demands in a pleasure resort – streets bright and spacious; trim gardens; pretty and commodious houses; and well-equipped and well-stocked shops. The old portion, which sits around a harbour of picturesque charm, is inhabited by the fishing population, the doings of whom are a source of perennial interest to every visitor, who, watching the fishermen mending their nets, landing their catch of silver fish, or putting out to sea in their boats – a sheer vision of beauty – realises some of the romance and adventure asssociated with the labour of those who reap the harvest of the sea.

AUCHMITHIE, perched on the cliff top south of Montrose, was tiny, about 350 people. *North Sea Pilot* said simply 'a good gravelly beach in front of it with no harbour . . . the long line and lobster fisheries are prosecuted with great success'.

AUCHMITHIE, a fishing village in St. Vigeans parish, Forfarshire, on a rocky Bank rising about 150 feet from the beach, 3½ miles NNE of Arbroath. It holds of the Earl of Northesk, is irregularly built, but contains several good houses, and has a sort of harbour at the foot of an opening in the rocky bank, a post office under Arbroath, a hotel, a public hall, and a *quoad sacra* parish church (1885; minister's salary, £120). Water and drainage works were formed in 1880. Auchmithie is the 'Musselcrag' of Scott's *Antiquary*. A new fishery harbour has been erected, but in storms the fishermen have still to haul their boats inward from the beach, to prevent their destruction by the violence of the waves. Pop. (1871) 412, (1881) 359, (1891) 353. (Groome)

It was the appearance of the village in Scott which gave it a brief place in Baddeley's *Guide*. The very basic facilities of the place also made it attractive to those who were 'fisherfolk' watchers. James G Bertram worked along the coast in the last 40 years of the nineteenth century:

Winding roads with steps lead down the side of the steep brae to the beach. There are a few half-tide rocks in the bight that may help to break the fury of the waves raised by easterly winds; but there is no harbour or pier for the boats to land at or receive shelter from, and this the fishermen complain of, as they have to pay £2 a year for the privilege of each boat. The beach is steep and strewed with large pebbles, excellently adapted, they say, for drying fish . . . Fisher life may be witnessed here in all its unvarnished simplicity. Indeed, nothing could be more primitive than the inhabitants and mode of life. I have seen the women of Auchmithie 'kilt their coats' and rush into the water in order to aid in shoving off the boats, and on the return of the little fleet carry the men ashore on their brawny shoulders with the greatest ease and all the nonchalance imaginable, no matter who might be looking at them. Their

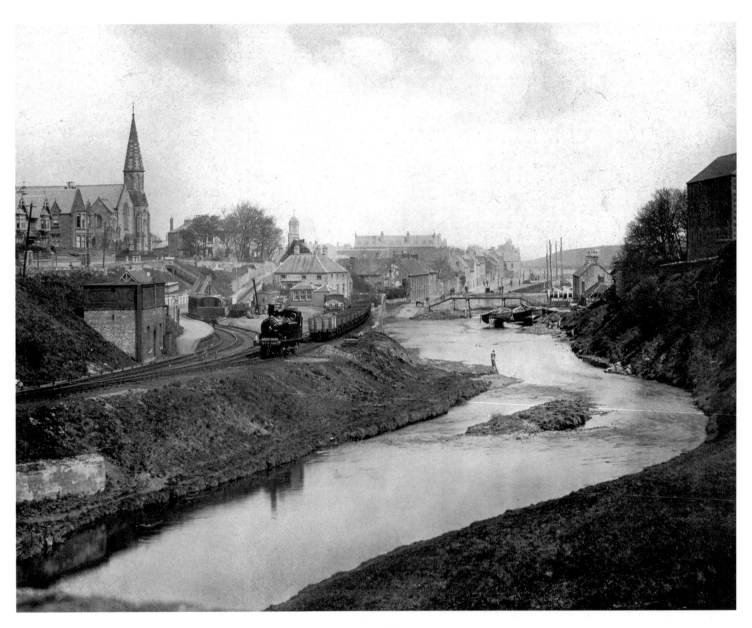

EYEMOUTH

peculiar way of smoking their haddocks may be taken as a very good example of their other modes of industry. Instead of splitting the fish after cleaning them, as regular curers do, they smoke them in their round shape. They use a barrel without top or bottom as substitute for a curing house. The barrel being inserted a little distance in the ground, an old kail pot or kettle, filled with sawdust, is placed at the bottom, and the inside is then filled with as many fish as can be conveniently hung in it. The sawdust is then set fire to, and a piece of canvas thrown over the top of the barrel.

EYEMOUTH was a major fishing port south of the Firth of Forth. It had a long and mixed history. In 1597 Eyemouth became a Burgh of Barony under the Homes of Wedderburn and during the eighteenth century acquired a reputation as a smuggling centre.

James Bertram disapproved strongly of the place in 1867:

It is a fishing village pure and simple, with all that wonderful filth scattered about which is a sanitary peculiarity of such towns. As a whole, they are a rough, uncultivated people, and more drunken in their habits than the fishermen of the neighbouring village . . . A year or two ago, a wave of revivalism took place at Eyemouth, and seemed greatly to affect it. The change produced for a time was unmistakable. These rude, unlettered fishermen ceased to visit public-houses, refrained from the use of oaths, and instead sang psalms, and said prayers. But this wave of revivalism, which passed over other villages beside Eyemouth, has rolled back, and in some cases left the people worse than it found them; and perhaps I may be allowed to cite the fish-tithes riots as a proof of what I say. These riots, for which the rioters were tried before the High Court of Justiciary at Edinburgh, and

some of them punished, arose out of a demand by the minister for his tithe of fish.

Groome's view was quite different: 'The Eyemouth white winter fishing boats are among the largest and finest in Scotland, and the fishermen among the best and most energetic anywhere to be met with.'

Valentine stood back from the town when he took his photograph and gave emphasis to the little branch line which linked the port to the North British Railway and, amongst other things, carried the fish to market and imported huge amounts of mussels from Boston in Lincolnshire to bait the lines. Whatever Bertram thought, Eyemouth had many places of worship. The Free church spire was on the hill to the left of the picture and the rounded tower of the Kirk itself in the town centre.

Eyemouth's deep misfortune was the loss of 129 men in the storm of 14 October 1881. The rotting sandstone of the Collin grave joined the disaster with the everyday disaster of infant mortality.

This was only one aspect of Eyemouth's very distinct iconography. The General Police and Improvement Act (Scotland) was taken up in 1866 and the resulting Town Hall (1874) was decorated with the fishing boat *Supreme*.

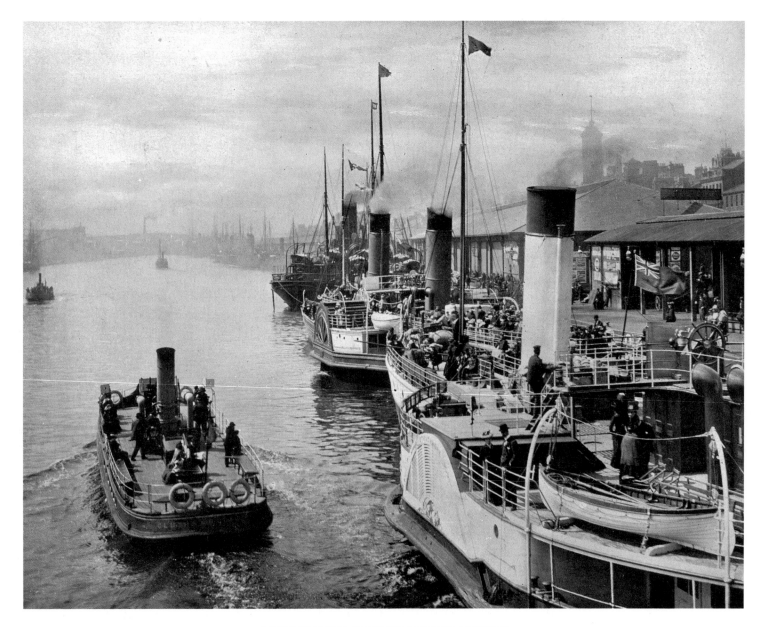

PADDLE STEAMERS AT BROOMIELAW QUAY, GLASGOW

CHAPTER 14

Paddle steamers, a railway and the Forth Bridge

There were few finer sights in late nineteenth-century Scotland than that of a paddle steamer turning in the loch or tied up at the pier head, discharging and gathering in passengers. The importance of Walter Scott in this account of looking at Scotland might suggest an obsession with the past, but the enthusiasm for the paddle steamer was about the modern. The paddle steamer was a product of fine engineering and technology. In as far as this collection is about a Scotland that was pleased with itself, then every last rivet was hammered home in Scotland. Those like the Rev. Gilpin, who had framed the 'rules' for the picturesque in the late eighteenth century, can have had little idea of the contribution of the paddle steamer, although J M W Turner was beginning to suspect. The steamer on the loch was the perfect subject. It was framed by mountains. It generated excitement, whilst the pier and landing stages led the viewer's eye around the picture.

Modernity, that is the experience of things modern, was about many things and one of the most important was an acute awareness of time. It was no accident that the status-seeking burghs in Valentine's pictures sought to have a public and prominent clock. Walter Scott, who wanted to demonstrate the modernity of *The Antiquary*, a half-concealed satire on himself, introduced his character in a turmoil of irritation because the Hawes Fly, linking Edinburgh to the ferry across the Forth, was a few minutes late. The timetable and keeping to timetable were vital for the paddle steamers and their passengers. Indeed, a

number of companies had come to grief because they had gained a reputation for bad timekeeping.

The timetable was the crucial link between passenger and the technology of the railway and the paddle steamer. Thomas Nelson, the publisher of many editions of Baddeley's *Guides*, took care to renew the timetable information with each year and printing. The information here was for 1908 on the most prestigious route of all, from Glasgow to Oban.

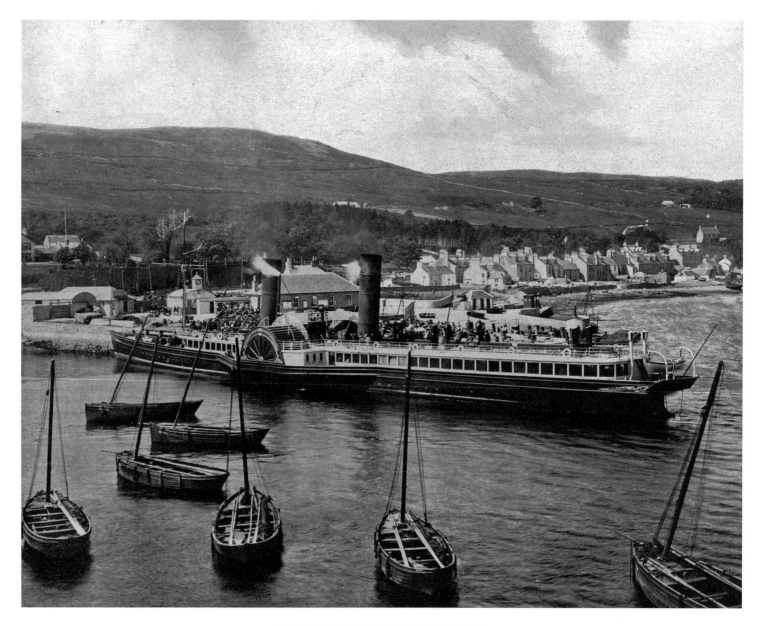

PADDLE STEAMER *COLUMBA* AT ARDRISHAIG

"Columba" Route.
(Map opp. p. 224. For times see *Yellow Inset*.)

Glasgow to Oban and Banavie, by the Kyles of Bute Loch Fyne, and the Crinan Canal (or Loch Awe).

Main Route. *Glasgow to Greenock (Princes Pier, 25 m., rail); Gourock, 26; Dunoon (steamer), 30;—(Glasgow to Dunoon, viâ Craigendoran, 33)—Rothesay, 40; Ardrishaig, 74; Crinan, 83; Oban, 115.*

Trains leave Glasgow (Central, St. Enoch, or Queen Street Station) from 8 to 8.30, Edinburgh between 7 and 7.30, connecting with the steamer as stated below.

"Columba" leaves Glasgow abt. 7 a.m.; Greenock (both piers), 9–9.10; Gourock, 9.20; Dunoon, 9.30—arriving at Ardrishaig about 12.40 noon, whence Oban is reached at 4.50 p.m.; Ballachulish, 6.40; Fort William 7.40; Banavie, 8.10 p.m.

Loch Awe Route.—*Ardrishaig to Ford (coach), 16 m.; Loch Awe Station and hotel (steamer), 38; [—Dalmally (rail), 41] Oban (train), 60.*

To Ardrishaig as above.—Coach leaves Ardrishaig about 1 p.m., connecting with steamer on Loch Awe, which is due at Loch Awe Station in time for the train reaching Oban about 6.30.

This timetable represented the first part of the so-called 'Royal Route', which ended up in Inverness. The route started at the crowded quay on the Broomielaw in Glasgow. The first stage took the passenger to Ardrishaig at the eastern end of the Crinan Canal. Now one of the dominant emotions aroused by the steamer was one of pleasure. The paddle steamer represented holiday and leisure. For Glasgow's wage earners the day out 'doon the watter' was the great release from work. The word 'steaming' was added to the many in the Scots language to indicate an excessive consumption of alcohol. The informed and judgemental practicality of M J B Baddeley was, and is, an essential commentary for the steamers.

Leisure and the enjoyment of the release from work was an essential part of being modern, and Baddeley going down the Clyde relished the choices and variety. The old schoolmaster was lyrical, even adding a bit of sociology for good measure:

The *Columba* steamship is for the purposes which she serves – that is, for inland-sea sailing – one of the finest vessels afloat, being considerably larger than the *Iona*, which some years ago enjoyed such a high and wide reputation on the route between Glasgow and Ardrishaig, and is now doing a second service on the same route. Like all the vessels which sail under the colours of Mr. MacBrayne, she is admirably fitted out, and affords the best accommodation at remarkably low fares. She starts from Glasgow every morning at 7 o'clock, but the great majority of 'tourist' passengers embark at Greenock, Gourock, or Dunoon according as they have travelled from Glasgow along the south or north side of the Clyde. Those who travel by the Glasgow and South-Western route from St. Enoch, leave the train close to Princes Pier at Greenock, which is connected with the station by a covered way. Caledonian passengers starting from the Central Station or from Edinburgh join at Gourock, where the train draws up on the pier. Passengers by North British route from Queen Street or Edinburgh embark at Craigendoran Pier, near Helensburgh, and join the *Columba* at Dunoon.

THE ROUTE. The *Glasgow & South-Western* route from Glasgow passes high up above the Clyde, and commands an extensive view northwards. The *Caledonian* keeps lower down, and nearer to the river, passing through *Port Glasgow*. The *River* route has nothing of special interest between Glasgow and Greenock except Dumbarton Castle . . . As we descend the river, the thud of the shipbuilder's hammer reminds us ever and anon of the trade to which it owes so much of its celebrity . . . Trains and steamer meet at GREENOCK and GOUROCK, and then the beauties of the Clyde commence at once. On the far side of the river, *Helensburgh,* with its long sea-frontage, shines in the morning light. On the left of our track the white houses and clear atmosphere of *Gourock* contrast happily with the grimness and smoke of Greenock. Beyond Helensburgh the *Gareloch* opens, revealing quite a little colony of pleasant looking villas, and making us envy the Glasgow merchant his unrivalled suburbs. As we proceed the feeling increases. LOCH LONG appears, its narrow waterway springing, as it were, at one bound into the wildest recesses of the Highlands. British

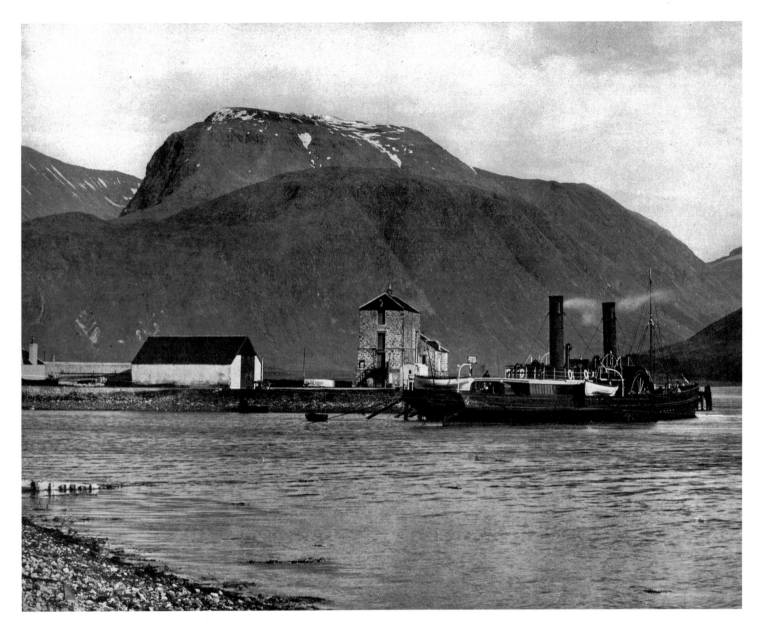

BEN NEVIS WITH PADDLE STEAMER *PIONEER* AT CORPACH

scenery is remarkable for the suddenness with which it breaks upon the view. A man breakfasts, we will say, at a reasonable hour, in the very vortex of Manchester smoke and turmoil. By 2 o'clock he may be lunching amid the evergreen fells and sparkling becks of Grasmere, and then, as an appetiser for dinner, be inhaling the wild 'sou'-wester' that sweeps the swarth summit of Helvellyn. The citizen of St. Mungo, however, beats his Manchester friend hollow. He may do a full day's business, jump into the 4 o'clock train to Balloch, and by 8 o'clock be lighting his pipe on the top of Ben Lomond, waiting to see the sun set, and directing his gaze, league after league, over a scene as innocent of human existence as the desert of Gobi. Or if primitive simplicity be his ideal of happiness, he strolls down to St. Enoch or the Central, takes the 5 o'clock express to Ardrossan, and at 7 is tumbling about like a porpoise in the blue land-locked waters of Lamlash, within half a dozen miles of a scene which might draw tears from the eyes of Salvator.

 . . . at short intervals, the steamer calls at *Kirn,* DUNOON, and *Innellan,* the three places presenting an almost unbroken sea-frontage of villas and other houses, 8 miles in extent. *Chief Hotels:* Kirn, *Queen's;* Dunoon, *Argyll, M'Coll's, Crown, Royal;* Innellan, *Royal.* On a mound near the pier at Dunoon are the remains of the old Castle, which existed in the days of the Bruce, and a monument to Burns's 'Highland Mary'. The Cloch *Lighthouse,* 80 feet high and showing a light visible for 12 miles, is a prominent object hereabouts on the south shore. Tourists may wonder at the vast number of people who, during this part of the journey, are availing themselves of the *Columba's* spacious accommodation, and some, perhaps, may be disappointed to find that the great steamer is not, after all, merely an express-mail boat running for the sole benefit of long-distance passengers like themselves, but also the popular 'parly' of Glasgow and the Clyde, hundreds of whose toiling inhabitants

take the return trip from Glasgow or Greenock to Ardrishaig and intermediate piers daily. The idea of thus hitting off the requirements of all ranks of society, gratifying the upper class with a comfortable consciousness that it is doing the 'correct thing', and at the same time giving the lower the advantage of excellent accommodation at singularly low fares (the return 'fore-cabin' to Ardrishaig is only 3s. 6d.), was little short of a stroke of genius on the part of the originators, Messrs. Hutcheson and Co., and it is admirably sustained by Mr. MacBrayne. Were it not for this happy combination there could be no *Columba* or *Lord of the Isles.* As it is, the two classes of society lend each other mutual aid, and derive a corresponding amount of mutual advantage.

The *Columba,* the largest and most prestigious of all the paddle steamers, gained a world-wide reputation. It was steel-built and launched in 1877 from the yard of J & G Thompson. It was built to compete with the new rail routes as well as the other steamer companies. *Columba* was one factor in David MacBrayne's eventual dominance of the west coast and island services. The accommodation was meant to impress and attract. There was a post office, a smoking room, and a barber's shop, with a small steam engine to drive the brushes. There were book and fruit stalls. Many passengers were en route for the shooting lodges and other leisure attractions to the north of Ardrishaig. Luggage, bicycles and sporting equipment were carried in large quantities. Especial care was taken with the catering. One member of London's financial elite, writing under the name of 'Christopher Crayon' and on his way to join a friend's private steam yacht, was especially lyrical. He took the Midland Railway's night express from St Pancras to Greenock and boarded the *Columba* with great anticipation:

To leave the train and hurry down the pier, and rush on board the *Columba* is the work of a minute, but of a minute rich in marvels. The *Columba,* is a fine saloon steamer, the finest in Great Britain or Europe, which

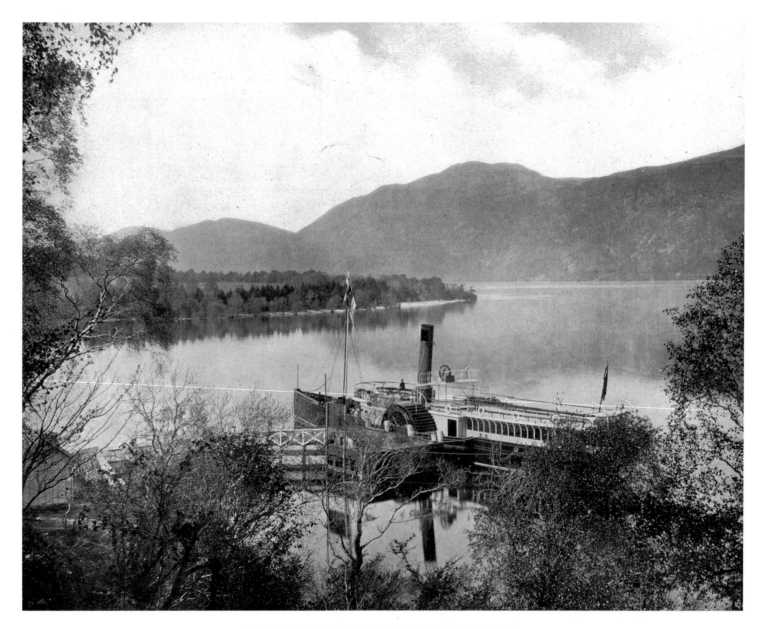

PADDLE STEAMER *GONDALIER* AT FOYERS ON LOCH NESS

waits for the train at Greenock, and thence careers along the Western Coast, leaving her passengers at various ports, and picking up others till some place or other, with a name which I can hardly pronounce, and certainly cannot spell, is reached. It must carry some two thousand or three thousand people. I should think we had quite that number on board – people like myself, who had been travelling all night – people who had joined us at such places as Leicester, or Leeds, or Carlisle – people who had come all the way in her from Glasgow – people who had come on business – people who were bent on pleasure – people who had never visited the Highlands before – people who are as familiar with them as I am with Cheapside or the Strand – people with every variety of costume, of both sexes and of all ages – people who differed on all subjects, but who agreed in this one faith, that to breakfast on board is one of the first duties of man, and one of the noblest of woman's rights. Oh, that breakfast! To do it justice requires an abler pen than mine. Never did I part with a florin – the sum charged for breakfast – with greater pleasure. We all know breakfasts are one of those things they manage well in Scotland, and the breakfast on board the *Columba* is the latest and most triumphant vindication of the fact. Cutlets of salmon fresh from the water, sausages of a tenderness and delicacy of which the benighted Cockney who fills his paunch with the flabby and plethoric article sold under that title by the provision dealer can have no idea; coffee, hot and aromatic, and suggestive of Araby the blest; marmalades of all kinds, with bread-and-butter and toast, all equally good, and served up by the cleanest and most civil of stewards. Sure never had any mother's son such a breakfast before. It was with something of regret that I left it, and that handsome saloon filled with happy faces and rejoicing hearts. The steward tells me he takes as much as £1,800 a day sometimes, and I can well believe him, for every one travels by the *Columba*.

The Valentine picture of the Broomielaw was a visual definition of 'crowded'. It is difficult to identify the boats with any certainty. The near boat looked to be a David Williamson boat with his white-and-black topped funnels whilst beyond was one of the smaller MacBrayne ships with the red and black. It was around midday with the big boats long gone. The next photograph was *Columba* discharging passengers at Ardrishaig. Baddeley summed it up as usual:

It is in no way remarkable except as the place at which passengers change their conveyance, and northward and southward bound tourists cross one another's path on their journey to and from Oban respectively. Between half past twelve and one o'clock Ardrishaig is the liveliest of places; what it is at other times is known to few.

Some would choose to go to Ford and then by steamer to Loch Awe station before completing the journey by rail: 'The coach, an open cross seated wagonette, leaves the pier at Ardrishaig at once.' Others would board the *Linnett* for the short journey down the Crinan Canal. *Linnett* was described affectionately as 'a sort of floating steam tram'. Most of the two-hour journey was spent getting through the ten locks. At Crinan passengers transferred: 'On entering the sea-steamer dinner is served.' At Oban, there was a wide choice of hotels from First Class to Temperance.

Travellers could travel to Fort William and take the train to Banavie or perhaps the morning slow boat to Corpach. Valentine's picture of Corpach framed by the vast bulk of Ben Nevis was an old one. The picture had first appeared in Valentine's register in 1879 and showed the steamer *Pioneer*, scrapped in 1895. *Pioneer* had been purchased by G & J Burns from the Glasgow, Paisley and Greenock Railway in 1847 and then transferred to Hutchesons in 1852. This was the partnership which David MacBrayne joined and was to run under his own name from 1879 onwards. In its 1874–75 refit *Pioneer* was lengthened some 27 feet and given the slanting straight stem, a second funnel and saloon, all of which can be seen in the photograph. *Pioneer* served on various routes from

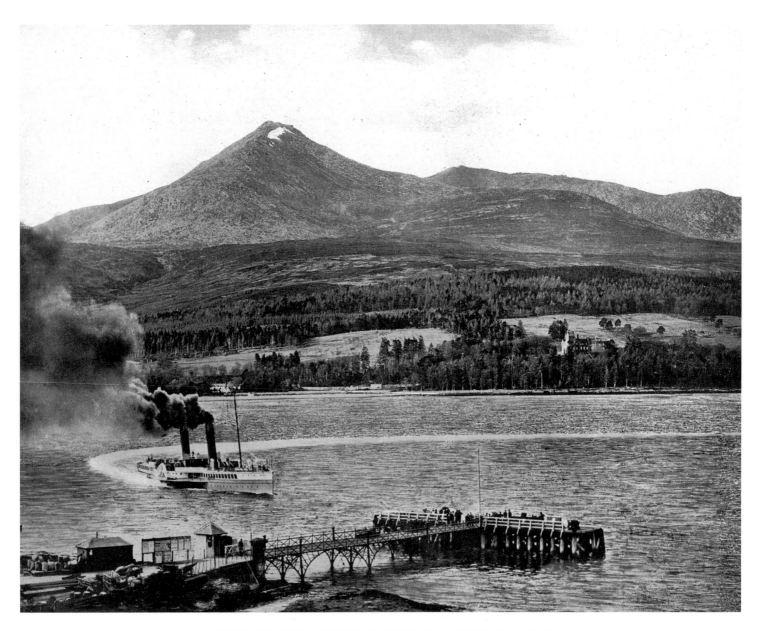

GOATFELL WITH PADDLE STEAMER *GLEN SANNOX* AT BRODICK PIER, ARRAN

Oban, to Mull and Iona as well as to Corpach. Banavie and Corpach were the places for joining the Caledonian Canal for the last leg of the route to Inverness. Again, Baddeley was the best guide:

> From Fort William we take train . . . to BANAVIE, 2 ½ m. Here the canal-steamer is waiting for the morning boat. Those who arrive by the evening one stay the night either here or at Fort William. The *Banavie Hotel* (greatly enlarged) is well situated and first-class. It looks across Corpach Moss to Ben Nevis, the finest feature of which, the northern precipice, is seen in *silhouette* across Corpach Moss. P.O., *del. abt.* 10.45 and 6.20 (callers); *desp.* 7.40 *a.m* and 12.50 (2.30 Oct. to June).

> The CALEDONIAN CANAL was first opened in 1822, after half a century of consideration and twenty years of construction. The engineer was Telford. In a few years, however, its use was abandoned in consequence of difficulties arising from the imperfect execution of the original plan. Its restoration was commenced in 1843, and it was finally opened in its present condition in 1847. The Great Glen of Scotland, through which it runs, consists of a chain of lakes, Loch Ness, Loch Oich, and Loch Lochy, connected by shallow streams, and to render it available for purposes of navigation these lakes had to be united by artificial channels measuring altogether 23 miles in length. The summit-level of the glen is 100 feet above sea-level – the height of Loch Oich above high-water mark at Corpach – and the total distance from Corpach to Inverness is 60½ miles.

> From BANAVIE to CORPACH, where the canal enters salt water, is a long mile by road or canal-side. Going underneath the Mallaig railway to start with, the canal descends by a series of locks called 'Neptune's Staircase'. CORPACH (*snug little Hotel*) is decidedly picturesque. It commands the upper reach of Loch Linnhe and the length of Loch Eil, Ben Nevis and the

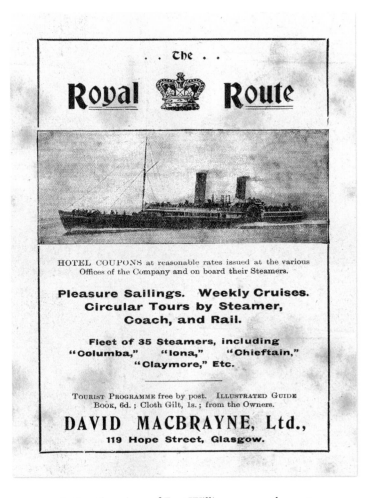

most attractive view of Fort William, across the water.

This part of the journey was undertaken by the *Gondolier*, photographed by Valentine at the Foyers Pier on Loch Ness. *Gondolier* had been built in 1866 especially for this part of the route and was noted for a bow and stern specially shaped for working in and out of the locks.

From the Inverness end Baddeley was equally enthusiastic. His assertive prose was a reminder that MacBrayne dominated the steamer services because of speed, quality accommodation on the boats and food but, above all, because his finances were underpinned by the Royal Mail contracts held since 1855 in the days of the Hutcheson partnership:

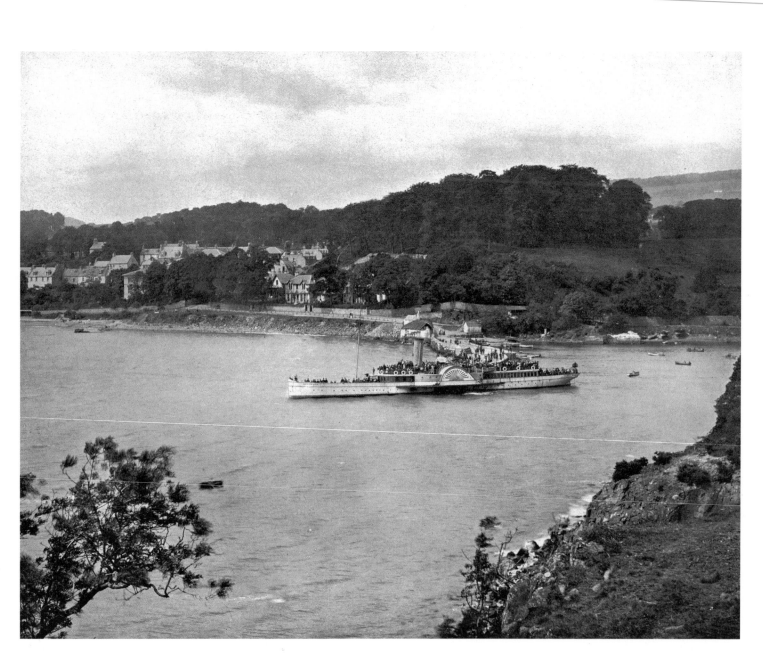

PS *TANTALLON CASTLE* AT THE PIER, ABERDOUR

Mr MacBrayne's service of Royal Mail steamers is admirably conducted, the boats themselves being roomy and furnished with every appliance calculated to conduce to the traveller's comfort. Good food is provided at moderate charges.

The starting place of the steamer is at *Muirtown Locks*, 1 1/2 miles from Inverness. Omnibuses from the different hotels convey passengers to the morning through-boat, and Mr MacBrayne's conveyances from Queensgate P.O. to the others.

The Hutcheson–MacBrayne routes from the Clyde to Inverness were only some of many contributions which the paddle steamers made to looking at Scotland. The picture of the *Glen Sannox* approaching the pier at Brodick, framed by the 2,866 foot Goatfell was one of the most dramatic in the collection. *Glen Sannox* had been built by the J & G Thompson yard in Clydebank in 1892 for the Glasgow and South-Western Railway Company to compete in matters of speed and comfort with the rival Caledonian Steam Packet Company on the Ardrossan to Arran run. The boat was noted for speed, over 20 knots on trials, and for high fuel consumption, a feature which may have accounted for the spectacular smoke in the photograph. Baddeley rather distanced himself from Arran, which, thanks to this mixture of rail and paddle steamers, became a major Glasgow resort:

Arran is a favourite summer resort for Glasgow people, who go there in hundreds at the end of the week, returning by the early boat on Monday morning. The island had abundant lodging accommodation of a primitive kind, a large proportion of the houses being small one-storied cottages of two or three rooms, with space often economised by the use of hammocks let into the side-walls for bedroom accommodation.

He drew attention to a pony track 'to within half an hour of the summit' for those who wanted to ascend Goatfell.

The east coast never had the same variety of steamer services as the west. That glorious mixed market of elite shooting-lodge seekers, middle-class walkers and scenery gazers, together with Glasgow's 'doon the watter' escapees, was never there and the coastline lacked the complexity of the west. Valentine included the picture of the *Tantallon Castle* at the pier at Aberdour on the Forth. Like most of the Firth of Forth services, this was a summer excursion service. The Leith–Burntisland link was the only regular run. The pier had been built in the early 1870s to combat the wide tidal range in the Forth. The *Tantallon Castle* was run by the Galloway Saloon Steam Packet Company from 1887 to 1898 when it was sold to Turkish owners.

Railways and railway locomotives were absolutely crucial to any appreciation of Scotland in 1907. They were a dominant part of the scene and vital for anyone who wanted to look at Scotland at a time when the bicycle was still the fastest thing on most roads. Despite this, Valentine was not excited by the railway. Locomotives rarely appeared in the pictures he chose for the 1907 collection and when they did they seem almost incidental, as in this picture of Aberfoyle. The map showed Aberfoyle as a place which had everything from the manse to the golf course. The line was opened in 1882 and, like the Eyemouth line, was a spur which linked to the major railway system, in this case the Forth and Clyde Junction Railway, which was essentially a connection for the population centres of east and west Scotland. The passenger service was one of many routes into the Loch Katrine and the Trossachs area.

BUCHLYVIE TO ABERFOYLE, 6 *m.* The Aberfoyle branch strikes northward about 1/4 mile on the Stirling side of Buchlyvie. For two miles the country even now almost realises the description of it given by the hero of *Rob Roy*:

'Huge continuous heaths spread before, behind, and around in hopeless barenness, now level and interspersed with swamps, green with treacherous verdure, or sable with turf, and now swelling into huge, heavy ascents, which wanted the dignity and form of hills, while they were still more toilsome to the passenger; neither trees

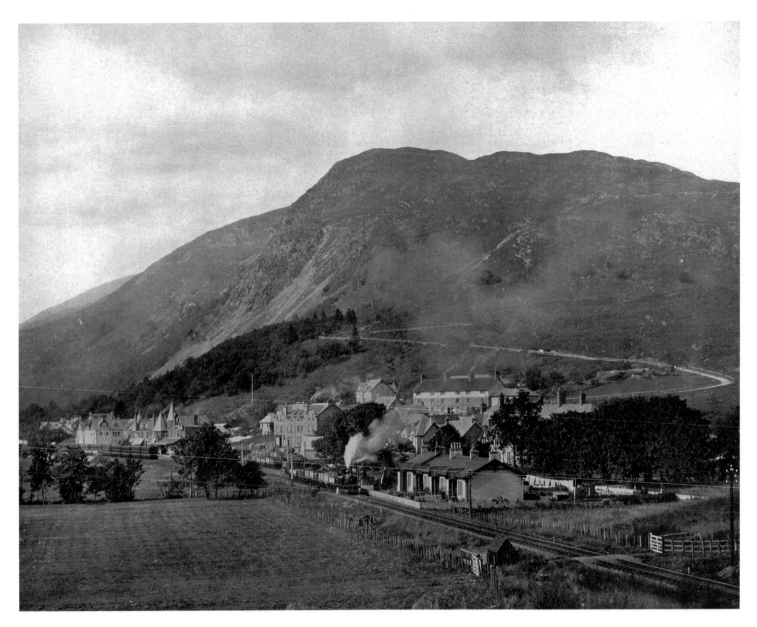

ABERFOYLE

nor bushes to relieve the eye from the russet livery of absolute sterility. The very heath was of that stinted, imperfect kind which has little or no flower, and affords the coarsest and meanest covering which Mother Earth is ever arrayed in.'

When, however, the Forth is reached, trees (mostly fir) and cultivation reappear. On the left of the line stands Gartmore House, and beyond it are wooded knolls. Here, too, Scott's description still holds so good that we cannot forbear quoting it. The Bailie, Frank Osbaldistone, and his trusty retainer Andrew, reach 'a beautiful eminence, clothed with copse-wood of hazels, mountain-ash, and dwarf oak. 'That's the Forth,' reverentially ejaculated the Bailie. 'Umph !' replied Andrew, 'an he had said that's the public-house, it wad hae been mair to the purpose.' The public-house referred to was the 'Clachan of Aberfoil,' or rather the chief establishment of the 'clachan' (village). For a description of it, and the

kind of accommodation afforded by it to travellers, see the graphic pages of *Rob Roy*. The only present relic of the scene there described is a coulter (like Rizzio's blood, periodically renewed!) fastened to a tree opposite the ABERFOYLE – *Bailie Nicol Jarvie* – HOTEL – a good and comfortable house, 300 yards from the station – and which is said to be the veritable weapon with which the Bailie set fire to the quarrelsome Highlander's plaid.

The remaking of that Scotland of the mind and of the eye which was embodied in the 1907 photographs often seemed to be overly concerned with the past. Anyone who doubted that Scotland was a modern country, and had not been convinced by the magnificence of the paddle steamers of the Clyde, simply needed to visit the Forth Bridge. It rapidly became an icon of modern Scotland. Visitors of all kinds came to inspect the Bridge both during construction and after completion. Baddeley noted that public conyevances left Edinburgh at frequent intervals, calling at the

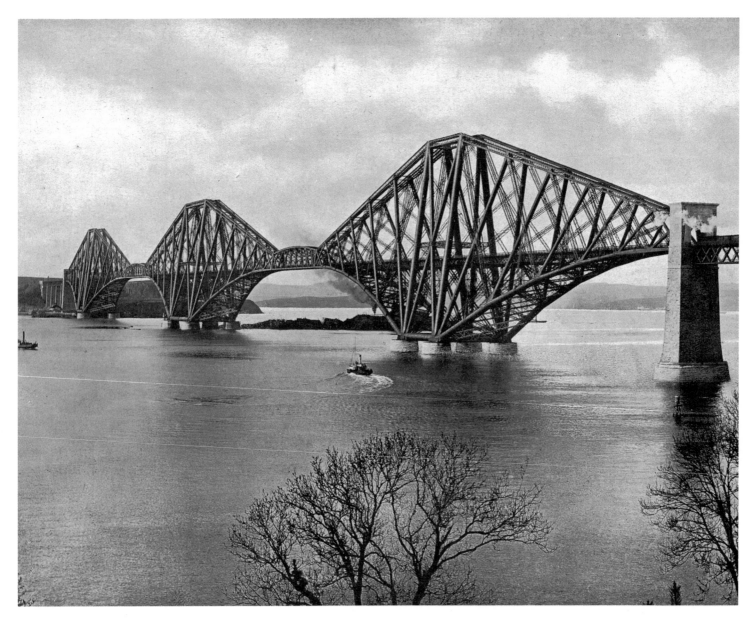

THE FORTH BRIDGE

principal hotels, return fare 2 shillings. The road was 'a good cycle route'. Pedestrians were encouraged to leave said 'public conveyance' at Cramond Bridge and walk through Dalmeny Park. Benjamin Barker recommended taking the steamer between Leith and South Queensferry as it passed under the Forth Bridge, giving 'a better idea of the enormous size'. The many photographs were simply not enough. Comparisons with that other contemporary national icon, the Eiffel Tower, were accompanied by the comment that the Forth Bridge was both bigger and, unlike the Eiffel, useful. William Valentine sensed another dimension to the bridge's place in international competition: 'The safety of the bridge in war time is secured by the great guns on Inchkeith'.

From the start it was the photographer's bridge. They all came. Washington Wilson was there. Alex Inglis came from Edinburgh as well as Valentine from Dundee. The bridge had its own official photographer, Evelyn Carey. He was one of the assistant engineers and his camera was guided by a knowledge of the engineering and by the organisation of the work on the bridge to produce pictures very different from the others. The bridge was perfect for Valentine's picturesque instinct. The bridge framed itself to produce a landscape full of meanings. Philip Phillips produced one of several accounts of the making of the Forth Bridge and saw at once its place in the making of Scotland. He dedicated his book to Sir William Arrol, the chief contractor, of Seafield, Ayr, Scotland. He sensed that the Forth Bridge placed Scotland on the world map as much as did the works of Burns and Scott: 'The completion of the Forth Bridge, which may be considered as a national achievement of Engineering skill, cannot fail to attract an enormous amount of attention, not only in this country, but throughout the whole world.'

One of his plates set the Forth Bridge against St Paul's, Cleopatra's Needle, the Great Pyramid, Cologne and several other cathedrals. Part of the culture of the next 90 years was endless books on engineering and railway wonders of the world and none were complete without the Forth Bridge. When young Malla Carr was given *The Wonder Book of Railways* for Christmas 1915, the Forth Bridge was there, illustrated by the Valentine photograph, along with bridges across Niagara and the Victoria Falls in Rhodesia, together with lessons on signalling and locomotive head codes. Even when larger bridges were built, said Phillips, 'still will Scotland hold her great work in triumph, claiming the first, and therefore the grandest of these mighty structures'.

William Westhofen, another engineeer involved in the construction, was the Forth Bridge's biographer. He had a fine sense of how it fitted into a 'modern' world:

> The justification for the construction of so great a work must, however, be sought in the desire to serve larger interests than those of local traffic merely. In these days of high pressure, of living and working and eating and drinking at top speed, the saving of an hour or two for thousands of struggling men every day is a point of the greatest importance, and every delay, however excusable and unavoidable, is fatal to enterprise. Nor must the bridge be looked upon as a thing standing by itself, but rather as a portion – certainly a somewhat expensive portion – of a gigantic system of railway lines converging from all directions upon the capital of Scotland, affording means not only of more speedy and more comfortable travelling, but also giving facilities for the provision of a larger number of those through trains which are con-stantly becoming more necessary by the yearly addition of many miles of both main lines and branch lines. Altogether those concerned in this great undertaking are sanguine that within a very few months the courage, the foresight, and the wisdom of the directors of the Forth Bridge Railway Company, and of the other interested railway systems, will be fully proved by results which it is impossible to estimate even approximately just now.

The accounts of the Forth Bridge were full of engineering details, endless explanations of the cantilever principle, of the shape of the girders and the placing of caissions so men could work below the level of the water. The most potent representa-tions of the Bridge were portraits drawn in numbers, sizes, quantities and dimensions.

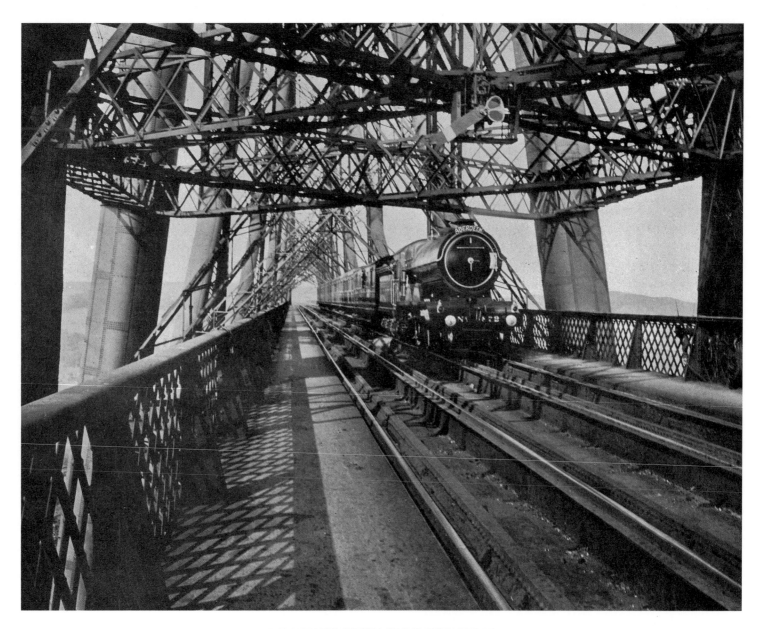

THE ABERDEEN EXPRESS ON THE FORTH BRIDGE

PRINCIPAL DIMENSIONS. &C.

When viewing the plates many points suggest themselves as to the dimensions of the various parts of the structure, but as for want of space it is impossible to enter into as full details as perhaps would be desirable, we shall content ourselves with devoting a few lines to this special purpose.

Total length	upwards of one and a half miles
Cantilever arms projection (outer)	680 feet
Depth over piers	342 feet
Depth at ends	41 feet
Distance apart of lower member at piers	120 feet
Distance apart of lower member at ends	31.5 feet
Diameter of largest tubes	12 feet
Top members, distance apart at vertical columns	33 feet
Top members, distance apart at ends	22 feet
Struts, largest diameter	8 feet
Ties, greatest length	327 feet
Central girder, span	350 feet
Central girder depth at centre	51 feet
Central girder depth at ends.	41 feet
Internal Viaduct, spans various	39 feet to 145 feet
Total amount of Steel in Bridge	over 50,000 tons
South Approach Viaduct, total	about 1980 feet

The Forth Bridge did not just represent Scotland in every Wonder Book of Railways and Encyclopedia of Engineering Marvels, but in a very material way the Bridge gave a unity to Scotland which had been denied by a fractured and stormy coastline. In the Baddeley *Guide* for 1886 the rail lines crossed the river at Stirling. The alternative was the ferry from Granton to Burntisland but, as Westhofen warned, 'on three or four days during the year gales blow with such violence as to stop even larger paddle boats from attempting the passage'. The place to finish this account of the Forth Bridge is with the annually updated timetables in the later editions of the *Guide*.

APPROACHES.

"EAST COAST ROUTE," G.N., N.E., and N.B.
(via Forth Bridge). WEEK-DAYS.

M.		A a.m.	B a.m.	C a.m.	D a.m.	E a.m.	F p.m.	G p.m.	H p.m.	I p.m.	K p.m.
—	L'ndon (K'sX) dep.	5.5	—	9.50	10.0	11.20	2.20	8.15	8.45	11.30	11.45
76	Peterborough ... „	6.36	—	10.33	10.37	12.16	3.29	8.17	10.20	12.33	12.33
—	Nottingham ... „	6.40		10.24	11.0	12.25	3.25	8.47	9.55	11.0	11.0
105½	Grantham „	7.21	—	11.14	12.5	1.2	4.26	10.19	11.5	1.34	1.49
156	Doncaster dep.	8.33		12.56	12.29	2.29	4.50	9.35	12.17	—	2.15
—	Hull „	8.30	—	9.53	12.5	12.55	5.5	8.40	11.25	—	—
—	Leeds „	9.5	9.40	11.55	1.3	2.20	5.20	10.50	—	—	2.40
188	York arr.	9.48	9.57	12.50	1.53	2.40	6.15	11.57	1.14	3.12	3.27
232	Darlington „	9.5	11.6	1.53	—	4.23	7.12	11.28	2.11	—	
272	Newcastle ... dep.	11.17	12.12	3.21	3.39	5.15	8.8	1.33	3.6	4.48	5.3
338	Berwick............ „		2.5	4.46	—	6.38	9.31	—	4.37	—	
395	Edinburgh arr.	1.35	3.30	6.5	6.15	8.5	10.45	4.0	5.55	7.15	7.30
—	Edinburgh ...dep.	2.5	4.0	6.30	6.30	8.15 p.m.		4.30	6.10	—	7.40
442	Glasgow ... arr.	3.25	5.7	7.35	7.35	9.33		5.35	7.23	—	9.5
—	Edinburgh ...dep.	2.5	4.0	6.30	6.30		via Leeds and Harrogate	4.30	6.10	—	7.40
464	Craigendoran arr.	4.29	5.42	9.9	9.9			7.27	8.33	—	10.19
485	Rothesay (St'r) „	5.55	—	—	—			—	10.15	—	11.42
554	Oban (St'r) „	—	—	—	—			—	4.50	—	—
564	Fort William ... „	9.21	9.21	—	—			9.42	11.48	—	2.12
566	Banavie „	—	—	—	—			9.56	12.1	—	5.16
606	Mallaig „	—	—	—	—			11.30	1.35	—	6.50
—	Edinburgh ...dep.	4.5	4.5	—	—	9.5		—	6.15	—	—
431	Stirling arr.	5.21	5.21	—	—	10.33		—	8.1	—	—
447	Callander ... „	6.7	6.7	—	—	12.35		—	8.46	—	—
518	Oban „	9.0	9.0	—	—	4.15		—	11.45	—	—
—	Edinburgh ...dep.	1.50	4.25	—	6.33	9.20		4.10	6.25	7.40	—
457	Dundee arr.	3.53	6.23	—	8.6	11.7		5.30	8.34	9.22	—
528	Aberdeen „	6.10	8.50	—	10.5	—		7.22 a.m.	—	11.30	—
—	Edinburgh.........dep.	2.15	4.30	—	6.38	9.5		3.55	—	7.30	10.10
438	Perth { arr.	3.32	6.26	—	7.51	10.36		5.0	—	8.55	11.21
438	Perth { dep.	3.50	7.15	—	8.15	12.50		5.15	—	9.25	11.50
453	Dunkeld arr.	4.45	7.42	—	8.50	1.26		6.5	—	10.7	12.36
466	Pitlochry „	4.35	8.5	—	9.22	1.52		6.37	—	10.20	1.10
473	Blair Atholl „	4.52	8.20	—	9.40	2.8		6.10	—	10.54	1.25
509	Kingussie „	6.5	p.m.	—	p.m.	3.29		7.22	—	12.2	1.50
521	Aviemore Junc. „	6.40	—	—	—	3.52		7.48	—	12.35	2.15
534	Grantown „	7.25	—	—	—	4.25		8.55	—	1.9	2.45
556	Inverness ... „	7.42	—	—	—	5.10		9.8	—	1.50	9.30
—	Kyle of Lochalsh „	p.m.				11.42 noon		1.40 p.m.		6.30 p.m.	p.m.

A. Luncheon Cars, Newcastle to Edinburgh.
C. E. F. Dining-Cars to Edinburgh.
D. Luncheon and Dining-Cars to Aberdeen.
E. *Via* Harrogate.
G. Sundays also, but not Sats.
H. Sundays also.
I. Sundays also. (*Sun.* arr. Aberdeen, 11.25 a.m.; Inverness, 1.50 p.m.).
K. Sundays also.
Sleeping Cars by all night trains.
Highlands I.—Yellow Inset.

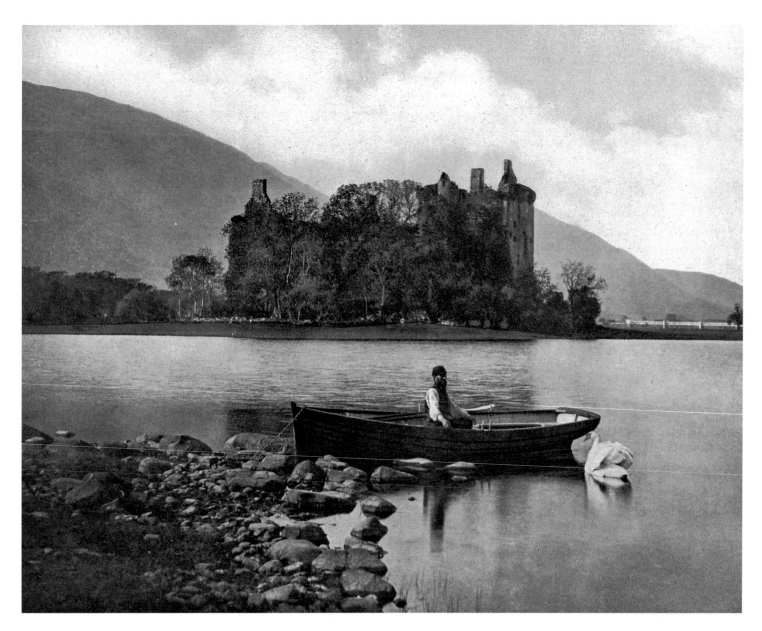

KILCHURN CASTLE, LOCH AWE

CHAPTER 15
Places and some Scottish history

In the summer of 1899, Miss Bessie McRay, a pupil at George Watson's Ladies College in Edinburgh, was awarded second prize for Arithmetic. She was presented with a copy of a book by George Eyre-Todd, *Scotland Picturesque and Traditional. A Pilgrimage with Staff and Knapsack*. Eyre-Todd was a Glasgow-based journalist who wrote for a variety of papers and periodicals, *The Scots Observer, Chambers Edinburgh Journal* and *The Modern Church* amongst others. He had links with a number of the Glasgow School of artists, such as John Lavery, James Guthrie and E A Horne. He was active in the Scottish Patriotic Society, promoting the 'proper presentation of Scottish history in Scottish Schools and the proper quartering of the Royal Arms when used in Scotland' and went on to be a leading member of the Glasgow St Andrews Society. He was not the most original of writers but he knew that, in the absence of a

well-defined state, the Scots learnt their national history from place. If Bessie had read her book, which was well illustrated, she would have been led around Scotland acquiring a rather disjointed history. Valentine was well aware of place as history and his camera sought out pictures that told stories.

Kilchurn Castle on Loch Awe was identified with the Breadalbane wing of the powerful Campbell clan, which had dominated so much of Scottish politics. The fifteenth- and sixteenth-century fortress was linked to the odyssean legend of Sir Colin Campbell returning from the Crusades, as well as to several generations of land acquisition. The effectiveness of these pictures of place as access to history lay in the open nature of the choices left by the visual. Kilchurn became part of the visual definition of Scotland. The 1849 *Gazetteer* and Beattie's slightly earlier account

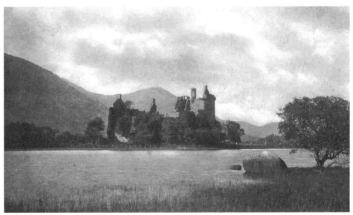

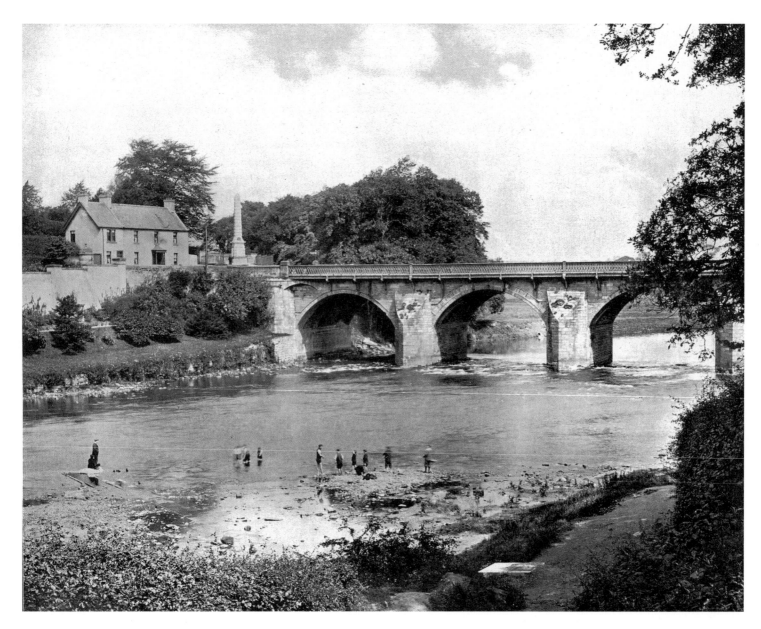

BOTHWELL BRIDGE AND THE COVENANTERS' MONUMENT

wrote as if the castle and its landscape had been 'arranged' to suit the aesthetic rules of the picturesque and romantic. Beattie included an engraving of a Horatio McCulloch picture with the usual exaggeration of the vertical and the slight rearrangement of walls, turrets and hills to perfect the picturesque drama. Washington Wilson provided a crisp photograph with his customary foreground mass. The Valentine picture promised easier access with the boat ready.

The real issue was the meaning of the Campbells. They were firmly identified with a Presbyterian Scotland and the Union of 1707. Two heads of the senior, Inveraray branch of the clan had been executed in the religious disputes of the seventeenth century, but then a third had returned in the revolutions of 1688–90 to take a dominant place in the power structure of Scotland and play a key role in the Union. The Campbells were Presbyterian heroes. They represented the restoration of order to Scotland. As a last act in the military history of Kilchurn, it had been garrisoned in 1745 to deny the Jacobites access to a key pass. Kilchurn Castle as a roofless ruin was a clear visual message that violence was no longer an element in Highland culture. When Dr Johnson visited the Duke of Argyll (head of the senior branch of the Campbells) in Inveraray Castle in 1773, he reflected on the nature of Presbyterian prayer, inspected a large collection of arms and observed, 'We can sit to-day at His Grace's table, without any risk of being attacked, and perhaps sitting down again wounded and maimed.'

By the late nineteenth century, not everyone was quite so sure of the Campbells. Eyre-Todd joined those who told stories of the MacGregors being hunted with dogs on the slopes of Ben Cruachan and the 'acquisitive deeds of Sir Colin'. Those who held land by 'right of the sword . . . were ousted on every indiscretion by the newer and more prudent race'.

For Scots like William Valentine, Bothwell Bridge was the site of a history lesson as potent as any in Scotland. For him and his like it was the Reformation, not the Act of Union, which was the turning point in Scottish history. Robert Chambers expressed this with uncritical perfection when he included this quotation in his *Domestic Annals of Scotland*: 'Lo here a nation born in a day; yea, moulded into one congregation, and sealed as a fountain with a

solemn oath and covenant.' Chambers's account of events at Bothwell Bridge was as good an account as any of the contradictory meanings signified by this picture for a thoughtful Presbyterian.

A deep spirit of resentment against the Council, and especially the prelatic part of it, was the natural result of all these occurrences. The worst passions of human nature mingled themselves with the purest and noblest aspirations; and men appealed, in language of bitterness, from the iniquity of their earthly rulers to the justice of God. The wisest and best natures were perverted by feelings which had become morbid by extreme excitement [the events of May 1679 proceeded with the murder of Archbishop Sharpe].

A volley of shot was poured upon his suppliant figure, and finally the unhappy prelate was hewed down with their swords, crying for mercy with his latest breath. They left his daughter lamenting over his body, which was afterwards found to bear such marks of their barbarity as could scarcely be credited . . . The Presbyterians never by any formal act expressed approval of the deed; indeed, many of them must have felt that it was an affair of the worst omen to their party. Neither, however, did they ever express themselves as offended by the violence of their brethren; and even half a century after the event, their historians are more anxious to shew that the archbishop deserved his fate, than to apologise for the barbarity of his murderers.

The blame of the murder has been the more plausibly thrown upon the whole party, that it was immediately followed by an insurrection. On the 29th of May, which was the king's birthday, a party of about eighty deliberately marched into the town of Rutherglen, three miles from Glasgow, where they publicly burnt all the acts of parliament against Presbytery . . . Having done this, they retired to a mountainous part of the country between Lanarkshire

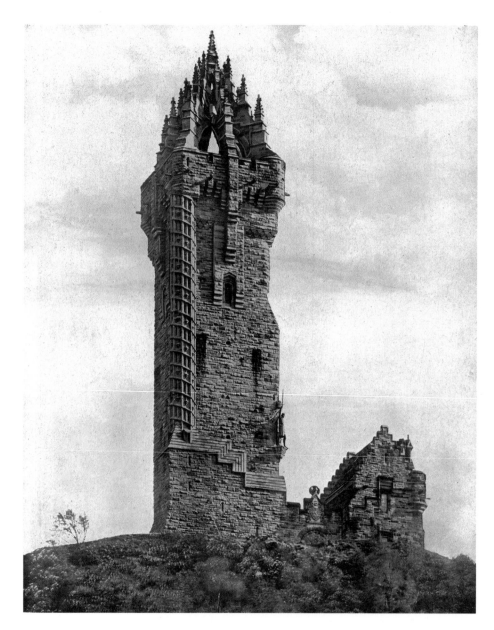

WALLACE MONUMENT, STIRLING

and Ayrshire, where there was to be a grand conventicle on the ensuing Sunday . . . [here they defeated an attack by the dragoons of Graham of Claverhouse] . . . They spent the three weeks during which they had existed as an army, not in training themselves to arms . . . but in disputing about the spiritual objects for which they were in arms . . . for which of course they could adduce an abundance of condemnatory texts . . . [defeat by the army of the Duke of Monmouth followed at Bothwell Bridge] . . . That point (the bridge) was stoutly defended, for nearly an hour, by some men from Galloway and Stirlingshire, under Hackstoun of Rathillet. At length, when their ammunition ran short, they sent back to the main body for supply, which was denied . . .

The prisoners were brought in a body to Edinburgh, and confined, like sheep in a fold, within the gloomy precincts of the Greyfriars' Church-yard, where, for four months, they had no seat or couch but the bare ground, and no covering but the sky. Two clergymen, Kid and King, were executed. Of the rest, all were set at liberty who would own the insurrection to have been *rebellion,* and the slaughter of the archbishop *murder,* and promise never more to take up arms against the government. Those who refused were sent to the Plantations; a mode of disposing prisoners which had been introduced by Cromwell.

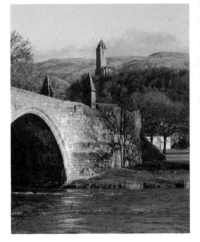

In the last half of the nineteenth century as the Scots remade their history place by place, nowhere was more significant than the Abbey Craig by Stirling. It was here that Wallace had hidden his soldiers before inflicting a bloody defeat on an overconfident English army crossing Stirling Bridge. It was here that a quarrelsome but committed group of Scots built the Wallace Monument in 1861–69. It was and is an astonishing building. It dominates the middle Forth Valley, seen here from Alloa.

Eighty thousand people attended the laying of the foundation stone and it has never ceased to attract visitors. Valentine abandoned his usual picturesque style and presented a sharp photograph which showed the wealth of architectural detail that asserted 'Scotland'; the tower, rough-hewn stone, crow-stepped gables, turrets, carved thistles and the crown spire. It was perfectly possible to picture the tower framed by Stirling Bridge and the Abbey Craig. That was not what was wanted. This was Scotland's distinctive contribution to the growing nationalisms of Europe. The Wallace myth had a long history in poetry and chapbooks. The last half of the nineteenth century celebrated Wallace and Bruce in speeches and monuments as the men who had won for Scotland the 'freedom' which lay behind the Act of Union of 1707. Inside the Tower was a Hall of Heroes which provided a complex view of Scotland. There were no women, no Catholics, no civic leaders and no members of parliament except William Gladstone. There were only two military leaders, Wallace and Bruce, but two scientists,

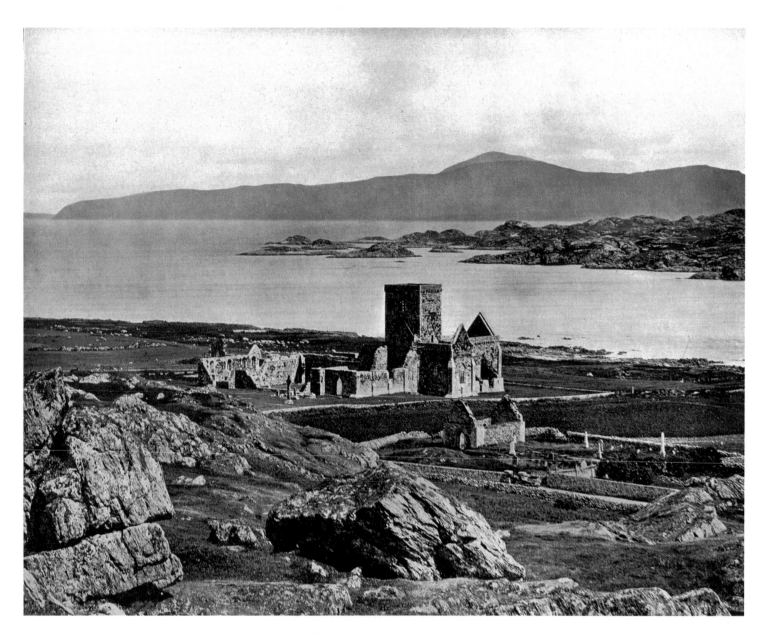

CATHEDRAL AND ST ORAN'S CHAPEL, IONA

several poets and men of religion, including Thomas Chalmers and Hugh Miller, two leaders of the Disruption of the Church of Scotland. A very 1900s version of Scottishness was William Murdoch, engineer, the inventor of lighting by gas, presented by the North British Association of Gas Managers.

For Scots and visitors alike, who wanted to learn their history from place, the island of Iona was holy ground. In AD563, Columba, with his 12 apostles, had come from Ireland, and created in Iona a base for a missionary activity which established over 30 churches. In the following centuries the settlement was raided and devastated by Norse pirates, but in the eleventh century, the monastery was restored by 'the saintly Queen Margaret'. The St Oran's Chapel on the island was believed to be eleventh century and had been taken as a model when the tiny 'Queen Margaret's Chapel' was restored in Edinburgh Castle in the late nineteenth century. The Monastery was held variously by Benedictine monks, and the Bishops of Dunkeld and of the Isles. In 1648, Charles I granted the island to Archibald, Marquis of Argyll. The eighth Duke of Argyll, a minister in Gladstone's government, was a man who took a very distinctive interest in the cultural meaning of Iona and the larger neighbouring island of Mull. In the 1840s, he took a growing interest not just in the sport fishing, which was excellent, but in the bird life and scenery: 'I found to my satisfaction, that a large part of this scenery belonged to our family estate, notwith-standing the great sales which had been made by my extravagant uncle.' This appreciation of the scenery, he had learnt, like so many other people, from Walter Scott, 'the great revealer'. In 1874–75, he initiated the repair and restoration of the Cathedral and excavation revealed the foundations of other buildings. A body called the Iona Club had already uncovered and laid out some of the tombstones associated with Iona's history as a prestige burying place, notably for the Kings of Scotland. In 1899, the Duke gifted the site and buildings of the Cathedral to trustees linked to the Church of Scotland, which immediately began to gather funds for further restoration. This process was brought to a halt by the First World War and not taken up again until the early days of what became the modern Iona Community.

The Duke himself produced what was to become one of the most frequently reprinted guides to Iona. It was not so much a guide as a meditation on the meaning of his island: 'The stranger must bring with him the knowledge and reflection which can alone enable him to enjoy what is of real interest in the associations and appearance of the place.' This, it must be remembered, was a man, two of whose ancestors had been beheaded because they were Presbyterians. 'Judicial murders of the worst type characteristic of the Stuarts', according to the eighth Duke who at the time he wrote this, was engaged on the disestablishment of the episcopalian Church of Ireland. His relaxation was visiting Iona. In September 1868, he wrote to Gladstone, 'I am off on Monday to stay a week on Iona, where I have established a little inn. I wish to see it in its morning and evening aspects. The outline of the "everlasting hills" and the colours of the sea are wonderfully beautiful there.' Like many others, the Duke would have liked to recruit Columba to Presbyterian ways. The Duke admired the 'noble work of missionary labour . . . self sacrifice was the spirit of all Christian service'. There was no 'symptom' of the cult of the virgin, or acknowledgement of the 'universal bishopric of Rome', but practice was not 'what we understand as Protestant'. Still, Columba was the main agent 'in one of the greatest events the world has ever seen, namely the conversion of the Northern Nations . . . Christianity was still spreading, but mainly by the spread and migration of those races whose conversion was completed then'. David Livingstone, Empire and the conversion of Africa were embedded in this picture. The Very Reverend Principal Storey, in his 1904 lecture, was less restrained. Columba was 'the heroic evangelist' and Iona, 'is the cradle of Scottish religion; the birthplace of the Scottish State'. The, by now, 'late Duke' had on behalf of his 'martyred ancestor', we were assured, 'a heart hatred of Popery, Prelacy, and all superstition whatsoever. He was a typical Scot in his love of the country where he was born and bred, of its traditions, of the sturdy Presbyterianism of its Church, and her free and popular constitution.'

Iona had been a major travel destination for many years. Dr Johnson had visited with some discomfort and produced his much-quoted criticism of those 'whose piety would not grow warmer amongst the ruins of Iona', and, in 1847, Queen Victoria made a diary entry.

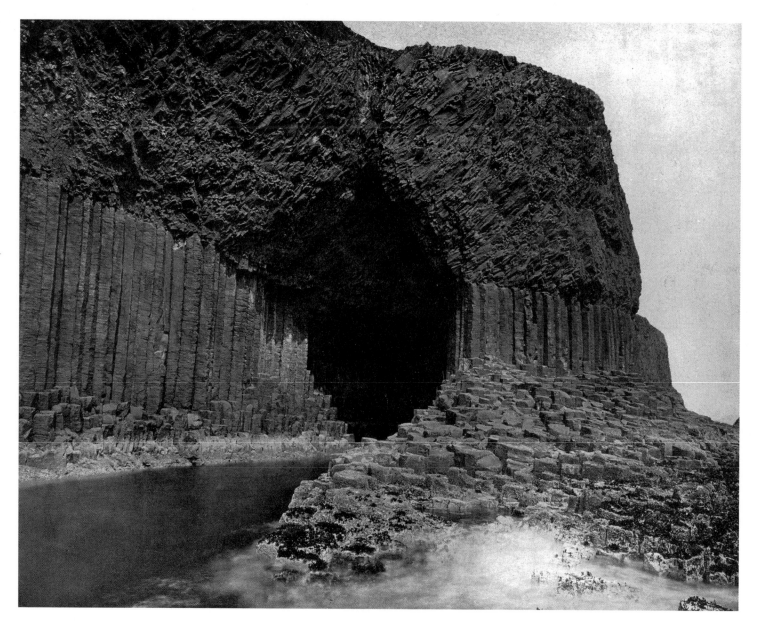

FINGAL'S CAVE, STAFFA

By the 1850s, the 'steamboats' had arrived and the tension between the mystical appeal of Iona and the tramp of mass tourism had begun. William Maxwell had served under Sir Duncan M'Dougall in the 79th Highlanders and had an equal contempt for tourists, the impact of tourism, Highlanders ('want of energy is the Highlanders besetting sin'), the kilt, the disappearance of which 'being a decided mark of civilization and the march of intellect' and of the bagpipes, which 'have yielded to the march of progress'. His scornful prose was ready for the encounter of tourism and Iona:

It is impossible to conceive the impertinence and pertinacity of the urchins of Iona in their attempts to effect a sale of their trifling curiosities. If an individual notice their selections of pebbles or shells, they all cluster around him, holding up their treasures to his very nose, with such an outcry of discordant voices, as would disturb the equanimity of the most apathetic. On no day do they appear more ragged or dirty than on 'steamboat days' with the view, we suppose, of influencing the tender sensibilities of the charitable. Woe betide that hapless tourist whom they find alone, for they surround him, *nolens volens,* until he opens his purse strings as a quit-offering. With the exception of the parents of those thus engaged, all living here reprobate their conduct. The clergymen and teacher have no influence over them, as, when the chance of money is in the case, all other things give place; they absent themselves from school in spite of all remonstrances. Unlike bashful Highland children in general, for barefacedness and impudence the youngsters of Iona might stand side by side with Glasgow juvenile criminals.

When the English radical journalist William Howitt visited, he was far more tolerant: 'The children here gain a trifle by offering in little dishes pebbles of green serpentine which they collect on the shore; and the old schoolmaster, who acts as guide, makes something by his profession and his little books descriptive of the place.' Howitt's illustrator produced a suitable account.

In 1891, Elizabeth McHardy summed up the discontents of the would-be contemplative tourist: 'Men can be excused entering the venerable ruins of the sacred monastery without

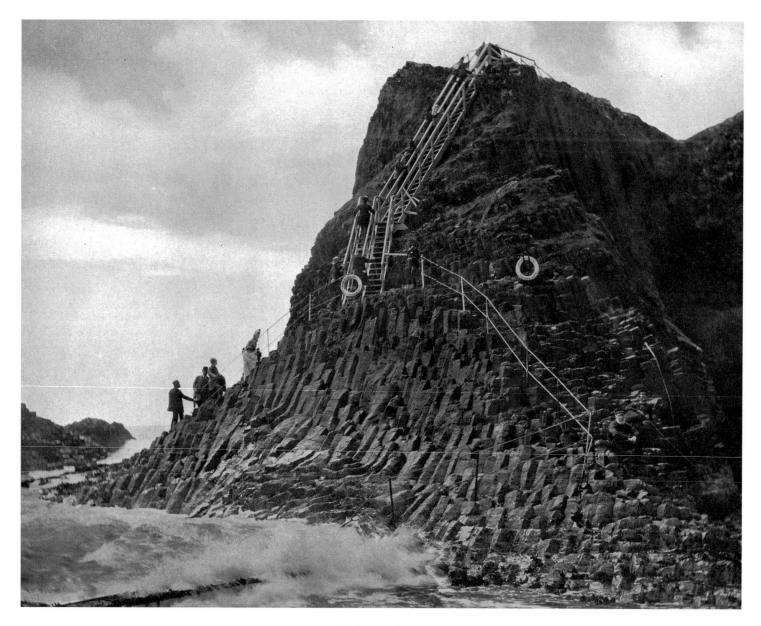

CLAMSHELL CAVE, STAFFA

uncovering their heads, as there is nearly always a strong draught there; but there is no excuse for smoking, or laughing, or trying to make clever remarks. Let them remember that they stand on the island where St Columba brought Christianity to our land.'

Which leads to some practical advice from M J B Baddeley before moving across to Staffa:

> OBAN TO STAFFA AND IONA. A voyage of about ninety miles occupying 10 hours, more or less. Ample time is allowed to examine the attractions of the two islands. Passengers are landed in small boats. Fare for the round, 15s., inclusive of everything except refreshments. Luncheon, 10 to 2, 2s.; dinner, after leaving Staffa, 3s. Steamer starts at 8 a.m.
>
> This voyage, a very enjoyable one in fairly quiet weather, makes the circuit of the island of Mull. The outward journey is by the Sound of Mull on Monday, Wednesday, and Friday, the return route being round the south side of the island; on the other days of the week the reverse route is adopted. During the sail through the sound there is little fear of a disagreeably rough sea, but for the rest of the way the traveller must take his chance. The Island of Iona (*St Columba*, Temp.; *Argyll*, Temp., 35s. a week; both small and satisfactory . . .)

There were, in fact, three Staffas. There was the scientific Staffa, 'discovered' by Sir Joseph Banks on his way north to Iceland, the year after returning from a voyage with Captain Cook to the South Seas. The Banks account was published by Thomas Pennant as part of the account of his *Tour* of 1772. The scientific look was full of descriptions of columnar basalt, comparisons with the Giant's Causeway on the north Irish coast and accounts of the growing knowledge of volcanic activity on Mull.

Then there was picturesque and romantic Staffa. The Duke, in his little guide, assured readers that no preparation or knowledge was needed; 'that great Hall of Columns standing round their ocean floor, and sending forth in ceaseless reverberations the solemn music of the waves. This is a scene which appeals

to every eye . . .' Wordsworth wrote some sonnets. Felix Mendelssohn visited in 1829. His overture, *The Hebrides*, usually just called *Fingal's Cave*, placed Staffa firmly on the romantic map of Europe. Painters, engravers, poets and prose writers were all inspired. For Elizabeth McHardy it was 'a mighty cathedral filled to its very roof with melody'. Robert Jaffray visited just before these photographs were published and had his impressions privately published when he got back to New York. He knew his limitations and joined so many by quoting Scott's *Lord of the Isles*: 'Nature here, it seemed would raise, A Minster to her Maker's praise.' When Turner made his northern tour of Scotland in 1831 in order to prepare material for illustrating an edition of Scott's poems, Staffa was an essential part of his plans.

Then there was the true tourist's Staffa. The steamboats allowed about an hour for visiting Fingal's Cave. Boatmen came across from the neighbouring island of Gometra to ferry tourists ashore and, if wind and wave permitted, into the caves. Staffa was well prepared for tourism. In the second photograph the boatmen, who had seen it all before, take their rest on the rocks. The carefully constructed staircase was essential for the heavily skirted women. Miller's *Royal Tourist Guide* had reassuring words:

> Only at one point on its eastern shore is the top of the island accessible; and at this landing, boats from the steamer or the neighbouring island of Ulva land visitors. The steamer's delay permits passengers to clamber to the top of the island . . . The surface of Staffa is fertile, the green grass feeding a few sheep, which do not resent the intrusion of visitors. Messrs. Hutcheson rent the island, and avoid putting Highland cattle on it, since these are apt to chase inquisitive tourists.

Scientific Staffa was still there. Those who wished could travel with Sir Archibald Geikie's *Scenery of Scotland* with an itinerary in the appendix which guided the eye along the geological features of the route and provided a fearsome engraving of the columns and layers of Staffa.

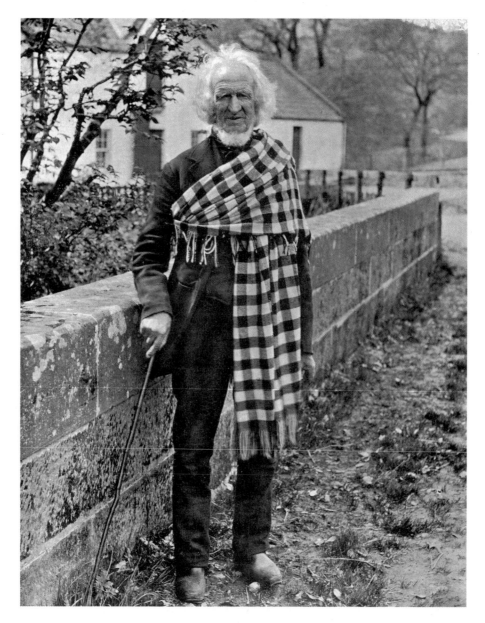

'THE COVENANTER'

CHAPTER 16
Fishermen and folk

A small but important part of the Valentine photographs was pictures of people or groups of people. Some were the big names, Scott, Burns and the rest, but others represented Scotland in a more subtle and general way. They were what can only be called 'folk'. Scotland was often presented and presented itself as a wild and empty place. Paintings, engravings, poetry as well as photographs showed mountains, glens, streams, woodland and trees but few people. In many of the novels of Scotland, the characters were continually crossing wild heaths and moorlands. Geikie and the geologists filled the landscape with great lava flows and glaciers. Columba was seen as coming to Iona because of its isolation and little mention was made of the accessibility of western Scotland in influencing his choice.

There was a lot of emptiness and space in the Valentine pictures but there were also considerable numbers of people. Some were caught by accident. They were a blur in the street, a shopping crowd or holidaymakers on the beach. Others were a more studied choice like the lines of children who defined the street or the square in so many small towns. In doing this he followed a long tradition. Early picturesque enthusiasts like Gilpin framed their pictures without people, but the generation which followed were keen to add meaning through small groups placed with care in

the foreground. This was conventionally referred to as 'staffage'. The choice of people to place in landscapes was a careful and deliberate one. David Octavius Hill, in the days before he teamed up with photographer Robert Adamson, painted a series of spectacular and disciplined picturesque landscapes to illustrate *The Land of Burns*, with a 'literary department' by Professor Wilson of Edinburgh University and Robert Chambers. There were three types of staffage in this series. Some were reminders of the economic activities associated with the scene depicted. The foreground of the 'twa brigs o' Ayr' contained the street entertainer with his peep show and the road mender with tools of his trade. Shepherds, cowherds and harvesters were great favourites. In other pictures the observer was brought into the picture. These two gentlemen were gazing from their wooded slope across to Kenmure Castle. They were helped by a folding stool and sketch book.

The audience became part of the performance, doing exactly what the guides to the picturesque told them to do, walking by the stream or gazing at the correctly constructed view.

Some were pure fantasy. The white-haired gentleman with a harp added Celtic mystery to a number of pictures.

The painter and the engraver had a freedom which the photographer might have envied, but it

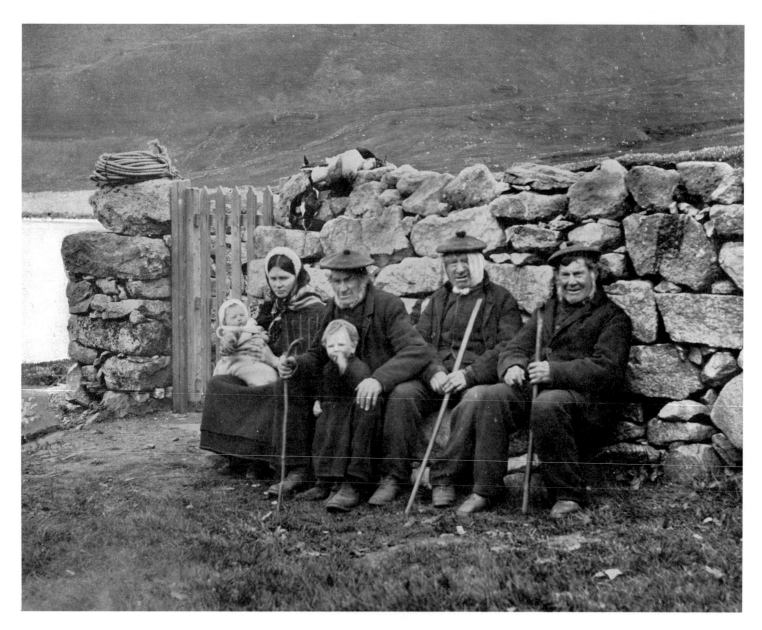

THE 'NATIVES' ON ST KILDA

would be wrong to underestimate the range of choice and invention open to the man behind the camera. Those who directed the camera and constructed the pictures had very specific ideas about the Scotland they wished to portray and the people who were to represent that late nineteenth-century nation.

The Covenanter was one of the most striking portraits in the collection. The man stands like an Old Testament prophet. His white hair looks very like the Adamson photographs of Thomas Chalmers, the leader of the Disruption of the Kirk. The steel-tipped boots and farm steading were real enough but the fine plaid was worn rather oddly. It would never have carried a lamb after the manner of the shepherds of south-west Scotland and was pinned in a way which had little chance of resisting the wind. It was there for display in a collection which had almost no place for the kilt. In Valentine's country, real Scots worn the plaid.

The text provided in the Leng publication made clear why it was there: 'There is no period in his country's history that the patriotic Scot regards with more pride than that associated with the brave fight for religious liberty in the seventeenth century . . . lonely graves on Scottish moorlands have inspired thousands to holy lives.' In the corner of the picture of Bothwell Bridge was the recently dedicated memorial to the Covenanters. Lord Overtoun at the unveiling claimed it was to the Covenanters: 'we owe the civil and religious liberty which we now enjoy'. The Covenanters had always had an equivocal place in the Scots' view of themselves. Robert Chambers in his *Domestic Annals*, a celebration of Protestant Scotland, was unsparing in his criticism of the murder of Archbishop Sharpe. The novels of the early part of the nineteenth century, Scott's *Old Mortality* and the less known *Ringan Gilhaize* by John Galt were marked by the tension between an admiration for religious commitment and a dislike of the obsessive and barbaric. By 1900, the Covenanter had become domesticated in the Scottish mind. The appeal to fund the memorial claimed the battle 'was one of the heroic contests in the long campaign for liberty of which Scotland was the scene in the periods of Reformation. Scotland for Christ and freedom for the people were the lofty objects for which the reformers laboured and the Martyrs fell.' S R Crockett brought them into the 'kailyard'

tradition in *The Men of the Moss Haggs* where the Covenanters were portrayed as good family people with an 'open bible' and a house 'bonny above the water side', with 'the girdle above a clear red fire of peat . . . wheaten cakes raised with sour buttermilk'. Readers could anger at the persecution of 'the hill folk' and shed a tear at the wee lassie whose psalm singing melted the hearts of the honest soldiers: 'True religion comes not by violence, but chiefly . . . from being brought up with good men, reverencing their ways and words.'

These pictures represented a triangular relationship between the photographer, the subjects of the pictures and the audience/purchaser. This was most evident in the picture from ST KILDA. Like Shetland, St Kilda was part of Scotland's exotic. There was a magic and a mystery about the island and its inhabitants. They were called 'natives' in account after account just as people in Africa and North America were 'natives' to be visited and observed.

The picture showed a group of four adults and two children seated in front of a dry stone dyke. This was probably the wall which sheltered the garden of the manse situated on the north-east side of the bay not far from the beach. Village Bay can be seen to the left of the picture and the village head dyke and a variety of shelters on the hillside beyond. On the wall was a coil of rope and some dead fulmars and puffins, symbolic of one of the mainstays of the island economy. The woman had a white frill in front of her head shawl which, for the islanders, was a sign that she was a married woman. One of the men had a bandage around his face, perhaps a result of toothache derived from eating sweets for which the islanders were known to have a great liking in this period. Bull's-eyes and peppermint lozenges were the favourites. The people seemed at ease with the camera. They were used to having their photograph taken but they also had a clear idea of the terms on which they would pose.

Richard Kearton, the naturalist, visited St Kilda in 1895 along with his friend, John MacKenzie Jnr, then the factor to the island. They were accompanied by Richard's brother, Cherry, a photographer, who had an important place in the history of ornithology, turning the study of birds into something which

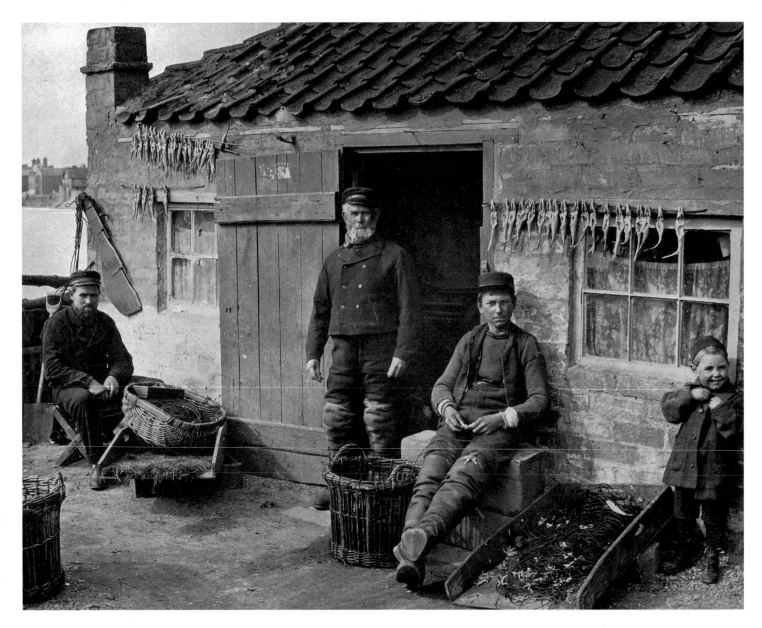

FISHERMEN, ELIE

required a camera rather than a gun. He also took many photographs of life on the island:

> It has also been said that the people expect to be paid for having their photographs taken. The men never objected to our photographing them, nor, so far as I could gather, expected anything for allowing us to do so . . . I was anxious to obtain two pictures in order to show the difference in the head-gear worn by married and single women, and offered half-a-crown each to anybody who would sit; but to my surprise no one would consent, and it was only by strategy, and a positive assurance that their portraits were not being taken to make fun of them that we succeeded in obtaining what we wanted.

Kearton gained two very fine portraits of a married and an unmarried woman but he never did get a picture of the women milking the ewes on the hillside for they were sure that people who saw such pictures would laugh at them.

The St Kildans had a very distinctive relationship with their visitors. Since the early voyages of exploration Europeans have always identified 'primitive' peoples with virtue unspoilt by civilisation. Norman Heathcote, another naturalist who visited in 1900, was clearly attracted by this:

> To people living in the midst of the turmoil and bustle of London life, it seems almost incredible that there should be a place within the confines of the British Isles where not only is there no telegraph or railway, but not even a road or a horse . . . where drunkenness and crime are unknown, where no policeman has ever been seen, and a doctor rarely comes.

There were dangers in this and the St Kildans were always threatened with a degrading loss of control. George Seton, an Edinburgh visitor, quoted a claim that 'the St Kildans may be ranked amongst the greatest curiosities of the moral world'.

Heathcote, who stayed on the island with his sister for some time, noted their suspicion of outsiders:

> I do not wonder that they dislike foreigners, so many of the tourists treat them as if they were wild animals at the Zoo. They throw sweets to them, openly mock at them, and I have seen them standing at the church door during service laughing and talking, and staring in as if at an entertainment got up for their amusement.

None the less, by 1900, tourism was a well-established part of life. The *Dunara Castle* or the *Hebrides* called once or twice a month in the summer leaving Glasgow on Thursdays. The fare including meals was 4 guineas. When tourists arrived, the men were prepared to put on a show for them but on terms set by the islanders and that meant a display of sea bird hunting on the cliffs around the islands and involved a calculated degree of showmanship. Matters were organised by the minister:

> three or four men from different parts of the cliff, threw themselves into the air, and darted some distance downwards . . . They then swung and capered along the face of the precipice, bounding off at intervals by striking their feet against it . . . we could see them waving a small white object, which we might have taken for a pocket handkerchief, had we not been told it was a feathery fulmar . . . A purse of a few pounds was raised by the party in the *Dunara Castle* . . . to compensate the cragsmen who illustrated the danger of their calling . . . the money was handed to the minister, with a view to his distributing it among them. The tourists were a minor source of income and were sold seabird eggs and knitted goods by the islanders.

Then there were the fishing pictures. They were again made for us by the eternal triangle of photographer, subject and audience/purchasers. These photographs have many layers. There was an

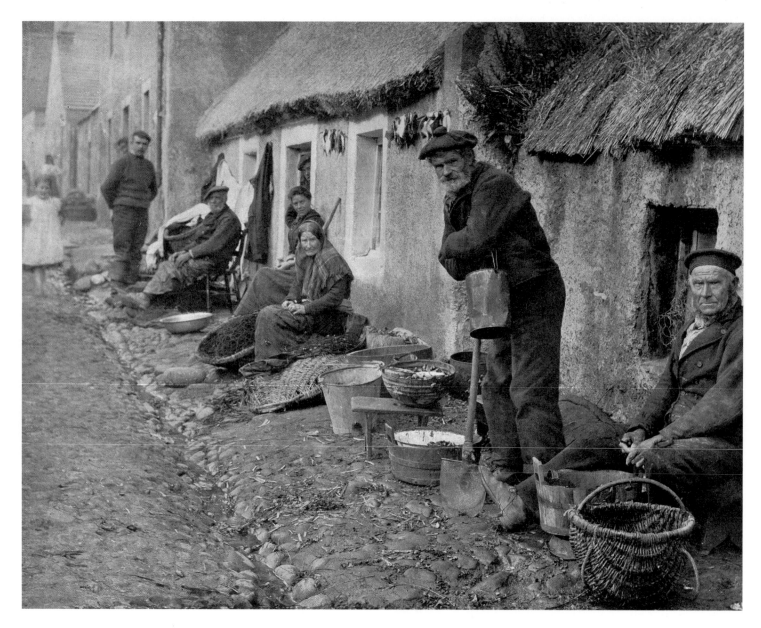

FISHERTOWN, CROMARTY

authenticity of clothing and equipment. They were also carefully staged and selected. These pictures provided access to a community often thought of as closed and apart. They were some of the few pictures in the Valentine–Leng collection which presented people in a working environment.

In part, fishermen were photographed because they were visible in places that attracted visitors and residents for leisure and holidays. James Bertram's much reprinted account of *The Harvest of the Sea* was often well-informed and perceptive, but he was an observer writing for an audience. His language emphasised that fishing people were different and well worth looking at: 'Used up gentlemen in search of seaside sensations could scarcely do better than take a tour among the Scottish fisher-folks . . . the quaint people. There are scenes on the coast worthy of any sketch book.' It was no accident that ELIE was chosen as the location for one of the pictures. Elie had long ceased to be an important fishing port, although its sheltered bay could be an important refuge for Fife boats escaping a storm. Elie was a thriving holiday and residential place with a fine audience for fishing scenes. The Elie picture was a prosperous picture. The men were well-fed and well-clothed. They were dressed in heavy work clothes but work clothes in good repair. They exemplified the claim that 'their idea of bodily comfort consists in having on a superabundance of clothes. Even during the warm months of July and August, whilst working hard in hoisting their catch to the carts on the quay, it is ridiculous the amount of clothing they have on them.' The picture was staged with great skill. The men were comfortable, if stern, in front of the camera. The three generations of males were a reminder of the family basis of the industry. The equipment for baiting the lines was laid out for the camera. The long line was baited with starfish. The man seated in the centre helpfully placed one on his knee. One aspect of the staging was the central position given to the four males whilst every account available suggested that it was the women who actually attended to the cleaning and baiting of the lines. The dried fish on the pantiled building where they were working were one of the key products of the industry. Elie was a great place for a photograph but Bertram and others went to places like NEWHAVEN and Buckhaven for a fuller account:

There is in the 'town' an everlasting scent of new tar and a permanent smell of decaying fish . . . Up the narrow closes, redolent of 'bark,' we see hanging on the outside stairs the paraphernalia of the fisherman . . . nets, bladders, lines, and oilskin unmentionables, with dozens of pairs of those particularly blue stockings that seem to be the universal wear of both mothers and maidens. On the stair itself sit, if it be seasonable weather, the wife and daughters, repairing the nets and baiting the lines – gossiping of course with opposite neighbours, who are engaged in a precisely similar pursuit; and to-day, as half a century ago, the fishermen sit beside their hauled-up boats, in their white canvas trousers and their Guernsey shirts, smoking their short pipes, while their wives and daughters are so employed, seeming to have no idea of anything in the shape of labour being a duty of theirs when ashore. In the flowing gutter, which trickles down the centre of the old village, we have the young idea developing itself in plenty of noise, and adding another layer to the incrustation of dirt which it seems to be the sole business of these children to collect on their bodies. These juvenile fisher-folk have already learned from the mudlarks of the Thames the practice of sporting on the sands before the hotel windows, in the expectation of being rewarded with a few half-pence. 'What's the use of asking for siller before they've gotten their denner?' we once heard one of these precocious youths say to another, who was proposing to solicit bawbees from a party of strangers.

. . . there are few houses among the working population of Scotland which can compare with the well-decked and well-plenished dwellings of these fishermen. Within doors all is neat and tidy . . . the house I was invited to was the cleanest and the cosiest-looking house I had ever seen. Never did I see before so many plates and bowls in any private dwelling; and on all of them, cups and saucers not excepted, fish with their fins spread wide out, were painted in glowing

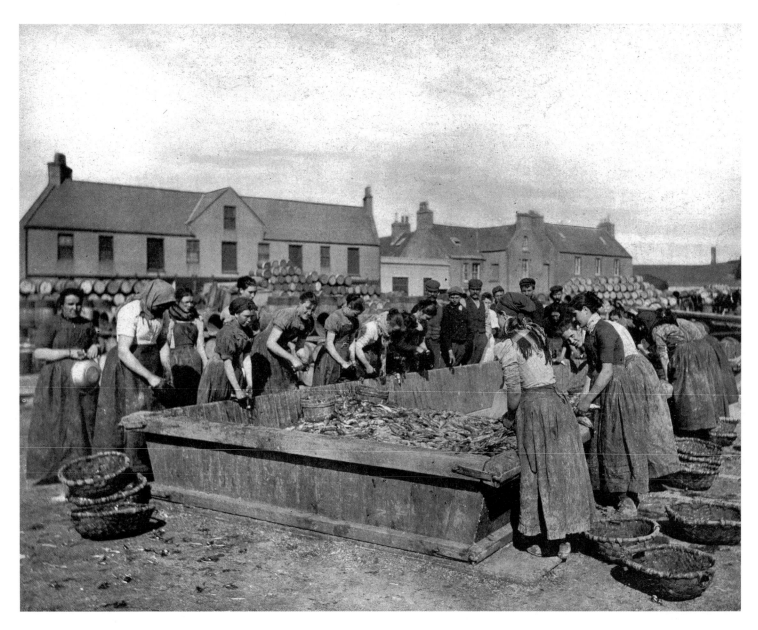

HERRING GUTTERS, STORNOWAY

colours; and in their dwellings and domestic arrangements the Newhaven fishwives are the cleanest women in Scotland.

The picture of the fishertown of CROMARTY was by no means so relaxed. The story had much in common with Elie. The man in the foreground was opening shellfish ready for bait. Another man was leaning on a bait spade which had perhaps dug the shellfish being opened. Beyond them was a woman in a shawl who was baiting the line from the skull by her side. At first glance, this was a picture of poverty and lack of content. The faces were lined and unsmiling. The houses were thatched and mud lined. At a second glance, the picture becomes more complicated. Thatch and mud walls were well adapted to the environment and many thought them easier to keep warm than more 'modern' houses. Out of focus in the background appear to be younger and fitter men and women. Did Valentine choose the older faces because they fitted his view of how Highlanders ought to appear, and did the unsmiling faces represent the barrier between the Highlanders and the man from Dundee with the camera?

The photograph of the herring gutters working at STORNOWAY was a fine picture of the collective cheerfulness of women working together and the harsh: messy nature of their work. Their task was described in some detail by W S Miln in the prize essay published for the International Fisheries Exhibition of 1883.

'Gutters' are those engaged to gut the herrings on their arrival at the curing-yard. Women are employed as gutters. The fish-curer engages a 'crew' of women for each boat. A crew consists of three persons. Two gut, and the other one packs the herrings gutted by them. There are over 20,000 women employed during the season. Their wages are at the rate of *3d.* per barrel, gutting and packing, per crew. Those who are fortunately with a curer having a large average make a good sum of money for the season, but there are also those unfortunately with a curer with a poor average, and therefore their wages are comparatively small. The gutting of herrings is a laborious occupation. It is common in a yard to hear women singing cheerily at their work, they having commenced at mid-day and continued work in the same bent-figured attitude till the early hours next morning. Once commenced, there is *no* stoppage till the finish . . . When the curer engages the gutting women, they are paid 'arle' money of from *35s.* to *55s.* each woman, according to their known qualifications as 'gutters' . . . Immediately on the herrings being delivered by the carter at the yard, and deposited or 'tumbled' into the farlin, i.e. gutting-tub, the coopers are careful to sprinkle them well with salt. This sprinkling of salt – called 'rousing' – preserves and revives the condition of the herrings while they are being gutted. The gutting women lose no time in commencing their work. With their short knife in the right hand, and the herring in their left, they, by a dexterous and experienced movement, withdraw the viscera and gills. . . . First-class cured fish keep beautifully clear and free from smell for nine or twelve weeks.

It was a hard and sometimes uncertain way of making a living. The day began for the women by bandaging up their fingers to reduce the injuries from the salt and the gutting knife. Accommodation was crowded and rough, but memories of this annual migration, which lasted into the middle of the twentieth century, were positive ones of women together, away from home. The photograph reflected this as the group opened out to stage a picture which looked into the farlin or gutting tub. There was a good-natured acceptance of the camera, one woman even bending forward to ensure she appeared on the final plate, although another young girl stands rather stiffly as if the only thing she knew about being photographed was that she must not move.

These pictures were different from the engravings in many ways. They were real. They were real people. The objects in the pictures were real objects which were used in work and home. There was an authenticity which gives access to a culture that was

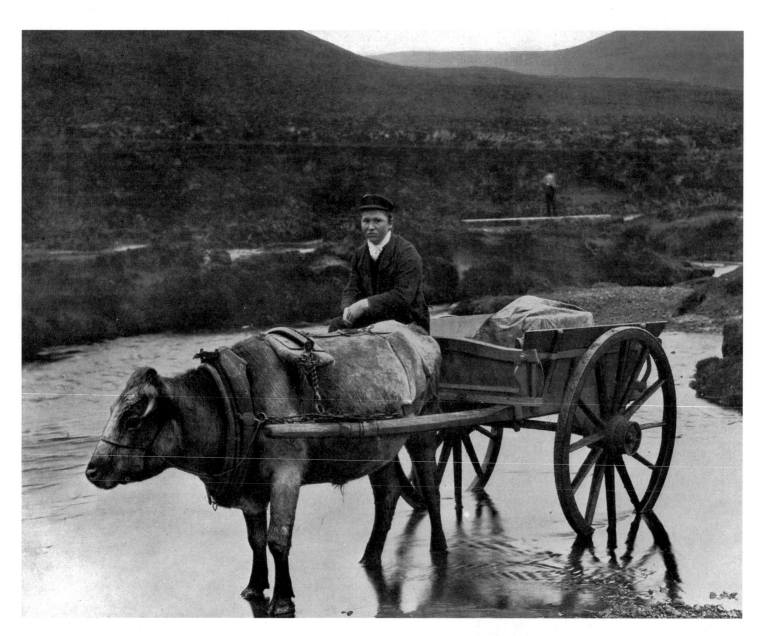

OX CART ON HOY, ORKNEY ISLANDS

distant from many purchasers. At the same time the pictures were staged. People posed and were arranged in a drama presented to the camera and the viewer. Then there were the more intangible forces which directed the camera to point one way rather than another, at one group rather than another.

Fishermen were much photographed because they were accessible and easy to view in a way that weavers, coal miners and even clerical workers could never be. They also represented an elemental confrontation with the sea. Here were the sort of emotions which the picturesque guides and romantic poets had long taught their audience to value. Fishwives bargaining with purchasers were notorious for exploiting this: 'Fish are no fish the day, they're just men's lives.' Leng's text was full of stock phrases about fishermen and fishing: 'Hardy sons of toil . . . at the cost of toil and peril . . . battling with the wind and waves'. Like all effective rhetoric, it had a hard reality which was brought to the newspaper press during the storms of winter. The image of the fisherman had an especial appeal to the Victorian and Edwardian idea of what a man ought to be. Fishermen were independent, hard working, strong and courageous in the face of danger. They were men of virtue. Frequent reference was made to their religious habits and regretful ones to evidence of drinking. Some of this interest was guided by a popular literature. Annie S Swan wrote about the villages of Fife and Hugh Miller's *My Schools and Schoolmasters* and *Scenes and Legends* were frequently reprinted and led readers to his native Cromarty. Religion was also a silent theme. Few Scots would be ignorant of the fact that the national patron saint, Andrew, and other disciples were fishermen and that the Christian religion was saturated with fishing metaphor.

There was a surprising lack of scenes of agricultural work so common in the staffage of D O Hill's paintings. This extract from the engraving of the painting of Sanquhar gave quite a detailed account of harvesting with the sickle.

Characteristic was the photograph of the ox cart on the island of HOY in the Orkneys. Oxen were indeed widely used for ploughing, for pulling stone rollers across the field as well as for transport. Leng's text was significant: 'Life in Hoy is primitive as the picture suggests but it has its charms and even comforts.' The expression on the young driver's face suggested that charm was not his dominant reaction to being made into an object for the camera and being asked to stop in the middle of the ford in a bleak imitation of Constable's *Hay Wain*. This fascination with the primitive ran through several of the pictures. Although fishermen were very much sought after, it was the drifter and line fishing that was valued, with not a steam trawler in sight. St Kilda was not just a curiosity but an icon of something fundamental to Scotland: 'an industrious Gaelic speaking community', as Leng labelled them.

The complexity of what was happening was expressed in a

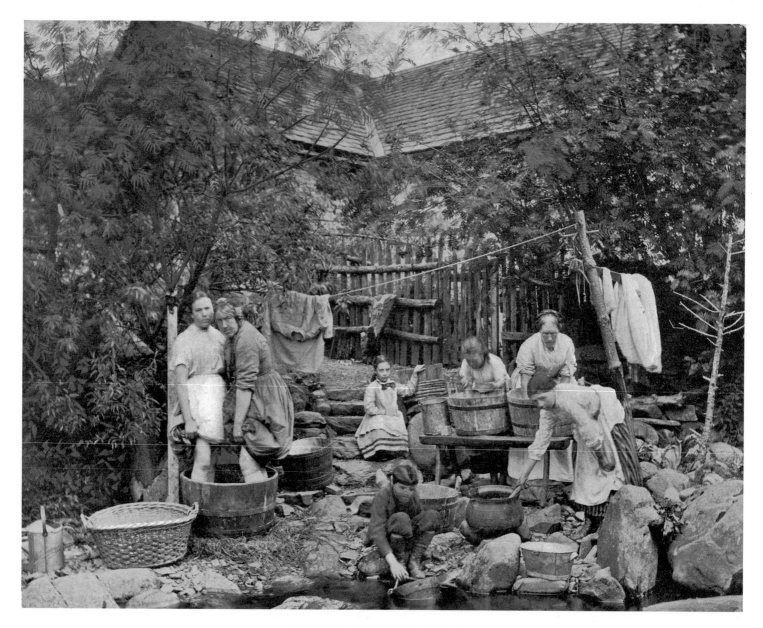

WASHERWOMEN WORKING OUTDOORS

series of lectures given in 1876–78 by Arthur Mitchell, Commissioner for Lunacy for Scotland, Professor of Ancient History to the Royal Scottish Academy and Secretary to the Society of Antiquities of Scotland. They were called *The Past in the Present,* a theme which he illustrated with an account of a woman spinning wool on the island of Fetlar with a spindle whorl made from soapstone found on the beach and looking just the same as ones found on many ancient archaeological sites.

> I had seen this possibly ancient thing in process of being made, as well as largely in actual use, in the corner of a country which is in the very front rank of progress. The most primitive of all known methods of spinning is thus found holding its place among a people who have for generations been spinning by the aid of the most complex machinery, – an art in its rudest state, side by side with the same art in its greatest perfection, both practised by the same people, the same in race, the same in capacity, the same in civilisation, and, from many points of view, the same in culture.

He taught his audience to value 'arrangements which seem rude and primitive, but which are in reality admirably adapted for their purpose'. He noted that 'the handiwork of the rude . . . becomes an object of veneration in countries with a high civilisation', and warned that, 'The mental power of those Scotch women who still use the spindle and whorl, is not a whit inferior to that of those who do not use it.' Placing value on this primitive culture was a way of responding to rapid change. He found a 'harmony' in such practices and associated objects and 'found [them] in harmonious companionship with other objects and practices, equally disclosing the past in the present'. This was part of a European movement that went beyond photographing 'natives'. Nordic countries were leading with the establishment of folk museums like that at Skansen in Sweden. Miss I F Grant was developing the interests that would lead to the establishment of the Highland Folk Museum. These interests could result in the sort of exploitative curiosity which the St Kildans feared. At its worst, it became

linked to racist and ethnic nationalism but, at its best, folk life studies placed a value on the material culture and practices of the past and their survival into the present, and that was why the ox cart rather than the best practice horse plough team featured in Valentine's collection. The third edition of Henry Stephens's *Book of the Farm* was published in Edinburgh in 1903. The detailed drawings of the mechanical reaper-binders drawn by teams of powerful horses were a world away from Hoy and of little interest to those who purchased pictures and postcards.

The picture of a group of women washing clothes on the bank of a stream or river was first registered in 1878 but continued in production as a colour postcard into the 1900s. At one level, it was a simple response to a widespread practice which Leng's text warned 'was not confined to the Highlands'. The text celebrated the romance of the primitive in the present: 'No damp wash house or steamy kitchen here: Nature has laid the floor and provided a water supply, and the sweet heather-scented air blows freely around the busy workers.' It was also not only a response to the nineteenth-century male's liking for watching women working but also to a more general assertion of the lack of dignity involved: 'Two women are seen treading or tramping the clothes, an operation necessitating some little display of native beauty.' The photograph itself was expertly staged, with every part of the process, from taking water from the stream to the shirts hanging on the

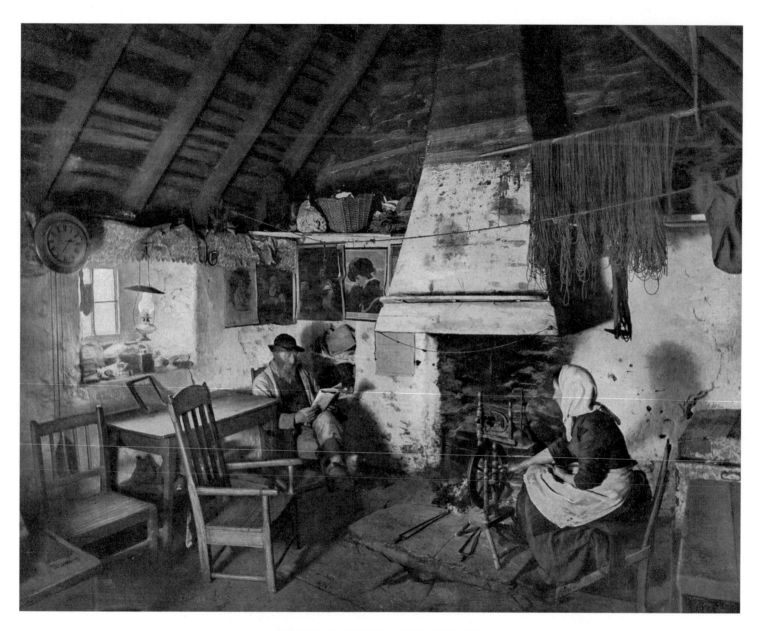

INTERIOR OF CROFTER'S HOUSE, SHETLAND

line, set out in a smooth narrative. Even the social class dimension was there in the person of the little girl in the centre. Was she the photographer's daughter or did she come from the 'big house'? The theme of washing by the stream was not new to Valentine. D O Hill's staffage for his painting of Irvine showed a different, rather kinder, version.

Superficially, the picture of the interior of the crofter's house in Shetland was an appeal to the exotic, the different and the primitive. The stone-flagged floor and the hinging lumb were very different from the experience of most urban purchasers. The picture was also a universal one of a man and a woman by the fire. It was a perfect representation of the domesticity which the nineteenth century had created. This was a well-furnished house with table and characteristic Shetland chair, probably locally made. The wag-at-the-wall clock, probably with an American-made mechanism, was a sign of a certain level of prosperity in the house. The man took his leisure in the home, although the signs of his work and prosperity were all around him. The short lines for fishing hung on one side of the fire and a basket of dried fish was shelved on the other side. The woman worked in the home with the eternal symbol of the spinning wheel in front of her. It was a literate household in contact with a wider Scottish and London-based culture. The man was reading his newspaper and the wall behind him was decorated with pictures from one of the illustrated papers, possibly *The Graphic*. These papers produced as supplements full-page illustrations with titles such as 'Portrait of a Lady' or 'Silvia . . . Shakespeare's heroines', showing women in period or fashionable dress (including hats). These were the pictures chosen here rather than the illustrations of military and imperial splendour that were also favoured in that decade.

The picture appealed to the sense of the past in the present described by Arthur Griffiths. He described a house, much poorer in quality than this one, on the island of Lewis, where a woman manufactured Craggans, which were hand-made clay pots baked by the fire:

> We saw in it [the house] cottons from Manchester, crockery from Staffordshire, cutlery from Sheffield, sugar from the West Indies, tea from China, and tobacco from Virginia. In that house, nevertheless, these rude Craggans were made for sale. They were abundant in it, and were largely in actual use, as indeed they were also in many of the houses of the townships round about. Here, then, was a woman, living in a wretched and perishable hut, built without cement, of unquarried and unshaped stones, busily manufacturing just such pottery as was made by the early prehistoric inhabitants of Scotland, – just such pottery as is now made by some of the most degraded savages in the world; yet her comforts and wants were ministered to not only by the great towns of England, but by the Indies, China and America.

Here, indeed, was the harmony which Griffiths and others were seeking in a period of rapid change.

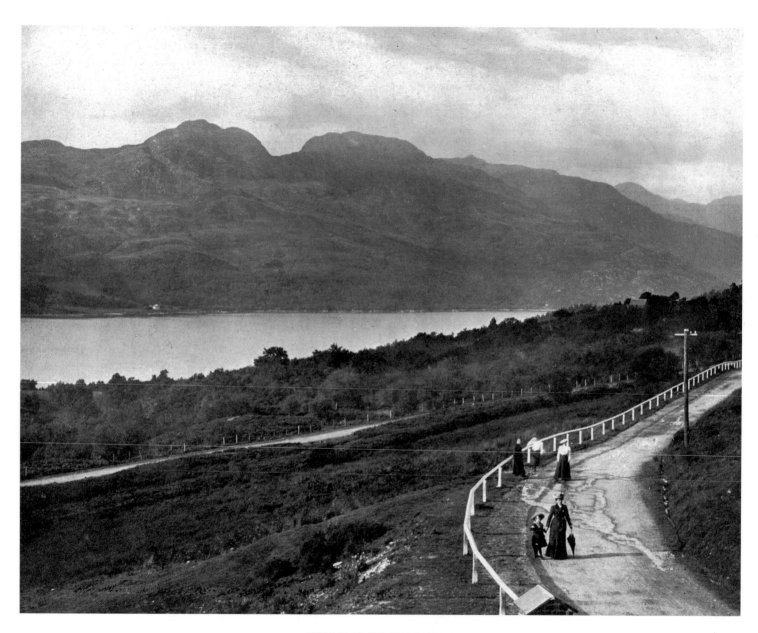

ARDKINGLAS AND 'THE SADDLE'

CHAPTER 17
Tourists in wild places

The population of Valentine's pictures was not entirely dominated by fishing people. The most important group were the tourists themselves or, as they were more often called, the 'holidaymakers'. Holidaymaking was a more active sort of activity. The holidaymaker could come from nearby Glasgow or Dundee as much as from England or further away. Holidaymaking was about enjoyment. The clerks, shopkeepers, miners, weavers and foundry men might appear to be absent from the pictures, but they almost certainly appeared dressed for the occasion as tourists and holidaymakers. They were the principal actors in their own performance. It was the task of those who made holiday places to provide them with the stage. This lady, dressed fit for a church parade, posed for Valentine at Ardkinglas by Loch Long, not because of the ancient castle, but because of the 14,800 acres presented by Mr A Cameron-Corbett, MP to the citizens of Glasgow, for 'recreation'.

These pictures were created and bought in 1907 because of the improvements in quality and accessibility of photographs in the previous 20 years. The new mass market for photographs had not killed the oil painting or the colour reproduction prints of oil paintings, which was the mass market

201

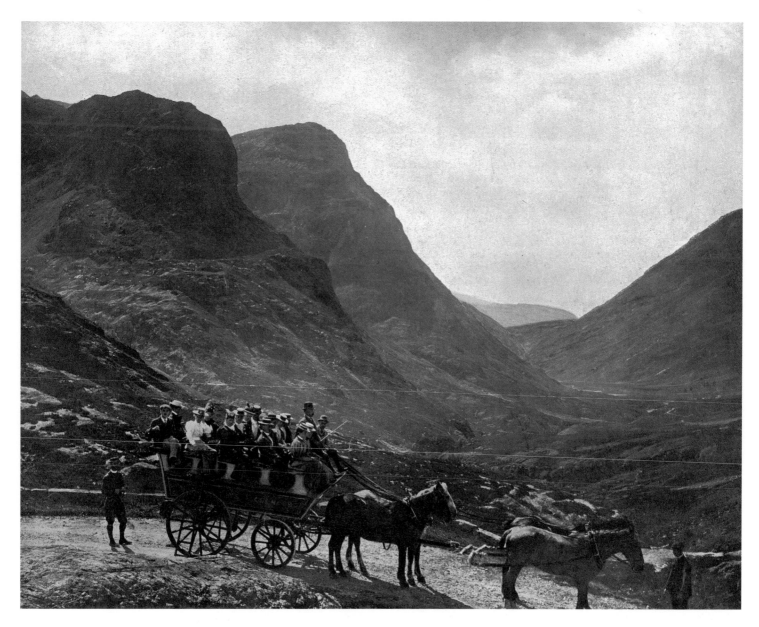

GLENCOE FROM 'THE STUDY'

GLENCOE. 239

through Glencoe in about 4 miles, after crossing a *col* of 1,484 feet. By adopting this the pedestrian saves 6 miles.

Our road next passes under a fine purple boss on the right, called " Sunny Peak," beyond which a tributary valley opens to *Stob Ghabhar* (3,655 *ft.*). Then, with the crags of Buchaille Etive on the left, we enter the Glencoe road a mile west of **King's House Inn** (greatly improved). There is usually an *al-fresco* refreshment-stall here. Far ahead, across the *Black Moor of Rannoch*, the peak of Schiehallion is seen—in shape like Snowdon from Portmadoc.

Kingshouse Inn to Fort William by the Devil's Staircase. 25 *m.*, 10 *hrs.* This track diverges to the right from the Ballachulish road 3 miles from Kingshouse, at Altnafeadh. It first climbs to a height of 1,800 feet, and then descends to *Kinlochmore* at the head of Loch Leven. From the highest part there is a fine mountain panorama. At Kinlochmore are large water-power works in process of erection, which will make this spot quite a hive of industry. From here a cart-track, passing several farmsteads, goes all the way to Fort William. Near Kinlochmore the Rev. Mr. Mackonochie perished in the winter snows of 1887–8.

Hence the first part of the way to Ballachulish is bare and wild. Notice the splendid cliffs of Stob Dearg—the highest Shepherd of Etive—on the left, towering above the road. After ascending a little we enter **Glencoe**. The best view of it is obtained from a parapet called the " Study," about 5 miles from " Kingshouse," and a short distance beyond the watershed, which is 1,011 feet above the sea. There are many valleys in Scotland which may vie with Glencoe in sterility and desolation, but none in the combination of those two attributes with that ruggedness which is produced by the preponderance of bare rock. The general angle of the hillsides also is extremely steep, giving the whole glen a very wild and precipitous appearance. The three towering peaks on the left are sometimes known as the three " Sisters " of Glencoe —" Faith, Hope, and Charity." Just below the " Study " is a pyramidal cairn of rough stones set up in memory of the late Dugald Stuart of Dalness. Some way down the glen we notice *Ossian's Cave*, a narrow slit high up on the left, occasionally visited by expert climbers. It is really not a cave at all, but a sort of gully set at a very high angle ; and Ossian certainly never was there ! And then, beyond a farmstead, we come to *Loch Triochatan*. The Glencoe Inn (*Clachaig Inn*) is placed at an angle of the glen and near the scene of the massacre—a green, hillocky spot marked by a rude dwelling or two. Between 2 and 3 miles further the shores of *Loch Leven* are reached near *Invercoe Bridge*. The peaked summit on the right hand, overlooking the loch, is the *Pap of Glencoe*. Between Invercoe and **Ballachulish Hotel** (first-class) the road is spoilt from a picturesque point of view by the vast and busy slate-quarries of Ballachulish *village*, after passing which, however, it again reaches a high degree of unmarred beauty. The *pier* at Ballachulish is nearly a mile beyond the hotel. For return to Oban, see *p.* 161. For *Ballachulish Railway, see p.* 242.

g...

Main Route continued p. 218.

Excursions from Ballachulish.
(Map opp. *p.* 239.)

(1.) **Glencoe and back** (18 *m.*) by coach.* *Fare, 5s. 6d.* Open conveyances leaves Ballachulish pier on the arrival of the morning steamer from Oban, and return in time for the afternoon one which reaches Oban about 7. Ample time is allowed at Ballachulish both going and returning for refreshments. The glen is traversed to within 2 miles of the "Study." Passengers proceeding thither on foot can return by the afternoon coach (if there is one). Best to walk back to *Glencoe Inn*.

Leaving *Ballachulish Pier* the road skirts Loch Leven for nearly 3 miles to the *Ballachulish Slate Quarries*, a teeming hive of industry, but an effectual marrer of the picturesque. In front is the *Pap of Glencoe*, the northern warder of the glen itself, which is entered in another mile at *Invercoe Bridge*. Here the road turns to the south-west, and for 3 more miles ascends gradually the wider and more cultivated part of the valley to (7 *m.*) *Glencoe Inn*, a little short of which on the right hand a knob of rock on a green mound, feathered with alders, is pointed out as the "Signal Rock" from which the order was given for the massacre. Hence the road turns east, and the wilder features of the glen reveal themselves at once. Cultivation almost ceases, and the trees may be counted on the fingers. The mountains come down in almost sheer rocky declivities on both sides, broken by deep ravines. The highest, if not the steepest of them, is *Bidean-nam-Bian*, on the south side. Presently the desolate *Loch Triochatan* is reached, beyond which, after passing the last farm, the ascent is in places very abrupt. High up on the left is the *Chancellor* ; on the right *Ossian's Shower-bath* and *Ossian's Cave*. The best view of the glen is obtained by looking down from a stone parapet at the top of a steep slope about 4 miles beyond the *Clachaig Inn*. This point is called the **Study**. From it the three peaks—*Faith, Hope and Charity*—are the features. Just below it is a rough stone pyramid, in memory of Dugald Stuart of Dalness.

The word *Glencoe* signifies the "valley of weeping," and the appositeness of the name is proved by the fact that the scene is much more impressive in storm than in sunshine.

* Rail (*p.* 243) as far as the slate quarries (2½ *m.*).

equivalent. Indeed the two could work together. It was possible to buy an album of reproductions of paintings of favourite tourist spots and then insert photographs of self and family. The Loch Katrine painting here was by an American artist, Alfred de Bréanski. It came from an album produced by a German company, TJSS and Co. probably one of Valentine's rivals. The photographs were two of the many *cartes de visite* made for friends and family since the 1860s. The gentleman was a studio portrait taken in Glasgow whilst the lady with her holi-day hat may or may not

have been outdoors. The album itself inclu-ded Grasmere, Blarney Castle, Cork, Snowdon, the Trossachs and Killar-ney. Bound in imitation leather with thick pages and a metal clasp, it looked a little like the family Bible. It certainly had the air of the sacred and special.

One of the great events of the holiday was 'The Pass'. This group perched in their charabanc are looking at Glencoe from 'The Study', one of the approved viewpoints, or they will be doing so when they have done turning their heads for Valentine's camera. Baddeley liked Glencoe but he was his usual sardonic and well-informed self with a few warnings.

1907 was a good year to take a holiday. The violence of the trenches of the Great War, of Ireland and even of the great campaigns for women's suffrage was yet to engulf the performers in these photographs. The modern world was held at bay for a moment. Baddeley could still have a chuckle over Ossian and direct his readers to the correct viewpoints like an eighteenth-century guide. Everybody wore a hat, the women dressed so never an ankle was on show and there was not a motor car in sight,

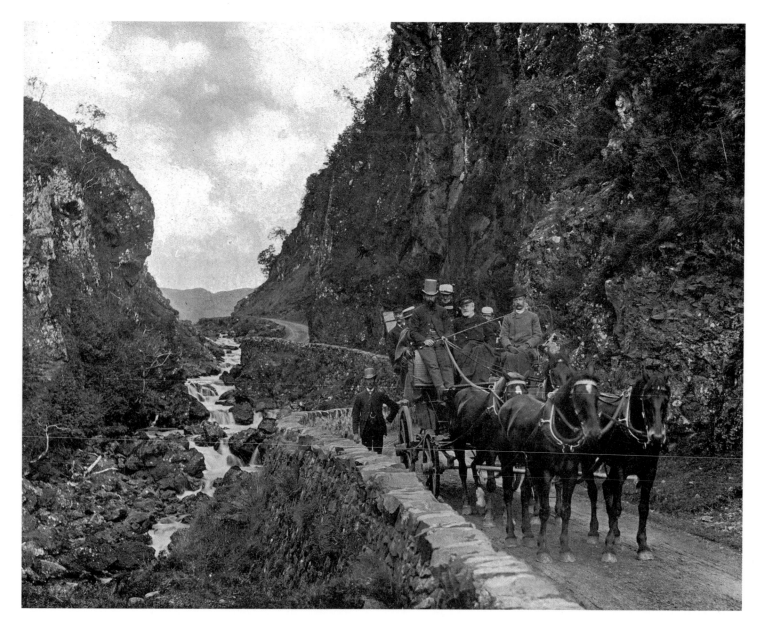

MELFORT PASS, NEAR OBAN

(2.) **Oban to Ford by the Pass of Melfort (coach) ; returning to Loch Awe (steamer) and Oban (rail).** Map p. 224.

Oban to Kilninver, 8 m.; Kilmelfort, 16 ; Kintraw, 24 ; Ford, 30. Good Hotel at Cuilfail (Kilmelfort).

Coach every morning in connection with afternoon steamer down Loch Awe, and train from Loch Awe Station to Oban. Fares for the round, abt. 17s. and 15s. 6d. An additional Coach to Cuilfail and back.

The road portion of this route has no pretension to grandeur. The hills nowhere along it exceed 1,200 feet in height, but it threads a succession of wooded glens, and skirts a couple of picturesque sea-lochs, and taken in connection with the sail down Loch Awe and the return by train from Loch Awe station to Oban, forms a by no means uninteresting portion of a very interesting day's tour. According to the time-bill the entire circuit takes about ten hours.

For the route as far as the head of **Loch Feochan** (3½ m.) *see* p. 230. Thence the road skirts the south shore of the loch as far as *Kilninver*, whence it ascends *Glen Euchar*, and after crossing the wood-fringed River Euchar, and affording a view of Mull, passes through another prettily wooded glen, succeeded by a bare upland valley, to the beautiful **Pass of Melfort.** This is a deep, narrow ravine, finely flanked by rock and wood, and quite the *bonne bouche* of the journey. The road goes high above it, and then drops to the **Cuilfail Hotel** (*mail-coach to Lochgilphead daily, 23 m., 6s.*), a comfortable house.

The return coach leaves Ford about 1.30 p.m., after the arrival of the boat which sails up the lake in connection with the morning train from Oban.

although Leng's publication had an advertisement for Daimler Cars, founded 1904, with an assurance of 'unparalleled success in all the principal genuine Hill Climbs, Races and Trials'. Valentine chose from a photograph of 1898 in which the well-dressed passengers were in the care of four sturdy horses. The coach trip from Oban recommended by Baddeley started with a train ride to the slate quarries and stopped two miles short of 'The Study' so the really keen appreciators of the view had to walk. The customers were likely to be fairly select as the fare was equal to a day's wages for most skilled men.

The 1908 Baddeley informed his readers, without comment, that 'a motor car now runs from N. Ballachulish to Fort William 2 or 3 times a day by Onich and Corran Ferry', but those who wanted to be part of the excitement of the modern world could call in at an increasing number of photographic studios and have their holiday pictures taken in an 'aeroplane'.

The trip along the Pass of Melfort to the south of Oban was a little more benign than Glencoe but still a substantial task for four horses. The passengers, exposed to a natural air conditioning, came well prepared with rugs and the lady at the back with a veil. The informed tourist had a combination of steamer and coach available.

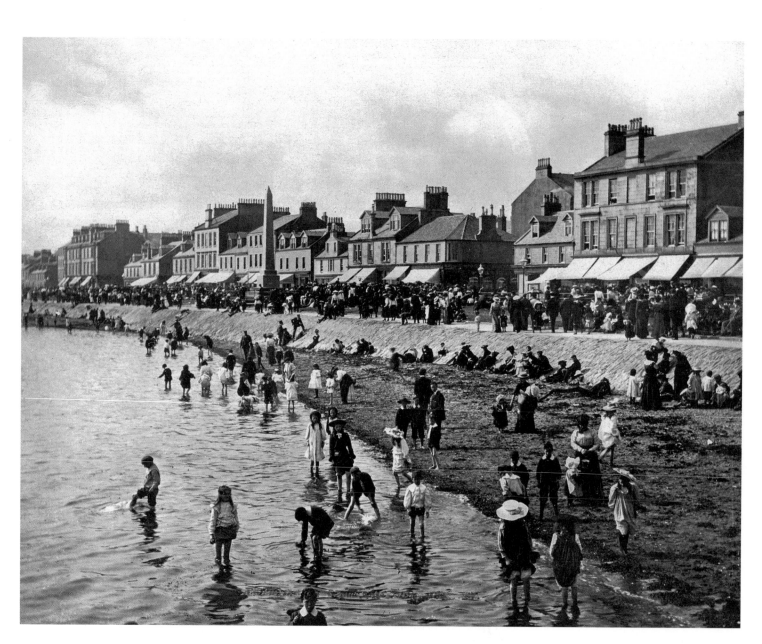

HELENSBURGH FROM THE PIER

CHAPTER 18
Paddling and golf

One topic on which the Scots and the English of the 1900s might agree was that real holidays were seaside holidays. By 1907, the seaside holiday had grown up and, within limits, had become democratised. Like tea, the seaside holiday could be taken in different ways. Some might stay in a favoured hotel for a fortnight, whilst others looked to the landladies of well-regulated boarding houses. The less well-off would be content with the day trip by train with those specific Scottish variants, the PORTO-BELLO tram and the steamer trip 'doon the watter' from Glasgow's Broomielaw Quay. Some of the true skills of the seaside holiday-maker were shared by all, how to build a shelter against the on-shore wind, how to roll up trousers for paddling or bathe with comfort and decency. It was possible to suggest that the holiday was a matter of health, of breathing in the sea air, or collecting shells and seaweed in the certain knowledge this was educational, but the real attraction of the seaside was the sense of freedom that it brought and this is where Miss Isa Cummings re-enters the story.

HELENSBURGH was always presented as a 'fashionable town'. Valentine claimed it as a miniature Paris, 'so beautifully is it laid out, and so plainly does it exist for wealthy leisure. It is largely the abode of Glasgow's moneyed men . . . fine dwellings, set often in charming grounds'. It was laid out by Sir James Colquhoun in the late eighteenth century with a well-ordered rectangular plan. Terraced houses and the paddling, promenading holidaymakers dominated the seafront. Behind were the substantial house plots and tree-lined streets of retired merchants and others who had made their wealth in Glasgow. Tucked away was Hillhouse

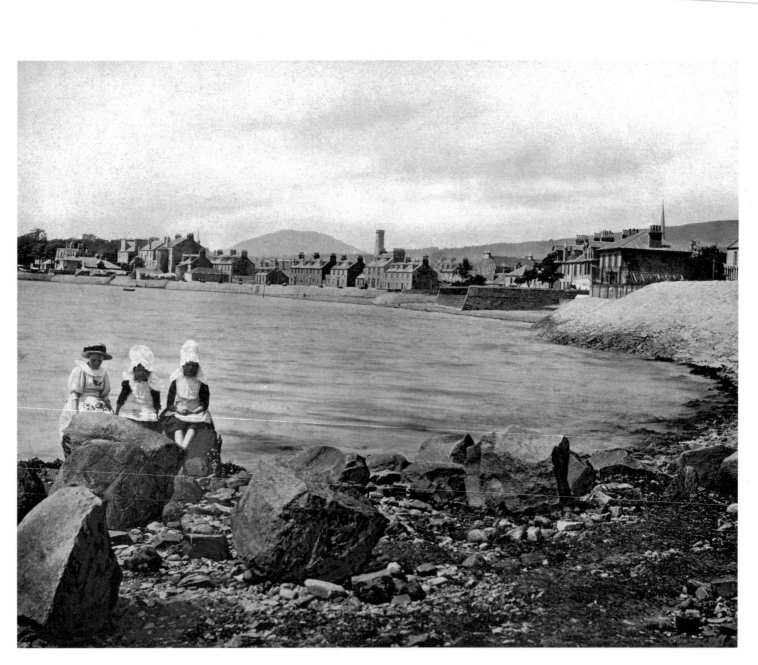

EAST BAY, HELENSBURGH

designed by Charles Rennie Mackintosh for the Glasgow publisher Blackie. Here were the gardens and the purchasers who inspired 'Glasgow School' painters like James Guthrie. The monument in the centre of the picture was the largest block of red Aberdeen granite ever set up in Scotland. It celebrated Henry Bell, who had come to live in Helensburgh where his wife kept the main hotel, 'The Baths', in 1807. In 1812 he launched the *Comet*, the first steam-powered ship in Europe. He was well worth celebrating as it was steam links to Glasgow which made Helensburgh what

it was. The railway arrived in 1857 and the excursions and regular steam services to Glasgow called at the Craigendoran pier. The pier and the rail terminus station had been built in 1880–82. The picture of the front was a respectable photograph; only children it seems were allowed to paddle, although some achieved a compromise between childhood and woman-hood by paddling in their hats. In the next picture, the three ladies sitting on the rocks are well covered with their hats and bonnets to keep their faces from sunburn, a reminder that a sun-tanned face was not yet regarded as fashionable but simply a mark of someone from the labouring classes who had to work out of doors.

Behind the photographs of the seafront were villas in the latest styles, the iconography of the new Police Burgh Town Hall, St Andrew on the gospel hall and one of the earliest cinemas in Scotland (surviving, just).

ROTHESAY allowed itself a little more bustle. Valentine summed it up neatly: 'the queen of Scottish watering places and a suburb of Glasgow'. Rothesay in 1907 was a product of the potent mixture of Glasgow wealth, building villas along the bay, followed

by a working class carried along by better railways, steamers, wages and holidays. The entry was by Wemyss Bay and the steamer to the pier with its purpose-built waiting room of the 1880s. Rothesay was a Royal Burgh with a ruined thirteenth-century castle and an industrial history of linen, cotton, leather tanning, boat building and herring curing. Its claims as a 'watering place' were based upon a Hydropathic, in 1843, the first in Scotland, and a mineral well which claimed purgative powers twice those of Harrogate. Together with the Aquarium and Museum this added the excuses of health and education to the fact that Rothesay was there for enjoyment.

Portobello had a double character. To the west of the Figgate burn were brick, tile and earthenware works exploiting an excellent bed of clay. To the east were the parts of the burgh which exploited the fine broad sands pictured by Valentine. It was a place of donkeys, ponies, bathing machines, entertainers and holiday-makers. Excursion steamers called at the pier built in 1870. There had been a rail link to Edinburgh since 1846, but for most Edinburgh people the way to Portobello was by tram, opened in 1875.

SALTCOATS was something different again. Groome's *Gazetteer of Scotland* might well explain that Saltcoats had once made its living from the salt trade and now thrived on 'the glorious salt air blowing off the Firth of Clyde' but this was easy-access seaside. It was jammed in between the fishing and coal-exporting port of Ardrossan on one side, and the colliery, foundries and explosives works of Stevenston on the other. Saltcoats was a step down the social scale from Helensburgh and Rothesay. The

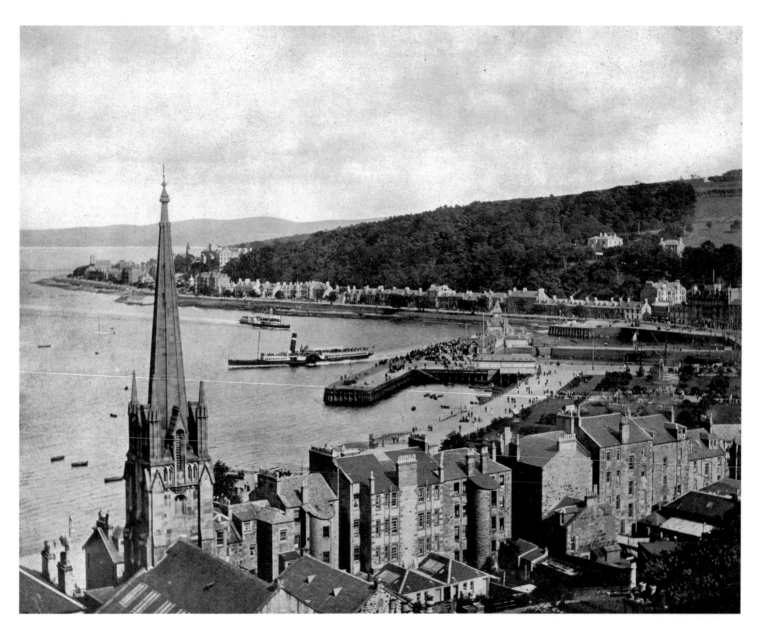

ROTHESAY

houses along the front were lower and less grand. The population of the photograph was dominated by men in flat caps; fathers taking daughters to the beach. These were people who did not pose for the camera or politely ignore, they stared with a 'what is that photographer chap doing?' expression in their body language. This was a hands-in pockets and arms-akimbo beach.

That is enough of that. Valentine presented the respectable face of the seaside. Behind all this was the drunkenness of the 'steamboats' and the fact that the alliteration of seaside was saucy. This takes us back to Isa Cumming. Miss Isa Cumming was an Edwardian young lady. Some of her correspondents addressed her as the 'post mistress' of Aviemore. Maybe she was, but we should beware of the Edwardians' love of word play and double entendre.

This was the age in which a witty young man might compliment a young lady for her good understanding, meaning that she had attractive legs. If you do not have a sense of humour which is a hundred years out of date, then think about this for a moment. Isa loved to receive and collect postcards. Amongst them was a lively correspondence with young men, which showed up the postcard as the e-mail of the age. Isa's postcards showed another side to the seaside but, like e-mails, the postcard exchange could get a little excitable. There was no way of telling what happened to that chap Nichol, to I M D and J Y. Did any of them marry Isa or were they to disappear in the trenches of 1914–18? At any rate, they left us a genteel taste of the seaside as a place of freedoms.

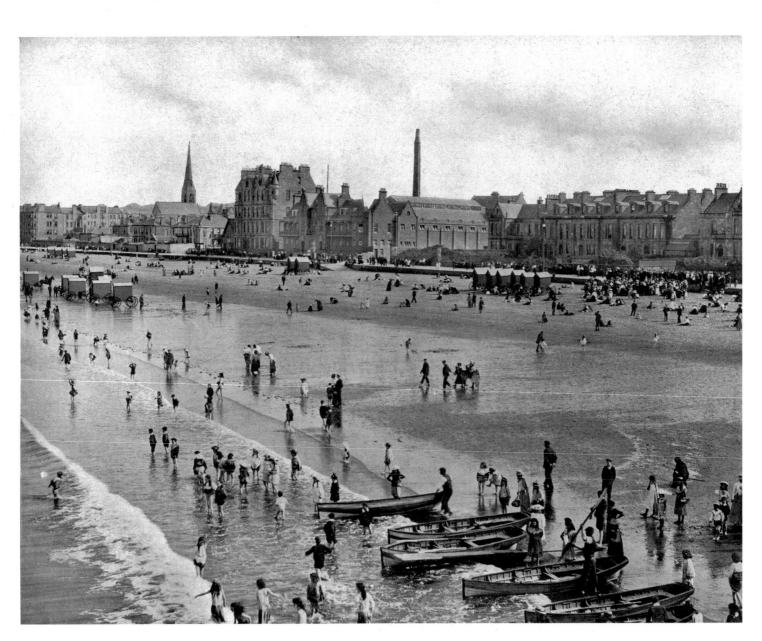

PORTOBELLO

The "PREMIER"
PICTURE POST CARD

HALF PENNY

Dear Jno, thanks for P.C. ...

Miss J. M. Cumming
To Mrs J Ross.
Cameron Cottages
Kingussie.
H. 13.

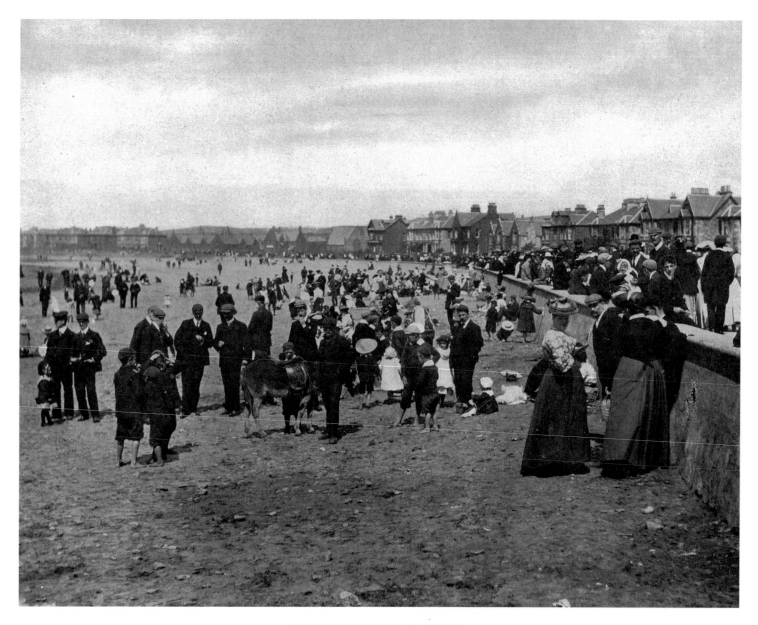

ESPLANADE AND BEACH, SALTCOATS